Motion Graphic Design & Fine Art Animation

principles and practice

Jon Krasner

ELSEVIER

Amsterdam • Boston • Heidelberg • London
New York • Oxford • Paris • San Diego
San Francisco • Singapore • Sydney • Tokyo

Focal Press

Focal Press is an imprint of Elsevier
200 Wheeler Road, Burlington, MA 01803, USA
Linacre House, Jordan Hill, Oxford OX2 8DP, UK

 Recognizing the importance of preserving what has been written, Elsevier prints its books on acid-free paper whenever possible.

Library of Congress Cataloging-in-Publication Data
Krasner, Jon S.
Motion graphic design and fine art animation: principles and practice / Jon Krasner.—1st American paperback ed.
 p. cm.
Includes index.
ISBN 0-240-80482-1 (alk. paper)
1. Animation (Cinematography)
2. Television graphics. I. Title.
TR897.5.K73 2004
006.6'96--dc22
 2004003187

British Library Cataloguing-in-Publication Data
A catalogue record for this book is available from the British Library.

ISBN: 0-240-80482-1

For information on all Focal Press publications
visit our Web site at www.focalpress.com

10 9 8 7 6 5 4 3 2 1

Printed in China

To my wife, Meagan, and to our children, Harris and Simon.

Thank you for your love, support, and patience. I could not have accomplished this without you.

"Kinetic Art is the first new category of art since pre-history. It took until this century to discover the art that moves. Had we taken the aesthetic qualities of sound as much for granted as we have taken those of motion, we would not now have music. But now, in kinetic art and animation, we have begun to compose motion. We've all been con-ditioned to viewing film as an adjunct to drama and lit-erature, as a medium for storytelling. These virtues are absolutely secondary to the kinetic fine-art end of motion composition."

— Len Lye

"Ten years ago, I tried to write my thesis in graduate school on main titles and they told me that it wasn't a weighty enough topic, and it wasn't really taught. Now I would be hard-pressed to find a curriculum in any school that didn't factor in motion graphics into a graphic-design education."

— Kyle Cooper

Contents

Acknowledgments

Writing a textbook of this nature has been an enormous undertaking. The success of this project would not have been possible without help, support, and encouragement from so many individuals.

Meagan, thank you for your love and ongoing support, patience, humor, and creative assistance during this two-year project. Without you, I could not have accomplished this goal.

I want to give special thanks to Ken Coupland for writing my Foreword. Knowing you has been a pleasure and an honor, and I hope that we have a chance to collaborate in the future.

Mom and Dad, you are two of the most remarkable people that I have ever known. You taught me that I could do anything that I set my mind on, and I love you both.

Ann and Alan Harris, your encouragement, advice, and copyediting is tremendously appreciated. Alan, the ongoing support you provided me with during periods of frustration with uncooperative technology will never be forgotten!

Ryan McKenna, thank you for your technical assistance and image development; you are a talented young man!

To my students and colleagues in the Communications Media department at Fitchburg State College, you are a unique group of individuals and a joy to work with. Each day you teach me more about the art of teaching.

I want to express my gratitude to my editors at Focal Press, in particular, Amy Jollymore and Kyle Sarofeen. It has been a pleasure working with such kind and knowledgeable individuals.

Finally, to all of those who generously contributed your work, you will serve as a source of inspiration to my readers. I am grateful to have had the opportunity to get to know each of you and hope that our paths will cross again in the future.

You have all helped me create something to be proud of!

Foreword

Ken Coupland writes about art, architecture, photography, and graphic and interior design, for an international roster of publications. A contributing editor of and regular contributor to *Graphis, Metropolis,* and *STEP* magazines, he has written for *Adweek, Critique, Elle Decor, Eye, Forbes, Form, HOW, ID, Interiors, Print, Publish, Sunset,* and *Wired.* "Screen Space," his column about design resources on the Web, has appeared monthly since May 2000 in Metropolis. He is the author of *SEARCH: The Graphics Web Guide* (Laurence King 2002) and has edited books on Web design, written and designed various Web-based works of fiction, coproduced a travelling video program and lecture on the art of film titles, and curated several exhibitions devoted to digital art and design.

What Mr. Krasner has done, with this textbook—to my knowledge the first of its kind—is to publish, in a single volume, a comprehensive guide to the entire spectrum of motion graphics and animation. This long overdue treatment of a notoriously underreported field is one that, as he points out in his introduction, encompasses both the aesthetic and technical aspects of the medium. Nothing if not ambitious in its seriousness and scope, *Motion Graphic Design & Fine Art Animation* deserves to have a long shelf life (as one would hope; it is after all, a textbook, and we should expect it to be a standard reference for years to come).

True, there have been plenty of excellent, lavishly produced coffee-table books over the years on the work of individual animators, individual films, and individual studios, but none with the broad range of contributions Mr. Krasner has brought to what is sure to become a standard reference work. And, with the dawn of the digital age, there have been a plethora of how-to books based on specific software programs that are inevitably obsolete by the time the next publishing season rolls around. This publishing landmark also follows a succession of poorly conceived and shoddily executed trade books that have tried to show without telling, by merely depicting isolated frames from a variety of sources without ever delving into the compelling artistic and technical issues underlying the work.

While I have published extensively in magazines both about motion graphics and animation, it has been in my role as a lecturer on motion picture title design that I have truly come to understand what a large and eager audience exists for this kind of work.

Touring with a program of video clips over the years, I have personally witnessed the huge and enthusiastic response from design students, educators, and professionals that Mr. Krasner has targeted with this volume. Now, too, I have an answer for all those people who have written beseeching my referrals to any definitive and informative guide to the history, aesthetics, and techniques peculiar to this fascinating medium.

It is no overstatement that the sweeping technological advances of the last few years have led to developments in motion graphics and animation that are fundamentally transforming the practice and process of visual art and design. In step with these developments, Mr. Krasner and his publishers have helpfully included a DVD whose gallery documents a score of seminal exercises in the art of motion. And that's a real bonus, because ultimately, when all is said and done it's in the actual experience of these works—complete with movement, accompanied by sound and music—that the significance of these endlessly entertaining, even visionary works of art and design resides.

Ken Coupland
kcoupland@aol.com

Introduction

Time—the fourth dimension. Its manifestations have been realized as vital forces in visual communication and fine art. Its powerful impact as a vehicle for expressing ideas has enhanced the landscape of thinking among graphic designers and artists.

Since the early 1920s, fine art has embraced the power of animation in film, installation, and performance art. Since the late 1970s, graphic design has evolved from a static publishing discipline to one that incorporates the study of animation across a broad range of communications technologies including broadcast, film and DVD titles, interactive media, and the World Wide Web. Today, graphic designers who have developed a proficiency with digital technology have the opportunity (and are often expected) to become animators, as well.

Digital media have revolutionized how animation is achieved; yet the software industry continues to advance at a dizzying rate. Because of its overwhelming pace and lack of standardization among tools, the technical proficiency that animators must acquire is challenging, if not intimidating. The river of creative ideas can run dry when so much energy is being poured into developing these skills. The objective of this text is to open the flood gates of the imagination. Here, you will find a foundation for understanding motion graphic design and fine art animation from both a technical and aesthetic perspective. You will discover references to a variety of industry standard software as they relate to common techniques such as frame-by-frame animation, key frame interpolation, rotoscoping, and nesting. Having said that, this book should not be mistaken as a software-specific guide; rather, it should be viewed as a resource to acquaint you with common principles and practices that are timeless and software-independent.

The human imagination has no limits. This book is written with the hope of inspiring artistic expression. If it succeeds in its purpose, you will discover entirely new visual possibilities and push ahead to the boundless frontiers of motion graphic design and fine art animation.

text overview

The sequencing of this textbook is critical in that its chapters build progressively from concept development and design to production and delivery. The first two chapters in Part One, "Animation in the Arts and in the Industry," discuss how kinetic images and typography have been used across various forms of visual communication including film, television, and digital interactive media. Part Two, "Concept and Design," illuminates the path in which ideas are born and developed. It fosters the creative process by providing insight into the expressive qualities of motion design, both pictorially and sequentially. Pictorial composition, as it pertains to the "animation frame" is critically analyzed in Chapter 4. Chapter 5 examines how progressive aspects of animation such as continuity and transition can be strategically choreographed. Part Three, "Animation Tools and Techniques," provides a detailed analysis of frame-by-frame animation, key frame interpolation, and animation compositing. The last three chapters of this book in Part Four, "Output and Delivery," deal with issues that apply specifically to film, video, and digital media, providing valuable solutions for overcoming the technical constraints that each medium imposes.

A disk icon appearing in the vicinity of a particular figure indicates that the information is also featured on the DVD in the form of animation.

about the DVD

The enclosed DVD features cutting-edge work from the following renowned professional animators, motion graphic designers, and animation studios in the Americas and abroad:

Stephen Arthur
　　Violette Belzer
Big Blue Dot
　　David Carson
Marilyn Cherenko
　　Scott Clark
Chris de Deugd
　　Susan Detrie
Fifteen Pound Pink
　　Hatmaker
hillmancurtis.com inc.
　　Humunculus
Candy Kugel
　　Harry Marks
Stephanie Maxwell
　　Eliot Noyes
Joris Oprins
　　Trees for Life
twenty2product
　　Oerd van Cuijlenborg
Viewpoint Creative

This disk can be played on most new consumer DVD players and computer DVD-ROM drives. A list of players that have been tested for compatability can be found on Apple's Web site at www. apple.com/dvd/compatibility.

i Animation in the Arts and in the Industry

1

experimental animation and film title design

FILM ANIMATION IN THE ARTS AND IN THE INDUSTRY

The moving image in cinema occupies a unique niche in the history of 20th century art. Experimental film pioneers of the 1920s exerted a tremendous influence on succeeding generations of fine artists. In the motion picture industry, the development of animated film titles in the 1950s established a new form of graphic design called motion graphics. Today, fine art animators and motion graphic designers continue to shape the landscape of visual communication.

"It seems inevitable to me that some day, in an elegant new hi-tech museum, someone will holler out in recognition and affection: 'Hey look, a whole room of Fischingers!'—or Len Lyes—or any of the great artist-animators of our century. They are the undiscovered treasures of our time."

— *Cecile Starr*

chapter outline

00 : 00 : 00 : 01

Precursors of Animation

Since the beginning of our existence, we have endeavored to achieve a sense of motion in art. Our quest for telling stories through the use of moving images dates back to cave paintings found in Lascaux, France and Altamira, Spain which depicted animals with multiple legs to suggest movement. Attempts to imply motion were also evident in early Egyptian wall decoration and in Greek vessel painting.

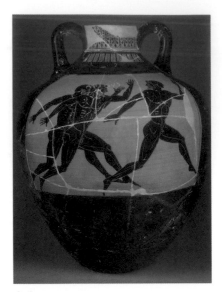

1.1

Panathenaic amphora, c. 500 BC. Photo by H. Lewandowski, Louvre, Paris, France. Réunion des Musées Nationaux © Art Resource, NY.

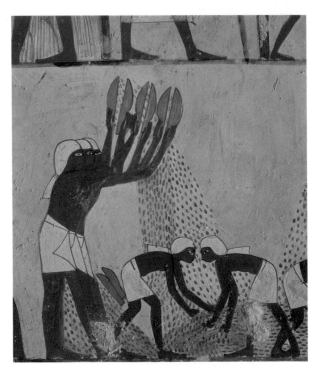

1.2

Detail of a wall painting in the tomb of Mennah (18th Dynasty) in the cemetery of Sheikh Abd al-Qurnah. © Erich Lessing/Art Resource, NY.

The discovery of persistence of vision is attributed to several individuals, including Greek astronomer Claudius Ptolemy, Roman poet Titus Lucretius Carus, Greek mathematician Euclid, British physicist Isaac Newton, Belgian physicist Joseph Plateau, and Swiss physician Peter Roget.

persistence of vision

Animation cannot be achieved without understanding a fundamental principle of the human eye: *persistence of vision*. This phenomenon involves our eye's ability to retain an image for a fraction of a second after it disappears. Our brain is tricked into perceiving a rapid succession of different still images as a continuous picture. The brief period during which each image persists upon the retina allows it to blend smoothly with the subsequent image.

The optical devices that are shown in this chapter belong to the Laura Hayes and John Howard Wileman Collection of Optical Toys. This permanent exhibition can be viewed at The North Carolina School of Science and Mathematics, 1219 Broad Street, Durham, NC 27705. For more information, contact Loren Winters (919-416-2775, winters@ncssm.edu), Department of Science, or Katie Wagstaff (919-416-2866, wagstaff@ncssm.edu), Foundation Director, Development Division.

Additional information on magic lanterns can be found at the British Magic Lantern Society at www.magiclanternsociety.org.

1.3

Illusionistic theatre box c. 1890. Photo by Dick Waghorne. Courtesy of the Wileman Collection of Optical Toys.

A twinkling effect is produced when light streams in through the holes in the back.

precursors of modern cinema

early optical inventions

Although the concept of persistence of vision had been firmly established by the 19th century, the illusion of motion was not achieved until several optical devices emerged throughout Europe to provide animated entertainment. Illusionistic theatre boxes, for example, became a popular parlor game in France. They contained a variety of effects that allowed elements to be moved across the stage or lit from behind to create the illusion of depth.

Another early form of popular entertainment was the magic lantern, a device that scientists began experimenting with in the 1600s. Magic lantern slide shows involved the projection of hand-painted or photographic glass slides. Using fire (and later gas light), magic lanterns often contained built-in mechanical levers, gears, belts, and pulleys that allowed the slides (which in some cases measured over a foot long) to be moved within the projector. Slides containing images that demonstrated progressive motion could be projected in rapid sequence to create complex moving displays.

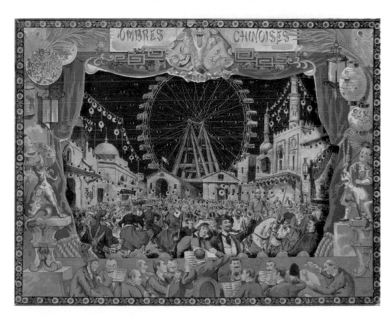

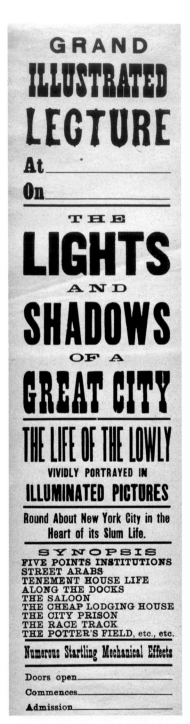

1.4

Magic lantern broadside for a Grand Illusion lecture. Courtesy of the National Museum of American History.

One of the first successful devices for creating the illusion of motion was the thaumatrope, made popular in Europe during the 1820s by London physicist Dr. John A. Paris. (Its actual invention has often been credited to the astronomer Sir John Herschel.) This simple apparatus was a small, paper disc that was attached to two pieces of string and held on opposite sides (1.5). Each side of the disc contained an image, and the two images appeared to become merged together when the disc was spun rapidly. This was accomplished by twirling the disc to wind the string and then gently stretching the strings in opposite directions. As a result, the disc would rotate in one direction and then in the other. The faster the rotation, the more believable the illusion. Although the thaumatrope did not imply motion, this invention, relying on the principle of persistence of vision, was one of the first to prove that the eye retains images when it is exposed to a series of pictures, one at a time.

In 1832, Belgian physicist Joseph Plateau introduced the phenakistoscope to Europe. (During the same year, Simon von Stampfer of Vienna, Austria invented a similar device that he called the stroboscope.) This mechanism consisted of two circular discs mounted on the same axis to a spindle (1.6). The outer disc contained slots around the circumference, and the inner disc contained drawings that depicted successive stages of movement. Both discs spun together in the same direction, and when held up to a mirror and peered at through the slots, the progression of images on the second disc appeared to move. Plateau derived his inspiration from Michael Faraday, who invented a device called "Michael Faraday's Wheel," and Peter Mark Roget, the compiler of *Roget's Thesaurus*. The phenakistoscope was in wide circulation in Europe and America during the 19th century until William George Horner invented the zoetrope, a instrument that offered major improvements over the phenakistoscope.

Experimental Animation and Film Title Design

1.5

Thaumatrope case and discs. Photo by Dick Waghorne. Courtesy of the Wileman Collection of Optical Toys.

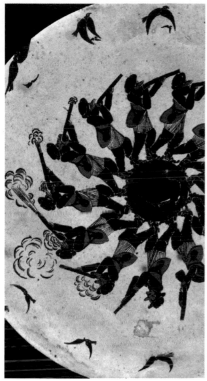

1.6

Phenakistoscope disc. Photo by Dick Waghorne. Courtesy of the Wileman Collection of Optical Toys.

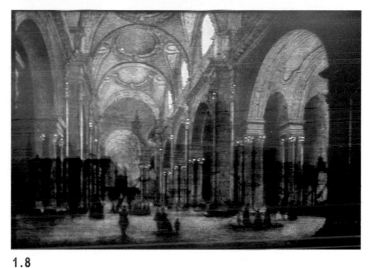

1.8

Lantern slide. Photo by Dick Waghorne. Courtesy of the Wileman Collection of Optical Toys.

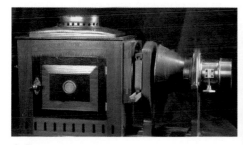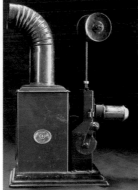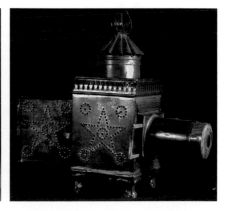

1.7

Magic lantern slide projectors. Photos by Dick Waghorne. Courtesy of the Wileman Collection of Optical Toys.

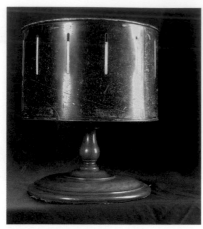

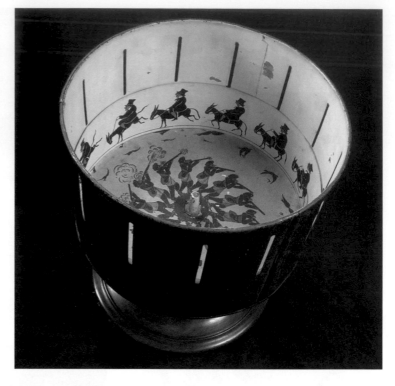

1.9

Zoetrope, top and side views. Photos by Dick Waghorne. Courtesy of the Wileman Collection of Optical Toys.

1.10

Zoetrope animation strip. Photo by Dick Waghorne. Courtesy of the Wileman Collection of Optical Toys.

The zoetrope did not require a viewing mirror, and because of its design, many people could view the animation simultaneously. Often referred to as the "wheel of life," the zoetrope was a short cylinder with an open top that rotated on a central axis. Long slots were cut at equal distances into the outer sides the drum, and a sequence of drawings on strips of paper were placed around the inside directly below the slots (1.9). When the cylinder was spun, viewers gazed through the slots at the images on the opposite wall of the cylinder, which appeared to spring to life in an endless loop. The faster the rate of spin, the smoother the animation.

The popularity of the zoetrope declined when Parisian engineer Emile Reynaud invented the praxinoscope. A precursor of the film projector, it was a refinement of the zoetrope, offering a clearer image by overcoming picture distortion caused by gazing through the moving slots. Images were placed around the inner walls of an exterior cylinder, and

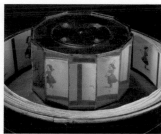

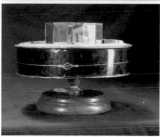

1.11
Praxinoscope (front and side view).
Photos by Dick Waghorne. Courtesy of
the Wileman Collection of Optical Toys.

**"Muybridge's photo-
graphs of the galloping
horse foreshadowed the
recorded image of man
walking on the moon."**

— Vi Whitmire

Muybridge's books *Animals in Motion*
(1899) and *The Human Figure in Motion*
(1901) are available from Dover Publishers.
Many of his plates are exhibited at the
Kingston-upon-Thames Museum and in the
Royal Photographic Society's collection.

each image was reflected by a set of mirrors attached to the outer walls of an interior cylinder (1.11). When the outer cylinder is rotated, the illusion of motion is seen on any one of the mirrored surfaces. Two years later, Reynaud developed the praxinoscope theatre, a wooden box containing the praxinoscope. The viewer peered through a small hole in the box's lid at a theatrical background scene that created a narrative context for the moving imagery.

Muybridge and motion photography

During the late 1860s, Eadward Muybridge earned a reputation for his photographs of the American West. During that time, former California governor Leland Stanford became interested in the research of Etienne Marey, a French physiologist who suggested that the movements of horses were different from what most people thought. Determined to investigate Marey's claim, Stanford hired Muybridge to record the moving gait of his racehorse with a sequence of still cameras. Muybridge continued to conduct motion experiments, some of which were published in an 1878 article in *Scientific American*. This article suggested that its readers cut the pictures out and place them in a zoetrope to recreate the illusion of motion. This fueled Muybridge to invent the zoopraxiscope, an instrument that allowed him to project up to 200 single images on a screen. This forerunner of the motion picture was received with great enthusiasm in America and England. In 1880 Muybridge gave his first presentation of the zoopraxiscope to the California School of Fine Arts, thus becoming the father of motion pictures. In 1884, Muybridge was commissioned by the University of Pennsylvania to further his study of animal and human locomotion and produced an enormous compilation of over 100,000 detailed studies of animals and humans engaging in various physical activities. These volumes were a great aid to visual artists in helping them understand movement.

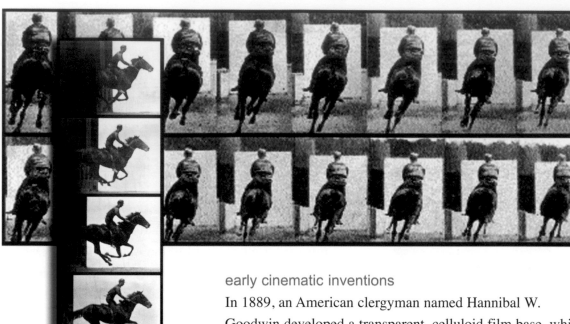

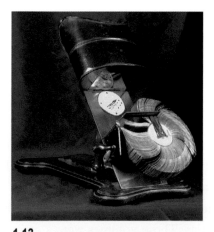

1.12

Motion studies, by Eadweard Muybridge. Courtesy of the National Museum of American History.

1.13

Kinora. Photo by Dick Waghorne. Courtesy of the Wileman Collection of Optical Toys.

early cinematic inventions

In 1889, an American clergyman named Hannibal W. Goodwin developed a transparent, celluloid film base, which George Eastman began manufacturing. For the first time in history, long sequences of images could be contained on a single reel. (Zoetrope and praxinoscope strips were limited in that they could only display approximately 15 images per strip.) New cinematic developments took the place of older optical toys such as the zoetrope and the praxinoscope.

In Britain, the kinora, developed by Louis and Auguste Lumiere, was a home movie device that consisted of a 14-cm wheel that held a series of pictures. When the wheel was rotated by a handle, the rapid succession of pictures in front of a lens gave the illusion of motion. Its design allowed only one person at a time to view a movie. An improvement of the kinora, Edison's kinetoscope (a precursor of the modern film camera) allowed viewers to see projected moving images through a peephole at the top of a large cabinet that threaded approximately 50 feet of film ribbon on a series of rollers. By 1894, coin-operated kinetoscopes were available in kinetoscope parlors in New York City, London, and Paris. The first true cinematographic films to be publicly

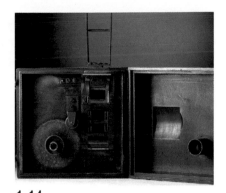

1.14
Cinematographe camera/projector.
Courtesy of the National Museum of
American History.

Kinora Ltd. was a British factory that, before 1914, sold and rented Kinora reels to people for personal home viewing. These reels were printed from professionally shot films that were processed and printed from rolls of 25.4mm paper or celluloid. People could have "motion portraits" taken in a photographic studio to be viewed on their home Kinora. The company also supplied an amateur camera that allowed people to create their own movies. In 1914, the factory burned down, and the company decided not to rebuild itself, since public interest in the Kinora had faded.

projected onto a large screen for a paying public were those of the Lumiere brothers. They were displayed with a Cinematographe, the first mass-produced camera-printer-projector of modern cinema.

Animation in Early Motion Pictures

In addition to filming movies, new developments led to the concept of creating drawings that were specifically designed to move on the big screen.

early animation techniques

figurative animation

Prior to Warner Brothers, MGM, and Disney, the origins of classical animation can be traced back to newspapers and magazines that displayed political caricatures and comic strips. One of the most famous cartoon personalities before Mickey Mouse was *Felix the Cat*. Created by Australian cartoonist Pat Sullivan and animated by Otto Mesmer, Felix was the first animated character to have an identifiable screen personality. In 1914, American newspaper cartoonist Winsor McCay introduced a new animated character to the big screen, *Gertie the Dinosaur*. The idea of developing a likeable personality from a living creature had a galvanizing impact upon audiences. As the film was projected on screen, McCay would stand nearby and interact with his character.

The cel animation process, developed in 1910 by Earl Hurd at John Bray studios, was a major technical breakthrough in figurative animation. Bray implemented the use of translucent sheets of celluloid for overlaying different moving parts on top of a static background. This compositing method reduced the number of times a background had to be redrawn. Further developments in cel animation included the use of multiple transparent pieces of celluloid, a peg system

The patenting of cel animation production was initiated by Earl Hurd in 1914. Because of the cost of celluloid and the license to use the patented technique, drawing and inking on paper was more popular among independent animators and animation studios.

to aid in registration, and the drawing of the background on a long sheet of paper to allow the camera to pan across the image. Early artists who utilized Bray's process included Max Fleischer (Betty Boop), Paul Terry (*Terrytoons*), and Walter Lantz (*Woody Woodpecker*).

stop-motion

Stop-motion animation can be traced back to the invention of stop-action photography—a cinematic tool that was utilized by French filmmaker Georges Méliès, a Paris magician. In Méliès' classic film *A Trip to the Moon* (1902), stop action photography allowed Méliès to apply his techniques, which were derived from magic and the theatre, to film. Additional effects, such as the use of superimposed images, double exposures, dissolves, and fades, allow a series of magical transformations to take place.

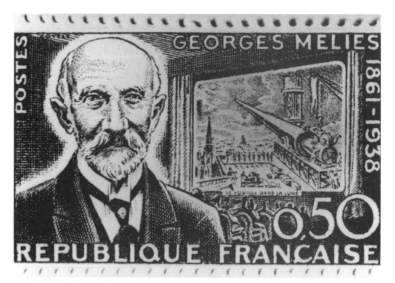

1.15
Ad for "Cineograph Theatre" showing a daily program of motion picture shows (1899–1900). Courtesy of the National Museum of American History.

1.16
Postage stamp with portrait of Georges Méliès. Courtesy of Anthology Film Archives.

Experimental Animation and Film Title Design

1.17

Portrait of J. Stuart Blackton.

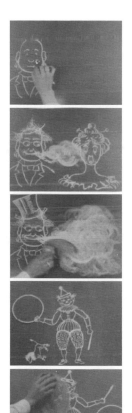

1.18

Frames from *Humorous Phases of Funny Faces* (1906). © Vitagraph.

Four years later, J. Stuart Blackton, an Englishman who emigrated to the United States, discovered that by exposing one frame of film at a time, a subject could be manipulated between exposures to produce the illusion of motion. (Although standard movie cameras exposed eight frames per turn of a crank, camera operators could alter the camera to expose only one frame per crank; this technique became known as "one turn, one picture.") In 1906, his company, Vitagraph, released an animated short titled *Humorous Phases of Funny Faces*, one of the earliest surviving American animated films. Blackton's hand is seen creating a line drawing of a male and female character with chalk on a blackboard. The animation of each face's changing facial expression was accomplished through single-frame exposures of each slight variation. When the artist's hand exits the frame, the faces roll their eyes and smoke issues from a cigar in the man's mouth. At the end of the film, Blackton's hand reappears to erase the figures. This new stop-motion technique shocked audiences as the drawings magically came to life.

live action, rotoscoping, and mattes

Two pioneers expanded the resources of animation by mixing live footage with hand-drawn elements: Emile Cohl and Max Fleischer. Known as the father of French animation, Emile Cohl, a newspaper cartoonist, is known for his first classic film, *Fantasmagorie* (1908). Cohl's 300 subsequent short animations were a product of the Absurdist school of art, which derived artistic inspiration from drug-induced fantasy, hallucinations, and insanity. These works combined hand-drawn animated content and live action.

Around 1917, Max Fleischer, an admirer of McCay's realistic style, patented the technique of rotoscoping. This process involved drawing frames by tracing over previously filmed live footage, allowing the animator to produce smooth, life-like movements. Fleischer's next invention, the Rotograph,

The original *rotoscope* was patented in 1917. Invented by Max and Dave Fleischer, it could project single frames of live-action film onto a drawing surface, enabling the artist to trace the images onto cels or other media. The traced frames would be rephotographed onto motion picture film. When projected, rotoscoped films were incredibly lifelike while retaining a traditional cartoon feel. Eventually, "rotoscope" became a generic term for tracing animation from live action, applying live action footage to animation or drawing on top of live action.

Rotoscoping is discussed in Chapter 6 with regard to frame-by-frame animation.

The use of mattes was another technical breakthrough that extended the possibilities of film. Edwin Porter, a producer and cinematographer for Thomas Edison, experimented with masks in his classic feature, *The Great Train Robbery* (1903). Two scenes were created by masking the camera and shooting double exposures. The effect quickly led to the development of opticals that allowed multiple layers of film to be printed onto a third piece of film.

enabled animated characters to be placed into live, realistic settings. A live action background would be filmed and projected one frame at a time onto a piece of glass. A cel containing an animated character would be placed on the front side of the glass, and the composite scene would be filmed. With this technique, Fleischer went on to develop the personalities of such famous characters such as Koko the Clown, Betty Boop, Popeye, and Superman.

fine art animation

the rise of Modernism

At the turn of the 20th century, postwar technological and industrial advances and changing social, economic, and cultural conditions of monopoly capitalism throughout Europe fueled artists' attempts to reject classical representation. This impulse led to the rapid evolution of abstraction in painting and sculpture. Revolutionary Cubist painters began expressing space in strong geometrical terms. Italian Futurists became interested in depicting motion on the canvas as a means of liberating the masses from the cruel treatment that they were receiving from the government. Dada and Surrealist artists sought to overthrow traditional constraints by exploring the spontaneous, the subconscious, and the irrational. These forms of Modernism abandoned the laws of beauty and social organization in an attempt to demolish current aesthetic standards of art. This was manifested in music, poetry, painting, graphic design, and experimental filmmaking.

fine art animation pioneers

The 1920s was a period of incredible growth in the movie industry. It was an era of huge movie palaces, fan magazines, and studio publicity departments that projected wholesome images of stars. (Few people knew the names of the directors.) Hollywood mass produced recipe-oriented romances and genre films that reaffirmed values such as family and

Information and films of the experimental animation pioneers discussed in this chapter can be found at the following organizations:

New York Fim Annex
(718) 382-8868
www.NYFAVIDEO.com

iota Center
(310) 842-8704
www.iotacenter.org

Anthology Film Archives
(212) 505-5181
www.anthologyfilmarchives.org

Filmmaker's Cooperative
(212) 267-5665
www.film-makerscoop.com

Harvard Film Archives
617-495-4700
www.harvardfilmarchive.org

patriotism. However, in Germany, France, and Denmark, filmmakers began to embrace more personalized animation techniques. Their basic motivation was not inspired by commercial gain; rather, it came from a personal drive to create art. "Pure cinema," as the first abstract animated films were called, won the respect of the art community who viewed film as an expressive medium.

Fernand Leger

A major contributor to the Cubist movement, Fernand Leger has been described as "a painter who linked industry to art." Born in northwestern France, Leger was encouraged by his parents to pursue architecture. However, after attending the Academy Julian in Paris, he desired to express his love for city life, common people, and everyday objects in painting. By 1911, he became identified with his tubular and curvilinear structures, which contrasted with the more angular shapes produced by other cubists such as Picasso and Braque.

During the 1920s, Leger began to pursue film and produced his classic, *Ballet Mechanic,* in 1923. This masterpiece (created without a script), demonstrated his desire to combine the energy of the machine with the elegance of classical ballet. Fragments of reflective, metal machinery, disembodied parts of human figures, and camera reflections were orchestrated into a seductive, rhythmic mechanical dance. Conceptually, this film has been interpreted as a personal statement in a world of accelerating technological advancement and sexual liberation. Artistically, it represented a daring jump into the territory of moving abstraction.

Man Ray

Born in Brooklyn, New York, as Emanuel Radnitsky, Man Ray became an enigmatic leader of the Dada–Surrealist and American avant-garde movements of the 1920s and 1930s. After establishing Dadaism in New York City with Marcel

Duchamp and Francis Picabia, he moved to Paris and became a portrait photographer for the wealthy avant-garde. By the early 1920s, he developed a reputation for his use of natural light and informal poses during a time when Pictorialism was the predominant style of photography in Europe. Commercial success allowed him the freedom to experiment, and his discovery of the "Rayograph" (later called the photogram) made a significant contribution to the field of photography. Throughout the 1920s, Man Ray produced several surrealist films that were created without a camera, including *Anemic Cinema* (1925–26) and *L'Etoile de Mer* (1928). Man Ray often described them as "inventions of light forms and movements."

Viking Eggeling

During the early 1900s, Swedish musician and painter Viking Eggeling described his theory of painting by way of music, in terms of "instruments" and "orchestration." His desire was to establish what he referred to as a "universal language" of abstract symbols and strived to accomplish this by emphasizing musical structure and avoiding representation.

As an orphan, Eggeling lived a complicated life. Born in Sweden, he emigrated to Germany as a teenager and studied art history and painting. After living in Paris and Switzerland during the beginning of World War I, he became attracted to the Dada movement and moved back to Germany with Hans Richter. The nihilistic tendencies of Dadaism gave Eggeling the freedom to break from conventional schools of thought, and he collaborated with Richter on a series of scroll drawings that utilized straight lines and curves of varying orientations and thicknesses. These structures were arranged in a linear progression across a long scroll of paper, forcing the viewer to see them in a temporal context. Driven by the need to integrate time into his work, he turned his attention to film. No longer restrained to a static canvas, Eggeling realized

1.19

Filmstrip from the work of Viking Eggeling. From *Experimental Animation*, courtesy of Cecile Starr.

that a moving surface allowed motion to be integrated into painting. After purchasing a film camera, he produced *Symphonie Diagonale* in 1923. Taking almost four years to complete, this frame-by-frame animation showed a strong correlation between music and painting in the movements of the figures, which were created from paper cutouts and tin foil. Eggeling died in Berlin approximately two weeks after his film was released.

Hans Richter

Born in Berlin, Hans Richter was an early German Dadaist who earned a master's degree from the Art Academy in Weimar, Germany. After gaining U.S. citizenship, he collaborated with Viking Eggeling to produce a large body of scroll drawings that demonstrated the transformation of geometric forms into each other. These were described as "instruments" that expressed "the music of the orchestrated form." In moving from scroll drawings to film animation, Richter saw motion as a logical step for expressing the kinetic properties of form. His early abstract animated films were heavily influenced by several modernist schools of thought, particularly Cubism. His interest in the subject declined, and the interplay positive and negative forms became the focus of his compositions. He saw the film frame as a space that could be divided and "orchestrated" in time by accepting the rectangle of the "movie-canvas" as the "form element." In a letter to Alfred Barr, Richter explained: "The simple square gave me the opportunity to forget about the complicated matter of our drawings and to concentrate on the orchestration of movement and time." In films such as *Rhythm 21* and *Rhythm 23*, motion is choreographed in horizontal and vertical movements and scale changes of the forms to establish depth. The subject matter is reduced to nonobjective lines and rectangles that move in alignment to each other. Figure-ground is broken from the changing interplay between positive and negative space. In *The Cubist Cinema*,

1.20
Hans Richter in 1974. Photo by Robert Naughton. From *Experimental Animation*, courtesy of Cecile Starr.

"Every form occupies not only space but time."

— Hans Richter

1.21

Film strip from *Rhythm 23* (1923), by Hans Richter. From *Experimental Animation,* courtesy of Cecile Starr.

1.22

Walter Ruttman, c. 1921. From *Experimental Animation,* courtesy of Cecile Starr.

Lawder explains that, with regard to *Rhythm 21* "Its forms, like those of an abstract painting, seem to have no physical extension except on the screen . . . the film is a totally self-contained kinetic composition of pure plastic forms." Later works such as *Film Study* incorporate a more diverse array of visuals. Abstract shapes, in conjunction with photographic images of heads and artificial eyes, produce an obscure reality where the element of fantasy is introduced.

Richter's silent films of the late 1920s demonstrated a more surreal approach that combined animation with live-action footage. At the time, these shocking films challenged artistic conventions by exploring fantasy through the use of special effects, many of which are used in contemporary filmmaking. In *Ghosts Before Breakfast* (1927), people and objects engage in unusual behavior set in bizarre and often disturbing settings. Flying hats continually reappear in conjunction with surrealistic live images of men's beards magically appearing and disappearing, teacups filling up by themselves, men disappearing behind a street sign and objects moving in reverse. In a scene containing a bull's eye, a man's head becomes detached from his body and floats inside the target. In another scene of a blossoming tree branch, fast-motion photography was used. Richter also played back the film in reverse and used negatives to defy the laws of the natural world.

Walter Ruttmann

After World War I, German painter Walter Ruttmann became impatient with the static quality of his artwork and saw the potential of film as a medium for abstraction, motion, and the passage of time. In 1920, he founded his own film company in Munich and pioneered a series of films entitled *Opus*. These playful animations explored the interaction of geometric forms. *Opus 1* (1919–1921) was one of the earliest abstract films produced and one of the few that was filmed in black and white and hand-tinted.

The technical process that Ruttmann employed remains questionable, although it is known that he painted directly onto glass and used clay forms molded on sticks that, when turned, changed their appearance. Ruttmann's later documentary, *Berlin: Symphony of a City*, gives a cross-section impression of life in Berlin in the late 1920s. The dynamism of urbanization in motion is portrayed in bustling trains, horses, masses of people, spinning wheels, fairground rides, and machines, offering an intimate model of Berlin.

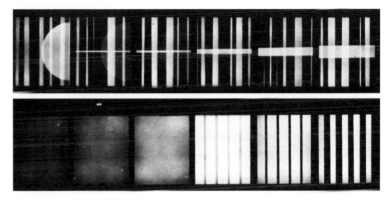

1.24

Frames from *Opus IV* (c. 1924), by Walter Ruttmann. From *Experimental Animation*, courtesy of Cecile Starr.

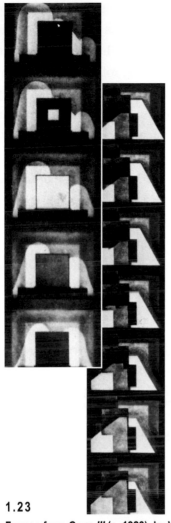

1.23

Frames from *Opus III* (c. 1923), by Walter Ruttmann. From *Experimental Animation*, courtesy of Cecile Starr.

Alexander Alexeieff and Claire Parker

In the 1930s, Russian-born filmmaker Alexander Alexeieff and American Claire Parker invented the pinboard (later named the pinscreen), one of the most eccentric traditional animation techniques. Born in Russia, Alexeieff spent his early career painting stage designs for production companies. Because of the poor wages, he taught himself engraving, etching, lithography, and woodcutting and produced illustrations for books. In Paris, Claire Parker, who was born in Boston and studied drawing at the Massachusetts Institute of Technology, was fascinated with Alexeieff's illustrations and asked him to give her lessons in engraving. Together, they

1.25

Alexander Alexeieff, c. 1955. From *Experimental Animation*, courtesy of Cecile Starr.

began searching for a method to make the engraved images move and built the first pinboard. This contraption consisted of thousands of closely-spaced pins that were pushed and pulled into a perforated screen using rollers to achieve varying heights. When subject to lighting, cast shadows from the pins produced a wide range of tones, creating dramatic textural effects that resembled a mezzotint, wood carving, or traditional etching. Some of the most ambitious pinboard animations used up to 1 million pins to create stunning expressionistic effects. (Alexeieff's original pinboard was huge in comparison to the hand-sized pinscreens that are sold today.) The extraordinary results of this process are evident in classic pieces such as *Night on Bald Mountain* (the first film created on pinboard) and *The Nose*, a film based on a story about a Russian major whose nose is discovered by a barber in a loaf of bread. In both films, forms have three-dimensional, chiaroscuro-like qualities as they dissolve from and into space. According to Parker, "we never consider the pins individually, but always in groups, like paint on a brush. Instead of brushes we use different sized rollers: for instance, bed casters, ball-bearings, etc., to push the pins toward either surface, thus obtaining the shades or lines of gray, black, or white which we need to compose the picture."

1.26

Frame from *Night On Bald Mountain* (1933), by Alexander Alexeieff and Claire Parker. From *Experimental Animation*, courtesy of Cecile Starr.

1.27
Len Lye, c. 1957. From *Experimental Animation*, courtesy of Cecile Starr.

"My excitement in life was to discover something that's significant to me. Now how the hell can I work it out if it has to be significant to an audience?"

— *Len Lye*

Len Lye

Revolutionary animator Len Lye once asked the question: "Why not just arrange motion?" Born in New Zealand, Lye became a remarkable innovator in experimental animation, as well as a leading theorist, kinetic sculptor, photographer, painter, and writer. He is best known for pioneering the direct-on-film technique of cameraless animation by painting and scratching images onto 35mm celluloid.

Lye often referred to himself as "an artist for the 21st century." His use of abstract, metaphorical imagery is a product of his association with Surrealism, Futurism, Russian Constructivism, and Abstract Expressionism, as well as his affinity for jazz, Oceanic art, and calligraphy. His use of catchy music, saturated color, and organic forms had a major impact on a genre that later became known as music video.

Living in Samoa between 1922 and 1923, Lye became inspired by Aboriginal motifs and produced his first animated silent film, *Tusalava* (1929), which he created to express "the beginnings of organic life." (The film's title in Samoan means "things go full cycle." British censors believed that it was about sex!) Grublike images suggest a life cycle by coming together, dividing, and morphing into what Lye calls "a cross between a spider and an octopus with blood circulating through its arms" (1.28). Lye stated, "Years later I saw that the grub and the attacking images were both a startling representation of antibodies and virus. The primitive side of my brain must have communed with my innate self enough to have reached down into my body and come up with gene-carried information which I expressed visually." This film took approximately two years to complete, since each frame was hand-painted and photographed individually.

After *Tusalava*, Lye moved to England, and in the 1930s, produced *Colour Box, Kaleidoscope, Rainbow Dance,* and

Len Lye was always fascinated with the idea of composition with motion. As a teenager, he used an old box as a frame and devised a pulley mechanism with a phonograph handle attached to a string. An object would be attached to the other end of the string, and when the handle was turned, the pulley wheels would make the object revolve inside of the frame.

Trade Tattoo. By painting directly on the film, Lye was able to attain motion, as well as being able to achieve color, which during that time, was not yet available. Unfortunately, he did not receive much recognition or support in London. In 1944, he moved to New York's Greenwich Village and became a leader of the kinetic art movement in the 1950s and 1960s. He continued working with film and fashioned kinetic sculptures that integrated sound and rhythmic movement. In a 16mm abstract film titled *Free Radicals* (1958), Lye scratched the content onto a few thousand feet of black film leader using tools ranging from sewing needles to Indian arrowheads. An African drum sound track magically put the motion of the scratches to a rhythm.

1.28

Frames from *Tulsava* (1929), by Len Lye. From *Experimental Animation*, courtesy of Cecile Starr.

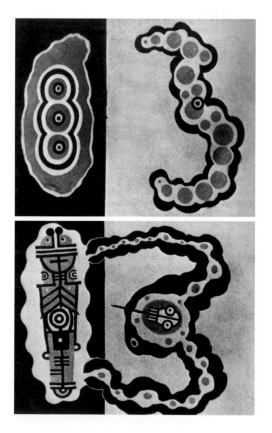

1.29

Frame from *Trade Tattoo* (1937), by Len Lye. From *Experimental Animation*, courtesy of Cecile Starr.

Lye experimented with stenciling abstract patterns onto discarded documentary film footage.

The Govett-Brewster Art Gallery (www.govettb.org.nz/lenlye/ default.html) is home to the collection and archive of Len Lye and holds regular exhibitions of his work. The Len Lye Foundation provides a biography of Lye's life and information about where to screen his films. It can be found online at www.govettbrewster.com/ NR/lenlye. *Free Radicals* is a collection of Lye's films and is available on video at Canyon Cinema at www.canyoncinema.com.

Roger Horroks' book *Len Lye, A Biography* gives an account of Lye's activity in film, sculpture, painting, music, and writing.

Norman McLaren

Norman McLaren has been described as a "poet of animation." Inspired by the masterpieces of filmmakers Eisenstein, Pudovkin, and Fischinger, McLaren began animating directly onto film, scratching into its emulsion to make its stock transparent. (At the time, he was unaware that Len Lye was conducting similar experiments.) In 1941, he was invited to join the newly formed National Film Board of Canada, and there, he founded an animation department and experimented with a wide range of techniques. Films such as *Fiddle-de-Dee* (1947) and *Begone Dull Care* (1949) were made by painting on both sides of 35mm celluloid. Incredibly rich textures and patterns were achieved through brushing and spraying, scratching, and pressing cloths into the paint before it dried. One particular film titled *Blinkity Blank* (1954) involved the investigation of "intermittent animation and spasmodic imagery." Images were engraved intermittently into the film with a penknife, sewing needle, and razor blade. According to McLaren: "I would engrave a frame here and a frame there, leaving many frames untouched and blank. Optically, most of the film consists of nothing at all. When such a movie is projected at normal speed, the image on a solitary frame is received by the eye for a 48th of a second, but due to after-image and the persistence of vision, the image lingers considerably longer than this on the retina, and in the brain itself it may persist until interrupted by the

You can find more details on Norman McLaren and his films at the National Film Board of Canada (www.nfb.ca).

appearance of a new image." For over four decades, McLaren produced films for the NFB that earned him worldwide recognition and served as an inspiration for animators throughout the world. In 1989, two years after his death, the head office building of the NFB was renamed the Norman McLaren Building.

Lotte Reiniger

Born in Berlin, Lotte Reiniger is known for her silhouette cut-out animation style during the sound-on film era of the 1930s. Her full-length feature production, *The Adventures of Prince Achmed*, was among the first animated motion pictures to be produced, taking approximately three years to complete. The main characters were marionettes that were composed of black cardboard figures that were cut out with scissors and photographed frame-by-frame. Each part was joined by thin wire hinges that became almost invisible when lit from underneath a glass table.

1.30

Lotte Reiniger in the 1920s. From *Experimental Animation*, courtesy of Cecile Starr.

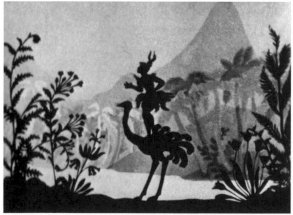
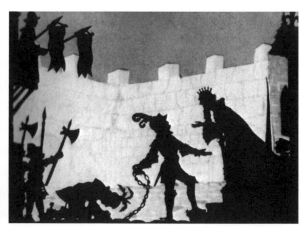

1.31

Frames from *The Adventures of Prince Achmed* (1923–1926), by Lotte Reiniger. From *Experimental Animation*, courtesy of Cecile Starr.

Robert Breer

Born in Detroit, Michigan, Robert Breer became a major force in experimental animation during the 1950s. After studying painting at Stanford, he moved to Paris and became heavily influenced by the hard-edged geometric qualities of neo-plasticism and in the abstractions of the De Stijl and Blue Rider movements. Eventually, Breer felt restricted by the boundaries of the static canvas and produced a series of animations that attempted to preserve the formal aspects of his paintings. He also experimented with rapid montage by juxtaposing frames of images in quick succession.

Mary Ellen Bute

Born in Texas, Mary Ellen Bute studied painting in Texas and Philadelphia and earned a degree in stage lighting at Yale. She became interested in filmmaking as a means of exploring kinetic art, and in collaboration with Joseph Schillinger, a musician who had developed a theory about the reduction of musical structure to mathematical formulas, began animating a film that would prove that music could be illustrated with images. Because of the intricacy of the images, however, this ambitious film was not completed.

1.32

Mary Ellen Bute, c. 1954. From *Experimental Animation*, courtesy of Cecile Starr.

Mary Ellen Bute incorporated many different types of found objects in her work including combs, colanders, Ping-Pong balls, and eggbeaters and photographed them frame-by-frame at various speeds. She intentionally distorted them by filming their reflections against a wall to conceal their origin. Her first film from the 1930s, *Rhythm in Light*, involved shooting paper and cardboard models through mirrors and glass ashtrays to achieve multiple reflections. Bute also explored oscilloscope patterns as a means of controlling light to produce rhythm. Between 1934 and 1959, her abstract films played in regular movie theaters around the country.

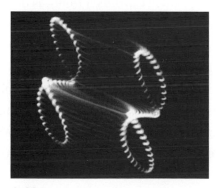

1.33

Frame from *Abstronic* (1954), by Mary Ellen Bute. From *Experimental Animation*, courtesy of Cecile Starr.

1.34

Frames from *Spook Sport* (1939), by Mary Ellen Bute, animated by Norman McLaren. From *Experimental Animation*, courtesy of Cecile Starr.

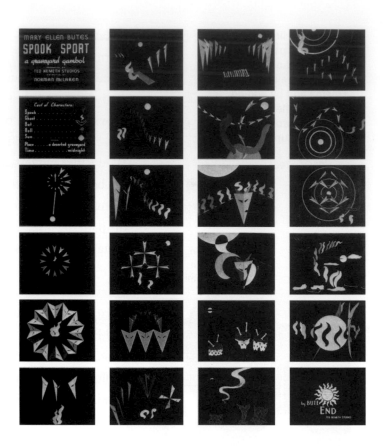

"I wanted to manipulate light to produce visual compositions in time continuity such as a musician manipulates sound to produce music . . . By turning knobs and switches on a control board I can 'draw' with a beam of light with as much freedom as with a brush"

— *Mary Ellen Bute*

"I treat objects in a very subjective way, and I treat subjects by themselves in a very objective way."

— *Frank Mouris*

Frank and Caroline Mouris

Frank and Caroline Mouris have been creating animated films since the 1970s. Their innovative use of collage in their Academy Award winning classic, *Frank Film* (1973), and in their more recent short, *Frankly Caroline* (1999), is characterized by an overabundance of images representing Western culture and iconography (food, money, body parts, etc.). The objective of these films was to provide a visual biography of their lives and their collaborative personal and working partnership. Frank Mouris describes *Frank Film* as a "personal film that you do to get the artistic inclinations out of your system before going commercial." The Mouris' animation style has appeared in many music videos and television commercials and on PBS, MTV, VH1, and the Nickelodeon channels. Their animated shorts have also been featured on programs such as *Sesame Street* and *3-2-1 Contact*.

1.35

Harry Smith with his *Brain Drawings*
(c. 1950). Courtesy of Harry Smith
Archives and Anthology Film Archives.

"For years Harry Smith
has been a black and
ominous legend and a
source of strange rumors.
Some even said that he
had left this planet years
ago—the last alchemist of
the Western world, the
last magician. Then one
day . . . Harry Smith gave
up the darkness and
appeared in the open."

— *Jonas Mekas*

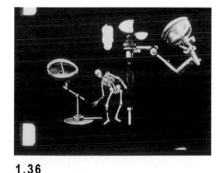

1.36

Frame from *Film # 12, Heaven and Earth
Magic* (1957–1962), by Harry Smith.
Courtesy of the Harry Smith Archives
and Anthology Film Archives.

Harry Smith

Born in Portland, Oregon, as the son of a salmon canning factory watchman and a teacher at a Lummi Indian reservation, Harry Smith began to record Native American songs and rituals as a teenager. He later was trained as an anthropologist and emerged as a complex artistic figure in the fields of sound recording, independent filmmaking, painting, and ethnographic collecting.

Intrigued by the occult, Smith often spoke of his art in alchemical and cosmological terms. His process involved hand-painting onto 35mm stock in combination with stop motion and collage. Similar to his life and personality, his compositions are complex and mysterious and have been interpreted as explorations of unconscious mental processes. Like an alchemist, he worked on his films secretly for almost 30 years. At times, Smith spoke of his films in terms of synesthesia, the search for correspondences among color, sound, and movement. His direct-on-film process was unique and painstaking. In his first animation, he adhered adhesive gum dots to the film's surface, wetted the film with a brush, and sprayed it with a dye. After drying, the film was greased with Vaseline, the dots were pulled off with tweezers, and color was sprayed into the unprotected areas where the dots had been. Another film was created using masking tape and a razor blade. Smith stated: "I worked off and on on that film for about five years pretty consistently."

Throughout the 1950s and 1960s, Smith's collage films became increasingly complex. He cut out pictures and meticulously filed them away in envelopes, building up an image archive which he used in later works such as *Film # 12, Heaven and Earth Magic* (1.36).

1.37

Painting (untitled) by Harry Smith.
Courtesy of the Harry Smith Archives
and Anthology Film Archives.

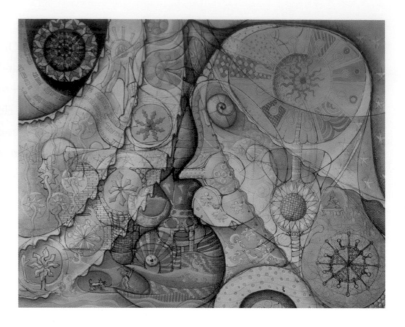

1.38

Film strips from *Early Abstractions* by
Harry Smith. Courtesy of Harry Smith
Archives and Anthology Film Archives.

Oskar Fischinger

Almost six decades before MTV, Oskar Fischinger helped
pioneer the future of music videos. As a leading innovator of
fine art animation and motion graphics, he believed that
visual music was the future of art.

Born in Germany, Fischinger was exiled to Los Angeles
when Hitler came to power and the Nazis censured abstraction
as "degenerate." During the early 1920s, his pursuit of the
Futurist goal to make painting dynamic manifested in a
series of film studies created from charcoal drawings of pure,
geometric shapes and lines. Constructed from approximately
5000 drawings, they demonstrated his desire to marry sound
and image. Fischinger also experimented with images pro-
duced from a wax-slicing machine and explored color film
techniques, cardboard cutouts, liquids, and structural wire
supports, and later developed a Technicolor-style camera for
Bela Gaspar, the first European system of color film. During
the 1930s, his films were being screened worldwide in theatres
and film festivals. Under contract to Paramount Studios,

Fischinger immigrated to America in 1936 and produced a handful of masterpieces, one of which was an abstract film titled *Allegretto* (his first film in the United States). William Moritz described this work as follows: "The colors are California colors—the pinks and turquoise and browns of desert sky and sand, the orange of poppies, and the green of avocados. The figures work themselves up into a brilliant and vigorous conclusion, bursting with skyscrapers and kaleidoscopes of stars/diamonds." In 1937, Fischinger also produced *An Optical Poem*, a short for MGM that was distributed to theatres everywhere. This work proved his ability, as an abstract artist and animator, to make his work appeal to a general audience. In 1938, Fischinger was hired by the Disney studios to design and animate portions of *Fantasia*. His presence in Hollywood helped shape generations of West Coast artists, filmmakers, graphic designers, and musicians.

Jan S˘vankmajer

Born in Czechoslovakia in 1934, Jan S˘vankmajer was one of the most remarkable European filmmakers of the 1960s. His visually rich and stylistically innovative works have helped expand the traditional definition of animated film beyond the concept of Disney cartoon aesthetics.

Early in his childhood, S˘vankmajer developed an affinity for drawing and collage. He embarked on a filmmaking career in his thirties and produced more than 20 animated shorts. His bizarre, often grotesque Surrealist style aroused controversy after the 1968 Soviet invasion of Czechoslovakia, and his opportunities to work in Czech studios were restricted. Nevertheless, he employed a wide range of techniques in order to fuse object animation with live action. He animated almost anything he could find, including man-made objects, animals, plants, insects, bones, and various tools. S˘vankmajer's love of rapid montage and extreme closeups

is evident in films such as *Historia Naturae* (1967), *Leonardo's Diary* (1972), and *Quiet Week in a House* (1969). Further, his surrealist orientation is evident in his use of somber, haunting images of living creatures and inanimate objects that are thrust into a world of ambiguity. The impact of his imagery dominates over the storyline. People take on the appearance of robots, and inanimate objects engage in savage acts of decapitation, suicide, and cannibalism. In his early short, *The Last Trick of Mr. Schwarcewalld and Mr. Edgar* (1964), a beetle crawls out of the heads of the main characters who wear wooden masks. In *Jabberwocky* (1971), branches blossom and apples drop and burst open to reveal maggots. A jackknife dances on a table, falls flat, and its blade closes to produce a trickle of blood that oozes out of its body. In another scene, a tea party of innocent-looking dolls dine at a small table, consuming other dolls who have been crushed in a meat grinder and cooked on a miniature range.

Stephen and Timothy Quay

Stephen and Timothy Quay (known as the "Brothers Quay") are among the most accomplished puppet animation artists to emerge during the 1970s. Their exquisite sense of detail and decor, openness to spontaneity, and use of extreme closeups have enchanted audiences worldwide, and their innovations contributed a unique sense of visual poetry to animated film.

Identical twins born in Norristown, Pennsylvania, the Quay brothers studied illustration at the Philadelphia College of Art. They became influenced by Eastern European culture, by the films of Czech animation maestro Jan Sˇvankmajer, and transferred to London's Royal College of Art to begin producing their first puppet animations. After the release of their award-winning *Nocturnia Artificialia* (1980), they founded Koninck Studios in London.

"We like going for long walks, metaphorically, into whatever country we go to—we could disappear in any country."

"It is not so much a nightmare. We really believe that with animation one can create an alternate universe, and what we want to achieve with our films is an 'objective' alternate universe, not a dream or a nightmare but an autonomous and self-sufficient world, with its particular laws and lucidity; a little like when we observe the world of insects, and we wonder where the logic of their actions comes from. They cannot talk to us to explain what they are doing, it is a bizarre miracle. So, watching one of our films is like observing the insect world. The same type of logic is found in the ballet, where there is no dialogue and everything is based on the language of gestures, the music, the lighting, and the sound."

— Stephen and Timothy Quay

Quay films can be purchased or rented at Zeitgeist Films (www.zeitgeistfilm.com). Several of the Quay's actual sets and puppets are on permanent exhibition at The Museum of the Moving Image in London.

The miniature sets of the Quays create a world of repressed childhood dreams. Absurd and incomprehensible images (e.g., antiquated-looking toys, machinery, bones, meat, etc.) exist in a chaotic, multilayered world where human characters live at the mercy of insidious machines. Unexpected, irrational events distort space and time beyond recognition. The harsh, grimy atmosphere of decay, the ominous quality of chiaroscuro, the dazzling use of light and texture and adept camera movement give their films an eerie, sublime quality. Some of their best known shorts include *Street of Crocodiles* (1986), *The Institute Benjamenta* (1995), and *In Absentia* (2000). The Quays have also produced commercials for Coca-Cola, MTV, Nikon, and Slurpee, as well as network IDs. They have also designed theater and opera productions for European venues and produced music videos, including Peter Gabriel's *Sledgehammer*. The Quay Brothers live in North London and work in South London at their studio, Atelier Koninck.

computer animation pioneers

Since the 1960s, advancements in digital technology have exerted a tremendous influence over succeeding generations of independent fine art animators and commercial motion graphic designers all over the world.

John Whitney

John Whitney hypothesized a future where computers would be reduced to the size of a television for home use. His interest in photography, electronic music, and film was influenced by French and German avant-garde filmmakers of the 1920s. Whitney felt that music was part of the essence of life; he attempted to balance science with aesthetics by elevating the status of the computer as a viable artistic medium in order to achieve a correlation between musical composition and abstract animation. In collaboration with his brother James, he devised a pendulum sound recorder that could produce

"My computer program is like a piano. I could continue to use it creatively all my life."

— *John Whitney*

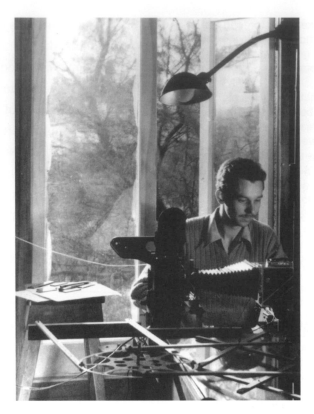

1.40

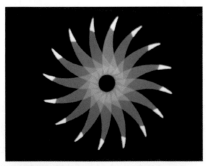

1.41

synthetic music for his kinetic abstract compositions. During World War II, Whitney discovered that the targeting elements in bomb sights and antiaircraft guns could calculate trajectories that could be used to plot graphics. From surplus antiaircraft hardware, he then built a mechanical analog computer (which he called a "cam machine") that was capable of metamorphosizing images and type. This later proved to be successful in commercial advertising and in film titling. During the 1950s, Whitney began producing 16mm films for television; another was the title sequence for Alfred Hitchcock's *Vertigo* (created in partnership with Saul Bass). He also directed short musical films for CBS and in 1957, worked with Charles Eames to create a large seven-screen presentation for the Fuller Dome in Moscow. In 1960, Whitney founded Motion Graphics Inc. and produced openings for shows such as Dinah Shore and Bob Hope. He also produced *Catalogue*, a compilation of the effects that he had perfected with his analog computer (1.41).

1.42

Cover from *Digital Harmony: On the Complementarity of Music and Visual Art*, by John Whitney. Courtesy of The Estate of John and James Whitney and the iota Center. All rights reserved.

Whitney's book, *Digital Harmony*, explains the influence of historical figures such as Pythagoras and Arnold Schoenberg on his creative process as an abstract filmmaker. It also provides an insight into his groundbreaking work in computer animation and an examination of the integration of music and kinetic art.

This gave him worldwide recognition, and in 1966 he was awarded by IBM the status of "artist-in-residence."

Stan Vanderbeek

During the 1960s, Stan Vanderbeek became one of the most highly acclaimed underground filmmakers to experiment with computer graphics. Fascinated with modern technology, he harnessed the potential of film, television, and computers to produce kinetic artwork in the spirit of Dada and Surrealism. He also explored multiple screen projection and produced films using a variety of traditional and digital processes including animated collage, hand-drawn animation, live action, film loops, video, and computer generated graphics. Vanderbeek is also known for the invention of the Movie-Drome theatre, a 360-degree overhead projection area that contained multiple projectors that surrounded audiences with images as they lay on their backs around the perimeter of the dome. This development later influenced the construction of worldwide "life theaters" and image libraries to advance international communication and global understanding.

1.43

Stan Vanderbeek. Courtesy of Anthology Film Archives.

Ken Knowlton

During the time that Vanderbeek was producing animated collage films, Ken Knowlton, an employee of Bell Labs, was developing computer-assisted techniques for creating film. In 1963, he developed the Beflix programming language for the production of raster-based animation, a system used by Vanderbeek. In collaboration with Leon Harmon, Knowlton also investigated pattern perception and developed an algorithm that digitized, fragmented, and reconstructed a picture using dot patterns. During the 1990s, he won several awards for his digital mosaics that, close up, depicted a complex array of objects (dominoes, puzzle pieces, etc.), and from a distance, became discernible as a recognizable image.

MIT, Bell Labs, IBM, and the University of Utah

In 1961, MIT student Ivan Sutherland created a vector-based drawing program called Sketchpad. Using a light pen with a small photoelectric cell in its tip, shapes could be constructed without having to be drawn freehand. At Bell Telephone Labs, E. E. Zajac used an IBM mainframe computer to create *Simulation*, a computer animation demonstrating how the altitude of a satellite could be modified as it orbits the Earth. Major corporations began to express an interest in computer graphics, and IBM released the IBM 2250 graphics terminal, the first commercially available graphics computer. At MIT, Sutherland invented the first head-mounted display for viewing computer generated scenes in stereoscopic 3D. (Twenty years later, NASA used his technique to conduct virtual reality research.) Dave Evans, who was hired to form a computer science program at the University of Utah, recruited Sutherland, and by the late 1960s, the University of Utah became a primary computer graphics research facility that attracted people such as John Warnock (founder of Adobe Systems and inventor of the PostScript page description language) and Jim Clark (founder of Silicon Graphics, Inc.).

Whitney and Demos

As a senior at Caltech in 1970, Gary Demos was fascinated by the work of John Whitney and, in 1972, went to work for Evans & Sutherland, a company specializing in building hardware. Here, Demos met John Whitney, Jr., and together, they formed a Motion Picture Products group in 1974. Their developments led to the first use of computer graphics for motion pictures while working on the film *Westworld* (1973). This film employed pixelization—a technique that produces a computerized mosaic by dividing a picture into square blocks and averaging each block's color into a single color.

Robert Abel

A few years earlier, Robert Abel, who had originally produced films with Saul Bass, established the computer graphics studio Robert Abel & Associates with his friend Con Pederson in 1971. He was contracted by Disney to develop promotional materials and the opening sequence to *The Black Hole* (1979) and later to produce graphics for Disney's movie *Tron* (1982). Abel won multiple awards, including two Emmys and a Golden Globe, and his company became recognized for its ability to incorporate conventional cinematography and special effects techniques into the domain of CGI.

Motion Graphics in Film Titles

Film title design evolved as a form of experimental filmmaking within the realm of commercial motion pictures. Today, a film's opening credits establish the context and set the tone of the movie. With the exception of trailers and marketing material, they are the first images that viewers experience once the lights are dimmed. In addition to providing information about the film, they arouse anticipation of the events that are to unfold.

> "Technology just frees us to realize what we can imagine. It's like being given the power to do magic."
>
> — *Robert Abel*

Movie title sequences have expanded the possibilities of graphic design and have come to challenge other forms of commercial animation, including television network identification, commercials, and music videos. Since the 1950s, when legendary Saul Bass revolutionized film title design, artists have jumped at the opportunity to integrate their ideas with the concepts that had been developed for films into the design of their opening sequence.

developments in title design

The origin of film titles can be traced back to the silent film era, where credit sequences were presented on title cards containing text. They were inserted throughout the film to maintain the flow of the story. (Ironically, they often interfered with the pacing of the narrative.) Hand-drawn white lettering superimposed over a black background provided information such as the title, the names of the individuals involved (director, technicians, cast, etc.), the dialogue, and action for the scenes. Sometimes the letters were embellished with decorative outlines, and usually the genre of the film dictated the style. For example, large, distressed block letters marked horror, while a fine, elegant script characterized romance. After the implementation of sound, titles began to evolve into complete narratives and became elevated to an art form. (Saul Bass once stated: "I had a strong feeling that films really began on the first frame. This was, of course, back when titles were strictly typography—mostly bad typography— and constituted the period when people were settling in, going to restrooms, or involved in chitchat.") Recently, desktop computers have simplified the process of creating title openings. Design firms and production houses are currently able to create stunning motion graphics sequences with affordable compositing and editing tools.

"The title sequence of a film is like the frame around a painting: it should enhance and comment on what is 'inside,' alerting and sensitizing the viewer to the emotional tones, the story ideas, and the visual style which will be found in the work itself."

— *Walter Murch*

Experimental Animation and Film Title Design

film title pioneers

Saul Bass

1.44
Saul Bass in his later years. Courtesy of Anthology Film Archives.

"We love doing titles. We do them in a nice, obsessive way—we futz with them until we're happy and do things that nobody else will notice but us. We like the notion of the bottom of the table being finished even though nobody sees it. There's a Yiddish word for it, 'meshugas,' which is 'craziness.' I admire obsessiveness in others."

— *Saul Bass*

During the 1950s, American graphic design pioneer Saul Bass became the film industry's leading film title innovator. His evocative opening title sequences for directors such as Alfred Hitchcock, Martin Scorsese, Stanley Kubrick, and Otto Preminger garnered public attention and were considered to be miniature films in themselves.

Born in New York City in 1920, Bass developed a passion for art at a young age and later studied at the Art Student's League in Manhattan and attended Brooklyn College. He became grounded in the aesthetics of Modernist design through the influence of Gyorgy Kepes, a strong force in the establishment of the Bauhaus in Chicago. After working for several advertising agencies, he moved to Los Angeles and founded Saul Bass & Associates in 1946. His work in Hollywood consisted of print for movie advertisements and poster designs. In 1954, he created his first title sequence for the film *Carmen Jones*. Bass viewed the credits as a logical extension of the film and as an opportunity to enhance the story's experience. His subsequent animated openings for Otto Preminger's *The Man With the Golden Arm* (1955) and *Anatomy of a Murder* (1959) elevated the role of the movie title as a prelude to the film. They also represented a rebirth of abstract animation since the experimental avant garde films from the 1920s.

Bass often used suggestive, metaphorical images as storytelling devices for priming the audience. In *Anatomy of a Murder*, he introduces a silhouette that disappears from view and reappears in disjointed parts that jump on and off the frame in concert with Duke Ellington's musical theme. A mood of betrayal and impending doom is established early on, keeping viewers on the edge of their seats. In *The Man*

In the film *Bass on Titles* (1977), Bass discusses the evolution of his opening title sequences and addresses the method that he uses to conceptualize motion pictures into graphic animation.

with the Golden Arm, a symbol of a jagged arm foreshadows the schizophrenic nature of the main character. In *The Seven Year Itch* (1955), abstract graphic elements form a sealed-off door that separates the main characters' apartments. In the opening to *North by Northwest*, bars of text ascend and descend to emulate the motion of elevators. Anticipation grows as racing horizontal and vertical lines invade the frame and intersect to form the grid pattern of a skyscraper for the film's opening shot. Bass' humorous closing sequence to *Around the World in 80 Days* (1956) shows a frantic clock on legs journeying around the world, encountering symbols that represent various places (i.e., elephants in India, pyramids in Egypt, saloon doors in the American west, etc.). In Hitchcock's comedy–thriller *Psycho* (1960), parallel lines and type convey the dark side of the human psyche. In an interview, Bass stated: "I liked giving more zip to *Psycho* because it was not only the name of the picture but a word that means something. I was trying to make it more frenetic and I liked the idea of images suggesting clues coming together."

Bass' use of typography was also revolutionary during a time when motion pictures used plain, static text for their credits. In *West Side Story* (1961) the credits are treated as graffiti, and in *The Age of Innocence* (1993) as epistolary script. In *Around the World in 80 Days*, they are displayed as fireworks that illuminate the scene when the clock encounters Paris. In the opening to *Cape Fear*, Saul and Elaine Bass enlarged a sign reading "Cape Fear" on a Xerox machine. Using a kitty-litter box, Elaine put ink in the water to make it more reflective, submerged the sign in the water, and created ripples with a hair dryer. As the shimmering water settled, the words slowly appeared. According to Elaine: "We didn't dare send Marty the entire shot because if he saw what it really was, it's not that he would think it didn't work, but it would cause him to reexamine it a little too closely."

Friz Freleng and *The Pink Panther*

Friz Freleng's opening cartoon for *The Pink Panther* (1963) became an icon of pop culture, appearing in a number of sequels and eventually its own television series. Freleng's cool contemporary design style, the use of spinning letters and unscrambling words, along with the distinctive theme music from Henry Mancini was a complete departure from the cheaply made theatrical cartoons of the time.

Maurice Binder and 007

American designer Maurice Binder is best known for his abstract, erotic openings for the classic James Bond movies. Beginning with *Dr. No* in 1962 and ending with *License to Kill* in 1989, Binder's stylish credit sequences for fourteen 007 films became a trademark of the series.

Binder was born in New York and began his career as a graphic designer for Macy's department store. He moved to the West Coast to become an Art Director for Columbia Pictures, and in the 1950s, relocated to the UK to design title sequences for Stanley Donen. His work on films such as *The Grass Is Greener* (1961) won the attention of Bond Producers Albert R. Broccoli and Harry Saltzman. Binder's 007 sequences have been described as a visual "striptease" of nude figures against swirling, enveloping backgrounds of color. In a time where pop music and fashion permeated mainstream entertainment, these sensual openings were a perfect match for Bond's character. The titles to *For Your Eyes Only* show a nude female figure in a background consisting of a close-up of a fiber-optic lamp. In the opening sequence to *The Spy Who Loved Me* (1977), female figures move like belly dancers, as if they were conjuring up the vivid masses of background colors. After Bond jumps off a mountain slope and his parachute opens, a silhouette of a woman's hands rises from the bottom of the frame to cradle the parachute as the tune of "Nobody Does It Better" begins.

Binder is known for his striking design in *The Mouse That Roared* (1959), the haunting opening of Roman Polanski's *Repulsion* (1964), and the main title sequence for *The Last Emperor* (1989).

Another source of information on Maurice Binder is a short documentary included on the DVD *On Her Majesty's Secret Service*.

In *You Only Live Twice*, Binder synchronized multilayered graphics to John Barry's title song. The credits begin with a close up of a deceased 007 lying in a pool of blood which transforms into a Japanese fan. A solarized background of an erupting volcano fills the screen with red lava, and silhouetted parasols burst from the lava, giving way to the silhouette of a mountainside fading into a sunrise.

The classic gun barrel opening that precedes the traditional pre-credits sequence in every 007 film was initially created by Binder for the title sequence to *Dr. No*. Gunshots, which are fired across the screen, transform into the barrel of a gun which follows the motion of a silhouetted male figure (Bond). The figure turns toward the camera and fires, and a red wash flows down from the top of the screen as the gun barrel becomes reduced to a white dot. Binder achieved this effect by actually photographing through the barrel of a .38 revolver. This sequence became a trademark of the 007 series and was used extensively throughout its promotion. (Each actor playing Bond had his own interpretation of the famous gun barrel walk-on, the first being stuntman Bob Simmons, then Sean Connery, George Lazenby, Roger Moore, Timothy Dalton, and finally Pierce Brosnan.)

Terry Gilliam and Monty Python

Terry Gilliam's contribution to animation is manifested in a series of bizarre title sequences and animated shorts that he produced for Monty Python. Born in Minnesota, Gilliam became strongly influenced by *Help!* and *Mad* magazine while studying at Occidental College in California. Gilliam joined *Fang,* the college's literary magazine, and sent copies of the magazine to Harvey Kurtzman, editor of *Help!* and co-founder of *Mad*. After receiving a positive response from Kurtzman, he went to New York and was hired as Kurtzman's assistant editor. Here, Gilliam met a British comedian named John Cleese and, in 1969, was asked by Cleese, Eric Idle,

Terry Gilliam also became involved in directing live action during the 1970s and 1980s. Quirky sets, bizarre costumes, and puzzling camera angles are seen in *Jabberwocky* (1977), *Time Bandits* (1981), *Brazil* (1985), *The Age of Reason* (1988), and *The Adventures of Baron Munchausen* (1989). In 1978 he authored the book *Animations of Mortality,* which offers a view into the mind of an animator. In 1996, the book was turned into an interactive CD-ROM. In 1994, he coproduced and created new material for a CD-ROM titled *Monty Python's Complete Waste of Time.*

"What I do in film is the opposite of what is done with the print image. Dracula is a very good example of the process. There is very little information on the screen at any time, and you let the effect unfold slowly so the audience doesn't know what they're looking at until the very end. In print, everything has to be up front because you have so little time to get attention. In film you hold back; otherwise it would be boring. The audience is captive at a film—I can play with their minds."

— *Richard Greenberg*

Terry Jones, and Michael Palin to join the Monty Python group as animator for the show's opening credits. Gilliam's outrageous, cutout animation sequences worked in concert with the group's comedy routine. His ability to transform images of mundane objects into outrageous "actors" not only has entertained his audiences but has demonstrated what stop-motion collage animation is capable of achieving.

R/Greenberg Associates

In 1977, Richard Alan Greenberg and his brother Robert founded R/Greenberg Associates. Richard, a traditionally schooled designer, established a name for his company by "flying" the opening titles for the feature film *Superman* (1978). This sequence demonstrated an early example of computer-assisted effects that enabled the animation of three-dimensional typography. Throughout the 1980s and 1990s, Richard Greenberg designed title credits for features including *Family Business* (1989), *Flash Gordon* (1980), *Altered States* (1980), *Another You* (1991), *Death Becomes Her* (1992), *Executive Decision* (1996), and *Foxfire* (1996). Many of these titles are treated as visual metaphors, setting the atmosphere for the movie. Greenberg once stated: "You have to take the people who have just arrived at the theatre and separate them from their ordinary reality: walking onto the street, waiting in line; you bring them into the movie. You want to tell them how to react; that it is alright to laugh, that they are going to be scared or that something serious is going on."

Pablo Ferro

For the past four decades, groundbreaking title sequences for classics such as *Dr. Strangelove* (1964), *The Thomas Crown Affair* (1968), and *A Clockwork Orange* (1971) earned Cuban-born filmmaker Pablo Ferro a reputation as a master of title design, along with Kyle Cooper and legendary graphic designer Saul Bass.

1.45
Inspired by Ferro's lettering, Yuji Adachi developed a font called Major Kong.

Pablo Ferro is also known for classic television animations such as NBC's Peacock and Burlington Mills' "stitching" logo.

During his advertising career in the 1950s, Ferro introduced several techniques to the commercial film industry including rapid-cut editing, hand-drawn animation, extreme closeups, split-screen montage, overlays, and hand-drawn type. His quick-cut technique, in particular, influenced what later became known in television as the "MTV style." In the opening sequence to the film *To Die For* (1995), Ferro developed the leading character through a montage of newspaper and magazine covers. (Nicole Kidman is so desperate to be a television newscaster that she convinces her lover to kill her husband so that she can pursue her career.) According to Ferro: "I wanted to set up her identity so well, that you knew this person before you met her."

Perhaps Ferro is best known for the revitalization of hand-lettered movie titles. In *Dr. Strangelove*, he conceived the idea of filling the film frame with lettering of different sizes and weights. This distinctive handwriting became one of his trademarks. Ferro's elongated, hand-drawn lettering is also apparent in his more contemporary film titles such as *Stop Making Sense* (1984), *Beetlejuice* (1988), *Good Will Hunting* (1997), *Men in Black II* (2003), *For Love of the Game* (1999), and *My Big Fat Greek Wedding* (2002).

Kyle Cooper

Influenced by pioneers Saul Bass and Pablo Ferro, Kyle Cooper was one of the first graphic designers to reshape the conservative motion picture industry during the 1990s by applying trends in print design and incorporating the computer to combine conventional and digital processes.

Cooper attended the Yale University School of Art and studied under legendary graphic designer Paul Rand. He became intrigued by the manner in which Soviet cinema master Sergei Eisenstein synthesized images in film and completed

his dissertation on Eisenstein. After earning his M.F.A. in graphic design, Cooper worked at R/Greenberg Associates in New York and contributed to the title sequences for *True Lies* and *Twister*. In 1995, his credit openings for David Fincher's psychological thriller *Se7en* immediately seized public attention. Cooper's exploration of integrating raw video footage and typography expresses the concept of a deranged, compulsive killer, putting the viewer inside his head before he is introduced. Scratched, hand-drawn letter forms nervously jump around on the screen to the soundtrack by Trent Reznor (Nine Inch Nails), and close-up shots of instruments of torture (scissors, trays, and tape) flash before the audience's eyes. Profane words appear in conjunction with biblical, nihilistic images to contribute to the mood of dementia and cold, calculated precision. When the negative was sent out for processing, the lab was told that pieces of film leader and twisted film were part of the finished product. Cooper stated: "We kind of had to encourage them to relearn, to rethink some of the ways that they had done things traditionally."

After designing the opening for John Frankenheimer's interpretation of H.G. Wells's novel *The Island of Dr. Moreau*, Cooper, Chip Houghton, and Peter Frankfurt founded Imaginary Forces in Los Angeles. From that point on, Cooper's work progressed to become even more compact and multilayered. The titles to Guillermo Del Toro's *Mimic* (Imaginary Forces' first project) introduced the crisis of a genetic experiment gone awry by displaying closeup images of moths and butterflies pinned to a wall. X-rays sporadically flash upon the screen to reveal the insects in menacing positions. These images are interchanged with pinned up newspaper clippings featuring an insect-based epidemic and photographs of children affected by the disease. Torn headlines that read "disaster" and "tragic" appear beneath the insects,

"Type is like actors to me. It takes on characteristics of its own. When I was younger, I used to pick a word from the dictionary and then try to design it so that I could make the word do what it meant."

— Kyle Cooper

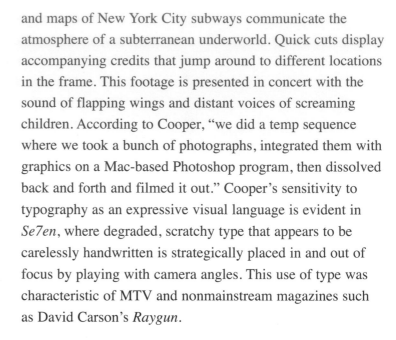

and maps of New York City subways communicate the atmosphere of a subterranean underworld. Quick cuts display accompanying credits that jump around to different locations in the frame. This footage is presented in concert with the sound of flapping wings and distant voices of screaming children. According to Cooper, "we did a temp sequence where we took a bunch of photographs, integrated them with graphics on a Mac-based Photoshop program, then dissolved back and forth and filmed it out." Cooper's sensitivity to typography as an expressive visual language is evident in *Se7en*, where degraded, scratchy type that appears to be carelessly handwritten is strategically placed in and out of focus by playing with camera angles. This use of type was characteristic of MTV and nonmainstream magazines such as David Carson's *Raygun*.

Contemporary Fine Art Film Animators

Works from the artists and companies that are described in this section can be found on the following pages and in other areas throughout this book. Video interviews and clips of their animations can be viewed on the accompanying DVD.

Stephanie Maxwell

Stephanie Maxwell is a California filmmaker who received her M.F.A. in film at the San Francisco Art Institute. She is currently an associate professor in the School of Film and Animation at the Rochester Institute of Technology. She directs RIT's Visiting Artists Series and Lectures Program and is codirector of the ImageMovementSound festival, an annual festival of multimedia artwork created by faculty and students from RIT, the Eastman School of Music, and SUNY College. Her unusual, award-winning animated films have been shown in international film festivals and television programs and have been collected by museums as works of art.

1.46
Frames from terra incognita (2001) by Stephanie Maxwell (animator) and Allan Schindler (composer). All rights reserved.

1.47

Frames from *Time Streams* (2003) by
Stephanie Maxwell (animator) and Allan
Schindler (composer).

1.48

Frames from *Passe Partout* (2002) by
Stephanie Maxwell (animator) and Allan
Schindler (composer).

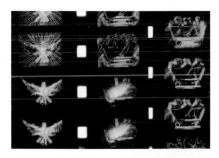

1.49

Filmstrip from *Pursuit/Flight* (1984), by
Marilyn Cherenko.

According to Marilyn: "The hand-painted
material was printed directly onto film
stock, producing something like a nega-
tive. The results were often unpredictable
(in a good way). The 'negative' was then
printed to another print stock to obtain a
positive. The resulting footages were
edited together and printed."

Strongly influenced by Len Lye, Stephanie's artistic process involves painting, etching, and collaging the surface of 35mm clear and black motion picture film. Her abstract compositions are an intuitive fusion of images and sounds that express the synthesis of light, movement, space, and sound. In films such as *Passe Partout*, she often employs hand-cut mattes, found objects, and liquid mixtures. The imagery is often altered and layered digitally during postproduction.

Many of Stephanie's films have been produced in collaboration with musical composers Allan Schindler and Greg Wilder. The music consists of instrumental, vocal, and environmental sounds that have been digitally sampled and manipulated.

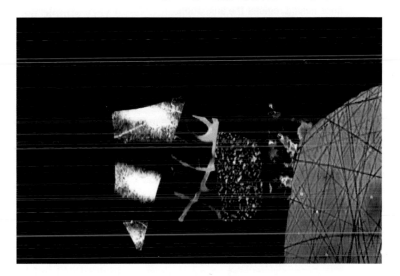

Marilyn Cherenko

In 1981, Marilyn Cherenko graduated from Emily Carr College of Art with a degree in fine arts. Influenced by Norman McLaren's cameraless films, she became interested in combining painting and animation. Cameraless animation was appealing, because of its advantage of being relatively immediate and requiring less expense in materials and equipment than other animation processes. After attending a

1.50

35mm film was photocopied with frame lines and used to plan the animation. This was retraced onto 35mm stock. The photocopied sprocket holes and frame lines helped register the animation. Courtesy of the Marilyn Cherenko. All rights reserved.

1.51

Frame from *Audition* by Candy Kugel. © 1980 Buzzco Associates, Inc.

This 9-minute film is created from cut-outs, photographic imagery, cel drawings, and ink and pastel on paper.

workshop conducted by Stephanie Maxwell on cameraless animation, Marilyn began to investigate direct-on-film techniques such as bleaching; scratching with implements like rasps, dental tools, and darning needles; stencil-making; and applying inks and Letraset to the film's surface. According to Marilyn, "Animation takes so much planning that I wanted to find a way to work more spontaneously." Technically, her approach combines traditional hand-drawn cels, scratching on film, line drawings, and watercolor renderings. Marilyn's subject matter deals with the poetic and spiritual qualities of life. *Pursuit/Flight*, for example, is a lyrical film that explores a woman's fascination with a bird and the consequences of trying to capture freedom. The intent of this film was to tell a very simple narrative: woman desires bird, captures bird, finds that the relationship is uncontrollable and that the relationship is benevolent only when each member is free to stay or go. *About Face* expresses a provocative message about procrastination and the emotional undercurrent of the daily work routine.

Candy Kugel

Candy Kugel became interested in animation while attending the Rhode Island School of Design. As an independent artist, her approach to animation involves the use of cutouts and drawing on paper and cels with pencil, pastel, and ink. The majority of her films, which have been produced in collaboration with Vincent Cafarelli at Buzzco Associates, are inspired by personal struggles from real life. For example, *A Warm Reception in L.A.* (1987) is a 5-minute short to an original song written by Cafarelli and Lanny Meyers about an author's struggle for success and glamour (not to mention the paycheck) in Hollywood. *(it was . . .) Nothing At All* (2000) is also based on a ballad composed by Kugel and Meyers that explores the nature of loss and addresses the question why is it easier to mourn the loss of an object than the loss of a loved one. *Audition* is a 9-minute film that

features an actress (Candy) being scrutinized during an audition. The combination of animation and live action intensifies the drame of the theme. Candy Kugel's past and present work in television is described in Chapter 2.

Stephen Arthur

Born in Vancouver, Stephen Arthur has been producing animated shorts (as well as full-length screenplays) for over 30 years. Stephen has explored the gamut of techniques including cutouts, direct-on-film, drawing on cels and paper, painting on glass, rotoscoping live-action footage, and two-dimensional bitmap animation. Having made most of his animated and experimental 16mm films before completing a degree in zoology at the University of British Columbia, Arthur then focused on narrative live-action while earning an M.F.A. in film production from the University of Southern California in the late 1970s. In 1990, he completed an M.Sc. in neuroscience from UBC, before discovering the emergence of new digital media.

Stephen's nonrepresentational films such as *Touched Alive* and *Transfigured* (both of which are owned by the National Film Board of Canada) made revolutionary use of the personal computer to transform the paintings of Vancouver artist Jack Shadbolt into a choreographed world of interacting "characters" that captured the painter's vision in a new medium.

1.52

"My films are labors of love, and nothing more. Only in recent years have I found it possible to even afford making my films, possible to match my wife with my half of the rent . . . I'll never own a home. I'll die destitute. Sound romantic?"

— *Stephen Arthur*

1.53

Frames from *The Recess* (1995), by Stephen Arthur.

This early bitmap animation film used 2D warping and morphing of photographic images to create new facial expressions and tell a personal story. It was designed for recording directly, in real time, from the display of a personal computer, at a time when animated raster imagery had just become possible on a PC.

1.54
#92 (1997), a painting by Scott Clark. All rights reserved.

"Nature provides us with so much information there isn't time to record it all. I try to isolate the images that scream out at me . . . Not only was the sights of Cullite Creek inspirational but also the sounds. Sounds of the ocean always on the move, of eagles, of the wind in the trees. This place made me want to become an animator."

— *Scott Clark*

Scott Clark

Canadian animator Scott Clark has been producing art for more than 20 years, investigating many creative paths. Animated filmmaking has allowed him to combine story-telling, music, and movement.

After attending the Ontario College of Art and Victoria College of Art in Canada, Scott gained public exposure as an acrylic painter in commercial art galleries and private exhibitions throughout Canada. His expressionistic watercolor paintings derive inspiration from nature. *Cullite* and *Cullite Headland*, for example, are products of working on the West Coast Trail, a part of Pacific Rim National Park on Vancouver Island, BC. Scott's most recent film, *Keeping Balance*, is based on the imagery of Hopi dancers, from whom he derived inspiration in Flagstaff, Arizona. 16mm live action footage was combined with classical-style animation to juxtapose the dream world with the world of reality.

Wendy Tilby

Born in Alberta, Canada, Wendy Tilby studied visual arts and literature at the University of Victoria and attended the Emily Carr Institute of Art and Design in Vancouver to study film and animation. As an independent film animator, Wendy employs a variety of approaches including paint on glass, cutouts, and paint and pencil on photocopied video frames. After completing her first student film, *Tables of Content*, Wendy joined the National Film Board of Canada in 1987 and produced *Strings* and *When the Day Breaks*, both of which were nominated for Academy Awards. She has served on numerous animation panels and festival juries, has taught animation at Concordia University, and has been a visiting lecturer at Harvard University. The characters in Wendy's films are articulated with exquisite detail. Since there is no dialogue or narration, she conveys their essence strictly

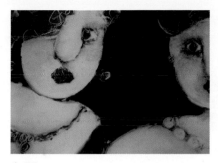

1.55

Additional information on Wendy Tilby and her animations can be found in the book *Animation 2D and Beyond,* by Jayne Tilling.

through the way they look and the manner in which they behave. Wendy described her challenge as "taking what is very ordinary and making it extraordinary."

Carol Beecher and Kevin Kurytnik

Carol Beecher spent the majority of her childhood years in Alberta, ending up in Calgary (where she was born) to study at the Alberta College of Art and Design. Admiring the work of Norman McLaren and the bizarre cutout animations of Terry Gilliam, she became inspired by enrolling in an elective class in animation. After graduating with a major in ceramic sculpture, she worked as an administrator for the Quickdraw Animation Society in 1990. Here, she began to investigate the process of cameraless animation and worked on her first 16mm film *Ask-Me*. In partnership with Kevin Kurytnik, Carol went on to create the animation company, Fifteen Pound Pink Productions, in 1994. A strong advocate of the independent animation community and member of the Association International du Film d'Animation, Carol takes her role as a professional artist and animator quite seriously. She continues to remain active in promoting the awareness of animation as a viable artistic form of expression.

Born in Norquay, Saskatchewan, Kevin Kurytnik studied graphic design and illustration at the Alberta College of Art and Design and began a film career in 1988. As an animation teacher and President of the Quickdraw Animation Society (a nonprofit film cooperative in Calgary), he worked on educational productions for clients such as Alberta Historic Sites Services and Alberta Education Network ACCESS. In 1994, he joined Carol Beecher in developing Fifteen Pound Pink Productions Inc. Kevin and Carol are completing an intense multiyear cartoon project, *Mr. Reaper's Really Bad Morning* (3.1), based on an original story by Kevin, about "the uneasy coexistence between life and Mr. Death."

1.56

Frames from *Abandon Bob Hope All Ye Who Enter Here* (1996), by Kevin D.A. Kurytnik. © Fifteen Pound Pink Productions, Inc.

According to Kevin, this animated collage film consists of "bits of Gustave Dore's Divine Comedy engravings of the Inferno and those oversized 'how to' animation books . . . The diametrically opposed bits were selected photocopied, chopped up and then processed in a blender before being forced at gun point onto film. As a final conceptual insult, this scathing critique of bland toons, made with $500.00, sand paper and cat hair, is only available for screening on video."

1.57

Frames from *Ask Me* (1994), by Carol Beecher. © Fifteen Pound Pink Productions, Inc.

This abstract cameraless animation was drawn directly on 16mm black leader film.

Joris Oprins

Joris Oprins is a student at the Design Academy Eindhoven in the Netherlands. He has produced several short videos and films and has been active in the process of video installation. Although he has not been trained in traditional fine art, Joris developed a method of drawing and animating based on an idea to produce a short animated movie about two people and their dog stranded on a mud flat on windy day. In his most recent work, titled *Wad*, the characters were created from mud and tar on wet sandpaper.

The Netherlands has a strong reputation in fine art animation with names like Gerrit van Dijk and Paul Driessen. Il Luster Productions (www.illuster.nl) is a young Dutch production company that specializes in independent and commissioned films, emphasizing creativity and originality. It distributes its films through international sales agents and has become a meeting point for the "next generation" of Dutch animators. Il Luster Productions currently distributes the work of well-known Dutch animators including Joris Oprins, Michael Sewnarain, Beatrijs Hulskes, Chris de Deugd, Adriaan Lokman, and Lauri Kramer.

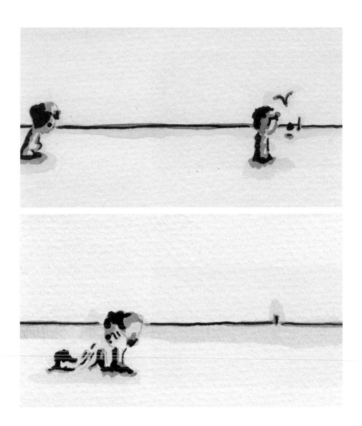

1.58

Frames from *Wad* (2003), by Joris Oprins. © Il Luster Productions.

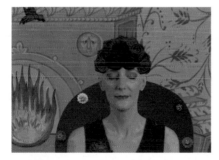

1.59

Frames from *Touched by an Angel* (2001), by Beatrijs Hulskes. © Il Luster.

Beatrijs Hulskes

Beatrijs Hulskes studied at the Academy of Arts Minerva in Groningen from 1980 to 1985. Beatrijs made several video installations and from 1986 she worked as a director for many television programs, such as *Marre* (1987), *Stapelbed* (1988–1989), and a documentary series titled *Geheim Gebied*. In 1988 she made computer animations for "Het Tenenkaasimperium." In 1991 she started work on her first independent film *The River Okkervil* that was shown in Rotterdam, Utrecht, and St. Petersburg and was bought by the Stedelijk Museum in Amsterdam and shown in the Paleis van Schone Kunsten in Brussels. In 2001 *Touched by an Angel* premiered in Utrecht and Amsterdam. Beatrijs Hulskes developed a style that combines cutout animation with live action and object animation. Combined with the use of bright colors it evokes a fairy-tale and dreamlike feeling.

1.60

Frames from *Hypochonder* (2002), by Michael Sewnarain. © Il Luster.

1.61

Frame from *Haar kussen waren lang* (2003), by Noga Zohar. © Il Luster.

1.62

Frame from *Daedalus' Daughter* (2001), by Chris de Deugd. © il Luster.

Michael Sewnarain

A true storyteller with an original "cartoonesque" style, Michael Sewnarain has worked on many commissioned films, animated commercials, and Internet movies. Recently, he decided to work on his own films and produced his first independent animation titled *Hypochonder*, a pilot for Il Luster's DICHT/VORM series. He is currently working on two more films, both of which obtained grants from the Dutch Filmfund and the Amsterdam art fund.

Noga Zohar

Noga Zohar is one of the numerous animators at the Lawson &Whatshisname animation studio in Amsterdam. According to Noga, "Some of it is traditional animation drawn straight into the computer. You can work fast and intuitively, without things getting too complicated on the timeline. But the good thing is that you can also mix different styles on different layers and still be able to draw in it. In one project for example, I started with some stop-motion footage which I imported into Aura. Then I could easily cut, paste and stretch it, and even draw directly into the source material . . . It's really like creating a moving painting."

Chris de Deugd

Chris de Deugd studied film and art at the Academy of Tilburg, The Netherlands, while learning animation techniques from acclaimed animator Borge Ring. Film animation allows her to combine music, kinetic images, and poetry into a single concentrated piece of work. Chris loves the riches of color, the luxury of a seemingly effortless sumptuous style in drawing, and a wealth of embellishments in motion. She used pastels, ecoline, watercolors, and colored pencils on paper and frosted cells for her directorial debut *Daedalus' Daughter* and digital cutout and single frame animation in films like *Psychopathia sexualis*.

1.63

Frames from *Crime and Punishment* (2000), by Piotr Dumala. © Acme Filmworks.

A fusion of red and brown tones are used to express the violent, uncleanly side of human nature.

Piotr Dumala

Born in Poland, Piotr Dumala is an acclaimed animator who is known for his innovative plaster technique that occurs under the camera. While studying sculpture and animation at the Academy of Fine Arts in Warsaw, he found that etching on a plaster slab and painting it with oil produced a surface that could make his drawings appear to move. The resulting light-and-shade effects allowed soft transitions to occur between sequences. According to Dumala, "I had a piece of wood covered with a special preparation—I kept it as a lesson of technology from art school—and I covered the wood with brown oil paint as background—I always liked Dutch painting and I knew they covered their paintings with black. I really liked this and scratched it with a needle. I could continue this and make a film."

Influenced by the philosophies of Kafka, Dostoevsky, and existentialism, Piotr's themes deal with dark, unexplainable forces that exist in human beings. *Crime and Punishment* shows the emotional state of a troubled soul before and after committing a murder. Other films such as *Little Black Riding Hood* (1983), *Gentle Spirit* (1985), and *Franz Kafka* (1991) have a profound and haunting effect on his audiences.

Trees for Life

Trees for Life is a nonprofit organization located in Wichita, Kansas, that uses animation and video technology as an effective instructional communication tool for people who are living in Third World and developing countries such as India. Since its inception in 1984, more than 2.5 million people have participated in their programs, and more than 30 million trees have been planted in developing countries. Each tree protects the environment and provides a low-cost, self-renewing source of food for a large number of people. According to Balbir Mathur, founder and president of Trees

1.64

Balbir Mathur, President, Trees for Life.

More information on Trees for Life can be found by e-mailing info@treesforlife.org.

for Life, the group teaches people how to plant trees—who in turn teach other people in their communities how to plant trees for the future. "Since many of the people in the target countries are illiterate, animation and video technology has proven to be an effective way to communicate with them." Canadian animator Frédéric Back won an Academy Award for *The Man Who Planted Trees*, a 10-minute film promoting planting fruit trees in developing countries. Frédéric has been an invaluable source of inspiration to the organization.

Terry Green and Nori-Zso Tolson

Terry Green and Nori Tolson are partners of twenty2product, a motion graphics production company in downtown San Francisco, California. Terry received a B.A. in graphic design from Rutgers in 1985, and an M.F.A. in computer graphics from the San Francisco Academy of Art College in 1987. Nori learned her craft within a family of television directors and designers at Tolson Visuals in New York City. She also worked as a production artist at Colossal Pictures, then later as a 3D animator at Synthetic Video, where she and Terry met and decided to form 22p in 1987.

Terry and Nori approach film design the same way they approach client work. The difference is that they get to choose both the subject and how it gets framed in their own shorts. They talk, then Terry generates sketches in Adobe Photoshop, from which Nori begins to animate them to the soundtrack. Then they render the composite project out and make notes about what's not working, make fixes, and re-render and evaluate until everything's right. According to Terry: "It's been great for us to have the opportunity to express noncommercial things with graphics in a space that's all ours to experiment and make mistakes. Time for that is probably the most valuable thing we bought with the money we made from client work. Since clients benefit from techniques we invent while making short films, it all works out."

1.65

Nori Tolson and Terry Green, founders of twenty2product.

Contemporary Film Title Designers

The film title designers and companies that are described in this section can be found on the following pages and in other areas throughout the book. Video interviews and clips of their animations can be viewed on the accompanying DVD.

Imaginary Forces

In 1996, Imaginary Forces (IF) was founded in Los Angeles by Kyle Cooper, Chip Houghton, and Peter Frankfurt. Since then, it has evolved into a multidisciplinary entertainment and design agency, with locations in Hollywood and New York. Its award-winning work in film title design includes films such as *Gattaca*, *Clockstoppers*, *Spider-Man*, *Daredevil*, *Men in Black I* and *II*, and *Signs*. IF's network branding projects have included clients such as MTV, Animal Planet, the Discovery Channel, and Court TV, as well as the on-air redesign for Lifetime. Additionally, IF has produced award-winning commercial spots for Nike, Kodak, and Smirnoff.

1.66

Frames from *Yuen-Po* (2003), by Terry Green and Nori-Zso Tolson. All rights reserved.

This lyrical short features the Yuen-Po bird park in Mongkok, Hong Kong. 16mm frames were pulled from a video transfer and digitally composited with saturated color sketches that incorporated additional bird images and animated graphics to lend the film a radiant quality. The end credits transition to black through color as they fade on in common letter groups, as "birds of a feather" would.

1.69

Frames from the opening title sequence to *Spider-Man*. Designed and produced by Imaginary Forces. © Columbia Pictures.

1.67

Frames from the opening title sequence to *Clockstoppers*. Designed and produced by Imaginary Forces. © Nickel-odeon Movies and Paramount Pictures.

1.68

Frame from the opening title sequence to *Gattaca*. Designed and produced by Imaginary Forces. © Jersey Films and Columbia TriStar.

1.70
Deborah Ross.

Deborah Ross Film Design

Raised in Los Angeles, Deborah Ross received a Diploma of Art and Design from Ealing School of Art in London in 1974. After working in London as a freelance designer, she returned to Los Angeles to assist Dan Perri, who designed titles for such classics as *The Exorcist* (1973), *Close Encounters of the Third Kind* (1977), *A Nightmare on Elm Street* (1984), and *Platoon* (1986). In 1979, she established Deborah Ross Film Design . Her animated openings have included *The Little Mermaid* (1989), *Hunt for Red October* (1990), *The English Patient* (1996), *The Talented Mr. Ripley* (1999), *Scary Movie 2* (2001), and *Cold Mountain* (2003).

1.71

Frames from the titles to *The Talented Mr. Ripley*. Designed and produced by Deborah Ross Film Design. © Miramax.

1.72

Frames from the opening title sequence to *Get on the Bus*. Courtesy of Big Film Design. © Columbia TriStar Studios.

The titles for Anthony Minghella's *The Talented Mr. Ripley* (1.71) is one of the longest openings (over 8 minutes) to be produced on an Apple desktop computer (specifically a Mac G4), using Adobe After Effects. (Trish Meyer of Cybermotion, Sherman Oaks, CA, was the predominent animator). Deborah played upon the theme of jazz by referencing 1950s and 1960s album cover art from the Blue Note jazz label; this look is characterized by the liberal use of graphic shapes and typography. A distressed typewriter font fades in and out in concert with emerging hard-edged shapes containing actor Matt Damon's face looking to the side in a contemplative pose. The letters of the title are compressed together with a rapid succession of adjectives that express Ripley's personality. Portions of the film were tinted with animated bars of color which were used as masks to create transitions between the scenes. According to Deborah: "This underscored the dueling musical themes of jazz versus classical in the story, as well as the bohemian 'coolness' of the period. Sometimes, these bars echo playful piano keys; other times, they are jagged shapes that foretell the disturbing psychological aspects of the story."

Randy Balsmeyer (Big Film Design)

After receiving a BFA from the California Institute of the Arts, Randy Balsmeyer became director of live opening sequences for *Sesame Street, Between the Lines,* and *Shaft.* He also worked as a designer/director at R/Greenberg Associates. In 1986, Balsmeyer and his wife and partner, Mimi Everett founded the motion graphics firm Balsmeyer & Everett, Inc. Based in New York, the company worked in collaboration with filmmakers such as Spike Lee, Joel and Ethan Coen, Harold Ramis, and Wayne Wang and became renowned for their elegant title treatments for films such as *Fargo*, *Dead Man*, *Kama Sutra*, *Magnolia*, *Naked Lunch, Get on the Bus,* and *Clockers* (1995). Randy Balsmeyer is currently Creative Director and President of Big Film Design (formerly Balsmeyer & Everett, Inc.).

2

animation in broadcast and interactive design

ANIMATION IN TELEVISION AND DIGITAL MEDIA

The potential of animation in television has been realized by motion graphic designers. Interactive forms of communication such as Web sites and disk-based presentations have also harnessed kinetic images and type as an effective means of delivering rich sensory experiences across narrowband, broadband, DVD, and CD-ROM media. Designing in time and space has become multidisciplinary, suggesting an approach that combines the language of traditional graphic design with the dynamic visual language of cinema.

"Once graphic design meant flat, static, two-dimensional. Now it encompasses multiple, hybrid media. It is not just visual, but involves a variety of the senses, more like life itself, which plays out in a four dimensional world."

— *Chris Pullman*

chapter outline

00 : 00 : 00 : 02

Motion Graphics in Television

Early cinematic techniques that were used in experimental avant-garde film and movie title sequences became adopted in broadcast motion graphics, as television became a new medium for animation.

animated network identity

Harry Marks

By the late 1960s, the majority of prime time television content was produced on color film. Tape recording technology also became available, and color videotape machines and tape cartridge systems were offered by RCA, providing stations with a reliable method of spot playback. Broadcasters stretched the limits of portability with large cameras and recorders. Program relay by satellite also emerged, giving viewers live images from all over the world. When there were just three television networks, brand identity was easily captured in three signature logos: NBC's Peacock, CBS's Eye, and ABC's round logo designed by Paul Rand.

During that time, Harry Marks, who was working for ABC, conceived the idea of the moving logo. This revolutionary innovation was made possible through the use of innovator Douglas Trumbull's slit scan camera, which he had developed as an extension of John Whitney's work. This assembly was mounted on a track and moved toward artwork that was illuminated on a table. In front of the art, an opaque screen with a thin vertical slit restricted the field of view of the camera to a narrow horizontal angle. Although this process was laborious and expensive, it introduced many graphic possibilities into the broadcast world. According to Marks: "There were maybe two or three of us paying attention to what the screen looked like . . . It happened around the time that I saw *2001*. I thought if we could translate that kind

2.1

Frames from NBC's *Monday Night at the Movies* with Dale Herigstad (1989). Courtesy of Harry Marks/Pacific Data Images and NBC.

Animation in Broadcast and Interactive Design

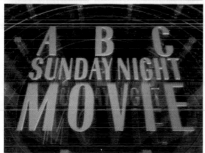

2.2
Frames from ABC's *Sunday Night Movie* campaign with Dale Herigstad (1989). Courtesy of Harry Marks/Pacific Data Images and ABC.

of animation into something readable we would have something that no else had . . . I think we opened the screen so it wasn't this three-by-four box any longer, but it had inferences of much bigger worlds outside the box. We were looking for a viewport." The animated opening sequence to ABC's *Movie of the Week* was a major accomplishment and captivated audiences nationwide. As a precursor to modern digital animation techniques, it brought about a major graphic design revolution.

Harry Marks' 30 years of experience as vice president and creative director at ABC and CBS has been recognized throughout the United States and the rest of the world. Throughout his career, he pushed the envelope of digital technology and produced cutting-edge work that earned many awards, including an Emmy and the first Life Achievement Award from the Broadcast Design Association. His company, Marks Communication, has pursued business-to-business multimedia projects such as point-of-purchase kiosks. According to Marks: "I'm bringing my television experience to the computer arena, and letting people see something familiar. So many people are frightened by computers, that if it looks more like television, they feel it's a little more friendly."

developments over three decades
Throughout the 1970s, the microprocessor, the Apple computer, and Microsoft contributed to important advancements in the computer graphics industry. Raster-based applications such as SuperPaint led to the introduction of computer graphics into television. Complex systems such as Animac, Scanimate, and Caesar were developed by Computer Image Corporation to allow images to be digitized and altered. "Live from the scene" news reporting became commonplace, improved one-inch formats were offered, and local stations

began investigation of the possible applications of teletext. Digital video products such as the timebase corrector and the digital VTR began to appear with the introduction of products containing microprocessors. The gradual introduction of digital technology and expensive workstations led to more innovative, graphics-intensive network image identities. Promotional styles became enhanced, and with the advent of faster, less expensive systems, animation began to emerge as an affordable medium for local and regional broadcasts.

In the 1980s, IBM introduced their first personal computer into the business community, and a new attitude toward PCs spread across the country. Corporations such as SIGGRAPH and Industrial Light and Magic (later spinning off Pixar) started to take off. High-performance Silicon Graphics computers led to sophisticated 3D imaging applications, and Apple released its first Macintosh personal computer in 1984. While many computer graphics studios were focusing on film, studios such as Pacific Data Images in Sunnyvale, California, turned their attention toward the creation of network identity animation in response to the arrival of more cable television channels. During that time, MTV became a place where young designers, working with small budgets and tight deadlines, were given almost total artistic freedom to produce in-house animation. Embracing digital technology in the spirit of experimental animators from the 1960s, this generation of artists broke the barriers of conventional television to fulfill the demands of its target audience. Unlike NBC or CBS, MTV was not afraid to experiment with its logo, and its bumper animations were treated as opportunities to explore new graphics techniques. According to Todd Mueller, who worked at MTV designing on-air promos and stage sets: "MTV was always figuring out what it was . . . But it was like, 'It's rock and roll. It doesn't matter.'" Mueller would "find a whole bunch of footage, group it into

categories—tribal, urban, technology—and affect it with a filter. We would design one setting and then just process a whole chunk of it and then over the next month cut it up and use it in several different episodes."

Throughout the 1990s, older, expensive workstations were replaced by desktop editing and compositing applications on personal computers, giving designers the ability to use lower-end tools to create broadcast animation within the Macintosh environment. The impact of digital technology on the broadcast industry has continued to infuse new design possibilities for television identity graphics.

2.3

Frames from a bumper pitch for MTV.
Courtesy of Joseph Silver Design.

2.4

Frames from a network redesign package
for Lifetime Television. Designed and
produced by Imaginary Forces.
© Lifetime Television.

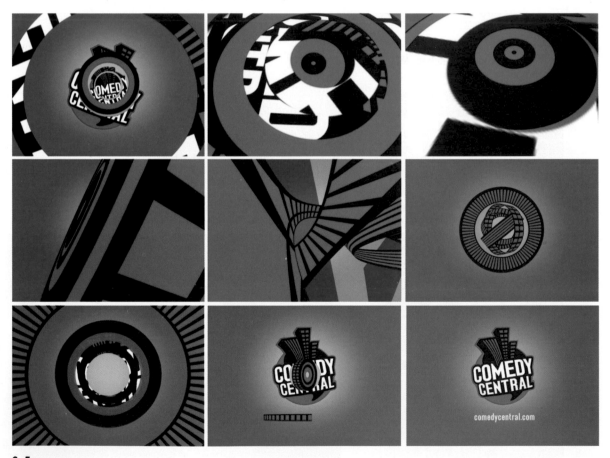

2.5

Frames from Comedy Central's network
package. Designed and produced by
Imaginary Forces. © Comedy Central.

2.6

Station ID storyboard for HBO Television.
Courtesy of Susan Detrie Design and
The Studio at New Wave Entertainment.
© HBO.

2.7

Motion network ID for Tech TV (2001).
Courtesy of Viewpoint Creative. © Tech TV.

2.8

Frames from Lifetime Television motion
IDs (1988). Courtesy of April Greiman
Made In Space. © LifeTime Television.

Robert Abel's influence on succeeding designers comes across in their memories of him. Bill Kovacs, who founded Wavefront Technologies once stated: "It's a tribute to Bob that so much was brewed there. He loved to stir the pot and make something greater than the sum of the parts." Richard Edlund, a Visual Effects Oscar-winner who calls Abel his mentor once said: 'We created photo-masochistic commercials with hundreds of motion-control passes . . . There was so much happening in each frame that you couldn't wait to see it again. If you had an idea, you just elbowed your way to a camera and shot a test. If it looked good, Bob would rush to New York and sell a commercial based on it. Then he'd come back and try to figure out how to make it work."

show titles

In addition to movie title design, the marriage of animated images and type found its niche in the world of broadcasting during the 1970s. The creative pursuits that computer graphics studio Robert Abel & Associates employed at the time played a major role in the advancement of television motion graphics. In addition to numerous technical breakthroughs, Robert Abel produced the opening sequence for Spielberg's *Amazing Stories*, campaign ads for Benson & Hedges, and a ground-breaking TV and print campaign for 7-Up and Levis. Abel's team was responsible for producing the "photo-fusion" look in spots such as 7-Up's Uncola through the use of computer-controlled cameras. Additionally, RA&A pioneered the use of the Evans & Sutherland's vector-based computer system to previsualize effects. Since 1999, Abel has been involved in interactive television projects for AT&T, VH1, AOL, Microsoft, and *Time*.

2.9

Frames from the main title sequence of *Ally McBeal*. Designed and produced by Imaginary Forces. Copyright © FOX Network.

2.10

Frames from a promotional campaign for *Threshold* (2003). Courtesy of Viewpoint Creative. © SciFi Channel.

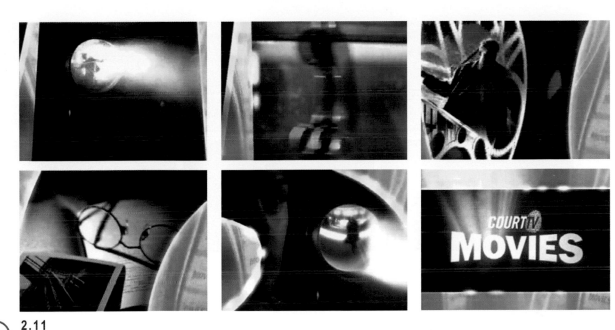

2.11

Frames from *Court TV Movies*, created and produced by Hatmaker. Courtesy of Hatmaker and Court TV.

Court TV wanted a direct yet engaging means of promoting their movie block. Hatmaker combined fresh takes on iconic cinematic imagery, suggested story snippets of original live action footage, and a rich theatrical palette to create graphics which embrace the genre but convey a sense of sheer entertainment.

2.12

Frames from the title sequence of *The Practice*. Courtesy of Imaginary Forces. Copyright © ABC, Inc.

2.13
Frames from a promotional campaign for Discovery Channel's *Nefertiti Resurrected* (2003). Courtesy of Viewpoint Creative and Discovery Channel.

music videos

From classical storytelling to information overload, music videos are multifaceted forms of art and popular culture. Based on performance or concept, combinations of sounds and moving images are synthesized to produce a unique visual experience through the television's screen and speakers.

> **"The shock aesthetics in music videos can be interpreted as a combination of the provocative modern art tradition and a cultural interpretation of teenage rebellion."**
>
> — *Sven E. Carlsson*

Cinematic traditions that have been carried over from film into music videos have been further enhanced with special effects. For example, a person giving a live singing or dancing performance is placed in a setting that is literally suggestive of the lyrics. On the other hand, music videos often deviate from the conventions of traditional cinema. Perhaps this is due to the impact that abstract film pioneers such as Fernand Leger, Walter Ruttman, and Oskar Fishinger made during the 1920s and 1930s. The abandonment of narrative structure is a strong example of this. Traditional notions of past, present, and future are often lost in an incoherent flow of pictorial content. Contradictions in meaning between the lyrics and the imagery are sometimes designed to invoke thought; rather

2.14

Frames from *Discoball World*, a music
video for David Garza, by David Carson.
Courtesy of David Carson Design.

than illustrating the song through the use of literal images,
music videos often attempt to create new meanings through
suggestive visual metaphors. When used well, these can
produce a poetic experience. However, the greater the gap
between the lyrics and the imagery, the more challenging it
becomes for the viewer to discern the context. Other times,
these contradictions are used purely as "eye candy" to create
a temporal experience in which narrative meaning is inter-
preted subjectively (depending upon personal musical taste
or imagination). In an article titled "Audiovisual Poetry or
Commercial Salad of Images," Sven E. Carlsson addresses
how visuals lacking a coherent narrative often rely on unify-
ing devices that are characteristic of the music. For example,
the movements of people or objects are synchronized to the
beat of a song, or camera movement is choreographed to
match the phrasing of the music.

Motion Graphics in Interactive Media

Web sites, disk-based presentations, and public information facilities have become effective communication vehicles, because of their ability to transmit messages in a nonlinear, multidimensional fashion. The education, entertainment, and advertising industries have made extensive investments in digital communications technologies, enabling rich sensory experiences to be delivered across narrowband, broadband, DVD, and CD-ROM media.

the interactive environment

For centuries, books have been a primary method of delivering information. Their internal format has remained unchanged, consisting of a table of contents, chapters, glossary, index, etc. Early forms of interactivity such as pinball machines, ATMs, television remote controls, and video games have allowed information to be restructured into systems that are closer than the book to our actual thinking processes.

"Once you made it, it stayed put. Great care was taken to get everything in just right spot, just the right relationship. Now, increasingly, the output is a variable, not a constant. Think of the way your web decisions look on somebody else's screen. The new problem is to design the rules for the relationship of things, not a single predictable outcome."

— *Chris Pullman*

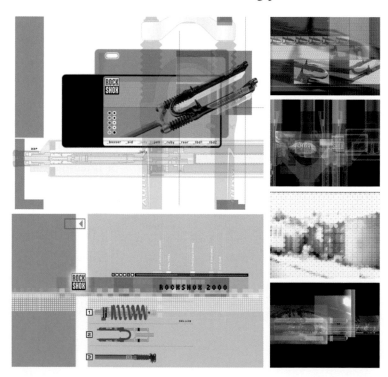

2.15
Interface designs for Rockshox's 2000 Web site. Courtesy of twenty2product.

More recently, computer-based interactive presentations have allowed more highly engaging sensory experiences to facilitate our ability to access and process information. Regardless of the complexity and diversity of the content, information can be presented in a highly organized and aesthetically satisfying manner. Unlike linear structures that imply continuity and have a prescribed beginning and end, the passive flow of information is redirected into a structure that is branching and nonsequential. As a result, the user's role has become increasingly active. Any number of possible paths through the material can be taken, and the manner in which content is displayed can be controlled by inputting information through mouse selections, keystrokes, touch screens, controllers, and voice commands. Corporate Web sites allow clients to navigate between items in whatever order they wish, without having to rewind or fast forward. DVD videos allow you the option of choosing the order of scenes you wish to see. Educational CD-ROMs challenge you to move to higher levels of performance by accumulating points or by inputting a correct answer.

animation in multimedia

The advent of film and television allowed independent and commercial artists to deliver to their audiences high quality moving images combined with sound. However, the cost of producing and showing films and videos was not affordable to most individuals and organizations; as a result, newer and less expensive technologies were developed to accommodate their needs. For example, multiple projector slide shows with dissolve control allowed animation synced with audio to be presented to large audiences. On the computer screen, the concept of animation and interactivity was first introduced in the mid-1980s with applications such as HyperCard, SuperCard, and Director.

2.16
Prior to digital multimedia, preparing animated preentations for multiprojection slide systems was a laborious, tedious task. Photo of Alan Harris, President and founder of AiH Group, Pittsburgh, PA.

Developed by Bill Atkinson (who also created MacPaint), HyperCard was released for the Apple Macintosh in 1987. Originally named WildCard during its development, this simple programming environment allowed users to construct "stacks" of "filing cards" containing text and simple graphics. Navigation between the cards could be performed by clicking on-screen buttons that contained hot spots. HyperCard's scripting language, HyperTalk (2.17), allowed you to program actions such as jumping from card to card. Simple animations could be created through several different methods including card duplication and changing the location of an card's coordinates on the X- and Y-axes using a "Loc" command. Before MS PowerPoint was introduced to the market, HyperCard programs were designed to produce interactive adventure games, simple databases, and educational learning tools. In the 1990s, Kevin Calhoun initiated the move to allow HyperCard version 3.0 to be used to produce QuickTime movies (in addition to color support and Internet connectivity). This version was never released, and HyperCard's decline in popularity came about with the growth of the World Wide Web, which was capable of delivering information in the same manner through the use of hypertext language.

During the mid-1980s, a company called MacroMind was formed by Jamie Fenton, Marc Canter, and Mark Pierce, who developed a program called VideoWorks. Based on a language modeled after Basic, VideoWorks Interactive Pro was licensed to Apple to be used in its "Guided Tours" for Macintoshes in 1987. A year later, its programming language was further developed into a more sophisticated object-oriented scripting language called Lingo, and the name of the software was changed to Director. In addition to authoring CD-ROMs, the program's animation capabilities included key framing, shape tweening, onion skinning, real-time

"wait until the mouse is down", "if it is not a number then beep", "get word 3 to 10 of line 8 of theAnswer", and "go to the last card of this stack"

2.17

HyperCard's scripting syntax, HyperTalk.

Animation in Broadcast and Interactive Design

recording, and step recording. (During this period, Director was used to generate computer graphic displays for the TV series *Star Trek: The Next Generation*.) In the mid-1990s, MacroMind Director was purchased by Macromedia and developed support for Apple's new QuickTime technology. Since then, Director has remained an industry standard tool for creating of interactive disk-based and Web-based content.

Over the years, more advanced desktop video and animation tools have allowed motion graphics to become an integral component of interactive CD-ROM and DVD titles.

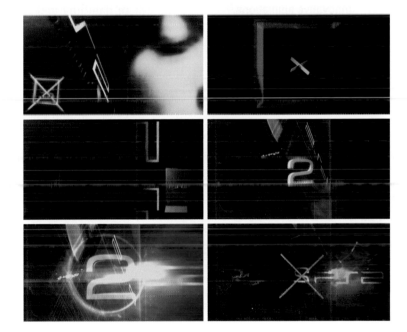

animation over the Internet

Although the prospect of facilitating real-time motion over the Internet has been a technical challenge, the Web has introduced opportunities for independent animators to exhibit their work to a wide audience and for graphic designers to convey their messages through movement. The concept of motion over the Internet, originally a text-only medium, was a pipe dream until the early 1990s, when Java was introduced. This network-oriented language enabled programmers

to create applications (called applets) that users could download off the Internet. It worked on all operating systems, though, only in conjunction with a browser. Today, Java continues to be used for producing interactive animations and incorporating movement into Web page design.

During the release of 4.0 browsers, another programming development that occurred was dHTML (Dynamic HTML). Composed from a combination of complex programming languages, dHTML allowed hierarchical layers to be displayed in Netscape and provided a more sophisticated way of handling text through the use of style sheets. Although dHTML was not developed to provide animation, it allows HTML elements to be altered in a manner that adds motion to a Web page. For example, a dHTML script can tell the browser to change the placement of an image, allowing it to travel around the page.

Like the animated GIF, dHTML animation is recognized by most Web browsers and does not require users to download extra components. It is, however, limited in its animation capabilities. Additionally, it is challenging to code dHTML content to behave the same way on all browsers. Although applications such as Macromedia Dreamweaver or Adobe GoLive can produce the script, it is not always consistent between browsers.

In addition to Java, the animated GIF was one of the initial forces to introduce motion to the Web. Unlike Java, however, the animated GIF format was an ideal low-tech option for adding motion to Web pages. Built into the GIF file format, animated GIFs have the ability to display sequential images in a single file. Since GIFs are color indexed, their size and bandwidth requirements are much smaller than those of non-compressed RGB images. The fact that animated GIFs do not

2.19

A dHTML script written in Macromedia Dreamweaver animates a layer horizontally across a Web page.

Animation in Broadcast and Interactive Design

require special plug-ins for viewing offers a significant advantage over other formats that have been introduced to the Web. Additionally, GIF animations can loop or be set to play back any number of times at a specified duration for each frame. Although they no longer represent cutting-edge technology, animated GIFs are still one of the most popular animation formats on the Web.

In 1995, Macromedia Director released the Shockwave plug-in, enabling Director animations and multimedia presentations to be displayed over the Web. Macromedia immediately began to distribute the Shockwave Player as a free utility. (Initially, Shockwave required users to download the plug-in.) By the late 1990s, Director's future with the Internet had been firmly established.

During that time, Jonathan Gay and Charlie Jackson founded FutureWave Software and developed a vector-based drawing program called SmartSketch. To avoid competition with Illustrator and FreeHand, they changed the product's name to FutureSplash Animator and focused on its animation capabilities, which were possible through a slow Java-based player. After the software became adopted by Microsoft and Disney, Gay and Jackson sold FutureWave Software to Macromedia in 1996, and FutureSplash Animator became Macromedia Flash 1.0. After version 4.0 of Flash was released, the Shockwave plug-in (originally used by Macromedia Director and Flash) became limited to Director, and Flash received its own plug-in, the Flash Player, while retaining the .swf extension to allow backward compatibility.

Although Flash has evolved from a simple Web animation program to a complete multimedia development tool, it is still the most effective and most widely used application for creating and delivering vector animation over the Web.

The Internet is still in a state of infancy and will continue to evolve in conjunction with the computer industry. With the development of higher bandwidth connections and streaming video, the prospect of animating specifically for the Web is exciting, as more opportunities will materialize for fine art animators and motion graphic designers to push their artistic envelope beyond the movie and television screen.

motion within the interface

The potential of interactive design has afforded motion graphic designers the opportunity to exercise their talents beyond the motion picture and television screen. Animation within an interface can enhance the user's experience if it is designed well and is logically integrated.

The concept of motion in interactive design has introduced many new design possibilities, many of which, ironically, have had a major impact on design trends in the film and television industries. The unique nonlinear environment of an interface allows many types of kinetic elements to coexist with static images and text in the same compositional space. Because users can travel from place to place, images and

2.20

Prototype Web designs. Courtesy of twenty2product. © Total Entertainment Network.

type can be continuously moving on the screen. For example, an animation sequence on a home page can continue to loop until the user chooses to visit a new location. Depending upon the complexity of interactivity, animation can enhance the navigational process by entertaining the user while emphasizing the hierarchy of information. Animated icons and rollovers can help place emphasis on items that users might otherwise overlook. In other cases, navigation may be animated simply for the purpose of entertainment.

2.21

Prototype Web designs for Clariden Bank and Skybridge. Courtesy of twenty2product. © Total Entertainment Network.

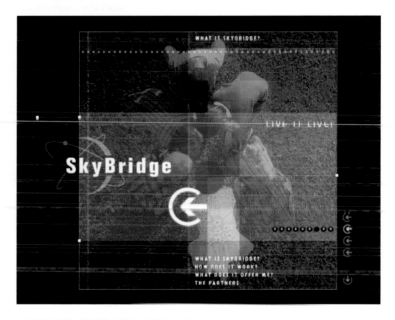

Animated transitions can be used to create smooth visual changes between different parts of an interface. Cinematic techniques such as zooming, panning, and tilting can be used to structure and inform the user ahead of time how information will be visualized. "Infinite zooming," for example, allows the computer screen's finite viewing space to become capable of infinite resolution. In a virtual space consisting of complex information, this technique provides the capacity to move between various levels of detail while maintaining the original context.

2.22

Shawn Design's home page represents a common navigation scenario in which thumbnail images depicting the company's work begin to scroll inside an "inner frame" when the mouse approaches them. Courtesy of Shawn Design.

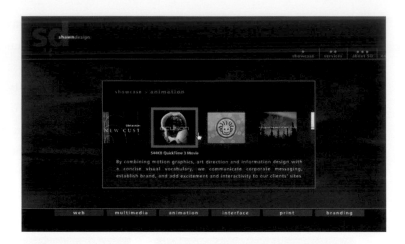

2.23

Stills from an interactive Director Projector for Indie Producer. © 2004 Craig Miranda Design.

Navigational items display small video clips when rolled over with the mouse.

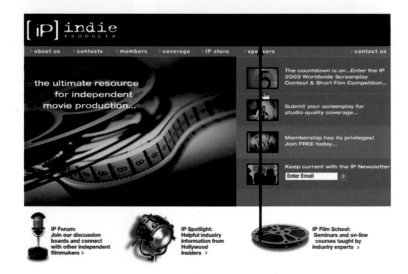

Contemporary Motion Graphic Designers

The motion graphic designers and companies that are described here can be found throughout this book. Video interviews and clips of their animations can be viewed on the accompanying DVD.

David Carson

David Carson's work for cultural, corporate, music, and other clients has been recognized by numerous groups including the New York Type Directors Club, American Center for Design, and *I.D.* magazine.

In the past few years, David has explored motion graphics in film and television—specifically commercials and music videos. His intuitive use of images and typography in motion graphics, like that in his print work, is expressive, experimental and multilayered. He reinforces content with form, and his use of subtle shape and color contrasts communicates the feeling of the subject matter, often eliciting an emotional response from the viewer.

2.24
Frames from a television commercial for Nike. Courtesy of David Carson Design.

2.25
Frames from a TV commercial for Leap
Battery. Courtesy of David Carson Design.

"I'm sure there's a
student out there
doing something that
we'll see in a couple
of years and just go
'whoa!' where did
that come from?"

— *David Carson*

Buzzco Associates, Inc.

As an aspiring artist during the 1970s, Candy Kugel worked
at Perpetual Motion Pictures as a intern for a salary of $25
per week as the assistant to the designer of television com-
mercials. She rose from the rank of in-betweener to anima-
tion director at Perpetual Motion Pictures, becoming the
youngest animation director at the time.

In 1981 Candy was invited by Buzz Potamkin to join the
creative team of the animation studio Buzzco Productions.
During that time, she created the first animated identification
for MTV (the famous "moonwalk"). Since 1985, Candy has
been part of the cocreative director of Buzzco Associates
with partners Vincent Cafarelli and Marilyn Kraemer.

2.27

Frame from *AGTV* show opening by
Candy Kugel, Vincent Cafarelli, and
Norm Bendel. © The Pleasant Company.

According to Candy, "*AGTV* was a pilot
produced by The Pleasant Company, the
folks responsible for the American Girl
dolls and merchandise. Because it is
geared to middle-school aged girls, it
was determined that animated girls of
that age wouldn't change as rapidly as
their live-action counterparts."

Big Blue Dot

Big Blue Dot, a kid-oriented broadcast design firm, is based
in Watertown, Massachusetts. Its parent company is Corey &
Company, Inc., and its sister firms include Corey McPherson
Nash, Hatmaker, and Bug Island. Clients have included
Disney, PBS, ABC, Parker Brothers, Simon & Schuster
Interactive, Microsoft, Scholastic, and the Cartoon Network.
Some of its most notable projects have been a new identity
design for Nickelodeon, a logo and positioning document
called Nickelodeon's "Rules and Tools," collaboration with
Children's Television Workshop and Nickelodeon to develop
Noggin, a digital channel and Web site for kids, and the
reestablishment of YTV (the Canadian equivalent of
Nickelodeon). The artists who work at Big Blue Dot are a
diverse group of individuals who are interested in creating
entertaining design for kids.

2.28

Frames from *Idea Squeeze* ID for Noggin's
launch package (1999). Courtesy of Big
Blue Dot and Nickelodeon.

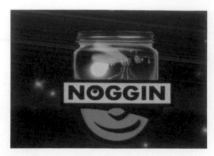

2.29

Frame from *Firefly Bump* for Noggin's launch package (1999). Courtesy of Big Blue Dot and Nickelodeon.

2.30

Frames from *see it sunday*, created and produced by One80 Visual and Hatmaker. Courtesy of Cinemax.

Lush colors, dimensional lighting and cinematic splendor helped transition Cinemax's fun, pop-art dot brand to a more upscale persona.

Hatmaker

Located in Watertown, Massachusetts, Hatmaker, a studio of Corey & Company, Inc., serves the entertainment industry with a strong focus in the field of broadcast design. The company has created numerous show openings, bumpers, network and channel IDs, and interstitials for ABC, Lifetime, Court TV, Cinemax, MTV, Nickelodeon, and Comedy Central.

Hatmaker recently brought the image of Court TV to a new level by shifting its focus from crime to the compelling and entertaining stories of the people that have been involved. The campaign places a greater emphasis on those aspects of crime that the viewer rarely considers. To help transition Cinemax's brand to "higher tier" movies, Hatmaker worked in concert with One80 Visual to direct *see it sunday*, a new movie spot for Cinemax to reflect the grandeur and sense of "event" to accompany its showing of hit movies (2.30). Hatmaker also created Cosmopolitan Television's branding to complement *Cosmopolitan* magazine, the number one women's magazine in the world. The goal was to allow for the magazine's expansion worldwide by communicating a sense of "local flavor with universal cohesion."

2.31

Frames from *Judgment Days—Sleepless Nights* image Campaign for Court TV, created and produced by Hatmaker. Courtesy of Court TV.

Hatmaker took a human view of the stories and people behind the facts. The result: a campaign that emphasizes the full cycle of crime and justice through highlighting those aspects that the viewer rarely considers.

2.32

Concept sketches for Apple's animated QuickTime logo (2000). Courtesy of twenty2product.

According to Terry Green, "The client asked us to take three weeks to produce three short logo animations. Our initial sketches outlined three possible directions, referencing broadcast identity, streaming media, and QuickTime's available programming channels. The client encouraged us to pursue all three directions concurrently. Nori and I wanted to use this project to try out a new working method: I would make initial sketches, hand them off to her to animate, and she would kick them back to me for remixing."

twenty2 product

Twenty2product is a San Francisco-based agency that provides design and project management for video, film, and interactive productions. Projects typically include Web interface prototyping, commercial spots, titles, broadcast identity, public service announcements, and in-store videos. 22p's client work appears as title design, broadcast identity, and commercial spots. 22p serves a technology, sports, and entertainment based clientele, including Nike, Apple Computer, Levi's, MTV, Yahoo!, and Hewlett-Packard. 22p has been widely featured in books and magazines, and their short films have appeared in festivals all over the world. A catalog of project images and QuickTime clips designed by 22p is available at www.twenty2.com.

Hillman Curtis

Hillman Curtis is the Principal and Chief Creative Officer of hillmancurtis.com, inc., a design studio that was founded in New York City in 1998. The company has evolved from one that produced small Flash advertisements to one of the most reputable new media design firms in the country, serving a multitude of clients such as Sun Microsystems, Inc., Adobe Systems, FoxSearchLight Pictures, *Rolling Stone*, MTV, British Airways, Softcom, and Apple. Hillman was named as one of the top 10 designers by the IPPA and one of the "World's Best Flash designers" by Create Online. His cutting-edge approach to broadcast and interactive motion graphics has earned him and his company numerous awards, including the *Communication Arts* Award of Excellence, the One Show Gold, Silver, and Bronze, and *How* magazine's Top 10 Award. Hillman has appeared as a keynote speaker at design conferences worldwide, and his work has been featured in a variety of major design publications. His books include *Flash Web Design* (New Riders, USA) and *MTIV: Process, Inspiration and Practice for the New Media Designer.*

Humunculus

In 1992, Saam Gabbay, a California director, composer, musician, and visual artist, graduated from UC Santa Barbara and formed a design firm in Venice called Gadget School, where he produced spots, network identity packages, and high-profile presentations for top agencies. After closing Gadget School to pursue freelance work, Saam served clients such as TBWA\Chiat\Day (for the launch of Sony PlayStation 2), The Game Show Network, and Fox Kids. In 2002, he and creative director Brumby Boylston, executive producer Dina Chang, and senior editor Arash Ayrom launched Humunculus, a broadcast design firm in Venice, California. Humunculus provides audiovisual content for television networks, ad agencies, entertainment companies, and major corporations.

2.33

Saam Gabbay, President and founder of Humunculus.

2.34

Frames from *The Lab*, a promotional animation for Humunculus. Courtesy of Humunculus.

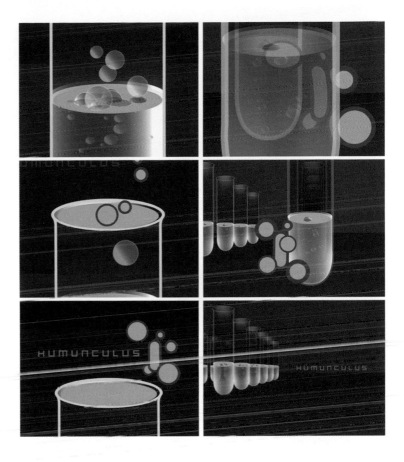

"I'd rather go with something eccentric—but beautifully eccentric."

— *April Greiman*

April Greiman

April Greiman grew up in New York and received her Bachelor of Fine Arts degree from the Kansas City Art Institute. She also studied at the Allgemeine Kunstgewerbeschule in Basel, Switzerland, and was elected to the prestigious Alliance Graphique Internationale in 1985.

As one of the first graphic designers to combine video images and bitmapped typography on the Macintosh computer, April earned her reputation in the 1980s as a revolutionary digital media pioneer with projects for Design Quarterly, Esprit, The Walker Art Center, and the Southern California Institute of Architecture. Her work is daring, depicting a digital fusion

of photography, airbrushing, and typesetting and is characterized by complex layering and manipulation.

Bordering downtown Los Angeles, April Greiman Made in Space has helped shape the landscape of graphic communication in visual identity, environmental and exhibit design, finishes and textile design, and broadcast graphics.

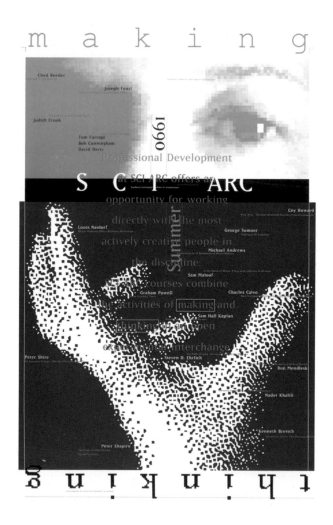

2.35

Frames from *Greimanski Labs* (1989). © April Greiman Made in Space.

2.36

Sci-Arc: Making Thinking, poster for Southern California Institute of Architecture (1990). Courtesy of April Greiman Made in Space.

2.37

left: Animation frames for Selby Gallery exhibition kiosk, Ringling School of Art (1997). © April Greiman Made in Space.

Viewpoint Creative

Since 1988, Viewpoint Creative has developed advertising and promotional solutions for an extensive list of national and international brands. As a single comprehensive resource, Viewpoint Creative consists of producers, writers, designers, editors, and composite artists totaling 24 staff members with offices in both Boston and Los Angeles. Its services include broadcast logo and identity design, main titles, program packaging, DVD menus, and interface design.

Viewpoint's diverse body of work has been produced for clients such as ABC, CNBC, the Discovery Channel, Animal Planet, Fox, ESPN, Boston University, AT&T Broadband, CBS, Disney Entertainment, Cinemax, FX, Hallmark, HBO, History Channel, PBS, Sci Fi Channel, Showtime, TLC, and the Travel Channel.

2.39

Frames from program IDs for *Unsolved History* (2002–2003), Discovery Channel. Courtesy of Viewpoint Creative and the Discovery Channel.

2.40

Valentines Day Network IDs. Courtesy of DesignEFX and Detrie Design. © Cartoon Network.

2.41

Frame from Destination Style, a show open for The Travel Channel. Courtesy of Detrie Design. Copyright © Discovery Communications Inc.

Susan Detrie

With a career spanning more than 17 years, Susan Detrie has received over 13 awards from the Broadcast Designers Association, the Tellys, the Monitor Awards, Promax, and the National Academy of Television Arts and Sciences.

Susan attended the University of Wisconsin-Madison and studied lighting design at the School of the Art Institute of Chicago under Gilbert Helmsley (designer at the Metropolitan Opera). She began her career working on premieres for the New York City Opera at Lincoln Center and designed lighting for fashion designers Perry Ellis and Geoffrey Beene, nightclub acts for Etta James, the New York Dolls, Grace Jones, and Whitney Houston. After moving to Atlanta, she produced special effects for Coca-Cola and designed on-air graphics for The Cartoon Network, CNN, TBS, The Learning Channel, The Discovery Channel, Comedy Central, and Panasonic. In 1997, she started Detrie Design in Los Angeles, and since that time, her work has been seen on ABC Network, CBS Network, The Travel Channel, E! Networks, and The Style Network. Susan recently designed the menu system for the Fine Living Network, as well as spots and a large campaign for Scripps Networks and The Food Network.

Animation in Broadcast and Interactive Design

Concept and Design

3

conceptualization

DISCOVERING AND CULTIVATING IDEAS

Since the beginning of the 20th century, artists have expressed their ideas through the medium of animation. In more recent years, graphic designers have harnessed the potential of animation to convey their ideas in television and movie titles, network identities, commercials, trade-show videos, Web sites, and multimedia presentations.

In the past, developing concepts to communicate their ideas was the first challenge. The current challenge that animators face is developing *unique* concepts.

"Creation is the artist's true function. But it would be a mistake to ascribe creative power to an inborn talent. Creation begins with vision. The artist has to look at everything as though seeing it for the first time, like a child."

— *Henri Matisse*

CLIENT: Syncra Systems

PROJECT OBJECTIVE:
to design a tradeshow animated presentation
marketing Syncra's supply chain management software

CONCEPT/VISUALS:
supply chain environments combined
with metaphors of collaboration/teamwork.

16 17 contact station
22 23 18
RENDERING
29 24 19
30 25 *STORYBOARD
31 DUE!!! *
(digital prelims
for client)
26

0 0 : 0 0 : 0 0 : 0 3

Assessing Your Project

defining the objective

Every production begins with an objective. Without a clear objective, however, your ideas can become lost in the ocean of right-brained activity. Before plunging back into the creative waters, it is best to clearly and succinctly define your goal on paper without a lengthy narrative.

Coming to terms with your project's objective may take time. Once it is established, it should be kept in mind from conceptualization through design to final execution.

targeting the audience

The goal of visual communication is to facilitate a reaction from an audience, and this audience should be clearly defined in order to meet your objective. In the industry, the individuals who are involved in marketing usually have already achieved this, although artists have been known to play a strong role in identifying the audience.

researching the topic

Research is key to effective communication. Intriguing concepts and cutting-edge design may not be enough to effectively communicate the information if adequate research is not conducted ahead of time. Diving into the creative waters too soon poses the danger of time and energy being wasted on ideas that may be dynamic but are not appropriate or even relevant to the project's objectives. Therefore, thorough analysis of your subject matter should occur before you begin to conceptualize.

Clients can mistakenly assume that the designers involved in the creative aspects of a project are well informed about the topic being considered. This can be dangerous to both parties. Therefore, it is best to assume the responsibility of

In the industry, clients often think they know what they want but can easily change their mind in the middle of a project. Therefore, it is best to review with the client a clear articulation of the project's goal before the creative process commences.

To define your target audience, ask yourself the following questions:

- What are the demographics of my viewers (cultural, social, economic, etc.)?

- What does the audience already know?

- What does the audience need to know?

- How has this information been communicated before?

- What single message should people walk away with?

- Should what is being communicated solicit a response?

- What kind of response should be expected from my audience?

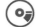

3.1

Stills from *Mr. Reaper's Really Bad Morning* (2003), by Carol Beecher and Kevin D.A. Kurytnik. © Fifteen Pound Pink Productions.

This film "plays off of two thousand years of death mythology, homages to animation's great directors, pop culture, revenge fantasies, and a zest for life. In the 20th century, Death, Mr. George Reaper, has become your average 9 to 5 working stiff, eking out an ineffectual existence, reduced to a pale shade of his former glorious self."

becoming educated about the subject matter at hand. A vast realm of resources are available to aid in your investigation. The Internet, for example, provides a quick method of retrieving information. Good old-fashioned libraries also offer an efficient means of gathering data. The direct source (versus the middleman) is, of course, the most valuable resource, and discussing the material with that individual is highly recommended. The more thorough your research is, the more effective your design will be.

3.2

Concept images for a trade-show video for Syncra Systems (2000), by Jon Krasner. Courtesy of Syncra Systems, Inc. and Corporate Graphics.

Developing the concept this series of animations involved becoming educated about supply chain management.

3.3

Frames from the opening title sequence to *Bill Moyers Reports: Earth on Edge.* Courtesy of Public Affairs Television and Edgeworx.

"With creative freedom, time, money, and reliable technical support, the potential here is limitless. Just imagine the possibilities!"

— *Jon Krasner*

"Better to have the creative reins pulled back than to be kicked in the flanks for more!"

— *Meagan Krasner*

understanding the restrictions

As artists, we aspire to exceed our own potential. Passion for creativity drives us to become better at what we do. Many of us create art not because we want to, but because we have to in order to feel personally rewarded. However, there are restrictions. Independent animators face budgetary constraints that limit the use of studio space, materials, equipment, and reliable technical support. Motion graphic designers may be presented with tight budgets that prohibit hiring an outside photographer or illustrator or purchasing as many stock images or video clips as they see fit. Deadlines (regardless of how unreasonable they may be) may force designers to be realistic about what can and cannot be accomplished within the given window of time that is available. Further, the opinions and biases of clients can be creatively restricting. Sometimes pride that is built on years of artistic training may have to be put aside in order to conform to decision makers who act as "creativity gatekeepers." On a positive note, these restrictions can be perceived as guidelines that give your ideas direction.

Addressing the client's needs up front will avoid frustrations down the road. Miscommunication is prone to happen when an intermediary intervenes between you and the client. If the opportunity presents itself, try to establish a one-on-one rapport with the "head honcho." A relationship based on mutual respect and trust provides you the opportunity to unlock the client's mind and convince him or her that your idea will work. (Be aware that the client controls your paycheck, your portfolio, and to an extent, your reputation.)

The following questions will help you determine the look and feel of your content:

- What percentage of typography will be incorporated into the animation?

- To what degree will photographic images be used?

- To what degree will illustrations be used?

- To what degree will live action be used?

- What elements need to be included at the client's request?

- What color and size restrictions are there?

- What will the general color scheme be?

- Will the imagery be representational, non-representational, realistic, or abstract?

considering style and atmosphere

The general mood or atmosphere of your piece is an important consideration that should be given attention prior to conceptualization. Generating a list of adjectives that describe what the setting will be like can help set the stage for promoting the concept and determine what type of content should be used.

The "flavor" of the visuals may take on a variety of characteristics—graphic, textural, tight, sketchy, blended, whimsical, realistic, abstract, layered, etc. Whether you are working traditionally or digitally, techniques such as cropping, lighting, distortion, color manipulation, deconstruction, layering, masking, and special effects can enhance the expressive properties of your content before it is integrated into a storyboard.

Conceptualization

Once the objectives, target audience, and restrictions have been defined and the subject matter has been thoroughly investigated, the floodgates of creativity can be opened to allow imaginative concepts to pour forth.

brainstorming

Brainstorming is the first step in generating ideas. It works best in an environment that is conducive to creative thought. Everyday annoyances such as junk e-mail, uncooperative technology, road rage, and telephone sales calls are detrimental to brainstorming. Therefore, scheduling a continuous block of time to think quietly without distractions is highly recommended. Some people react well to background music while others require complete silence in order to concentrate. As thoughts enter, they should be recorded immediately in a physical, tangible format. Putting pencil to paper is an invaluable process that, like musical improvisation, keeps ideas fresh and moving. Pencil sketches (or roughs) should be small and loose, allowing for the quick generation of

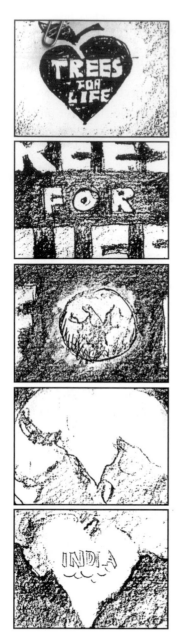

3.4
Rough sketches for *Trees for Life Story,*
by Frédéric Back. © Trees for Life, Inc.

ideas. Spending too much time polishing a drawing breaks your creative momentum. Depending upon your level of software proficiency and availability of digital content, sketches can also be generated on the computer in a paint-based or vector-based application.

obstacles to creative thinking

It's easy to become lured into stylistic trends that have been overused. Biased notions and contrived ideas of what's "hot" can intrude on the flow of ideas, limiting the range of creative opportunities and preventing you from being original. The range of digital effects that are currently available require minimal skill or sophistication. Although they can be beneficial if used intentionally, they lack ingenuity, and their ease of use can also impede imaginative thinking and obscure artistic judgement. Today, the abundance of stock photography, illustration, fonts, and clip art makes it easy for designers to rely on ideas relating to popular culture rather than on their own capacity to conceptualize. Last, the demand for acquiring technical proficiency, due to the rapid pace of software development, can be an impediment to creativity.

Being aware of these obstacles is the first step in avoiding them.

pathways to creative thinking

The creative process requires time, patience, and nourishment. Inspiration, risk taking, and experimentation contribute to innovative thinking, allowing ideas to develop naturally.

inspiration

Inspiration is the motivating force behind innovation. Unlike a job that ends when the shift is complete, a source of inspiration can motivate you to search for new angles and attempt to smuggle your ideas into each new project.

Artists who can identify with their subject matter usually produce the most meaningful work. For example, in an assignment based on visual metaphor, a student once chose to express the theme of domestic violence. Based on her prior experience with victims of domestic abuse, she was able to think deeply about the psychological consequences that the victims faced. Her emotional identification with the subject inspired her to develop ideas that were effective in their authenticity and integrity.

Looking at the work of other designers and design movements for inspiration can also help foster new ideas. However, this should be exercised with moderation; relying too greatly on other styles can be dangerous.

3.5

AML's Web site, html and Flash versions by Jon Krasner. © AML Moving & Storage.

The ideas of pride in workmanship and lasting family traditions served as an inspiration to the design.

3.6

Concept "sketch" for an introductory animation for Salon de Fatima's Web site (2001), by Jon Krasner. © Salon de Fatima.

The objective was to express elegance and sophistication. The experience of chatting informally with customers and witnessing a body massage and manicure contributed to the concept of water, steam, and images from nature.

"The greatest Art is achieved by adding a little Science to the creative imagination. The greatest scientific discoveries occur by adding a little creative imagination to the Science."

— James Elliott

risk taking

Imaginative thinking requires risk taking. Throughout history, stylistic movements in art and graphic design were manifested from groundbreaking visionaries and experimenters who deviated from the norm. Most of them did not gain artistic satisfaction from following the same design recipe; rather, they embraced and celebrated the power of imagination by keeping an open mind and considering the unexpected idea.

Taking risks means venturing into new, unfamiliar territory. This may feel uncomfortable, because of the potential dismissal of an idea by your client or audience. (Pragmatically, you can always fall back on an alternative, perhaps less radical approach.) Despite the level of discomfort, not going out to the edge and instead resorting the same formula can become intellectually dull, and your creative resources can become stale if you remain on the plateau for too long. The consequences of not being accepted by the mainstream are certainly worth your chance of discovery.

experimentation

Like science, artistic concepts are based on an evolution of discovery through experimentation. Experimentation contributes to ideation by opening up your thought processes, broadening your feelings, and eliminating contrived or trendy solutions. It relies on the element of play and embraces the unexpected, allowing accidents to become possibilities. New discoveries can lead to more sophisticated approaches to problem solving. Further, experimentation gives you the opportunity to attain individuality. Since risk taking is involved, it is not intended to produce mediocrity; rather, its objective is to make life less predictable.

A friend and colleague once defined the act of art-making as "studied playtime." In order to maintain that state of mind and keep the pathways to innovation open, take the "scenic route" and allow your mind to wander. If you find yourself coming back to an idea that lacks ingenuity, remove yourself from the situation and revisit it later from a fresh perspective.

3.7

Frame for an MTV bumper (1999). Courtesy of Imaginary Forces. © MTV.

The experimental, rebellious nature of MTV challenged the conventions of corporate identity by introducing an entirely new edgy style that eventually spawned new approaches to broadcast animation for channels such as CNN, VH1, and Nickelodeon.

When evaluating your ideas, the following questions should be asked:

- Is this concept appropriate for the objectives of my assignment?

- Will this concept capture and hold the attention of my target audience?

- Is the level of this material too high above the client's or audience's head?

- Is this concept based strictly on technique or trend?

- Does this concept deviate enough from what has already been done?

- Is this concept realistic enough to implement technically?

- Will the means needed to implement this concept fit within the client's budget?

Cultivating Ideas

To grow a successful garden, you must fertilize, weed, prune, and water. Visual concepts also need to be cultivated in order to mature properly.

evaluation

Once your concepts are generated through brainstorming, evaluating them objectively helps you decide what to keep and what to throw away before plummeting into production.

selection

Once evaluation has taken place, selection can be a difficult process. On a positive note, you get to make the first cut before the client begins his or her jurying process. Although it can be painful to let go of invigorating ideas that may be more appropriate for another project, presenting too many concepts can be counterproductive. Consequently, the client can develop the expectation that you will always provide numerous possibilities for every project. Relinquishing this much creative control to the client can result in him or her choosing a concept that you do not strongly support. In your absence, bits and pieces of your ideas may be mixed and matched in a way that is not in line with your thinking. Further, the opinions of other coworkers not involved in the project may be taken into consideration; such uninformed input can be detrimental to what you are trying to accomplish. Therefore, it is in your best interest to be discriminating and submit only the concepts that, in your opinion, are the best.

clarification and refinement

Depending on the reaction and response from your client and test audience, the concept that is chosen will most likely require further clarification. Pencil thumbnails may not be adequate to fully describe your idea in visual terms. More finished roughs should give a clearer representation of the

Each new project is a growing experience, and the fruits of your labor do not have to be wasted. Ideas do not have to be completely discarded; they can be written down, drawn on paper, voice recorded, or filed away digitally for future use. (Keep in mind that sometimes new ideas are abandoned and replaced with old ones.)

design of the look and feel of the visuals, compositional treatment, use of typography, and motion strategies. Collage, photomontage, and photocopying allows quick composites to be generated with a variety of sizes and tonalities. A wide range of natural media including brush, marker, and colored pencil can also be used to introduce color and texture. Digital refinement can offer a degree of polish. You can go a step further by producing small motion studies that roughly show the types of movements that will be used.

Finalizing Ideas through Storyboarding

Planning an animation requires preparatory mental visualization. Once a concept is approved, the designer can begin the phase of storyboarding. The storyboard provides a visual map of how your concept will be expressed over time.

Scientific studies have increasingly demonstrated that thinking in images is the natural process of receiving and deciphering information. Evidence suggests that both learning and retention levels are enhanced with images rather than with words. History clearly tells us that the earliest forms of graphic communication were purely visual. Contemporary graphic communication suggests a better understanding of how the human brain processes information. Today, words are more commonly used to support graphic information, unlike traditional advertising and copywriting practices that used images to support written information.

The storyboard provides a visual explanation of how a theme will be potentially communicated in a time-based context. Its purpose, simply, is to tell a story with pictures. It consists of a cohesive series of static compositions (in most cases between four and eight) that are sometimes accompanied by supporting text. A storyboard can serve as a basis from which

3.8

Storyboard illustrations from a promotional campaign for Discovery Channel's, *Nefertiti Ressurected* (2003). Courtesy of Viewpoint Creative and Discovery Channel.

"Potentially one of the biggest archeological finds since King Tut, the goal of this campaign was to communicate the magnitude of this finding. We sought to demonstrate the beauty, drama and mystery surrounding Nefertiti and show how the Discovery Channel resurrects one of ancient Egypt's most famous and powerful queens."

— *Michael Middeleer, Viewpoint Creative*

additional creative opportunities can be pursued during production (although major decisions have already been worked out ahead of time prior to production).

stages of development

Choreographing animation requires dedicated thought and adequate planning. After a concept has been refined, sketches should be then translated into a *storyboard rough*—a series of polished sequential sketches. Although a rough can look much like a final comprehensive, the client may never see it. In most cases, it is used to allow you to evaluate the work based solely on your own professional expertise. Since there is still room for further improvement, elements may be altered, simplified, exaggerated, added, or deleted.

pictorial and progressive continuity

Storyboards are intended to help the artist establish a sense of visual continuity ahead of time, prior to production. There are two levels of continuity: pictorial and progressive.

3.9

Storyboard sketches for *Keeping Balance* (2001), by Scott Clark. Courtesy of the artist. All rights reserved.

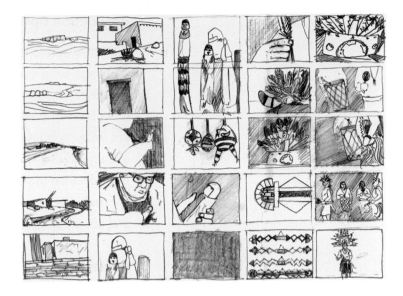

If your project calls for the development of a storyboard, its goal should also be to establish consistency in the style and mood of the imagery across its frames. The style of the visuals should clearly express the mood of the concept as well as the type of audience that is being targeted. The storyboard also should illustrate how elements are organized spatially within the frame. This is pictorial continuity.

Storyboards should demonstrate what the sequence of events will be and how the events will take place between its frames. The general order of events should be clearly expressed, and transitions between them should be cohesive and clear. This is progressive or transitional continuity. Many of the examples in this chapter demonstrate a variety of approaches to choreographing the way things enter and leave the frame and the types of movement and direction of travel they take. All exemplify a logical storyline, where transitions flow smoothly and can be easily deciphered.

production tips

digital execution

Although hand-executed artwork is often used in the creation of comps, digital execution has become the favored method of storyboard production. Conventional pencil sketches may not be appropriate enough to represent the subject matter, and digital images can have a more polished feel than the most detailed drawings, especially if photographic visuals are used. Further, hiring an illustrator may not be affordable, and not all graphic designers are great illustrators.

In addition to paint-based and vector-based imaging software, storyboard applications allow flexibility in generating ideas and composing frames quickly. ShotMaster, for example, can import screen captures, add text, and print with multiple printing options. Power Production Software's Storyboard Quick and Storyboard Artist are previsualization programs containing features that are designed for preproduction planning. Sequences of frames can be viewed and changed around if necessary. Captions can be written, and scripts from screenwriting programs can be imported to accompany the visuals. Even Microsoft PowerPoint has been deemed as an acceptable storyboarding tool, because of its popularity among corporate clients.

URLs for stock photography, illustration, and video footage:

www.gettyimages.com
www.pro.corbis.com
www.graphxedge.com
www.gimp-savvy.com
www.eyewire.com
www.photostogo.com
www.eaglestock.com

If you do not have the time or budget to develop content or hire an illustrator or photographer, stock photographs and illustrations are available online or by purchase of CD-ROM content by numerous suppliers. Search methods make it easy to locate specific types of content, and most thumbnails can be accessed and used for storyboards with the possibility of future online purchase. (You should carefully read the terms and conditions to avoid using materials illegally without permission.) If time is not a critical factor, you can begin composing scenes in your application and incorporate rendered

3.10

Storyboard for The Devereux Group Web site, by Jon Krasner. © 2004, JK Design.

frames into a storyboard. Since Adobe After Effects' layering capabilities are similar to those of Photoshop, elements can be placed in the frame and designed specifically for preproduction. (After Effects also allows action-safe and title-safe borders to be viewed so that the variable 10% zone around the perimeter of the composition can be considered at an early stage.)

brevity and clarity

A storyboard should be succinct, featuring key transitions. It should not show every detail of motion, but rather show major events that will occur. The number of panels usually depends on the length of the work. As a general rule of thumb, 6 to 10 frames may suffice for a 30-second spot, while a 1 to 2 minute movie trailer might require 12 to 20 frames. Station identifications and Web site introductions usually require a maximum of eight panels. Most importantly, transitions between frames should be easily readable.

evolution

Evolution is the key to successful storyboarding. Creative ideas are meant to build upon one another over time. The designer can take into account the movement of each element separately, forcing him or her to make purposeful decisions regarding every aspect of the work. Another approach is to work toward the center, designing the first and last frame and then creating the frames in between.

It is important not to go too far down a road with a concept before submitting a rough storyboard. The business risk may be too great to plunge into the waters too quickly. The client should be kept in the loop along the way in order to avoid too much time being spent on perfecting ideas only to have them rejected later. Unless your concept has been accepted verbally or in writing (preferred), proceed with caution!

Posting storyboard frames to the Web can save valuable time in getting approval. Motion studies that are used as storyboard frames should be kept simple; the labor of getting the pacing perfect should wait until you get the go-ahead.

professionalism

Professionalism is critical to convincing the client (and yourself) to settle on an idea. Sloppy execution, lack of attention to detail, and ambiguity of presentation can create a negative impression.

Today, digital images, because of their degree of polish, are commonly used to generate final comps. The most impressive-looking storyboards consist of high-quality prints pasted up on bristol board. Supporting text concerning movement and transition can be added as a supplement; however, it should not be used as a substitute for a lack of clarity in the images.

3.11

Storyboard for a tradeshow video for Louisville Lawn and Garden Exposition, by Jon Krasner. Courtesy of Belden-Frenz-Lehman Marketing, Inc.

3.12

Storyboard frames from *Live Like You Mean It* for the Fine Living Network. Courtesy of Another Large Production and Detrie Design.

4

"The painter's canvas
was too limited for me. I
have treated canvas and
wooden board as a build-
ing site, which placed the
fewest restrictions on my
constructional ideas."

— *El Lissitzky*

pictorial considerations

DESIGNING OVER SPACE

Fundamental aesthetic principles that are associated with traditional forms of art and graphic design are also applicable to those forms that are time-based. Form, color and texture, type and image relationships, and the organization of two-dimensional space have significant conceptual and aesthetic implications that are specific to both independent and commercially produced animation.

With regard to composition, innovative design strategies offer the potential of overcoming the homogeny of the fixed rectangular frame that is associated with film and television. They can also be used to overcome technical constraints that are inherent to interactive media.

chapter outline

y

z

x

0 0 : 0 0 : 0 0 : 0 4

4.1

Mechanical object studies by Ferah Ileri and Aimee Lydon.

The objective of this assignment was to choose and refine the most dominant structures, eliminating unecessary detail. Students were also encouraged to exaggerate the geometry and relative sizes of the forms.

4.2

Suprematist Composition (1915), by Kazmir Malevich. Wilhelm Hack Museum, Ludwigshafen © Erich Lessing/Art Resource, NY.

Nonobjective abstraction became widely practiced during the Modernist movements in early 19th century Europe. Malevich's Suprematist style is founded on the extreme reduction of images to pure, elemental geometric shapes.

Properties of Kinetic Images and Type

form

In addition to line, form is the most basic element of visual communication. Geometric forms with mathematically defined parameters have been used to represent culturally based ideas such as the red octagon signifying "stop." Ubiquitous images such as a vertical rectangle with a folded corner or a hollow circle with a diagonal line running through it have become universally recognized. Natural forms are usually derived from organic elements such as water droplets, flower petals, and microbial organisms. (Structures such as honeycombs and crystals can display geometric qualities of symmetry and pattern.)

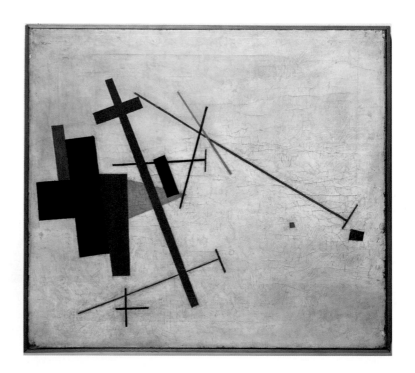

Pictorial Considerations

In animation, an emphasis of graphic form was evident in early German avant-garde films from the 1920s that made the transition from abstract painting to animation. Hans Richter's motion studies, for example, explored the linguistics of rhythm and motion through the use of pure geometric structures. Walter Ruttmann's *Opus* series investigated how converging abstract shapes could exhibit playful animated qualities. Viking Eggeling's films demonstrated a painstaking analysis of linear forms and their positive-negative interplay.

Both graphic and typographic form has also played a major role in the field of motion graphic design, as demonstrated in many of the examples throughout this book.

value

Value, a measure of lightness or darkness of tones or colors, is one of the strongest methods of visual contrast. It can enrich visual messages and can be used to create focal points in a composition. In the title sequence to the film *Magnolia*, an image of a blooming magnolia is superimposed with street maps and frames from the film, producing a dynamic blending of tonal ranges. This interplay of light and dark helps express the concept of people's lives overlapping and intersecting.

4.3

Title frame from *Magnolia*. © MXMXCIX, Fine Line Features. All rights reserved. Photo by Peter Sorel. Photo appears courtesy of New Line Productions, Inc.

4.4

Frames from *Esprit Kids* (1986), broadcast throughout Japan in in-store boutiques. Courtesy of April Greiman Made in Space. © Esprit.

color

Applying color principles creatively and appropriately can produce a desired audience response. Although color choices are subjective, you should exercise appropriate color usage according to the type of message you are communicating as well as its target demographics. Familiarity with basic color principles can help you simplify color decisions and help you make intentional color choices.

color contrast

A color that stands alone in a visual field is perceived quite differently than one that is surrounded by other colors. Color characteristics of images and typographic elements are affected by four types of contrast: *value, temperature, complementary,* and *simultaneous contrast.* Value contrast between light and dark is the strongest and most effective method of distinguishing colors. Color temperature contrasts can be used to suggest spatial depth. The quality of recessiveness in the cool blue-green spectrum has been used to indicate distance, while warm color ranges from the red-yellow spectrum have been used to express closeness. Some pieces are intended to have a warm or cool scheme, while others strive to preserve the relative balance between warm and cool. Complementaries as colors are opposite from one another on the color wheel. Generally, complementary opposites that are placed in close proximity to each other can produce intense, dramatic, even shocking effects. In comparison, analogous colors that are in close proximity to each other create a soothing, restful atmosphere. The principle of simultaneous contrast is based on the fact that color is relative to its surroundings. It is most prominent when neutral gray tones assume the complementary tone of colors that are in close proximity. For example, if a neutral gray tone is in close proximity to a green element, it will appear as a warm, reddish gray. A neutralization process results in perceiving the opposite color in the afterimage (4.6).

Pictorial Considerations

4.5
Simultaneous color contrasts.

Several studies claim that human beings make subconscious judgements about a person, an environment, or an item within 90 seconds of initial viewing, and that between 62% and 90% of that assessment is based on color alone.

psychological and gender associations

Differences in color contrast can evoke different emotional responses. For example, we "feel blue" when we are sad or turn "green with envy" when we are jealous. Light blue is associated with tranquility, while darker blues are known to induce depression. Light red generally produces cheerfulness, while bright or dark red can invoke danger or irritability. Gender color perceptions also vary. Studies have indicated that men are generally more tolerant of black, white, and gray than women. Additionally, women have a clear preference for cool, subtle shades, while men prefer stronger colors with higher saturation levels.

cultural and universal associations

Cultures also interpret colors differently. For example, North American mainstream culture associates red with urgency, heat, love, blood, and danger, and green with nature, health, money, and abundance. Chinese culture represents death with white, while Brazilian culture depicts death with purple. Greek culture interprets yellow as sadness, while the French associate it with jealousy. Universally, light red can represent cheerfulness, while bright or dark red can induce irritability. Light yellow-green can depict freshness and youth; however,

4.6

Frames from the program opening for Hallmark Channel's, *Crown Cinema* (2001). Courtesy of Viewpoint Creative. © Hallmark Channel.

Colors that are assigned equal or close values are not as eye-catching as those that have a greater range of values.

a darker shade of green can represent sadness and decay. Light sky blue can evoke tranquility, while deeper blues can produce melancholy.

texture

The representation of surface provides a sensory experience of touch. In painting and collage, tactile surfaces are produced through layering media (paint, crayon, chalk, etc.), superimposing materials or techniques such as rubbing, scraping, impressing, or embossing.

The "activated surface" was a driving force of Fauvist and Impressionist painting during the 1800s. It yielded tactile image characteristics that escaped the blended, photographic quality of traditional realist painting. Experimental processes such as dripping, scraping, squirting, scratching, and exploding lead to developing and refining new techniques of image making in the works of Abstract Expressionist artists such as Jackson Pollock, Grace Hartigan, and Willem De Kooning. Kurt Schwitters, whom many acclaim to be the 20th century's master of collage, juxtaposed media and materials into spontaneous but carefully organized compositions.

4.7

Frames from *Tables of Content* (1986), by Wendy Tilby. Courtesy of the artist.

The emulation of surface texture in animation has increased since the days of traditional cartoon marker renderings. Film animators have scratched, painted, and chemically altered the surface of film to achieve rich, tactile-looking imagery. Motion graphic designers in broadcast and digital interactive media have also incorporated textural effects into their work, as seen in the examples throughout this book.

4.8

Frames from *The Big Screen* for TBS Network; design and animation by Susan Detrie. Courtesy of Detrie Design and DesignEFX.

4.9

Mixed media illustration project (2002), by Jesse Welch and James Paquette. All rights reserved.

4.10

Lions, Dragons and Jesters (1999), by
Jon Krasner. © 2004, Jon Krasner.

**This group of illustrations was originally
designed to be animated in an interactive
children's alphabet.**

Pictorial Composition

Pictorial composition is the blueprint from which visuals are
organized in a two-dimensional space. In painting, it describes
the canvas. In graphic design, it depicts the viewing area of a
poster, book cover, or interactive interface. In animation and
motion graphic design, it describes the frame. The aspect ratio
of film and video frames, in association with television and
motion picture production, has significant aesthetic implica-
tions that should be given serious consideration.

Compositional styles have differed across cultures and across
art movements throughout history. Japanese painting, for
example, delights in the generous use of negative space and
intuitive placement of objects within an asymmetrical layout.
Art Nouveau, Arts and Crafts, and Vienna Secessionist artists
were characterized by their use of arbitrary compositional
arrangements, while De Stijl and Constructivist painters
carried abstraction to its furthest limits in their quest for
rational, geometric order. In animation, experimental film
pioneers gave high regard to the manner that pictorial space
was organized. Taken out of context, individual frames from
Hans Richter's *Rhythm* series demonstrate daring a liberal

use of negative space, an interplay between figure and ground, and a purposeful alignment of shapes to the edges of the frame. Motion graphic designers have also used composition as a device for controlling how a viewer's eye travels within the boundaries of the frame.

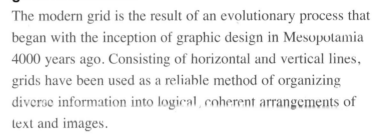

4.12

Most beginning-level photography courses introduce the basic "Rule of Thirds," using a grid to divide a space into three equal segments, where the points of focus are at the intersections of the grid lines. This strategy can improve one's pictures by preventing elements from being placed in the dead center of the composition. The weakness of this solution, however, is that something more than placing an eye-catching image at an intersection may be needed to engage the viewer's eye. © 2004, Jon Krasner.

grids in animation

The modern grid is the result of an evolutionary process that began with the inception of graphic design in Mesopotamia 4000 years ago. Consisting of horizontal and vertical lines, grids have been used as a reliable method of organizing diverse information into logical, coherent arrangements of text and images.

In both independent and commercial animation, grids can help refine your approach to spatial organization and establish consistency within the format you are working in. They can achieve balance and help organize complex information within a rectangular space, allowing your message to be communicated clearly and effectively. Should you decide to use a grid, it is best to sketch it out it on paper first and then implement it in the application that you are using. (Most animation programs provide guidelines that can be adjusted and locked to position elements into vertical or horizontal alignment.) Once a general format has been established, you can always deviate from it. Certain elements can occupy specific regions of a grid, while others can deviate and intrude into other regions.

4.13

Underlying grid structures used in print and Web design can also be applied to animation to provide pictorial order to a moving composition. Here, action-safe and title-safe regions have been incorporated.

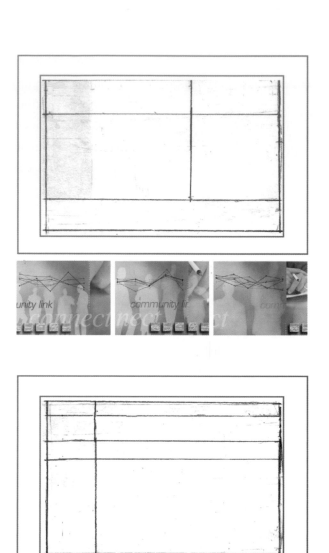

4.14

Stills from a CD-ROM presentation for Ascential (2003). Courtesy of Corporate Graphics. © Ascential Software.

Gestalt theory

Originating in Germany around 1912, the Gestalt school of psychology explored how visual elements in a composition could be comprised into an integrated "whole" to achieve a sense of harmony. The conviction of this theory is that the whole is greater than the summation of its parts. A guitar,

4.15

Frame from a kinetic typography assignment (2001), by Mike Duval. All rights reserved.

for example, is made up of strings, a body, a neck, tuning knobs, and so forth. Each of these components is unique and can be examined individually. The guitar as a unit, however, is greater than the addition of its parts.

Understanding how the human eye naturally seeks gestalt can help you use visual devices such as figure–ground, direction, balance, negative space, and scale to produce a clearly articulated frame in which all elements are unified together to create a sense of purpose and completeness.

figure-ground and positive-negative

In the term "figure-ground," *ground* (also known as the picture plane) defines the surface area of a composition, and *figure* defines the subjects that occupy the foreground space. Throughout history, works of art have ranged from clearly

"One can furnish a room very luxuriously by taking out furniture rather than putting it in."

— *Francis Jourdain*

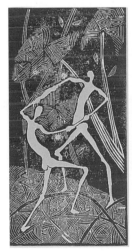

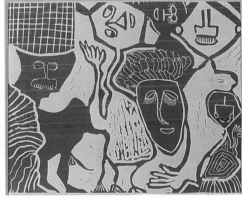

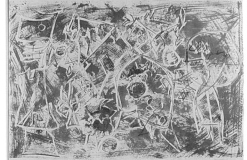

4.16

left: "Eketete and Erbeybuye"
top right: "Igbo and His People"
bottom right: "Chaos"
Courtesy of the Harmon Foundation Collection and NARA.

These three paintings vary from a clear interpretation of figure-ground to its extreme obliteration.

4.17

Frame from Mijnwitplafond (2002), by
Violette Belzer. © il Luster Productions.

Interchangeability between foreground
and background elements eliminates the
sense of figure-ground.

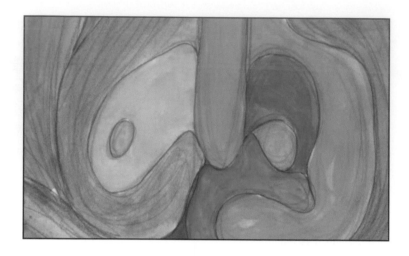

Foundation drawing classes often disregard
the fundamental principle of composition.
Although students are taught to master
proportion, to model through light and shad-
ow and to be expressive with the medium,
they are seldom provided with adequate
information on how to plan their picture
space. As a result, many students render
their subject with little thought given to
placement. Negative space is poorly
planned and does little to contribute toward
the expression of the piece.

defined delineations of foreground and background elements
(for example, a figure posing in a landscape) to the complete
erradication of figure-ground, where space becomes ambigu-
ous to the viewer. Abstract Expressionist and Cubist paint-
ings have continuous two-dimensional space, where negative
and positive forms become interchangeable (4.17). In anima-
tion, figure-ground relationships in the frame can change as
the positioning, orientation, and sizes of elements change
over time. Unexpected positive forms emerge when

4.18

Frames from a station identification
assignment (2001), by Jim Reynolds. All
rights reserved.

Pictorial Considerations

4.19

An image can appear "heavy" or "light" depending on the dimensions of the frame it occupies.

4.20

Frame from *Destination Style* opening for The Travel Channel, by Susan Detrie. Courtesy of Detrie Design.

Extreme scale contrast can enhance the visual impact of a composition.

letters are juxtaposed and superimposed. Related to figure-ground is the concept of positive-negative space. Positive spaces are areas that are occupied in the composition; negative spaces are areas that are unoccupied or empty (the ground). Negative space is equally important as the positive elements that have been placed upon it. It has weight and mass and plays an important role in giving structure and balance to a composition. Dramatic or subtle, its use can affect the viewer visually and emotionally.

size versus scale

Size, in two-dimensional design, relates to the format (or the frame) that elements are placed in, and scale describes the relative relationships that exist between elements. Whether objects are static or moving, both principles play a major role in pictorial composition.

Size can contribute conceptually to the overall message being communicated by establishing weight or mass. For example, an object may appear "heavier" or "lighter" depending on the dimensions of the frame it occupies. Size can also help improve composition. The use of large elements gives you the opportunity to subdivide a frame into a variety of positive and negative structures. These, in turn, can establish a more active two-dimensional architecture (or temporary grid) from which smaller elements can be positioned and directed to move along. Many compositional possibilities can be derived from manipulating size and relative scale.

Scale is the most elemental and widely used form of visual contrast. Along with value and color, it can provide emphasis on a point of particular interest in a composition. It can also create the illusion of spatial depth. In visual perception, smaller objects naturally appear to recede into the background,

4.21

Frames from *Cosmo Fun Zone* (channel launch—2000), created and produced by Song Design and Hatmaker. Courtesy of Cosmopolitan Television and Hearst Entertainment & Syndication.

Differences of scale can create the illusion of depth and accentuate the impact of the subject.

while larger objects appear to project closer to the viewing picture plane. In contrast, larger elements can appear to be further back when smaller items are superimposed. Extreme differences in scale can capture the imagination of the viewer. For example, taking an object out of its original context and juxtaposing it with other objects that have been altered in size can dramatize its impact.

balance

Balance is a desired component of our day-to-day lives. We seek it in our experiences to make order out of work and play, finances, family life, and so forth. Within a two-dimensional space, balance also suggests a sense of cohesiveness and unity. It is one of the primary devices that designers use to create stability or instability.

Compositions can be balanced symmetrically or asymmetrically. Symmetrical balance is the division of a space into parts that are equal in size and weight. As human beings, we are symmetrically balanced on a vertical plane. Synthetic objects such as cars, tables, and chairs also exhibit symmetry. In the early days of film, titles were usually placed symmetrically in the center of the frame. Radial balance is a type of symmetrical balance in which images are emitted from a central focal point (i.e., ripples emanating from a stone thrown into water). Crystallographic balance (also referred to as "all over" balance) contains numerous focal points that are strategically arranged into a repeating pattern. Quilts, for example, consist of crystallographic patterns that are arranged in a gridlike design. The random effect of scattered confetti also produces a sense of crystallographic balance as attention is evenly distributed throughout. However, there is too much uniformity without enough variety.

4.22

Mechanical object form study (2002), by Anthony Sciabarrasi.

The objective of this assignment was to develop a graphic from a photographic image and explore its usage within a variety of asymetrical formats.

4.23

Type study (2002), by Audrey Lewis.

Space and form is dispersed unevenly, creating the feeling of energy and motion through asymmetry.

Balance does not always necessitate symmetry. For instance, a small object in a composition that is visually engaging in color, texture, or shape can balance a much larger object that is visually less exciting. Asymmetrical balance can be used to push the envelope of composition in order to create a more dynamic sense of organization or establish emphasis. It can effectively communicate tension by redirecting the viewer's eye throughout the frame. Bauhaus designers, for instance, strove to create compelling, unstable layouts that were uninhibited by traditional spatial norms. The major advantage of asymmetrical composition is that there are rules or limits. It allows a more dynamic use of negative space, giving the artist greater freedom in composing the frame.

edges

Throughout art, edges have been an essential component of design. They define a composition's parameters and play a critical role in establishing eye movement and hierarchy. Early Egyptian manuscript design, for example, strongly emphasized the relationship of visuals to the borders. Edges were given considerable attention with regard to the placement of illustrations and hieroglyphics (4.24).

In many cases, edges are an important consideration of animation. Unless you employ the technique of screen division, they provide you with four possible points of entry and exit into or out of the frame. There are numerous methods of incorporating the frame's edges into your design. For example, an object can touch an edge, and its movement can be strategically aligned to it, reinforcing the vertical or horizontal nature of the frame.

4.24

Psychostasis (weighing of the souls). Book of the Dead of Tsekhons. Ptolemaic period. Museo Egizio, Turin © Erich Lessing/Art Resource, NY.

Egyptian civilization established a consistency in design format with a rigid set of compositional rules. Horizontal bands containing small illustrations were often placed across the top while larger images and adjacent hieroglyphic text columns hung from the top border.

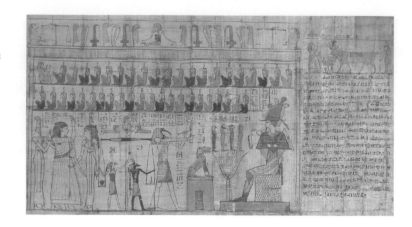

4.25

Frames from a commericial for Citibank. Courtesy of David Carson Design.

Elements are purposefully aligned to the edges, emphasizing the the frame's horizontal and vertical structure.

4.26

Composition assignment (2002), by Kane Rozell. All rights reserved.

direction

Direction has powerful control over how a viewer's eye moves within a space. It helps establish a sense of purpose to a composition by enhancing the foundation that its architecture is built on. Most of us have been conditioned to accept design arrangements that emphasize horizontal and vertical eye movement. Graphic designers continue to study the compositions of Dutch painter Piet Mondrian, who, inspired by Cubism, embraced stability by reducing images of nature and Parisian building facades into interlocking networks of vertical and horizontal structures. Constructivist and Bauhaus graphic designers from Germany, The Netherlands, and Russia, however, were among the first to implement diagonal movement within a square or rectangular format.

Direction can provide a point of entry and exit for the viewer. In busy compositions, it can be used to organize, connect or separate dominant and subordinate elements. Direction can also be used as a means of counteracting motion in order to stabilize eye movement within the frame. For example, Figure 4.27 shows how a diagonal direction is neutralized by

4.27

Interlocking planes and directional tangents help reinforce eye movement.

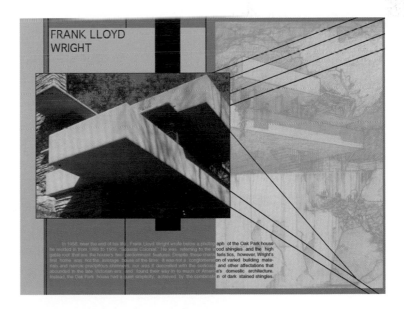

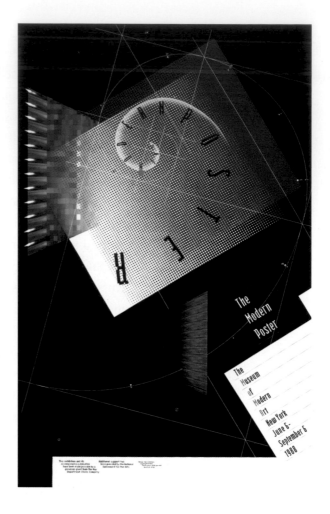

an opposite diagonal direction. Figure 4.29 illustrates how the animation of an image from the top edge toward the bottom half of the frame is counteracted by horizontal type elements that enter from the right and animate toward the left. In Figure 4.30, the horizontal motion of an element is stabilized with a vertical wipe that exposes a new background image. In Figure 4.31, a large letterform animates from the bottom left corner toward the top right edge of the frame. A series of smaller typographic items, aligned parallel to the image's path of motion, animate into the frame from the left edge, reinforcing eye movement diagonally upward.

4.29

Neutralization of direction is created by counteracting vertical and horizontal motions.

4.30

Horizontal direction is counteracted by a vertical wipe.

4.31

The alignment and repetition of structures tilt the eye toward the top right edge of the frame.

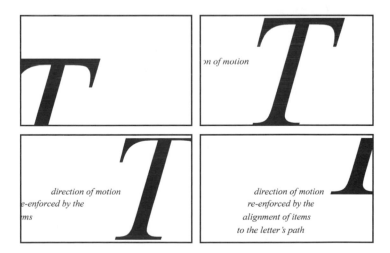

4.32

Frame from *Unsolved History* (2002–2003), a program ID for the Discovery Channel. Courtesy of the Discovery Channel and Viewpoint Creative.

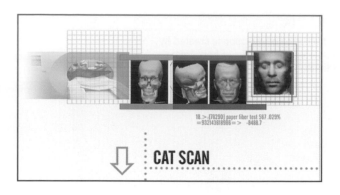

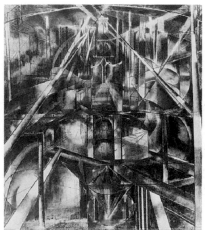

4.33

Cubist painting of the Brooklyn Bridge (c. 1917–1918), artist unknown. Courtesy of NARA.

4.34

Frame from *Live Like You Mean It* for Fine Living Network; design and animation by Susan Detrie. Courtesy of Detrie Design and Another Large Production.

pictorial rhythm

Pictorial rhythm is the recurrence of one or more elements within a static visual format. It is a pattern that is produced by repetition and variation. Andy Warhol's Pop Art paintings, for example, demonstrate rhythm through the monotonous repetition of images to convey the idea of consumerism. In furniture design, the articulation of surfaces through decoration and ornamentation can be visually engaging because of the rhythm of repeating forms and textures. In painting, graphic design, and animation, pictorial rhythm is established inside the frame through the visual spacing between elements. In Figure 4.33, a rhythmic vocabulary of architectural, volumetric forms is established in the manner in which the image is fragmented into overlapping geometric planes.

It is important to recognize the distinction between pictorial rhythm and sequential rhythm. *Sequential rhythm* is characterized by the continuity and recurrence of elements between frames; *pictorial rhythm* considers the distances that they are repeated in space within the frame.

Repetition and variation can contribute to pictorial rhythm. For example, evenly spaced lines on a ground establish a repetitious rhythm; varying the proximity between the lines produces a more dynamic rhythm. Pictorial rhythm can range from monotony to chaos, depending on the degree of variation that is introduced.

4.35

Frames from *Loop* (2003), a film by Terry Green and Nori-Zso Tolson. Courtesy of twenty2product.

This animation, which romanticizes about the concept of alternative energy, was inspired by a cover design produced for the July 2001 issue of *Hemispheres*, a United Airlines' *in-flight* magazine. Pictorial rhythmis established through variation of shapes, textures, and patterns of movement. In addition to sequences of filmed footage of wind farms, sunsets, and cityscapes, two-dimensional graphics were created to communicate solar energy and to reinforce the piece's overall continuity. According to Terry, "We shot supplemental footage the wind farms at Altamont Pass, time-lapse sunsets and city views of San Francisco."

4.36

Frames from a kinetic type assignment (2003), by Carolyn Kosinski. All rights reserved.

juxtaposition

Pictorial (versus sequential) juxtaposition is the placement of two or more things that are related or unrelated in meaning in close proximity to suggest a new meaning. During the Modernist era, the Surrealist movement employed bizarre juxtapositions of objects in unusual settings and in absurd situations. Pop artists juxtaposed fragments of popular culture in painting. Further, motion graphic designers and fine art animators have developed unique methods of juxtaposing images and type. Hatmaker's Cosmo Fun Zone for

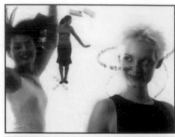

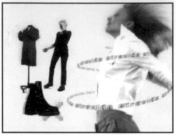

4.37

Frames from Cosmo Fun Zone channel launch (2000), produced by Song Design and Hatmaker. Courtesy of Cosmopolitan Television and Hearst Entertainment.

4.38

Frames from *Live Like You Mean It* for the Fine Living Network. Courtesy of Another Large Production and Detrie Design.

Cosmopolitan Television (4.37) for example, is a teen-targeted identity package that juxtaposed spirited, joyful young women and iconic objects to suggest a playful, liberating atmosphere. The use of white space, clothing palette, general look, and ending logo banner also helped target women in the home and the aspirational "Cosmo woman."

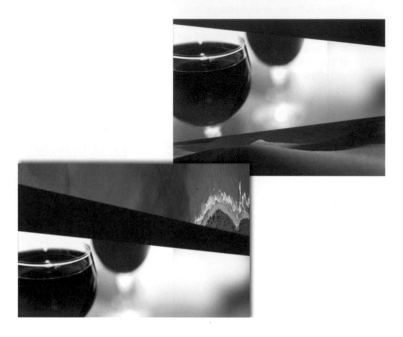

superimposition

Superimposition involves overlaying one item on top of another. (In broadcast production, a title can be "supered" over live background footage.) In collage, superimposition allows the original identity of found objects to be maintained in tandem with the new meaning that each takes on in association with other objects. In photomontage, it provides a method of combining two or more images to create a new image or scene. Independent and commercial animators have used superimposition to create seamless compositions of moving images and type. Digital compositing techniques have become more advanced and are at the heart of today's animated network identities, television show openers, commercials, and movie title sequences.

This Web site demonstrates the use of superimposed, sequential video frames.

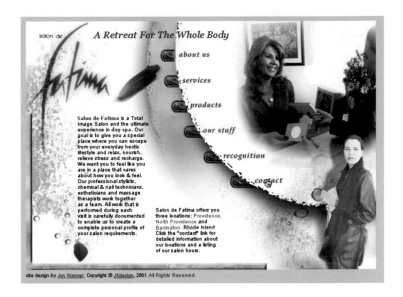

contrast

Contrast is one of the most important design principles in graphic communication. As a powerful tool in graphic expression, it introduces variety into a composition, allowing for a wider range of design possibilities. It can be harnessed by motion graphic designers to clarify or simplify information, intensify meaning or expression, or refine the sensation of the message being communicated. Contrast sets up a counter-force to our need for balance and can create complex and compelling visual interactions between elements. The most common types of visual contrast include scale, value, color, shape, proximity, and orientation.

4.40

Varying the orientation of objects draws the viewer's eye in different directions.

4.41

Frames from *Destination Style* show opening for The Travel Channel. Courtesy of Susan Detrie Design.

Dissimilar shapes can create interest by introducing visual conflict.

4.42

Color contrast is evident in an animated banner ad for Washington Mutual. Courtesy of twenty2product.

4.43

Additional methods of visual contrast.

straight vs. curved

cohesion vs. disparity

connected vs. separated

deliberate vs. spontaneous touching vs. isolated

constricted vs. expanded

ornamental vs. simple

objective vs. abstract

hierarchy

A principle that is related to contrast is hierarchy. (In fact, it is usually dependent upon contrast.) Most viewers rely upon visual clues to direct their attention. Visual hierarchy is a product of their need for direction. It allows you to organize compositions and control the attention of the viewer's eye in a way that clearly distinguishes varying levels of information. In a publication design, headings, subheadings, paragraphs, and side notes are treated differently with regard to font, size, spacing, color, and so forth.

In motion graphic design, visual hierarchy of static and kinetic information can be achieved pictorially (within the frame) through differences in value, scale, orientation, color, and proximity. Subordinate elements can be accentuated by assigning them different colors or supplementing them with graphics such as bullets. Further, a dominant object can be oriented to point in the direction of items of "lower ranking."

breaking spatial conventions

Since the early 20th century, artists have challenged classical assumptions of space in order to break the homogeny of the rectangular frame. Throughout the modern era, Cubist and Constructivist painters gravitated toward nontraditional approaches to composition by investigating multiple viewpoints, asymmetry, and diagonal eye movement. During this period, graphic designers also began to deviate from popular spatial conventions. Russian Constructivists broke away from vertical and horizontal arrangements in favor of diagonal layouts. Later, Swiss and Dutch postmodern designers began pushing scale contrasts, angular forms, and dramatic camera angles in their compositions.

In animation, nonconventional approaches to composition can help you avoid the restrictions that have been imposed by norms that have become standard over time.

Attempts to break the rectangular picture format were most striking during the early 20th century. Modern artists such as Robert Delaunay, Piet Mondrian, and Giorgio de Chirico were among the first to introduce circular, diamond, and triangular compositions. Eventually, painters began to investigate ways to extend their content beyond the confines of the frame. Many negated the idea of enclosure and considered borders as virtually nonexistent (or self-defining) visual devices. For example, Frank Stella's mixed media constructions from the 1970s broke the deadlock of the pictorial surface by leaping off the wall onto the gallery floor. His book *Working Space* (1986) has inspired generations of artists to rethink how two-dimensional space can be manipulated. Influenced by Cubist aesthetics, American photographer David Hockney also brought to the late 20th century an increased desire for spatial exploration. His photocollages, constructed from 35mm prints, were compiled to create a "complete" picture by eliminating the idea of a fixed field.

4.44

Byzantine painting (476–1453). © Erich Lessing/Art Resource, NY.

escaping the "box"

The fact that film and television screens are rectangular does not imply that your work must be designed conform to the frame's rectangular format! (In fact, many interactive motion graphic artists feel confined by the fixed aspect ratios and zoning laws of film and television screens.)

nonrectangular boundaries

As paintings during the early Renaissance were created strictly for religious purposes, artists took into consideration the structures that existed in ecclesiastical vaults of churches (4.44). When the context shifted from religious to secular, canvases were needed to display artwork. As a result, the rectangular frame became the most widely accepted picture format.

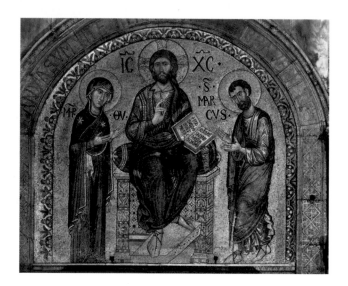

It is possible to deviate from this conventional format in independent and commercial animation. Although the viewing area may remain fixed, an unlimited number of compositional structures inside the frame can be explored—all of which do not have to conform to the screen's rectangular boundaries. The animation in Figure 4.47, for example, was designed to conform to the edges of a nonrectangular shape within the frame, rather than to the frame's boundaries.

Pictorial Considerations

4.45

Screens from Candle's Intelliwatch CD-ROM, by Jon Krasner. Courtesy of Candle Corporation and The Devereux Group. s© 2004 Candle Corporation.

4.46

Frame from *Heritage: Phase 3*, by Jon Krasner. © 2004, Jon Krasner.

4.47

Mural painting in Hell's Kitchen, Manhattan, New York. Courtesy of the EPA and NARA.

absence of boundaries

In animation, space can also be suggested, rather than defined by the physical boundaries that the screen imposes. This allows the eye to consider the possibility of time passing through an infinite, undefined viewing area that continues in all directions. For example, the backdrop of the inner city playground in Figure 4.47 abandons the idea of boundaries within a fixed frame. The five main figures leap forward out of the inner circle, providing a feeling of continuous space without borders.

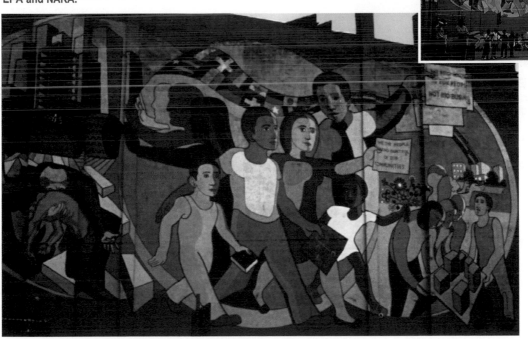

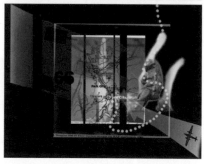

4.48

Frames from Slamdance Film Festival trailer. Designed by Brumby Boylston and Elizabeth Rovnick. Courtesy of Fuel.

In this animation, the frame only serves the purpose of "housing" an open compositional format.

spatial division

The divided screen is one of the oldest special effects to be used in the film industry. Its tradition was founded by the silent film pioneer Lois Weber in 1913, who originally used it to depict telephone conversations between people. Its concept was then entertained by filmmakers who were a product of formal modernist aesthetics. Abel Gance, for example, produced a three-screen silent classic titled *Napoleon* in 1927. His film utilized a process that he called "Polyvision." Gance predicted that the capacity of the viewer to navigate through multiple images was a result of an increasingly shortened attention span. During the 1960s era of drugs and free love, underground filmmakers such as Jordan Belson and the Eames brothers projected multiple images in light shows in galleries, planetariums, and public settings. Their technique of superimposing images (with as many as 70 individual projectors) became known as the expanded cinema (a quintessential method of expressing the effect of a hallucinogenic drug trip). Pop artist Andy Warhol also applied a split-screen technique in *Chelsea Girls* (1966), the first double-screen film to be commercially released.

Multi-image slide projection throughout the 1970s allowed numerous dissolving images to be displayed in unison with sound. Video wall technology during the 1980s elaborated on this idea by offering modular, multiscreen systems that could display large images without sacrificing resolution. Exciting compositional possibilities could be attained as signals from different sources could appear across multiple adjacent monitors or be divided up, repeated, and shown separately in various shape and size configurations.

Today, prime-time television shows and motion pictures are becoming proponents of split-screen juxtaposition. Since the opening to the 1970s television show *The Brady Bunch*, the

Interface design for Rockshox's 2000
Web site. Courtesy of twenty2product.

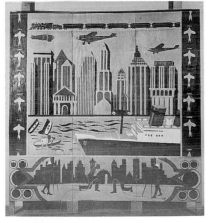

4.50

Mural painting for the Harlem Art work-
shop. Courtesy of the Harmon Foundation
Collection and NARA.

This city mural demonstrates the concept
of spatial division as a means to show
multiple views of Harlem.

revitalization of the divided frame is largely attributed to the arrival of nonlinear editing systems such as the Avid and Media 100. In Mike Figgis' film, *Timecode* (2000), the screen is subdivided into four panels that depict four different but interconnected personal experiences. Each story unfolds in real-time throughout the entire movie. Stephen Hopkins' television drama *24* also embraced this technique to depict a range of viewpoints and camera angles in as many as six simultaneous scenes.

In independent and commercial animation, the technique of screen division introduces numerous visual possibilities that go beyond the four borders of a single composition. The technique of splitting up the screen can fracture time and space, allowing the viewer to use his or her peripheral vision to observe several actions and perspectives simultaneously.

5

progressive considerations

DESIGNING OVER TIME

Musical composition is the structuring of sounds into a predefined arrangement, and dance is the organization of highly refined sequential movements. Further, animation is the choreography of events, motion, and change over time. Orchestrating the way events are sequenced and the manner in which things move and change inside a frame is a developmental process that, with dedicated thought and adequate planning, can enhance artistic expression and conceptual impact.

"The ability to deconstruct a movement and reassemble it in a new or convincing way is the animator's territory. Many artists have realized their visions using animation as a means to externalize their inner thoughts and unique points of view. Animation gives the viewer the opportunity to gaze at a frozen moment of thought and to experience another person's rhythms."

— Christine Panushka

chapter outline

00 : 00 : 00 : 05

Sequencing Events

Progressive considerations relate to how animations are sequenced and how motion is choreographed.

birth, life, and death

The sequencing of events is established in the life, duration, and death of elements. In animation, these terms refer to the method by which elements are introduced into the frame, the duration for which they remain in the frame, and the method by which they leave the frame. All of these factors should be given substantial consideration when establishing the overall sequence of events in an animation. Elements can simply move into and out of the frame from any of its four edges, can be scaled up or down, or can be faded in or out. Elements can become constructed piece-by-piece, be introduced by other elements, or be transformed through morphing.

The life or duration of events that happen relative to each other in the frame is more difficult to communicate in a storyboard, because of the limited number of frames that are usually presented. However, this factor should be taken seriously, as it affects the pacing of an animation.

transition

In structuring your composition, it is important to consider how the major events will be linked together. As opposed to *straight cuts*, transitions allow smooth changes to take place. The most basic type of transition is a *dissolve*. (In sound, it is commonly referred to as a *crossfade*.) This involves a gradual decrease in the opacity of one source while another source appears in its place. This transition method is used to soften abrupt changes between frames. If a dissolve is frozen, a *superimposition* results, producing ghosted images of two different sources. (Stopping a crossfade would produce

5.1

Stills from an online advertisement for Lycos. Courtesy of hillmancurtis.com, inc. Vertical lines animate horizontally across the screen to introduce the individual letterforms of each heading.

a mix of two different audio sources.) A *fade in* is a dissolve
from black or any solid color. A *fade out* dissolves the image
to black or a desired background color. Fades are generally
used at the beginning or end of sequences to signal a major
change in the content.

Another common type of visual transition is a *wipe*. Similar
to a dissolve, it produces a gradual replacement of one image
source into another. Rather than changing opacity, wipes
begin in one portion of the viewing area and move across the
screen in a particular direction and pattern. Its motion can be
vertical, horizontal, or diagonal. It can begin as one shape
and morph into another. (Split-screen effects are often created
by wipes that are partially completed.)

Pictorial transitions can move you between scenes in a more
subtle, yet more provocative manner. For example, in a Flash
advertisement for SquarePig TV, hillmancurtis, and Craig
Frazier Studio utilized a zoom effect to make a transition
between actions (5.2). In an online advertisement for Roger
Black Interactive Bureau, pieces of geometric forms come
together from opposite sides of the frame to form symbols
that eventually fade out (5.4).

Further, complex graphic transitions can be customized or
purchased to produce a variety of visual effects.

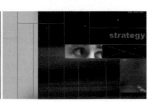

5.4

Frames from an online ad for Roger Black Interactive Bureau. Courtesy of hillmancurtis.com, inc.

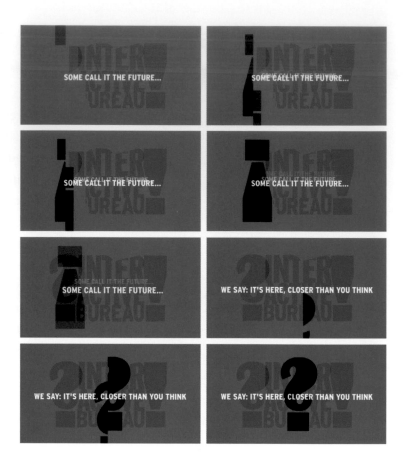

5.5

Media 100i's Timeline and Edit Suite. Courtesy of Media 100.

Customized dissolves, wipes, and specialized effects can be created in most consumer motion graphics packages as well as in nonlinear editing systems. In Media 100i, you can create customized wipes from the luma values of any 8-bit grayscale PICT file. The transition is applied to the overlapping portion of two video clips in an "fx" track in the timeline (top). A cut arrow indicates the location and direction of the transition. The dark green area represents the inactive video portion of the clip that is trimmed by the transition. The Edit Suite (bottom) allows you to set parameters that control the way transitions are applied.

Choreographing Motion

The manner in which you choreograph the way elements move can play an important role in delivering your message. The linguistics of motion can be traced back to pioneers of character animation and experimental abstract film.

direction

There are two types of directions in which things can move: *linear* and *nonlinear*. Pendulums and mechanical objects travel uniformly in predictable, linear directions. Living subjects and natural phenomena, however, move in unpredictable, nonlinear directions. They can also change their orientation as they travel; for example, a kite flying through the sky turns as its path of motion changes in the wind.

In interpolation software, motion paths provide control over the direction in which elements travel over space during a given time interval. They are represented as straight lines, curves, or combination of lines and curves.

velocity

Like direction, velocity can be linear or nonlinear. Linear velocity proceeds at a steady, predictable rate. Clocks, tape players, and electric fans are a few examples of mechanical objects in which the rate of motion progresses at a uniform incremental pace. Although this type of movement does not lend itself to lifelike animation, it may be in concert with the subject or look and feel that you are trying to communicate in your work. In general, linear velocity works well with objects that travel in linear paths of direction. Sudden changes in speed can be abrupt and visually disturbing to the eye, since there is no transition.

It is seldom that living things in the natural world move at a constant pace. According to Newton's laws of motion, objects that have mass naturally accelerate as they move through space over time. It is highly unusual for things to start or stop instantaneously. Inexperienced animators often overlook this fact and produce work that feels too "linear." In contrast, some of the most sophisticated animations contain subtle, less predictable changes in the way things move and appear. This offers more gradual, fluid-looking animation, where the content can assume a more dynamic, realistic persona, versus the steady pace that linear motion produces.

5.6

Frames from *Fall Forward Spring Back* (2000), by Stephen Arthur. Paintings by Peter Voormeij. Courtesy of the artist. All rights reserved.

Abstract images have been recombined and animated through interpolation. The directions that shapes travel in as they playfully interact with each other were carefully choreographed.

principles of motion

Some of the animation principles that are described here were established back in the early days of Disney. They not only are applicable to character animation but can be applied to motion graphics as well.

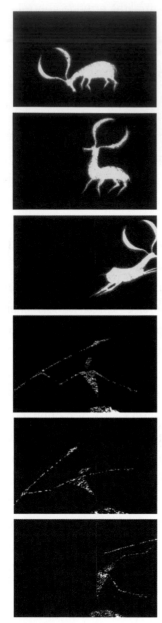

5.7

Frames from *Mr. Reaper's Really Bad Morning* (2003), by Carol Beecher and Kevin D.A. Kurytnik. © Fifteen Pound Pink Productions.

Anticipation is evident in the movements of the animal before running as well as in the backward motion of the hunter before throwing his weapon.

squash and stretch

The technique of squash and stretch gives motion the illusion of weight and volume through distortion. This distortion can range from subtle to extreme. It has been used in all forms of character animation from a bouncing ball to the body weight of a figure in motion.

anticipation

For every action, there is an equal and opposite preceding action. For example, in throwing a ball, a pitcher rears his arm back, allowing the arm to throw with more force; before swinging the club, the golfer twists her body into a coil, bringing the club over the head; before leaping off the diving board, the swimmer executes a downward motion. Anticipation has the power of implied action, informing the audience that something is about to happen.

pause

Pause in animation is as important as silence in music or a comma in a sentence. It can keep your movements from appearing too busy or mechanical and allow the viewer to get a chance to catch his or her breath. Further, it can create expectations and, to a certain degree, tension. For example, a pause occurs when a person walking stops and changes direction. On a swing, there is approximately a half-second pause at the top of each arc.

timing

Timing involves choreographing how actions are spaced according to the sizes and personalities of objects. In frame-by-frame animation, the more drawings there are between actions, the slower and smoother the action is. Incorporating a variety of slow and fast actions in an animation creates a much more dynamic sense of movement.

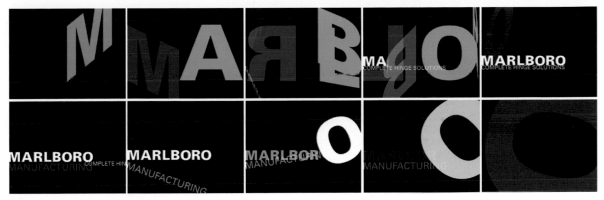

5.8

Frames from Marlboro Manufacturing's introductory Web site animation (1999), by Jon Krasner. © 2004, JK Design.

The word "manufacturing" rotates from its left edge downward prior to accelerating upward to hit "Marlboro," creating an impact when knocking off the letter "O."

acceleration and deceleration

Natural movement in the real world begins slowly, speeds up, and slows down again, unless it is interrupted by an obstacle. Acceleration and deceleration help to establish natural movement. Emulating a subject's movement frame-by-frame involves creating a large amount of drawings near the starting pose, less in the middle and more drawings near the next pose. As the object approaches the middle pose, it begins to accelerate, and each calibrated distance it travels is further than the previous one. In interpolation software, velocity changes for an object's position, scale, and rotation can be controlled between key frames (5.9).

5.9

Adobe After Effects provides a speed graph that allows you to determine how an layer's velocity changes over time. Here, acceleration and deceleration are established.

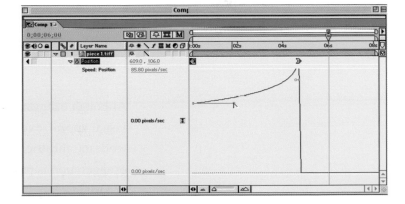

5.10

Frames from an animated mechanical object assignment (2001), by David DiPinto. Courtesy of Communications Media Department, FSC.

As the object falls to the bottom of the frame, its impact is established through acceleration. Movements are then carefully choreographed to emulate those of an inch worm slithering out of the frame.

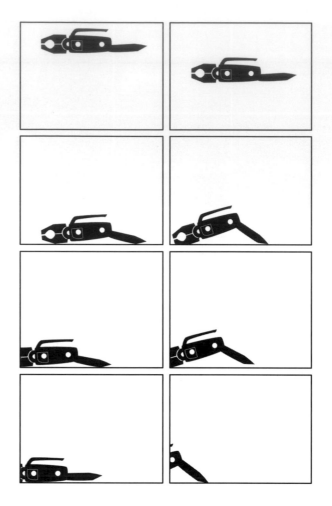

exaggeration

In figurative animation, the objective is not to depict totally realistic movement; that is the goal of live action. Rotoscoped movements that are accurately traced from live footage may appear precise but stiff and mechanical. Rather, the technique of exaggeration can help get a point across and make the content enjoyable to watch.

Although exaggerating an element's action can enhance its visual appeal, excessive use of this technique can make your work too theatrical or contrived. Determining the amount of exaggeration is purely intuitive and comes from experience, experimentation, and attentiveness.

5.11

Frames from *Mr. Reaper's Really Bad Morning* (2003), by Carol Beecher and Kevin D.A. Kurytnik. © Fifteen Pound Pink Productions.

Exaggeration of motion is apparent in the movements of the figures as they run after the animal.

parenting

In public, parents usually hold their child's hand to keep him or her from straying away. As the parent moves, the child naturally moves with the parent and follows wherever the parent goes. However, the child maintains the freedom to turn or move freely within his or her own space; those motions are not transferred back to the parent.

Parenting in animation is a powerful technique that allows you to create relative (no pun intended) movements between elements by setting up hierarchical relationships. For example, the chimes and hands of the clock can rotate independently while following the position of their parent, the clock, as it moves across the screen.

Similar to the real-life example described above, most actions that are applied to a parent are automatically passed on to its children; however, a child's action does not necessarily affect the parent. A parent can have an infinite amount of children. However, a child can only have one parent. Child layers can be parents to other layers, and there is no limit to the hierarchy that you can build.

Cinematic Camera Techniques

The concept of camera movement throughout an animation can create a dynamic, multidimensional space where the viewer feels like an active participant. Basic cinematic effects that have been used in traditional filmmaking have

been recreated in animation in order to breathe life into a scene and achieve different framings of the composition. *Panning* and *tilting*, for example, are horizontal and vertical pivoting motions that change the motion of an image across the field of view. *Zooming* involves changing the focal length of the camera's lens or changing the distance of the camera from the subject in order to change the audience's field of view.

emulating camera movement

In traditional cinema, the familiar sweep of the background, caused by camera motion, can be simulated by moving an image that is wider than the field of the frame under a stationary camera. In a step-by-step manner, each frame is exposed. In interpolation software, key frames relating to an object's horizontal or vertical position in the frame can be

5.12

Frames from *About Face* (2000), by Marilyn Cherenko. Courtesy of the artist. All rights reserved.

Cinematic techniques of dollying and zooming allow the viewer to follow the cat from room to room at spatial distances that range from wide shots to extreme closeups.

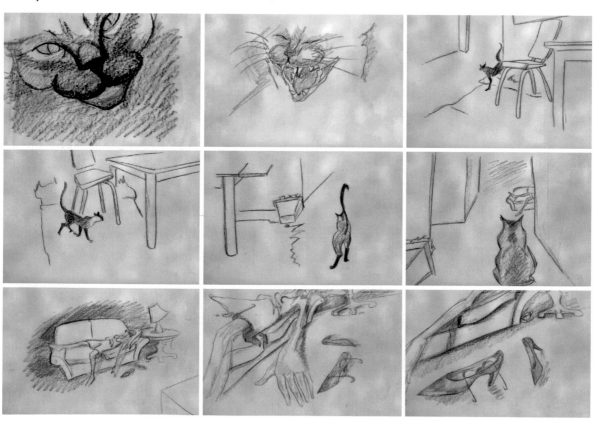

Progressive Considerations

created on a timeline. A repeating background element can animate horizontally across the screen repetitively to emulate a continuous pan. Further, zooming can be achieved by key-framing an image's scale.

camera animation

Until recently, camera movement could only be performed in 3D animation programs. Adobe After Effects' introduction of 3D layers in version 5.0 allows camera objects to be inserted into a composition as layers and interpolated on the timeline. Panning, zooming, dollying, and rotating can be combined to enhance the impact of a composition. Panning involves translating the camera on the X or Y axis to reveal parts of an image or all the images of a scene; zooming is achieved by moving the camera along the Z axis. Dollying is performed by moving the camera horizontally while pointing at an element that is also moving on the X axis. Rotating a camera around static or kinetic objects can be performed in concert with any one axis or a combination of X, Y, or Z axes. Further, cameras can be assigned to motion paths to follow specific courses of direction. They can also be pointed toward particular objects during their animation.

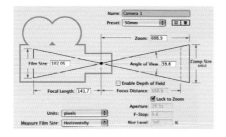

5.13

Adobe After Effects provides several camera presets, all of which simulate the capabilities of common real-world lenses and 35mm film. These are named according to focal length, which describes the distance between the image display and the viewer's perspective.

5.14

In After Effects, cameras are treated as layers in and are interpolated using key frames. Cameras contain Z-axis values for "Position" and "Point of Interest." Position refers to the camera's location in 3D space, and Point of Interest indicates the spot that the camera is aimed at.

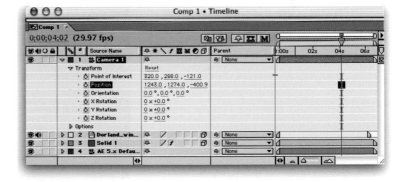

5.15

After Effects' orbit, Track XY and Track Z tools are used to manipulate a camera's view along the X, Y, and Z axes.

5.16

Different views of a scene allow you to view layers from different angles. Adobe After Effects' multiple-view layout lets you navigate a camera in one view while observing the result in the other.

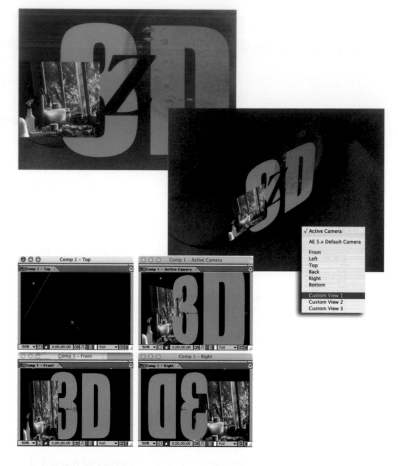

5.17

Portions of this animation are rendered from different viewpoints and edited together in the final production.

Progressive Considerations

Establishing Rhythm

In musical arrangements, individual notes and progressions of notes that repeat at regular intervals contribute toward the flow of information, creating unity and interest in the "beat" of the music.

Sequential rhythm is the recurrence of one or more elements within a visual or audible format that is time-based—for example, music, professional dancing, and animation. It establishes the mood of a composition in all its different phases from beginning to end, moving the viewer in such as way that he or she feels the "beat" of the piece. It also creates predictability and coherence, a sense that all of the parts are working together to achieve harmony. There are parallels between music and animation; the difference is that in animation, timing is sensed by the eyes as well as by the ears.

Rhythm does not have to be uniform; in fact, it can change over time in order to introduce a variety of moods throughout the phases of an animated piece. Think of a symphony. Unlike dance music, where the rhythm is steady and continuous, a variety of tempos characterize different movements throughout a composition. In animation, rhythm can be established during the early stages of storyboarding and during postproduction through editing.

repetition, variation, and emphasis

Repetition involves a series of matching elements that occur regularly over time. Durational sonic patterns in music are often repeated to establish rhythm. In classical music, certain themes may be duplicated to give the piece a unique personality that differs from other arrangements. Without repetition, a musical composition can stray away aimlessly in too many directions, lacking a focus. In fine art and graphic design, repetition is often used to create a sense of structural continuity and cohesiveness within a composition. It is also used to produce the feeling of motion, inviting the eye to move rapidly or pass smoothly from one element to the next.

Repetition in animation is achieved through a series of matching or similar actions that recur between frames. This can help establish sequential continuity and maintain a sense of pace. Experimental animations from the 1920s relied heavily on the concept of repetition to achieve rhythm. Viking Eggeling's *Symphonie Diagonale* (5.24), for example, choreographs each movement to a steady, mechanical tempo. Rhythm is articulated by the manner and speed by which geometric elements appear and disappear in the frame, along with the duration for which they remain on the screen. In many instances, figures build over time, line by line, and varying shades of gray create the effect of images fading in and out to the underlying musical score. The arrangement of different themes within the whole piece can be compared to the orchestration of a symphony.

Rhythm was also a key element in Hans Richter's work and seems to have contributed to his approach of combining spontaneous improvisation with formal organization. In *Ghosts before Breakfast* (1927), people and everyday objects (i.e., clocks, hats, and ladders) interact in unusual, irrational settings. Sequential rhythm is preserved by juxtaposing scenes of objects and people that move similarly at equally spaced intervals from each other at similar speeds. Their repeated actions are used to establish a uniform sense of timing. In many cases, the number of objects between successive frames, as well as their relative spacing from one another, remains constant at regular intervals throughout the film. Scenes where the camera is stationary and objects move inside the frame are often juxtaposed with those where the camera travels along with the objects. According to Richter, "The rhythm of a swing or a clock, the orchestration of hats or legs, the dance of kitchenware or a collar—could become expressions of a new sensation." Richter's attention to rhythm is also evident in his abstract compositions such as *Rhythm 21*.

Variation allows new material to be introduced into repetition. It can help break predictability and be used to emphasize a particular point of interest. Wendy Tilby and Amanda Forbis used variations of graphic, numeric, and typographic elements between frames in a Harvard Film Archives film trailer (5.19) to engage the audience's interest while keeping the rhythm and timing of shots consistent with the music.

Emphasis marks an interruption in the fundamental pattern of events. It can also break predictability and define a point of focus. In music, emphasis is achieved by providing accents in order to make certain notes or combinations of notes stand out. In character animation, it is used to exaggerate movement. In motion graphic design, it is used to contribute toward the visual hierarchy. For example, an element that flies or tumbles into the frame calls more attention to itself than one that moves slowly and uniformly.

5.18

Frames from an in-store video featuring Nike's Air Max2 running, basketball, and cross-training shoes. © 1994 Nike. Courtesy of twenty2product.

Repetition of the footstep image unifies the beginning and ending of the piece.

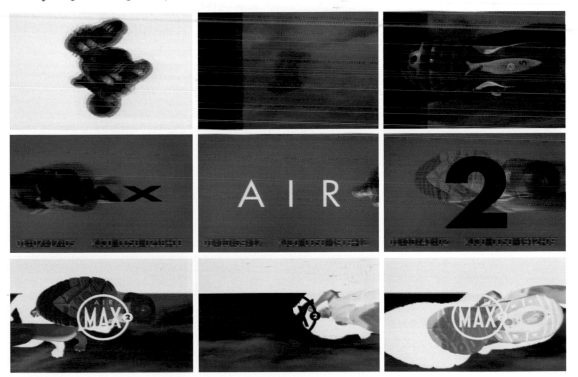

5.20

Stills from the *Harvard Film Archive Presents* movie trailer by Wendy Tilby and Amanda Forbis. © Harvard Film Archives.

 5.19

Frames from a music video bumper for Flux Television (1994). Courtesy of twenty2product.

Sequences consisting of animated shapes, typography and live video are repeated throughout the bumper.

juxtaposition and montage

Sequential juxtaposition involves placing two or more unre-
lated elements in close proximity over time to form a new
idea. In music, juxtaposing sounds are used to convey rhythm
and meaning. In animation, images and type can be juxtaposed
pictorially inside the frame and sequentially *between* frames.
Montage, an early cinematic technique that utilized juxtapo-
sition, involved deconstructing the content by cutting up the
film and editing it back into a condensed series of events. It
often relied on devices such as repetition, closeups, rapid
cuts, dissolves, and jump cuts to capture and hold the audi-
ence's attention. Montage has often been used to shift the
viewer through time in order to suggest a passage of events.
A classic example is the rapid cutting of newspaper articles
to depict a series of incidences that would normally occur at
a much slower rate. In other cases, events are smoothly con-
nected, giving the viewer latitude to infer the meaning of the
concept. Individual associations that are inherent to the images
are eliminated to form a more complex meaning. The brain
concurrently assigns rhythmic beats to them, finding associa-
tions by assuming that they are derived from the same source.

Examples of sequential montage can be seen in avant-garde
films from the 1920s. Walter Ruttman's *Berlin: Symphony of
a Big City* (1922–1927) is an extraordinarily beautiful docu-
mentary that provides an intimate model of urbanization by
juxtaposing sequences of images of horses, trains, bustling
crowds, and machines to express the dynamism of Berlin.
Associations between the everyday lifestyle of the working
class and that of the wealthy elite suggest a basic similarity
(as opposed to a class struggle). The linking of these scenes
effectively unifies the content of the film, depicting a cross
section of a city in motion, the interaction of its parts con-
tributing to the whole. *Ballet Mechanique*, produced by
French Dadaist painter Fernand Léger and cinematographer

Dudley Murphy around 1923, is another experimental avant-garde classic film that approached the possibilities time and motion through the use of sequential juxtaposition. Diverse, fleeting images of mechanical objects and people are combined through repetitive, rhythmic motions. The film's continuous, rapidly cut movements and compositions produce a type of complex, multilayered structure that can be easily described as a kinetic exploration of Cubist form.

In Russia, filmmakers such as Sergei Eisenstein and Dziga Vertov utilized montage to express ideas about popular culture. Influenced by the Soviet avant-garde, Eisenstein was a leading practioner and theorist of constructivist aesthetics. His introduction of montage in filmmaking changed the direction of Soviet cinema. Films such as *Towards the Dictatorship* (1924) and *Potemkin* (1925) demonstrate a complete rejection of conventional documentaries that involved linking scenes in a smooth, undisturbing manner. His films made complex visual statements by shocking his audiences with totally unexpected scenes that were composed of numerous different shots. Many of today's music videos employ Eisenstein's theories of montage.

iii Animation Tools and Techniques

6

frame-by-frame animation

In the early 1880s, British photographer Eadward Muybridge pioneered a body of experiments in motion photography that analyzed the movement of live subjects. His research demonstrated that a maximum of 10 to 12 images depicting incremental movement can give a convincing illusion of motion when viewed in sequence. This spawned the birth of classical frame-by-frame animation for film, a method that continues to be employed by artists and motion graphic designers today.

"Animation's ability to instantly dissolve the representational into the abstract, to leap associatively with ease, and to render simultaneously a flood of images, perceptions, and perspectives, makes it an unparalleled form of cinema."

— Tom McSorely

chapter outline

00 : 00 : 00 : 06

6.1

Frames from *Variations on Joyce* (1990) by Stephen Arthur. All rights reserved.

Executed with pencil on paper, this GIF sequence was created specifically to be exhibited over the Internet.

Frame-by-Frame: An Overview

If you have ever made or used a flip-book, then you have experienced frame-by-frame animation. Each sheet in a pad of paper contains an individual, unique drawing. The illusion of continuous motion is produced when these images are displayed one after the other by flipping the pages quickly. The more frames there are per second (or for a given moment), the smoother and more believable the motion will be when they are played back in sequence.

Similarly, when a series of consecutive frames are displayed in rapid sequence, the subject matter springs to life. The number of frames may vary, depending on the degree of movement or change required. Generally, small numbers of frames per second produce less fluid change, while greater numbers produce smoother transitions. Depending on the subject matter, however, it is not always necessary for a looping animation sequence to contain large numbers of frames. In fact, four or five key images can be sufficient if a frame sequence is looped to produce a constant rhythm of motion or change or a continuous repetition of events.

Whether your image content is generated by conventional or digital means, animating on a frame-by-frame basis imitates processes that were employed widely in the 1930s in which thousands of individual images were drawn or painted by hand. Clearly, this is a time-consuming undertaking. However, it is well suited for animations in which the visual properties of an image change (for example, volume, shape, color) rather than the image simply moving through space. The great advantage of frame-by-frame animation is having ultimate control over every mark, line, and brush stroke to create artistic, personal expression.

A fine arts degree is not necessary to use cel animation tools effectively. (In fact, sometimes the most primitive drawings can contribute effectively to the mood of an animation.) However, some degree of drawing or painting experience is beneficial, along with creativity, imagination, and patience.

classical versus cel animation

Classical or "old school" animation for film during the 1930s and 1940s was a labor-intensive undertaking involving the generation of two-dimensional artwork frame-by-frame. Since film runs at a rate of 24 frames per second, 1 minute of film required 1440 individual drawings. Original drawings were executed on paper or on semitransparent vellum to allow previous frames to show through the frame on which the artist drew. (This technique is known as *onion skinning*.)

Cel animation, invented by Earl Hurd in 1914, streamlined the process of classical frame-by-frame animation. The technique takes its name from celluloid, the transparent material used for animation in the early days of filmmaking. Animators executed drawings on clear acetate cels, instead of paper. Celluloid film sheets were used to overlay foreground, middle-ground, and background imagery. Films animated in this way might contain thousands of cels, and individual frames might be composed of a single cel or a combination of superimposed cels.

In early character animation, artists drew outlines of figures on the front side of a cel, while color fills were applied to the back side to help eliminate brush strokes. Background images were often drawn on separate opaque media and then the cels and background would be layered in front of a camera. This process shortened the time and labor of illustrating entire frames, as only elements that changed had to be created.

A cel setup is a combination of two or more cels (with or without a background) working together to form a complete frame. Cel levels are individual cels that are combined into a cel setup. Technically, it was rare for two or more elements to occupy a single level. Usually, each character had its own cel, and a scene usually no more than five levels.

Original hand-painted cels have become a commodity among art galleries, dealers, and collectors. As one-of-a-kind pieces, they evoke the beauty, memories, and emotions of the early cartoon classics. One could purchase an original production cel for just a few bucks each at Disneyland's Art Corner shop during the late 1950s and early 1960s!

Today, the process of cel animation can be assisted with the use of a computer and a variety of software.

traditional animation techniques

hand inking and xerography

In the 1930s and 1940s hand inking and xerography were the two most commonly used methods for transfering hand-executed artwork from paper to animation cels. Both of these techniques are still being practiced today.

Before the late 1950s, the process of tracing animation drawings onto clear acetate cels was known as *hand inking*. Quill pens and brushes were used to perform this extremely complex and laborious task. (You might compare traditional inkers to the monks who spent hours hunched over in monasteries producing illuminated manuscript books during the Middle Ages.) Today, it is possible to see examples of hand-inked cels from the 1950s in art galleries. A classic example is Disney's *Fantasia*.

During the mid-1930s, Disney Studios developed a photographic technique for reproducing drawings onto animation cels. Images were first created at full size and then reduced photographically to fit the scene. This produced hairlines that looked more precise than those that could be achieved by hand inking. This technique was utilized throughout the early 1950s until the development of xerography.

The photographic line technique was first used in *Snow White and the Seven Dwarfs*.

Despite its precision, hand inking had its artistic drawbacks. Maintaining the richness of an original drawing can be difficult because of the use of pens or brushes (versus pencils), the smooth, slick surface of the cel, human imperfection, and loss of spontaneity. Animators who prefer to work in pencil have an alternative option: xerography.

Xerography, also created by Disney Studios, involved photocopying pencil drawings directly onto animation cels. Although the result was harsher and more sketchy, it was quicker and less expensive than hiring an inker. Most importantly, it produced a better depiction of the artist's original pencil work and enabled much greater spontaneity than hand inking. Additionally, effects such as simulating a camera zoom by reducing or enlarging objects over time could be easily performed with the Xerox technique.

traditional rotoscoping

Rotoscoping, developed in 1917 by Max Fleischer, is a traditional form of animation that originated by tracing filmed frames of live action footage onto paper. During the silent film era, this technique was often used as an aid for animators to become better acquainted with motion and timing by enabling them to analyze the movement of live subjects that might have been too difficult to draw freehand. Raw film footage was literally traced over as a reference for evoking naturalistic movement. This process soon became a core element of Walt Disney's in-house art training.

Rotoscoped films appeared quite lifelike while retaining a traditional cartoon quality. Animation legend Max Fleischer and his crew used the rotoscope extensively to give action sequences a more powerful impact in early *Out of the Inkwell* films such as *Koko the Clown* and the 1940s Superman series. However, there were limitations, such as lengthy production time, cost, and trends, which were set mainly by Disney.

Today, the process of rotoscoping is used not only to trace animation from live action but to integrate live-action footage seamlessly with animated images.

6.2

Frames from *Keeping Balance* (2001), by Scott Clark. Courtesy of the artist. All rights reserved.

Rotoscoping is used as a transition from animation to live action.

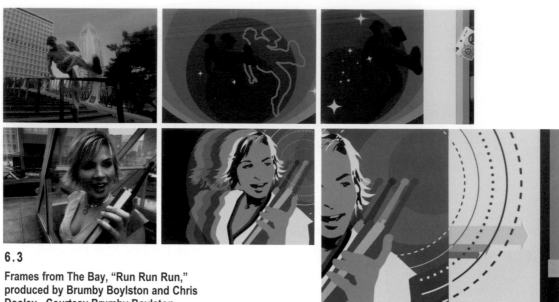

6.3

Frames from The Bay, "Run Run Run,"
produced by Brumby Boylston and Chris
Dooley. Courtesy Brumby Boylston.

**Targeted toward fashion-conscious
department store shoppers, digital
rotoscoping live-action footage is used
in this piece to achieve "flat, disco, live-
action-to-illustration transitions."**

Traditional nondigital animation techniques
described here reference practitioners
whose prolific animated works have become
recognized for their unique style of imagery
and storytelling. Additionally, their technical
contributions to the field have influenced
subsequent generations of animators.

Nondigital Production

Producing frame-by-frame animation with conventional tools
and techniques is filled with artistic possibilities that can have
a powerful impact on an audience.

Since the early 1900s, the processes of two-dimensional
animation have undergone many revolutionary changes.
Traditional techniques can now be easily automated by the
computer. Both off-the-shelf and specially developed in-
house systems have been designed to accommodate the
needs of large animation houses, corporations, and television
networks. However, the pace, diversity, and overabundance
of digital technology in the industry can be overwhelming,
and the latest "toys" are not always the best.

Today, many independent and commercial animators prefer
traditional production, as the quality of hand-executed
imagery has a certain warmth and charm that computer-
generated animations often lack. (Ironically, many digital
processes are designed to mimic the look of classical animation,

similar to digital effects being developed for video to simulate the look of old film grain and dust.) Although you may choose to manipulate, composite, or output your work digitally, your initial frames do not have to originate from the computer.

freehand animation

The process of freehand animation (painting or drawing on frames) covers a gamut of styles and genres from traditional cartoons to expressive, abstract painting and spontaneous gesture drawing. In animation history, the process of generating frames by hand is the dominant form of production. Almost any type of physical medium, whether it is conventional or alternative, is applicable. (Chapter 8 discusses a variety of media and substrates that can be used to generate image content during preproduction. These also apply to production.)

key frames and in-betweens

Freehand animation includes two types of frames: key frames and in-betweens. *Key frames* (also called *extremes*) are nonadjacent frames that identify the most major changes or positions of elements in a scene. These are used as guides for construction of the *in-between* or intermediate frames, which complete the transitions between the key frames.

In the early days of cel animation, drawing in-between stages by hand was a laborious, meticulous process. (Quality animations entailed high frame rates, e.g., to 24 frames per second for film or 24 individual drawings for every second of animation.) It was determined back then that senior-level animation artists should not be burdened with this task; rather, their time should be spent choreographing the most important actions with pencil on the master (key) frames. Therefore, *key assistants* (or *in-betweeners*) were assigned the task of refining the key frame images by erasing and smoothing the pencil lines. These drawings were called

Animators often learn their trade by performing cleanup and in-between work. Many large animation production houses have their "tweening" performed overseas or by entry-level artists.

cleanups. The responsibility of rendering these in-betweens was delegated to one or more in-betweeners.

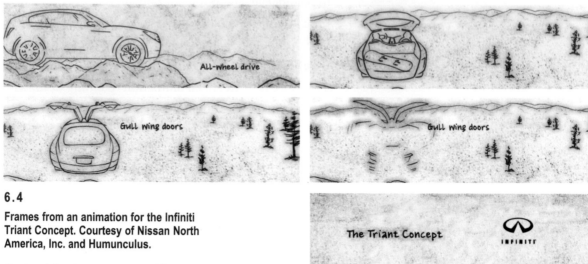

6.4

Frames from an animation for the Infiniti Triant Concept. Courtesy of Nissan North America, Inc. and Humunculus.

Freehand drawings were created from animation cells and digitally composited.

substrates

The benefits of paper include affordability, availability, flexibility, and acceptance of a wide range of conventional media. A major drawback, however, is that paper's opaqueness and density can make it difficult to view drawings on previous frames while creating new frames. There are ways to compensate for this. Papers vary in opacity, and even a minimal amount of transparency may be enough to reference images that occupy previous frames. Underlighting can simulate the effect of onion skinning.

The term *direct-on-film* refers to the cameraless technique of creating images directly on a strip of film. American animator Len Lye, a major figure in experimental filmmaking, pioneered the technique of painting and scratching images directly onto the celluloid surface of film. Over the years, animators have continued to explore the creative possibilities inherent in film as a substrate for animation: among them, applying long brushstrokes, pencil lines, and scratches across a series of frames, and collaging elements onto filmstrips.

> Before cel animation and xerography, many animated productions created from drawings on paper combined foreground and background images on a single sheet. Individual elements had to be recreated by hand for every new frame.

The direct-on-film method is best suited for large, bold images with strong colors. (Accurate movement of small elements can be difficult to achieve with this process.) A variety of visual effects can be produced with traditional art media, chemical compounds, and alternative processes such as scratching, burning, and rubbing. The emulsion coating of black film can easily be scratched into or removed chemically.

6.5

Frames from *Driving Abstractions* (1997), by Stephanie Maxwell (animator) and Allan Schindler (composor). Courtesy of the artist.

In most of her fine art animated films, Stephanie Maxwell employs the direct-on-film method to achieve a rich palette of light, color, texture, and motion.

Alternative substrates are abundant and offer unique visual properties for experimenting with production. Nonabsorbent materials such as glass, Plexiglas or ceramic tiles are ideal for implementing the modified base technique, since paint or ink can easily be wiped away. Additionally, you can be spontaneous and playful like a small child using finger paints, as images do not become immediately "fixed" to the surface.

Throughout history, freehand animators have experimented with a multitude of substrates. J. Stuart Blackton's *Humorous Phases of Funny Faces* (1.18) was produced with chalk on blackboard. Each time a frame was photographed, part of the picture was rubbed out and redrawn. Contemporary Polish animator Piotr Dumala employed the modified base process on plaster by painting and etching images into the surface and photographing each subtle alteration onto film.

other traditional animation styles

collage

The technique of collage in painting and graphic design was widely practiced throughout various modernist art movements during the 20th century. Collage involves assembling pieces of photographs, drawings, and printed and found materials. The method allows the elements of chance and spontaneity to liberate ideas, producing a heightened sense of artistic freedom. Unlike photomontage, where clarity of the subject matter is maintained, collage elements may also be layered to the point where patterns and textures dominate image legibility. In two-dimensional animation, a broad range of collage styles have been explored from busy, heavily layered compositions that are totally abstract to representational works of art where foreground and background objects are easily deciphered.

The effect of motion is created by photographing or recording one frame at a time as individual elements are moved in small steps. This process is called stop-motion. Stop-motion animations are known for their disjointed, jerky feel. *Monty Python's Flying Circus* is one of the best-known examples. Animator and director Terry Gilliam combined ludicrous photographs of animal heads and bodies to give his moving collages their quirky charm. Independent filmmakers Frank and Caroline Mouris pushed the envelope of animated collage in classic shorts such as *Frank Film*. Their innovative process has been featured on VH1, MTV, PBS, and HBO in commercials, documentaries, music videos, and programs including *Sesame Street* and *3-2-1 Contact*.

6.6

Frames from *The Beckoning: Part 3*, a collage animation by Jon Krasner. © 2004, Jon Krasner.

cutout

Cutout animation, a technique widely practiced in Finland, is a type of collage animation in which figures are pieced together from found materials.

0.7

Frames from Madan and the Miracle Leaves, by Frédéric Back. © Trees for Life, Inc.

This cutout animation is intended to promote the use of the drumstick tree (a rich source of vitamin A) in villages in India that are facing vitamin deficiencies.

6.8

Frames from a sand animation for the letter "A," by Eliot Noyes. Courtesy of Sesame Workshop.

sand

Sand animation is a more obscure analog process involving the manipulation of sand under a film camera. It also uses a stop-motion technique in which each alteration is photographed one frame at a time. Since each change wipes away portions of the previous image, the artwork is nonpermanent, in a state of constant evolution. This improvisational freeform process allows spontaneity and chance to become significant components of the artistic process. Tools for implementing sand animation include brushes, wooden sticks, stencils, strainers, and fingers.

Portuguese animator Yael Biran also experimented with various sand media and techniques. One particular animation entitled *The Bird Maker* has been viewed worldwide in animation festivals. The sand animations of Hungarian artist and filmmaker Ferenc Cakó also have met with considerable international success. His animated film *Ashes* demonstrates the provocative results of backlighting. In collaboration with

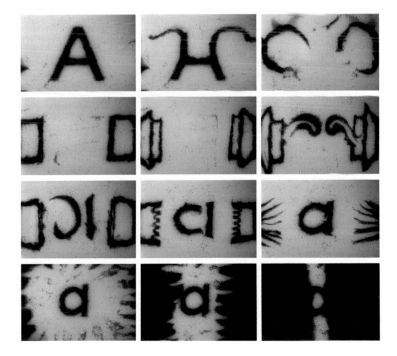

violinist Bartha Katalin (ex-concertmaster of the Kotkai Symphonic Orchestra), Cako developed a musical sand painting performance in which the process is projected onto a film screen in harmony with the music. This production has been performed all around the world at social events, festival openings, and symphonic orchestra concerts. In Hungary, Cako is asked to perform nearly every week.

Another approach to sand animation is to underlight a sand painting with a lightbox. This technique creates the effect of high-contrast silhouettes, providing an excellent opportunity to experiment with positive and negative structure. An example is *The Dancing Bulrushes*, coproduced and codirected by Joanna Priestley and Steven Subotnick. This sand animation of an Ojibwa Native American folk tale about a coyote was created by a film camera on backlit Plexiglas.

6.9

Claire Parker moving pins with a roller on the negative side of a pinboard. From Experimental Animation, courtesy of Cecile Starr.

The depth of the pins affects the degree and distribution of light and shadow areas across the board. This apparatus is like the toy sold at Spencers that saves the 3D state of your face or hand when pressed up against its surface.

pinboard

One of the most eccentric traditional animation techniques is the pinboard (later named the *pinscreen*), invented in the early 1930s by Russian filmmaker Alexander Alexeieff and his American wife, Claire Parker. The contraption consisted of closely-spaced pins that could be set to varying heights. When subjected to light, it casts shadows that produce dramatic textural effects resembling wood carving or traditional etching. The forms have a soft, chiaroscuro-like quality as they seem to dissolve and resolve in space. In the pinboard technique, rollers push and pull thousands of individual moveable pins into a perforated screen that is lit to create areas of light and dark. A wide range of possible tones can be achieved when experimenting with lighting in this way. Some of the most ambitious pinboard animations used as up to 1 million pins to create stunning expressionistic effects.

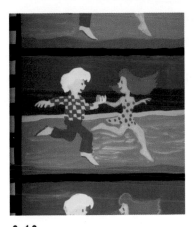

6.10

Frames from *We Love It!* (1992), by Candy Kugel. © 1980 Buzzco Associates, Inc.

Henri Matisse influenced this film's style in combining cut paper and traditional ceis.

mixed media

Traditional frame-by-frame animation does not need to rely on any one process. Combinations of the techniques described above have been used by animators to create richness and ambiguity of content and visual style. Candy Kugel's *We Love It!* combined cut paper with traditional animation cels (6.10). Another imaginative example is Joris Oprins' *Wad,* an animation portraying two characters and their dog stranded in a Netherlands landscape. Oprins' drew his desolate vision in mud and tar on wet sandpaper (1.62).

frame capture

Motion film technology is as old as frame-by-frame animation. The rich, soft quality of film is attributed to the light-sensitive emulsion that coats its surface. This emulsion is capable of capturing high resolution images photographically (unlike video, which records images as electronic signals). Because film does not provide instantaneous playback and it is more costly to process, one could argue that the waiting period actually enhanced the abilities of "old-school" animators by forcing them to concentrate more intensely on getting the choreography correct the first time around!

With the exception of painting directly on film, traditional analog animation processes such as freehand, collage, pinboard, sand, and mixed media requires time, patience, and investing in a good camera.

If you cannot afford 16mm film, Super 8mm is an acceptable format for capturing animation frame-by-frame. Super 8mm footage can be easily digitized for storage and postproduction. Companies such as MovieStuff specialize in transferring Super 8 footage to mini-DV tape, which then can be digitized from a DV camcorder to a computer via a Firewire connection.

Because the availability of Super 8mm stock is limited, it is best to purchase it directly from Kodak.

guidelines for nondigital animation

production tips

Depending on the length and complexity of your subject, nondigital frame-by-frame productions require substantial time, energy, and patience. Here are a few production tips to help streamline your process:

1. Do thumbnails.

Start traditional frame-by-frame animation by creating loose thumbnail drawings in pencil. These will serve as a guide in resolving staging issues and key poses of the elements in a scene. They also can help determine how your scenes will fit into the visual flow before you create a storyboard.

2. Work smart.

Create key frames first, since they depict the most dominant changes. They determine what will change and what will remain the same. Next, generate subsequent intermediate frames. Develop nonchanging elements such as backdrops and static images only once (as opposed to recreating all of the images for each frame). Use them repeatedly throughout the animation in different frames. Elements that change their physical characteristics also should be developed separately, allowing them to be superimposed on top of nonchanging backdrops. Just to be sure, use an overhead marker. (In the old days, key frame drawings would be passed on to apprentices, who would develop the in-betweens.)

3. Become pals with the photocopier.

The photocopy machine can be a wonderful production tool in creating complex animations. Although Xeroxed images may appear harsh or sketchy, this raw look can be a satisfying

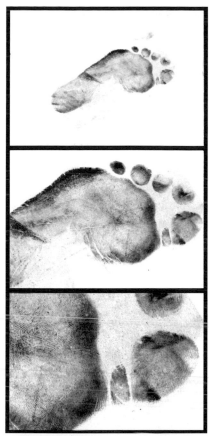

6.11

Photocopying an image at a variety of
sizes can emulate the effect of zooming.

trade-off for the time and energy required to ink individual frames by hand. Photocopying also allows you to create certain camera effects such as zooming by reducing or enlarging the images.

In the case of free-floating images for cut-out style animations, cutting out images from magazines or other sources can be painstaking, especially when they are complex. Photocopying images with white backgrounds onto transparencies can eliminate this meticulous chore and unless you are using a surgeon's scalpel and a magnifying glass, the results are much cleaner. The contrasty look of photocopied images can be effective from both a conceptual and aesthetic perspective. Read the photocopier manual and experiment with its different functions. Many visual effects can be achieved by fiddling with the brightness and color settings.

4. Plan motions individually.

Choreographing simultaneous movements can be confusing. Establish a basic game plan ahead of time so that you are prepared when it comes time to shoot. As a general rule, longer actions require more frames than shorter actions. For example, 15 or more frames may be necessary for a walk cycle, where only 2 to 3 frames may be needed to animate the subject blinking its eyes.

5. Layer.

If you envision your animation with various levels of foreground and background elements, create the images on overhead transparencies or on official celluloid sheets. Overlaying them gives you freedom and flexibility in adding depth to the frame. As an alternative to creating images on transparency, consider photocopying opaque artwork onto transparencies. Kinkos, Office Max, or Staples are affordable options for getting this done.

6. *Let the camera do the work.*

Effects that involve camera motion, such as panning and zooming can be performed by changing the camera's position in relation to the artwork in small steps. Alternatively, you can move the imagery; repetitive motions such as rolling, vibrating, or lifting the base can produce the effect of waves at sea, walking, or experiencing an earthquake.

7. *Loosen up! You don't have to be a cartoonist.*

Be expressive and experimental in your artistic style. Most of the animations referenced in this chapter succeed in using a wide array of drawing approaches.

6.12

Frame from *About Face,* by Marilyn Cherenko. Courtesy of the artist. All rights reserved.

8. *Sacrifice detail for pictorial continuity.*

Complex textures and details can lead to inconsistencies that become eyesores when your frames are played in sequence. Moving foreground characters in traditional cel animations are usually painted with flat colors, as opposed to background scenery, which is often more detailed and complex.

9. *Break conventions and push the medium.*

The fact that frame-by-frame animation is a traditional process should not inhibit your artistic practice. Content can be

executed with a wide array of media. Don't be afraid to be imaginative. The most successful contemporary animators have pushed the envelope by breaking conventions established long ago by studios such as Disney and Warner Brothers.

10. Mix media and techniques.
Animation does not need to rely on any one of the techniques described here. Investigate these methods further in order to discover what feels natural to you. There is no "right" or "wrong" formula. Combining any number of processes can enrich your style and personalize your work.

11. Employ the modified base technique.
Photographing artwork frame-by-frame after each modification offers a spontaneous way to simplify production. Stop-motion clay animation is a perfect example. Each time the subject is slightly altered, the camera advances to the next frame and records. Polish animator Piotr Dumala employs this technique on plaster (1.63). Implementing this technique on paper demands a durable stock to prevent tearing or wrinkling. It also is best to use a soft medium, such as chalk, pastel, or charcoal, which can be easily erased or smudged.

recording tips

1. Purchase a sturdy tripod or copy stand.
A tripod is an essential animation tool for achieving a stable and consistent result. Although cost may be a factor, consider the value of the camera that will be mounted to it. Invest in a tripod that will provide long-term reliability (versus a cheap one that will be discarded over the years). Sony's remote tripods are easy to adjust and allow you to zoom, record, start, and stop without even touching the camera. A copy stand can serve as a nice alternative and can be used for animating sand and collage elements. (Many have a tripod thread that will fit any camera.)

6.13

Soft charcoal sticks, charcoal pencils, and a kneaded eraser are effective media for employing the modified base animation technique on paper.

2. Pay attention to lighting.

Lighting is one of the most vital aspects of filming. Bad lighting can cause unwanted shadows or overexposure. Make sure that you have plenty of light to work with. Studio lights are designed to match the color balance of the film. If you cannot afford them, desk lamps or halogen lights can suffice with filters or manual white balance on digital cameras.

3. Shoot "on2s," "on3s," etc.

Animations that do not require seamless motion can be shot on every other or every third frame. This works well for collage or cutout techniques that are meant to use jerky motion.

From a technical standpoint, reducing the number of frames that are recorded helps to limit file size. This is especially beneficial with animations that are intended to be delivered over the Web.

Digital Production

Most of the ideas for two-dimensional computer animation have been adopted from conventional frame-by-frame practices such as onion skinning, key framing, and in-betweening. Over the past two decades, digital technology has helped to streamline the production process of frame-by-frame animation. The versatility of imaging software has enabled animators to mimic traditional techniques and narrowed the gap between preproduction and production without the need for a film camera. Phenomena such as cel flair, scratches, dust, and dirt are nonexistent in the digital realm. Image modification is quicker, cleaner, and more precise. The cost of materials declines since neither paper nor cels are used (although there are other expenses such as software, hardware, and a more highly trained and more highly paid staff). Natural phenomena that are difficult to execute by hand can be expressed by digital image alteration and special effects. All of these factors, combined with reduced time, labor, and cost, explain the industry's eager embrace of computer-based production.

6.14
Frames from *Keeping Balance* (2001), by
Scott Clark. Courtesy of the artist. All
rights reserved.

The variety of two-dimensional animation software on the market offers an attractive alternative to traditional frame-by-frame rendering. Applications such as Procreate Painter, Pinnacle Systems Commotion, Macromedia Director, and Flash contain useful sets of tools as well as production short-cuts, such as freehand painting, onion skinning, automation, rotoscoping, and vector-based animation.

Digital production does not require computer-generated imagery. In fact, any one or a combination of traditional, hand-rendered techniques described in the previous section can be integrated into the process. It can be as simple as digitizing frames and playing them back directly on a computer. It can involve altering and optimizing the frames in preparation for digital playback on the screen or outputting them to film or videotape. Animation frames also can be generated digitally through freehand drawing and painting, layering, and vector-based imaging tools.

digital capture

The advantages of capturing frames on a computer are instantaneous playback, preservation, and affordability. Instantaneous playback enables you to get the feel of the work as it progresses without waiting for a lab to develop the work. Digital storage preserves the quality of the work, unlike film or videotape that degrades over the years. Finally, there are no developing costs. The most common types of digital capturing devices include DV cameras, digital still cameras, scanners, and Web cams.

input considerations
Unlike film cameras, the majority of consumer camcorders do not have a built-in single-frame capture mechanism. However, an analog or digital camcorder can be used as an input device to record animation frames into the computer (versus recording them onto videotape).

Unlike consumer camcorders that do not have single frame capacity, Sanyo's iDshot digital camcorder can record animation frames onto a tiny (50.8mm) 730MB magneto-optical disk (manufactured by Sony) which is capable of storing approximately 12,000 pictures as JPEG files. There is no videotape or computer involved. This unit costs approximately $1500 U.S.

frame capture software

Standard analog and digital video camcorders are made to shoot several frames each time the button is pressed. Unless your camera has built-in single picture functionality, you will need to invest in software that allows for single-frame capture.

Single-frame capturing programs designed for PCs include Stop Motion Pro, Video Capturix (Capturix Software Technologies), Animator DV (wmmedia), and Stop Motion Animator (Anasazi). Stop Motion Pro will accept input from a DV camcorder, analog camcorder, or Web cam, as well as individual image files generated by a digital camera, by a scanner, or from software. Video Capturix is an affordable nonlinear video application that contains a powerful freeze-frame capture feature. Animator DV is relatively new to the market and made specifically for DV camcorders with Firewire compatibility. Stop Motion Animator is a free utility made strictly for PCs that have analog connections. (Those of us who own analog camcorders will appreciate this!) Although online support consists solely of a built-in Help menu, the price is right for beginners and those with low budgets.

For Macintosh users, Frame Thief (FrameThief Inc.) and BTV-PRO (Ben Software) are two affordable and worthy frame capturing programs with informative online documentation. Frame Thief's functionality compares to a video frame grabber that is capable of capturing video-quality still images. The program works with almost every type of Macintosh and QuickTime compatible video source including USB Web cams, video capture boards, still digital cameras, and DV camcorders. Both Mac OS 9 and OS X are supported natively. Rotoscoping can be performed directly in this application, and a lightbox feature allows onion skinning. Purchase of this shareware includes e-mail technical support.

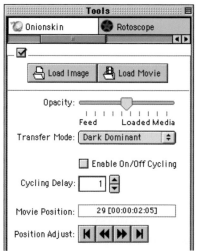

6.15

Frame Thief's resolution and rotoscope windows.

Frame-by-Frame Animation

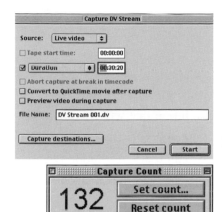

6.16

BTV Pro's capture window keeps track of the number of frames being recorded.

If you intend to purchase an analog video card, be sure it has both video in/out and S-video connections so that you can connect your computer directly to a device such as a VCR. If you already have a built-in DV Firewire card, make sure that the type of camcorder and software you are using is Firewire compatible. Most analog capture cards have S-video and RCA inputs for video and sound.

The Tagged Image File Format (TIFF) is the most stable and interchangeable file format.

BTV-PRO also has advanced capturing capabilities and accepts any Macintosh-compatible video input source including built-in video, video cards, USB, DV, and Firewire.

frame capture hardware

If you are using an old machine, it is likely that you will experience choppy playback due to the computer's limited capacity to keep up with the amount of data being captured. Investing in a video card or a computer with a faster processor, more RAM, and a fast hard drive may be necessary.

If your computer does not have built-in analog or digital video input, you will need a compatible video card with either a DV Firewire connection or—for an analog camcorder—standard RCA and S-video connectors. (The popularity of DV cameras for average consumers boosted the availability of Firewire cards and Firewire-equipped personal computers.)

digital cameras, scanners, and Web cams

Still digital cameras, scanners, and Web cameras today are remarkably inexpensive, and most of the frame capture programs discussed earlier will accept USB or Firewire connections. Although image resolution on a Web cam is far less than on a camcorder, a Web camera is a simple, affordable way to learn animation principles and techniques.

file formats

The most common raster-based file formats are TIFF, JPEG, PICT, and Photoshop. When frames are digitized, they should be saved in a master format, as opposed to a final animation format. If the animation will be delivered on DVD or the Web, the final format must be compressed. Since compression results in loss of image data, your original master frames should always be saved and backed up in their native formats.

1. Determine the input resolution in advance.

Since pixel-based images are resolution dependent, visual quality decreases if they are scaled up. Therefore, be sure to scan your frames at a resolution that will accommodate scaling. If you intend to enlarge your image by 200% on the screen while it animates, scan it at a resolution twice as high as your target resolution. Otherwise, its quality will degrade as its pixels become larger.

2. Prepare for large storage requirements.

The number of animation frames that you can store is limited only by your hard drive space. When planning a project, be careful not to underestimate the amount of available disk space that will be required. Depending upon the dimensions and length of the animation, you may need extra storage.

The file size of a single uncompressed 24-bit color frame measuring 640 x 480 pixels is approximately 0.9 MB. A 12 fps, 30-second animation would consist of 360 static frames, totalling over 324 MB of disk space.

6.17

A folder containing a sequence of frames named with "padded" numbers.

3. Be aware of the amount of memory that is built into your system, as well as the amount of memory needed to run a specific application.

If you are working with full-screen video, a rule of thumb is 1 frame per MB of RAM. For example, if your computer has 256 MB of RAM, your system and application might use 80 MB. You would be able to use the remaining 170 MB for 170 frames of animation.

4. It is beneficial when working with most applications to keep sequences of frames in separate folders.

Because frames can be imported in numerical order, it is helpful to have them named with "padded" numbers.

6.18

Photoshop's "Batch" menu.

An action is selected and applied to a source folder that contains a group of images to process. A destination folder is then chosen to output the images.

Founded in the early 1970s, the Quantel Paintbox (once called the "digital graphic design studio") remains a powerful industry standard workhorse that is specifically designed for 2D television motion graphics. At approximately $50,000, this stand-alone technology was ideal for creating multilayered animations for program titles, commercial spots, music videos, feature films, broadcast promos, and station IDs.

frame processing

single-image processing

Raster-based imaging tools can be used during production to enhance or manipulate individual image frames before they are assembled into an animation sequence.

multiple-image processing

Batch image processing can improve your work flow by applying operations to multiple images simultaneously. You can achieve this productivity spike in Adobe Photoshop by applying an action to a folder of images. Once you create an action in the Action palette, the batch command allows you to apply it to a folder containing several images that need to be altered.

There are a variety of applications that are specifically designed to perform batch image processing. Equilibrium's DeBabelizer, for example, is capable of most of Photoshop's commonly used functions, although it also can export more obscure file formats.

digital animation techniques

freehand

Digital painting techniques can be used effectively to produce animations from scratch, frame-by-frame.

"natural media" tools

Throughout the 1970s and 1980s, expensive workstations (called *paint systems*) were owned by large broadcast facilities and production houses. The development of desktop applications such as Pinnacle Commotion and Procreate Painter has provided a more affordable range of frame-by-frame paint and effects tools for independent animators. Both of these programs offer a full selection of "natural media" tools that are programmed to imitate conventional, physical media

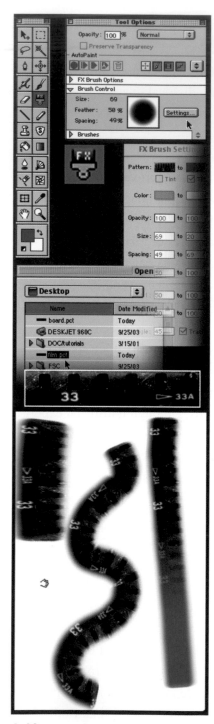

6.19

Commotion's FX brush uses the data from an image as a paint pattern.

such as charcoal, acrylic paint, oil, watercolor, crayon, chalk, and fountain pens, to name just a few. Freehand drawing can be performed on a frame-by-frame basis. In fact, Commotion allows you to simulate the direct-on-film technique by painting on or manipulating a range of frames simultaneously, versus working on one frame at a time.

Rather than being limited to a palette of predefined tools, Commotion allows you to customize brushes with regard to their shape, size, and degree of softness. You can simply select an image or part of an image to use as a brush. A versatile FX brush can reference a full-color image as a paint pattern and apply that data to another image based on the pressure, speed, and tilt of the mouse on a pressure-sensitive stylus.

Procreate Painter, originally designed as a brush emulation tool by Fractal Design, is also an extraordinary frame-by-frame animation program. Its array of natural brush media and effects can be applied to images in a *frame stack*—a unique file format that is inherent to Painter. Frame stacks are composed of sequences of images (or frames) that share the same dimensions and resolution. Like a flip book, they can be played back in sequence and altered with any one or combination of freehand drawing or painting tools. (This process resembles traditional approaches to animated illustration that involved working with stacks of drawings.) A Frame Stacks palette appears when a movie file is created or opened, making it simple to navigate between frames in an animated sequence. Thumbnails of the frames are displayed, and the number of thumbnails that appear is determined by the amount of onionskin layers specified when creating a new movie file. Individual frames can be inserted, edited, or deleted at any location within a stack.

6.20

Procreate Painter's Frame Stacks palette. Animation by Mark Bellevue.

Frame numbers appear under the thumbnails, and the current frame is shown with a red triangle superimposed.

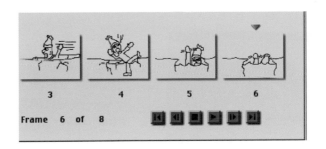

The term *onion skin* in two-dimensional animation is derived from the translucent property of onionskin paper used in traditional animation production.

The practice of onion skinning in early cel animation involved a light source that was placed beneath a finished drawing on a translucent page. The animator used the positioning of elements as a reference from which new elements were drawn in slightly different positions on a new cel.

onion skinning

Onion skinning is an aid to analog and digital animation production that lets you smoothly animate images without having to flip back and forth through frames. Ghosted images of previous frames are used to determine where elements should be drawn and what changes should occur in subsequent frames in order to maintain visual continuity.

Procreate Painter's onion skinning allows you to view multiple frames simultaneously in a dimmed mode while working on a new frame. This makes it easy to determine the amount of change between frames. When a movie is created or opened, the number of onion-skin layers that are specified determines the number of frames that will be visible in the Frame Stack.

Layers of Onion Skin:
 ○ 2 ○ 3 ○ 4 ● 5
Storage Type:
 ○ 8-bit gray
 ○ 8-bit color System palette
 ○ 15-bit color with 1-bit alpha
 ● 24-bit color with 8-bit alpha

6.21

When a movie is created or opened in Painter, the number of onion-skin layers determines the amount of frames that will be visible in the Frame Stack. Transparency also can be specified.

6.22

Activating Painter's onion-skin icon reveals previous frames with varying levels of transparency. Animation by Mark Bellevue.

6.23

Intuos 4 x 5", 6 x 8", and 12 x 18" tablets are battery-free and feature a cordless pen that can attain up to 1024 levels of pressure sensitivity.

6.24

Wacom's Cintiq 18SX and 15X interactive pen displays allow you to adjust the incline and rotate your work surface.

More information and pricing for Wacom's Intuos tablet can be found at www.wacom.com.

drawing tablets

Pressure-sensitive drawing tablets (also known as *graphics tablets*) optimize the process of freehand frame generation and help you achieve a sense of heightened artistic expression in the digital environment. Wacom's Intuos tablet (6.23), which works best with a pressure-sensitive pen, allows lines and strokes to be drawn with enhanced sensitivity, producing more natural results. Pressure control yields the same interactive experience that you would have using a real pen or pencil; lines become lighter, darker, thinner or fatter, depending upon the speed and pressure that is applied. An eraser at the opposite end also responds to pressure and speed. Coming from a traditional painting background, graphics tablets are excellent long-term investments as they increase retouching speed (and prevent carpal tunnel syndrome). Wacom's Cintiq interactive pen displays allow you to work directly on the screen (6.24).

freehand automation

A powerful feature in both Painter and Commotion is the capacity to record and convert an entire painting process into an animation. An evolving image can be saved and played back from beginning to end. This technique saves time and improves consistency between frames, since each action is recorded in sequence until the Pause button is clicked.

Procreate Painter features a unique automation method which records an action as a script and converts the script into a frame stack. The frame stack then can be further altered or saved in several different file formats for post-production or distribution.

Commotion's Autopaint feature is a powerful tool that, with a little experimentation, can produce a variety of dynamic animated effects. Like Painter's scripting mechanism, this this operation has the capacity to record a brush stroke or a

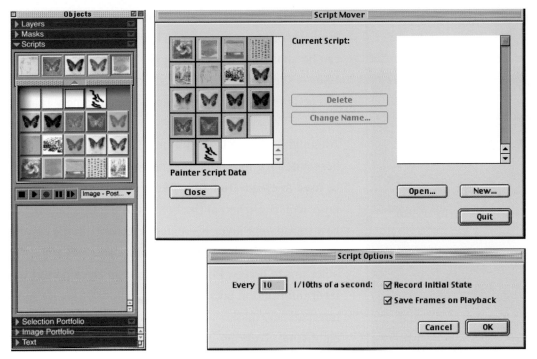

6.25

Painter's scripting feature can automate freehand painting into an animation.

series of strokes as they are painted and play back the process over a predetermined range of consecutive frames. This allows simple write-on effects to be animated. Strokes can be made to wiggle or move differently each time they are played back. Further, different paint tools and tool settings can be applied to create a variety of interesting effects.

collage

The beauty of digital collage is that many different types of elements (e.g., typography, photographs or portions of photographs, objects, textures, illustrations) can be combined in ways that would be difficult to achieve with physical materials. Synthesizing images and text through digital layering can mimic the technique and feel of collage or cut-out animation, as well as produce effects such as transparency and blending.

Layers can be treated as the digital equivalent of cels or cut-out parts of moving images. The modified base technique can be applied to layers using Adobe Photoshop. Each time a layer is slightly shifted, resized, rotated, or altered, the file can be duplicated, flattened, and saved as a new frame.

Although Pinnacle Commotion's layering capabilities are best suited for interpolation and compositing, they also can be used to create frame-by-frame animation. Each time the layer icon is clicked at the bottom of the timeline window, a new transparent layer is created. Elements in the layer can be painted on, rearranged, rotated, and scaled without affecting other image layers. Photoshop files can be imported with layer information preserved. This includes transfer modes, transparency, masks, and effects such as drop shadows and embossing. Working in this integrated way, Commotion allows you to work with still image layers and modify them frame-by-frame.

It is important to understand the layering capabilities of your application before animating with layers. Each program functions slightly differently, with its own instructions for layering frame-by-frame. For example, Painter allows you to

6.26

In Pinnacle Commotion, transparent layers can be painted on frame-by-frame. Activating the onion skin mode in the Clip window allows you to view the ghosted previous frames in order to create a flowing animation.

 6.27

Frame from (it was . . .) Nothing At All by Candy Kugel and Vincent Cafarelli. © 2000 Buzzco Associates, Inc.

Codirectors Candy Kugel and Vincent Cafarelli utilized the layering capabilities of Adobe Photoshop and After Effects to establish a rich variety of textures.

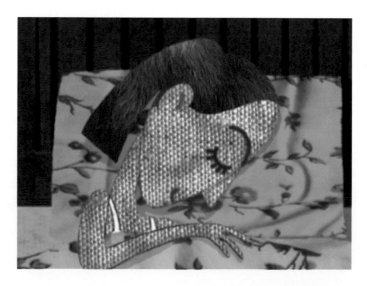

add, group, and move multiple layers together; however, once you close the file or leave a frame by jumping to another, its layer is automatically "dropped" and its content is flattened into the background. In Painter, therefore, it is best to animate the background elements first and work forward, one layer at a time. Commotion's layering methodology is more forgiving.

rotoscoping

As distinguished from other 2D animation processes, roto-scoping uses live-action footage as a guide or as an integral component of an animation. The original filmed or video-taped footage may or may not be included in the final product.

rotoscoping techniques

Unlike traditional rotoscoping, which involved the hand manipulation of frames, digital rotoscoping applies digital imaging techniques to animation sequences after they have been assembled. In frame-by-frame animation, rotoscoping fulfills many purposes including freehand frame generation, image alteration, enhancement, and touch-up. It also is used for compositing imagery from different sources.

Originally, rotoscoping involved "tracing" stages of move-ment from real-life subjects shot on film or video one frame at a time. The objective was to attain believable motion. This practice has held up over the years, especially with regard to complex situations that are difficult to visualize without a frame (or in this case, frames) of reference. Today's digital technology automates the process of tracing over live action video frames and making them look as if they had been hand drawn or painted with a variety of natural media. Figure 6.29 demonstrates how hand-drawn animation is performed in Corel Painter by tracing over a video clip of a gracefully dancing couple. When the clip is opened in Painter, it is converted into a frame stack. A new movie file (or frame stack) with the

6.28

Freehand rotoscoping in Pinnacle Commotion is performed by painting on a transparent layer above a video clip, frame-by-frame.

6.29

Freehand rotoscoping in Corel Painter.

A video clip of 20 frames is converted into a frame stack, a new frame stack with the same number of frames as the video is created. With the tracing paper feature activated, the footage appears in the new stack as if were overlayed with tracing paper. Brush settings are applied, and the underlying imagery on frame 1 is painted on. The source and destination frame stacks are advanced to the next frame, and the destination movie is painted on again.

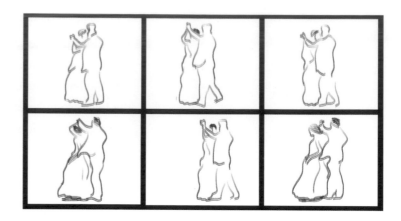

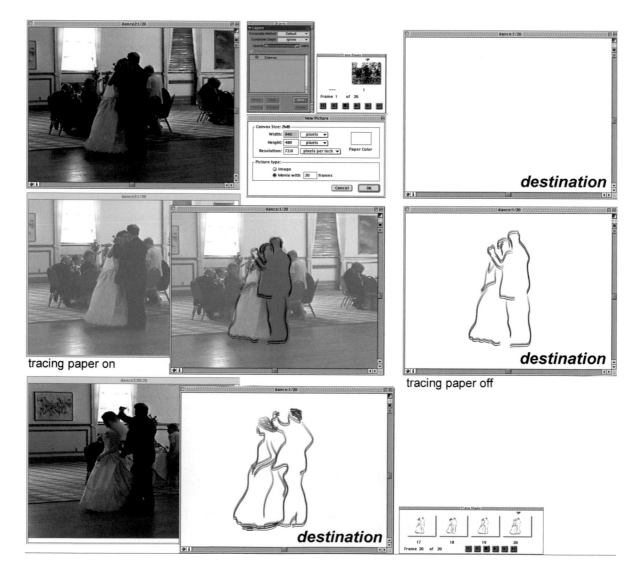

tracing paper on

destination

tracing paper off

destination

same number of frames and same dimensions as the source clip is created, and Painter's tracing paper option is activated. The imagery from the source clip is traced over with various brush tools on each empty frame of the destination framestack.

The visual possibilities of "painting on movies" are limitless. Live film or video subjects and freehand graphic imagery can complement one another if used together wisely. Figure 6.31 illustrates how loose gesture drawing over live footage can heighten spontaneity and enliven the images.

Procreate Painter's frame stack technology makes it easy to rotoscope lighting, color, and texture effects to an existing animation or video clip. Its Scripting feature can record one or more actions as a script and then apply that script to a single frame or to every frame in an entire movie.

Digital rotoscoping can involve manipulating the pixels of each image one frame at a time through the use of filtering operations, color and value adjustments, smudging, blurring, dodging, burning, tinting, and so forth. With control and precision, you can easily achieve painterly effects in programs such as Commotion, Flipbook, Painter, and even Photoshop. Almost any raster-based operation can be applied to a frame or to a range of adjacent frames. In Figure 6.30, a clip of live footage is exported from Adobe After Effects as a filmstrip file and opened and manipulated in Photoshop. Color alteration and brush work is applied across a series of frames and directly to individual frames. The finished work is saved out as a filmstrip to be translated into another useful format such as QuickTime movie or animated GIF.

Filter operations can be useful for rotoscoping these types of artistic effects. If you are purchasing third-party filters, make sure they are compatible with the application you are using.

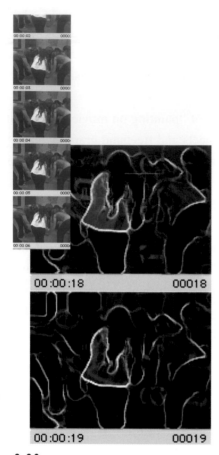

6.30

A movie clip is exported from Adobe After Effects in filmstrip format to be rotoscoped in Photoshop.

In standard video editing, Commotion's Superclone tool can remove that giant pimple from the center of your son's forehead on the day of his bar mitzvah in every frame of his Haftorah reading. Just pick a clear area on his head and create a Superclone setting of that spot. In a snap, his third eye can be painted out on every subsequent frame. The result will appear as if he had eaten no chocolate in the last two years!

Filters can be applied manually to each frame or to an entire frame sequence of an animation or video clip. This can save loads of valuable time. (Keep in mind, however, that work that has valuable time invested in it becomes valuable work.)

You can also use rotoscoping to color correct, de-emphasize, eliminate or seamlessly replace images with others across a series of frames. This especially applies to live video versus straight animation. This process, however, is not quick and painless. Even the most advanced rotoscoping tools require plenty of time and patience. There are, however, several ways to streamline your activity.

Cloning tools are the most useful for touching up animation frames. (Disney animators would have saved tons of money and produced 10 times the number of feature films if these were available back then!) Commotion's Superclone tool works in the same manner—only with multiple frames. Perhaps a more familiar example would be correcting mistakes or removing unwanted artifacts such as smudges and pencil notes by simply painting them out.

In addition to cloning, standard operations such as blending, blurring, dodging, and burning allow live images to be directly manipulated as they move. Color correcting and value adjustments can emphasize things that appear too subdued or de-emphasize things that are too overpowering in relation to other elements in the composition.

In complex situations where elements are constantly in motion, it can be challenging to continually adjust where you are working. Advanced tools such as Pinnacle Commotion's Motion Tracker can monitor an area of adjacent pixels and use that information to apply a change to a desired range of frames. Depending upon the quality of your digitized video footage, Commotion can maintain a pretty accurate trace of

the tracking area based on its chroma and luma differentiation. Figure 6.31 shows a video clip containing a distracting element that needs to be discarded. Motion tracking is used to generate a motion path based on the X and Y coordinates of those pixels; next, Commotion's Clone and Autopaint tools are used to automate the removal of those pixels across the entire clip. Touch-up paint strokes are recorded on the first frame, and Autopaint is programmed to repeat those same strokes on every subsequent frame. Painting 150 frames seems like a waste of precious time when Autopaint can magically carry out most of the work!

rotoscoping software

Many motion graphics applications provide rotoscoping tools. Independent animators consider Pinnacle Commotion the top-of-the-line tool for frame-by-frame rotoscoping, as its paintbrushes are fully integrated for precise, complex work. Of special note is Commotion's SuperClone tool, a powerful utility that lets you copy pixels from any location on any frame from one clip to another (6.32).

6.31

The techniques of motion tracking, cloning, and autopainting are used in Commotion to touch-up a video clip.

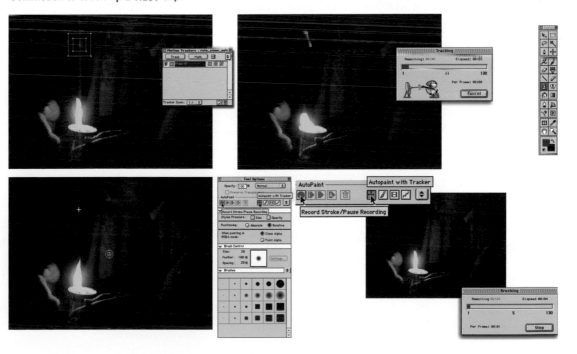

A demo of Stop Motion Pro can be downloaded free of charge at www.stopmotionpro.com.

Additional information on Flip-Book, Satori, Liberty, and Studio Artist can be found online at the following URLs:

www.digicelinc.com.

www.satoripaint.com

www.real-image.com

www.synthetik.com

Stop Motion Pro has a useful rotoscoping feature in addition to its single-frame video capture ability, DigiCel's Flipbook, originally designed for pencil testing, has a rotoscoping utility that can trace over imported video clips. A "Semi-Automatic Painting" function can rotoscope multiple frames simultaneously. Satori provides a comprehensive set of natural media drawing tools that can perform advanced rotoscope operations on a single frame or on a multiple-frame basis. Liberty (Real Image) is a high-end paint system for Windows or IRIX platforms that contains a set of advanced rotoscoping tools that are designed for retouching and painting for postproduction and broadcast animation. Synthetik's Studio Artist contains an "autorotoscoping" function that allows you to paint on top of a frame and then apply those paint strokes to every other frame in the animation.

High-end programs such as Avid's Matador and Media Illusion, Discreet's Combustion and Flame, Quantel's Domino, and Hammerhead Productions' Roto contain automated rotoscoping operations that are applicable for frame-by-frame compositing of multilayered content.

6.32

Pinnacle Commotion's Supercloner and Autopaint tools are used to duplicate the subject from different frames.

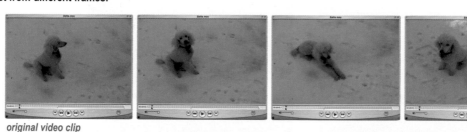

original video clip

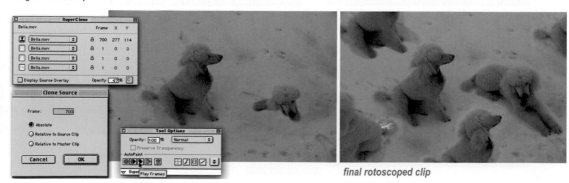

final rotoscoped clip

tips

Rotoscoping is a labor-intensive undertaking; however, the results are extremely rewarding if the process is approached seriously. Here are some tips that will enhance your work from both a pragmatic and an aesthetic perspective.

1. Work efficiently and at a steady pace.

In the early days of cartoon animation, character generation required careful study of living and nonliving subjects in order to simulate realistic motion. If your goal is to work tightly from live-action footage in order to achieve a realistic result, carve out a considerable chunk of time in your schedule to get the job done right. Impatience can lead to sloppiness, and sloppiness can impede professionalism. Create a comfortable environment for yourself before you dive into this monotonous process!

2. Use a drawing tablet.

Using the right tools can be the difference between endurance and insanity. A drawing tablet will expedite the work flow by providing greater control of your brush tools and ease the pain in your carpal tunnels. Wacom's Intuos graphics tablet and a pressure-sensitive stylus will give you maximum control over the way you clone, manipulate, and apply brush strokes.

3. Exercise artistic judgment.

Before diving into the mind-numbing act of rotoscoping, decide if and how this process should be used. For example, a fictional character may not have the same proportions as a human being or animal. Consider using live-action footage as a general reference rather than as a strict guide. The degree of realism in your drawings should be considered with regard to the look and feel of the subject that is being rotoscoped (as well as to the piece as a whole).

6.33

Make sure that your rotoscoped imagery does not clash visually with other elements in the scene.

4. Maintain artistic expression.

Rotoscoping has been used as an aid for learning the natural timing and motions of live subjects (something that all animators try to attain). However, if you just mechanically trace your filmed footage, the result can appear lifeless and boring. (Early rotoscoped drawings often lacked the spontaneity of traditional freehand animation.) Rotoscoped footage looks as mechanical as you make it. The motion of an image, as well as its physical attributes, can be exaggerated to make it appear more lively and animated. Movement can be enhanced by processes such as acceleration, squashing or stretching to express impact.

5. Choose the best frame rate.

High frame rates between 15 and 30 fps provide smooth playback but more frames; lower frame rates result in fewer frames but choppier playback. Unless you are stranded on a desert island or serving a long prison sentence, find a compromise between smooth playback and the amount of drawing time needed to generate the frames. Frame rates between 8 and 15 are sufficient for Web or multimedia delivery and can achieve adequate results.

6. Perform final tweaking.

The most advanced digital rotoscoping tools and techniques are not perfect; chances are there will be inconsistencies that require tweaking on individual frames, especially if you are working with low-resolution source footage.

7. Prepare the video for storage.

If you are rotoscoping live footage as a reference for freehand frame generation, be aware that video files require large amounts of disk space. Unless the footage will be

Frame-by-Frame Animation

integrated into your final piece, render it in a program such as Adobe After Effects or Premiere as a jpg sequence with a low output compression setting (between 3 and 5). Image quality is less critical than your ability to view the motion clearly. A small file size will save disk space and allow memory to scrub through the frames as you draw over the footage. It is also best to rotoscope small segments at a time and link the pieces together later. (Import only those frames that will be rotoscoped.) Separate the portion for rotoscoping in an editing application such as QuickTime Player, After Effects, or Premiere, and bring in only the frames you need. Further, work on a copy of the clip and save the original master footage separately; you may need this "raw material" later.

8. Adobe filmstrip files have specific guidelines.
Filmstrip files are a unique, native format to Adobe and are only supported by and created in applications such as Premiere, After Effects, and Photoshop. Inside Photoshop, a filmstrip appears as a long, vertical image that encompasses each frame of a QuickTime movie. The frames are subdivided by borders, each containing a number and time code.

Unless you have over 128 MB of RAM installed on your computer, filmstrip files can be a headache because of their size. If you use a Mac running OS 9 or older, turn off virtual memory and allocate at least 100 MB of RAM to Photoshop. Process your filmstrip in segments of no more than 90 frames.

Filmstrip documents have certain guidelines that must be followed. Do not paint on or alter in any way the time code located on the borders; this data is critical for the piece to be translated and played back as a QuickTime movie. Second, filmstrip files can only be saved in filmstrip format if they do not contain layers. Be sure to flatten your layers; otherwise the document will be saved in native Photoshop format.

vector-based animation

Vector graphics are useful in digital collage animation, type animation, or cut-out animation since they can easily be edited and resized without sacrificing image resolution. As a graphic is altered by point manipulation, it can be saved under a different file name. This results in a sequence of individual frames, each a distinct, subtle variation of the one previously saved. The entire progression of images can be imported into a program such as Macromedia Flash and played back frame-by-frame. Alternatively, the content can be created directly in an animation program and modified one frame at a time.

6.35

The modified base technique is applied to a vector-based graphic in Painter.

A vector shape is created in the first frame of a new movie. A second frame is generated by clicking the Advance button in the Frame Stacks palette, and that frame automatically contains the graphic from the first frame. On the second frame, the shape is altered by moving anchor and control vertex points. This process continues up to twenty frames, each depicting a subtle variation of the previous image. Before rewinding to frame 1, the shape layer is dropped.

tips

1. Name your frames appropriately.

If you are saving frames from a vector imaging application such as Illustrator, name them with a uniform prefix followed by an incremental number. This will ensure that if they are imported into Flash, they will appear on the Timeline in the correct sequence.

2. Choose tools that are comfortable for you.

Vector imaging is a skill that requires practice and patience. Chances are that you are either an Illustrator or Freehand devotee. If you are using Flash as your final production tool, Macromedia suggests using its vector art application, Freehand, as its "front end." However, it is a better practice to stick with the application that you are most familiar with. If Illustrator is your staple imaging tool, you can use Flash to import Illustrator files as long as they are saved in a version compatible with your version of Flash. Alternatively, you can copy and paste paths from Illustrator directly in Flash.

As an imaging tool, Macromedia Flash is quite different from mainstream vector-based programs. Its native drawing tools are distinct from those of Illustrator or Freehand. To some, they feel natural and intuitive; to others, they are too eccentric. Devote some time to learning them if you decide to perform the modified base technique directly in Flash. Although it was not originally designed to function as an image editor, Flash may suit your personal drawing style. Its most recent release adds a more standard pen tool for creating paths.

3. Limit the number of vertices.

Large numbers of vertices make frame-by-frame editing more time-consuming, increase file size, and slow down playback. Images that have been traced from complex photos should be cleaned up by eliminating unneeded vertices.

One significant advantage of Flash is its scalability. Vector images, in general, are resolution-independent and retain the same clarity when enlarged on the screen. Flash files are also small, requiring minimal storage.

6.36

Removing redundant vertices results in less editing during production and yields a cleaner, more refined looking image.

7 interpolation

ANIMATING ON A TIMELINE

Chapter 6 suggests the immense amount of time and labor associated with creating animation frames through traditional and digital media and techniques. Interpolation, which involves the use of software to calculate the values of intermediate frames, can generate animation sequences much quicker, with less effort and greater control over how motion and change are choreographed over time and space.

"All of a sudden it hit me—if there was such a thing as composing music, there could be such a thing as composing motion. After all, if there are melodic figures, why can't there be figures of motion?"

— *Len Lye*

chapter outline

Rotate Rotate Rotate

in·ter·po·late {in-'t&r-p&.'lAt}
To insert or introduce between
other things or parts; To
estimate values between two
known values

Position

00 : 00 : 00 : 07

Interpolation is also referred to as *tweening*, which is short for *in-betweening*. *Spatial interpolation* involves the path that an object travels over distance or space. *Visual interpolation* involves the animation of properties including color, texture, opacity, and shape geometry. *Temporal interpolation* refers to the rate at which an element travels or changes over time, taking into account factors such as acceleration and deceleration.

Interpolation and Key Frames

Video gives the illusion of motion by displaying sequences of static images fast enough to fool the eye. Trying to create the illusion of smooth motion on a frame-by-frame basis is a difficult and time-consuming process. The smoother the movements must be, the more important it is that each frame be accurately drawn.

the relevance of key frames

Interpolation allows many types of movements and changes to occur between two or more points in time by calculating intermediate data. These points are defined by *key frames;* and as a result, new in-between frames are generated to fill in the gaps. Key frames capture the most extreme changes in animation, marking the beginning and the end of an animated sequence. A minimum of two key frames are required for interpolation. In Figure 7.1, two key-frame values describe two different X and Y coordinates of the element's position at two different time intervals. The computer performs the task of creating the "in-betweens" by calculating incremental values between the key frames. Together, key frames and intermediate frames are referred to as a *frame range*.

Creating effective animation requires substantial focus and experience with the techniques of key framing and being sensitive to aesthetics. Beginning animators often create too many keys, resulting in jerky movements (and painstaking editing). Others allow the software to perform too much of the work, resulting in unnatural movements.

the relevance of time

Animation happens over time, and interpolation requires a fundamental understanding of how time is measured on a timeline using key frames.

7.1

Adobe After Effects and Macromedia Flash use key frame event markers. Start and end key frames relating to an object's position in space contain different X and Y coordinates on the timeline, and intermediate frames contain incremental values. The last key frame of a frame range denotes the starting key frame of the next adjacent frame range.

In 1967, the U.S. Society of Motion Picture and Television Engineers (SMPTE) introduced *timecode*, a method of calculating time in the form of an eight-digit 24-hour clock, consisting of 0 to 23 hours, 0 to 59 minutes, and 0 to 59 seconds. (For example, 00:02:23:15 means 0 hours, 2 minutes, 23 seconds, and 15 frames). Seconds are subdivided into frames, and the number of frames varies depending upon the specified frame rate, which is measured in *frames per second* (fps). This efficient method enables events to be matched up or synchronized accurately.

Frame rate indicates the number of times per second that pictures are updated sequentially to create the illusion of continuous motion and change. The standard rate for film is 24; the standard rate in the United States for broadcast video is 29.97. Frame rates for multimedia and Web delivery can vary between 8 and 30 fps. A frame rate of 12–15 fps usually yields adequate results on the Web.

7.2

In Adobe After Effects, movie duration, dimensions, and frame rate are specified when a new composition is created.

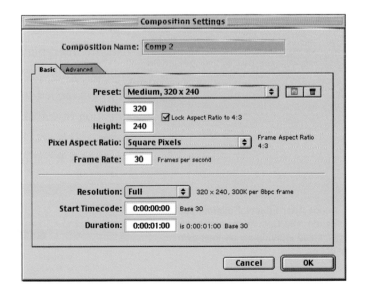

7.3

Moving an object's anchor point away from its center of origin enables a wider circumference of rotation. Repositioning the object's anchor point also allows it to rotate from one end, like an elbow joint.

7.4

In Adobe After Effects, Position, Scale, Roitation, and Opacity properties are key-framed individually on their own timelines.

Spatial Interpolation

Spatial interpolation (or *path animation*) involves animating an object's position, orientation, or scale in space and over time. In most cases, it relates exclusively to the property of position, specifically the horizontal and vertical direction in which elements travel along a predetermined "route."

transformations

Position, rotation, and scale are the most utilized types of spatial interpolation. These transformations can be combined.

Spatial interpolation in Adobe After Effects involves establishing key frame values for any one or combination of transformations on a timeline. In Figure 7.5, a layer is moved into position 1 and a starting key-frame value for the position property is established at 0:00:00:00 seconds. This is achieved by clicking the stopwatch icon to the left of a layer's position property in the Timeline. The time indicator is advanced to 0:00:10:00 seconds. At this point in time the object is moved to position 2. A second key frame containing a new set of X and Y coordinates is automatically generated, and intermediate data are interpolated across the frame range between the key frames. A third key frame is added at 0:00:05:00, and the object is moved to a different location, resulting in a curved direction of travel. At this key frame, the default rotation value of 0 is set by clicking the stopwatch icon to the left of the layer's Rotation property. The time indicator is advanced

7.5

**Interpolation of Position and Rotation in
Adobe After Effects.**

to 0:00:10:00 (the last key frame), the object is manually rotated to 90 degrees, and a second key frame is generated for the rotation property.

Spatial interpolation in Macromedia Flash is also based on setting key frame values for a layer. Unlike After Effects, key frames are generated prior to the type of interpolation specified. In Figure 7.6, a symbol containing a graphic is dragged from the Library onto the Stage into its first position. An instance of the symbol automatically becomes a layer on the Timeline, and the first frame is designated as a key frame. A key frame is then inserted at frame 35, allowing the object to "live" on the Stage for 35 frames. At the second key frame, the object is moved to a new position. The first key frame indicating the start of the interpolation is selected, and a motion tween is specified. Intermediate position data are automatically calculated across the frame range.

Although Flash is a full-fledged authoring application, it started out as a simple vector animation program. To this day, it remains an industry standard tool for creating fast-loading animations to deliver over the Web.

7.6

Spatial interpolation of an element's position in Macromedia Flash.

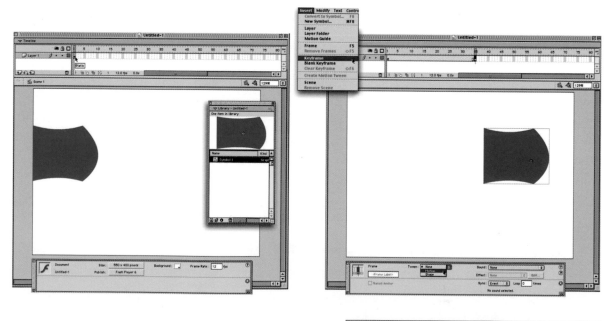

tweened sequence indicated by an arrow against a blue background

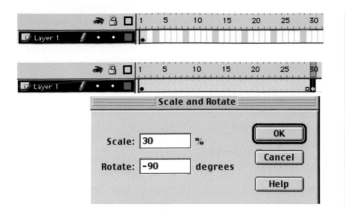

7.7

Spatial interpolation of a layer's position, scale, and rotation in Macromedia Flash.

Although position, rotation, scale, and opacity properties do not have individual timelines, they can be separated through symbol nesting, a process discussed later in this chapter.

motion paths

Motion paths provide control over the direction that elements travel through space over time. They can be represented as straight lines, curves or combination of the two. Most motion graphics programs utilize Bezier splines to generate motion paths. Linear paths consist of corner points, and curved paths contain smooth points that produce curves.

Motion paths can be generated directly in animation software or can be imported from an imaging application such as Adobe Illustrator, Photoshop, or Macromedia Freehand. They can be fine-tuned by repositioning their anchor points or altering their tangent handles to adjust the direction in which objects travel.

motion path editing

The process of altering a Bezier motion path in After Effects is similar to editing a vector image in a program such as Adobe Illustrator. Anchor points corresponding to key frames can be repositioned, and control points at the end of each tangent handle can be redirected to influence the curve.

In After Effects' Composition window, a Bezier spline is generated as a result of interpolating a layer's position (7.8). The path is reshaped on the Timeline by moving the points that correspond to the layer's key frames, or in the Comp window by redirecting the control points on the ends of the tangent handles. Instead of traveling in a linear direction, the object moves along a curved path. Introducing a third key frame between the start and end frames allows you to create a more complex direction of travel.

7.8

In Adobe After Effects, a motion path is created when two key frames are set for a layer's position property. Vertex points correspond to the object's key frames on the Timeline. The path can be re-shaped by moving anchor and control points to modify the direction of travel. Introducing a key frame between the start and end key frames can create a more complex direction.

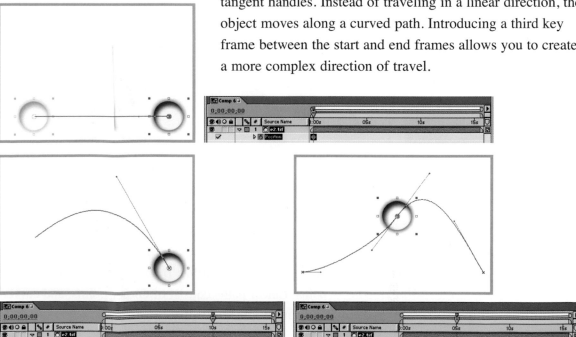

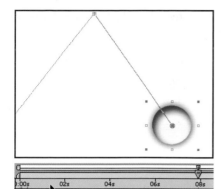

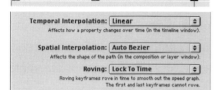

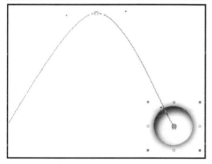

After Effects offers several types of spatial interpolation. By default, *Auto Bezier* produces smooth, steady changes in direction. If the value of an Auto Bezier key frame is changed, its direction handles are realigned accordingly to maintain smooth transitions between the key frames. If a direction handle is manually adjusted, the corresponding key frame changes to *Continuous Bezier*. Similarly, this method enables smooth rates of change through key frames. If the direction handles are manually adjusted, the shape of the path segments on either side of the anchor point change are reconfigured (7.10). *Linear* spatial interpolation is appropriate for situations

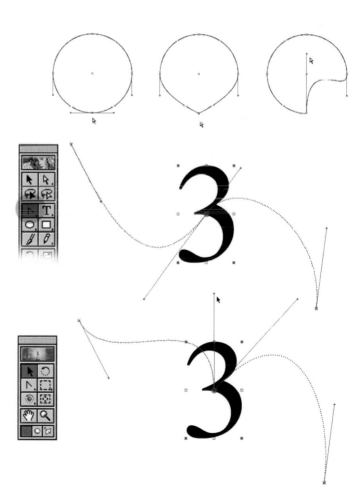

7.9

In comparion to Linear Bezier interpolation, Auto Bezier interpolation produces steady transitions in direction, avoiding abrupt changes or hard angles.

7.10

Adobe Illustrator's convert point tool can retract a control handle into its center, eliminating the curve that traveled through the point. This tool can also be used to break the hinge of a control handle, allowing the handles on either side of the point to operate independently.

In After Effects, a control handle's hinge can also be broken. As a result, the key frame is changed to Bezier, and handles on each side of the key frame can operate independently, allowing shifts between straight lines and curves.

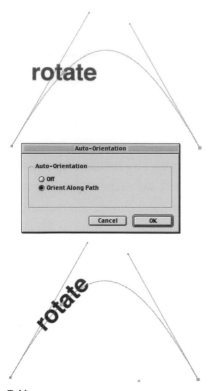

where objects need to move in straight lines or sharp angles. After Effects' Auto-Orient rotation option (7.11) enables a layer to rotate automatically as it travels along a motion path. For example, you can animate a kite flying through the sky, turning and changing direction as moves.

masks as motion paths

Bezier masks, which are used to make certain regions of images transparent for compositing, can also be used as motion paths to control the direction an image travels. In Figure 7.12, a Bezier mask is generated on a layer, cut to the clipboard, and pasted into another layer's Position property on the Timeline. This generates beginning, intermediate, and end key frames. The animation of the smaller layer follows the edges of the larger layer's mask by using the points from the mask as a motion path.

7.11

After Effects' Auto-Orient option.
Top. before Auto-Orient rotation
Bottom. after Auto-Orient is applied

7.12

In After Effects, the vertices from a layer's mask are copied and pasted into the layer's Position property on the Timeline. The vertices are converted into key frames.

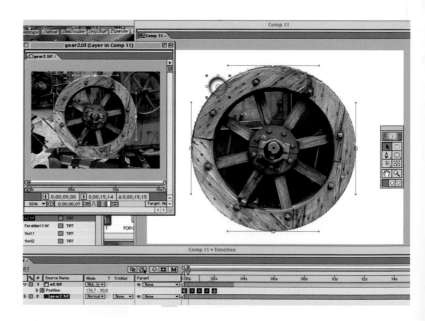

Motion Sketch and Path Text

After Effects features a Motion Sketch tool that allows you to create complex freeform paths instantaneously by drawing them in real time, similar to drawing with a pencil on paper. With the help of a pressure-sensitive drawing tablet and a stylus, you can vary a path's velocity by speeding up or slowing down as you draw. After Effects records the process and applies it to a specific frame range in the timeline where the motion is supposed to start and stop. As a result, position key frames are automatically generated. A "Smoother" feature allows you to fine-tune the path by removing redundant key frames to make future adjustments easier.

7.13

After Effects' Motion Sketch feature.

After Effects records the process of drawing a motion path and generates the key frames on the Timeline for a layer's position. A "Smoother" feature removes redundant key frames to make future editing easier.

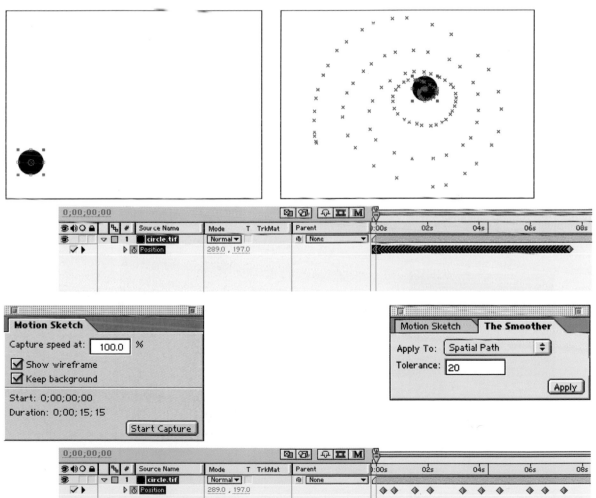

A major advantage of After Effects' text effects is that the content can be exported in a vector-based SWF format to play directly over the Web.

A versatile Path Text plug-in enables you to animate type along a motion path. Individual text characters can be treated independently while maintaining their connection to a path. A string of type can be applied to a layer by entering characters in the Path Text dialogue, and the text becomes immediately visible on a simple Bezier path in the Comp window (7.14). You can then specify properties such as font, size, color, tracking, and alignment in the Paragraph and Character settings inside the Effects Controls palette. Move the text path's anchor points and control point tangent handles to improve or change the curve shape. Once the path has been defined, the "Left Margin" setting parameter allows the text to be animated along its path. In Figure 7.14, an initial setting is keyframed at 0 seconds on the timeline and a second setting is applied at the 5 second marker. (A second key frame is generated automatically.) "Jitter" and "Visible Characters" are then applied to simulate the effect of the letter forms being typed in and randomly displaced over time as they move along the curve.

7.14

After Effects' Path Text plug-in.

Text that is applied to a layer by entering characters in the Path Text dialogue becomes immediately visible on a Bezier spline. The "Left Margin" parameter is set to animate the text along the path. "Jitter" and "Visible Characters" operations are then applied to simulate the effects of the letters being typed in and randomly displaced as they follow the curve of the path.

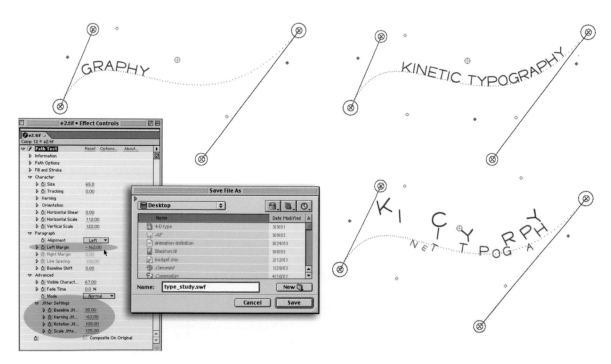

original path drawn in Illustrator

7.15

A Bezier spline that is created in Adobe Illustrator is copied and pasted into a layer's Position property in After Effects. Key frames are automatically generated.

Illustrator and Photoshop paths

Motion paths can be drawn in applications such as Adobe Illustrator or Photoshop, and their data can be copied and pasted into the Position property of layers in After Effects. Resulting key frames will automatically be generated and set to rove in time—meaning that After Effects will determine how they should be spaced to achieve a uniform velocity along the path (7.15).

Flash's motion guides

Unlike After Effects' spline-based motion paths, tweened elements in Flash initially move in a straight line. However, motion paths can be created inside of "Guide Layers" that contain paths along which static or animated symbols can travel. A tweened animation sequence is applied to a predefined motion guide. With Flash's "Snap to Objects" option activated, the animated layer's registration point is snapped to the path's beginning vertex at the first key frame and to the path's ending vertex point at the last key frame. The resulting motion follows the guide's geometry precisely (7.16).

7.16

A tweened animation sequence is applied to a motion guide in Flash.

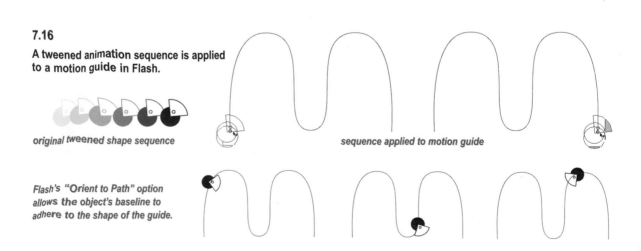

original tweened shape sequence

sequence applied to motion guide

Flash's "Orient to Path" option allows the object's baseline to adhere to the shape of the guide.

An alternative to creating motion paths inside Flash is to create them in Illustrator or Photoshop and paste them inside a guide layer. (Tip: Change Illustrator's default Files and Clipboard preferences to AICB with the "Preserve Paths" option selected.)

Several different objects can travel along the same path by placing each, as a different layer, underneath a guide layer containing a motion path on the Timeline and snapping their registration points to the path's beginning and end points.

combining relative motions

Multiple transformations can be combined on a timeline, allowing an element's position, scale, and rotation properties to be animated simultaneously. However, if you intend to establish coordinated movements between elements, you should consider exploring more advanced techniques such as nesting and parenting.

nesting

In the case of complex animations where many different types of movements occur, *nesting* (also referred to as *instancing*) is a process that allows you to organize those movements into individual animations that can later be combined. Figure 7.17 demonstrates how the technique of nesting can be used in Adobe After Effects to achieve the effect of "butterfly" type fluttering around the screen. First, the layer's Rotation property is interpolated in Composition 1 to achieve lifelike movements. (The anchor point of the layer has been shifted to allow the rotation to occur from the base of the word.) A second composition is created, and Comp 1 is brought into the Timeline as a layer. This layer is flipped horizontally. A third composition combining instances of Comps 1 and 2 is created. Comp 3 then is brought into Comp 4, and here, its scale is interpolated over a series of frames to achieve the effect of the subject flying closer to and further away from the viewing plane. Finally, in a fifth composition, the Position property of Comp 4 is interpolated along a motion path.

The beauty of this process is that each transformation can be preserved and further modified independently.

7.17

Composition nesting performed in Adobe
After Effects to combine movements.

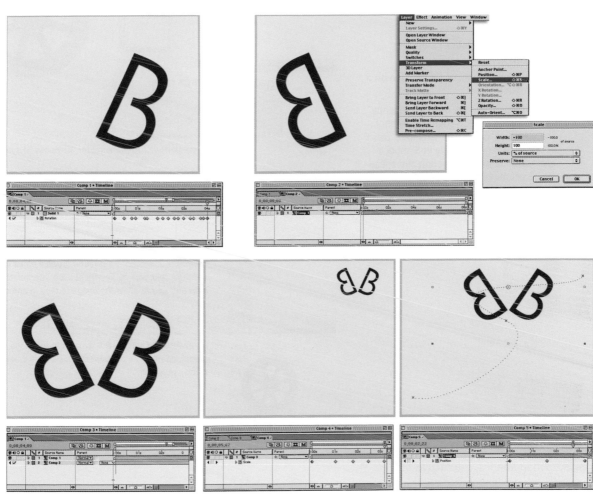

Nesting is also discussed in Chapter 8 with
regard to animation compositing.

Unlike Adobe After Effects, individual transformations in
Macromedia Flash do not have their own timeline and are
therefore more challenging to control independently. For
complicated animations, nesting can be applied to different
animated symbols. In Figure 7.18, the rotation of an image is
animated in Symbol 1. Symbol 2 interpolates the scale of
Symbol 1's instance, and Symbol 3 interpolates the position
of Symbol 2's instance across the Stage. Rotation, scale, and
position properties can then be modified separately.

7.18

Symbol nesting in Macromedia Flash.

Symbol 1:
interpolation of rotation

Symbol 2:
interpolation of Symbol 1's opacity

On the Stage:
interpolation of Symbol 1's position on a motion guide

Each interpolation can be independently refined inside of each animated symbol. The speed of rotation, for example, can be adjusted independently in Symbol 1 without affecting the direction and speed the object moves.

Interpolation of rotation set for 30 frames in symbol 1.

In symbol 2, symbol 1's rotation loops 4 times over 120 seconds, and opacity key frames are interpolated at the start and end to allow the image to fade in and out..

An instance of symbol 2 is brough to the stage, and interpolation of the animation's position is created with a motion guide.

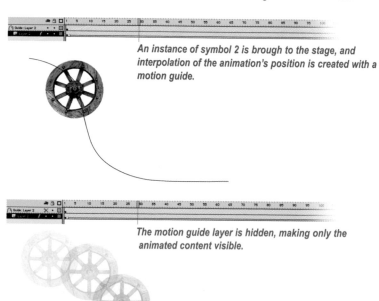

The motion guide layer is hidden, making only the animated content visible.

Symbols in Flash can contain vector-based graphics, bitmap images, interactive buttons, movie clips, and sounds. Any symbol that is created becomes part of the library. When a symbol is moved from the library onto the stage, it can be reused infinitely. Because it is stored only once inside the library, file size is kept to a minimum. Therefore, it is best to use symbols when using motion tweening, especially if they contain imported bitmap images or complex graphics. (The use of symbols also increases playback speed, since a symbol is downloaded to a browser only once.)

214

Interpolation

parenting

Parenting enables elements to inherit the properties of other elements in an animation. In Figure 7.19, parenting is used in After Effects to apply the concept of character animation to a subject. Each layer corresponds to each part of the subject's "anatomy." After the origin points of each layer were moved to the appropriate pivot positions, a parental hierarchy was created to connect the parts.

When parenting in Adobe After Effects, transformations that are applied to a parent are passed on to its children. However, a child's motion can be independent without affecting its parent. A parent can have an infinite amount of children; however, a child can have only one parent. Children can be parents to other children, allowing you to build complex hierarchies of objects.

If you wish to perform animation on a parent without having it carry over to its children, you can attach the parent and its children to a Null Object (a "dummy" layer represented by outlines but does not render in the final output). This allows the parent's coordinate system to be somewhat detached from its children. In Figure 7.20, parenting is used to animate a complex mechanical object. A Null object in a layer is parented to all the layers containing the moving parts. Each of the children can perform their own independent animation, while transformations that are applied to the Null parent do not affect any of its children.

7.19

In After Effects, a parental hierarchy is built to animate the parts of the subject.

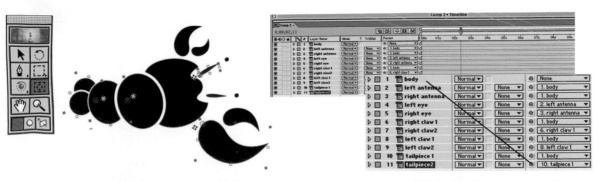

Each layer's origin point is reset with After Effect's Pan Behind tool to allow each part of the subject to pivot appropriately.

Parent-child relationships are established in the Time Layout window.

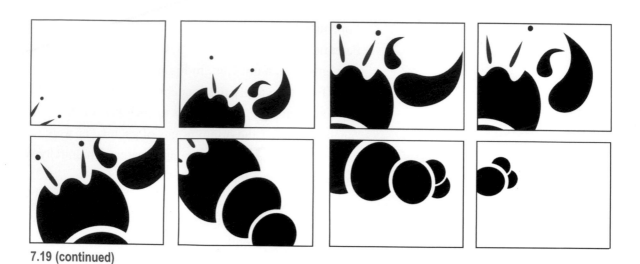

7.19 (continued)

7.20

A Null object is used as a parent, allowing each of its child layers to have their own coordinate systems.

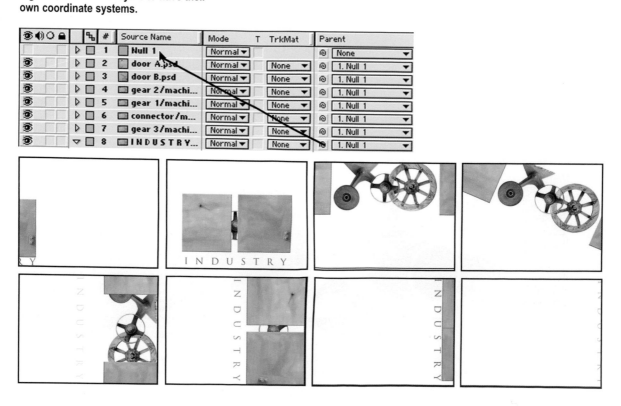

Interpolation

Temporal Interpolation

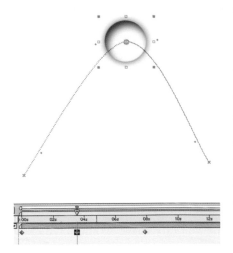

7.21

In After Effects, a layer's temporal key frames are adjusted in the Timeline, and its spatial key frames are modified in the Composition window.

Compressing the distance between the key frames produces greater velocities as the duration of the animation is reduced. The space between the dots on the motion path is wider, indicating a greater velocity.

Temporal interpolation is the manner in which elements move through time (versus over space). Controlling the direction of an object on a motion path affects its spatial interpolation; controlling the speed in which the object moves on a value graph affects its temporal interpolation. In After Effects, you can adjust a layer's temporal key frames on the Timeline by numerically entering values or by modifying the speed graph of a particular property such as Position (7.24).

controlling velocity

The amount of distance between two key frames dictates the amount of time that it takes for an object to animate. Closing down or opening up the space between key frames on a time-line shortens or lengthens the duration of events. This is the quickest method of adjusting the speed at which things move or change. You also can control velocity by modifying the degree of interpolation that occurs over time. Numerically or manually you can change the start or end values corresponding to an element's position, scale, or rotation.

The rate of speed in which something moves or changes can be linear or nonlinear.

linear velocity

Linear velocity produces movement that proceeds at a steady rate. The degree of change in the speed at which an object moves between key frames remains consistent. Linear velocity works well with animations that involve linear motion paths and a maximum of two key frames. If an element follows a complex path that changes its direction dramatically, main-taining a constant rate of speed from one key frame to the next can be challenging. In Figure 7.22, the spatial distances between key frames on the motion path vary. The dots along

Creating complex motion paths is an easy task; sharp angles and graceful curves are all easily accomplished with Bezier splines. However, making an object travel smoothly along a complex path is another story. This is where roving key frames can be beneficial.

the path indicate that the rate of speed changes abruptly over the element's course of travel. If you are working in Adobe After Effects, you can counteract these sudden velocity changes with *roving key frames* in order to achieve uniform speed. When the key frames between the start and end frames are set to "rove in time," their positions are readjusted on the Timeline to space them at equal intervals. Although their X and Y positions in space are maintained, the time at which changes in direction occur shifts to maintain a smooth, consistent speed. (If acceleration or deceleration had been previously applied, the velocity curve would have changed back to a straight line, creating a uniform rate of change across all of the key frames.)

7.22

Roving key frames in Adobe After Effects.

Compare the spacing between the dots in the original motion path to that in the revised path that contains roving key frames. Acceleration and deceleration have been replaced with a constant, linear velocity across the frame range.

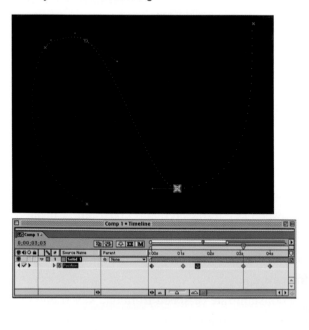

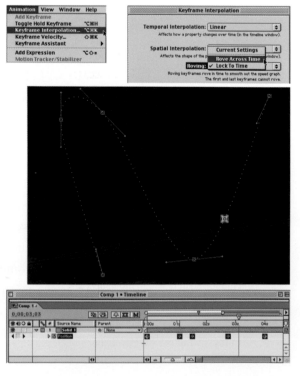

Interpolation

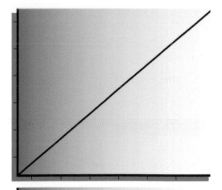

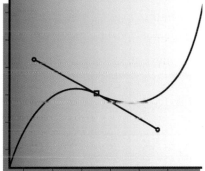

7.23

A linear motion profile of acceleration and deceleration illustrates a straight line climbing upward or pointing down. This produces a sudden change from a static to an active state and an abrupt halt at the end of the interpolation.

A nonlinear motion profile of acceleration and deceleration illustrates a curve where more gradual, realistic transitions in speed occur start to finish.

nonlinear velocity (acceleration and deceleration)

Nonlinear velocity, which creates less predictable motions, is represented on a speed graph by a curved line (7.23). As a result, smooth transitions occur between incoming and outgoing velocities.

Bezier interpolation

In After Effects' Comp window, velocity is indicated in the spacing of the dots on a motion path (7.22). Altering the shape of a motion path is one method of controlling an element's velocity. Bezier interpolation provides the most accuracy in establishing acceleration and deceleration. After Effects provides a speed graph that utilizes a standard Bezier control handle to define the shape of a curve in the Timeline. By adjusting these handles interactively, you can create smooth transitions through key frames (7.24).

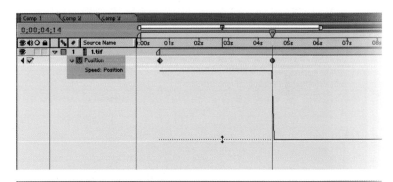

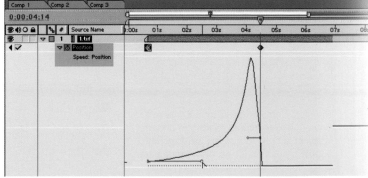

7.24

After Effects' velocity graph is displayed for the Position property of a layer. Manipulation of the Bezier curve enables the layer's speed to be altered as it leaves the first key frame and approaches the next key frame.

Motion Graphic Design & Fine Art Animation

7.25

The velocity curve on After Effects' speed graph is manipulated to create the effect of a bouncing ball.

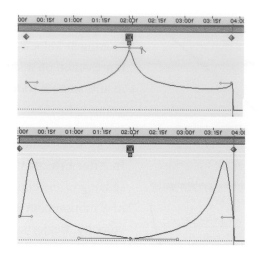

7.26

The velocity curve on After Effects' speed graph is manipulated to create the effect of the motion gradually stopping and starting again.

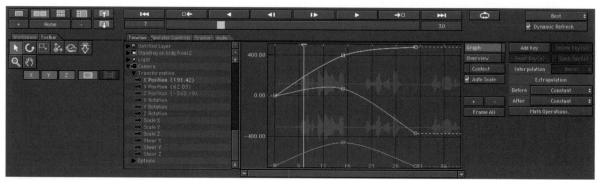

7.27

Similar to Adobe After Effects, velocity curves in Discreet Combustion can establish nonlinear interpolation.

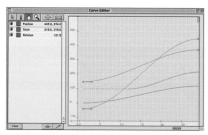

7.28

Pinnacle Commotion's Curve Editor lets you control velocities relating to different types of actions in a single window. Here, a layer's position, scale, and rotation are displayed simultaneously.

ease operations

Most applications offer *ease-in* and *ease-out* algorithms that you can use to create the effect of acceleration or deceleration. (These operations offer limited control; manual alteration of velocity on a speed graph gives you more precision.) Macromedia Flash's "ease in" and "ease out" feature uses a standard velocity curve. After Effects offers three key frame assistants: Easy Ease In, Easy Ease Out, and Easy Ease. In Figure 7.29, Easy Ease In is applied to the last Position key frame and the result is a gradual deceleration in the velocity of incoming frames as the object approaches its end position. When Easy Ease Out is applied to the first Position key frame, acceleration in the velocity of the outgoing frames at the beginning of the interpolation results. When Easy Ease Out is applied to both key frames, the velocity of both

incoming and outgoing frames is affected. (Notice that the spacing between the dots on the motion paths is uniform before each effect is applied.) Initially, the graph displays a straight line, indicating a constant speed of translation along the path. After each algorithm is applied, the spacing between the dots represent acceleration and deceleration.

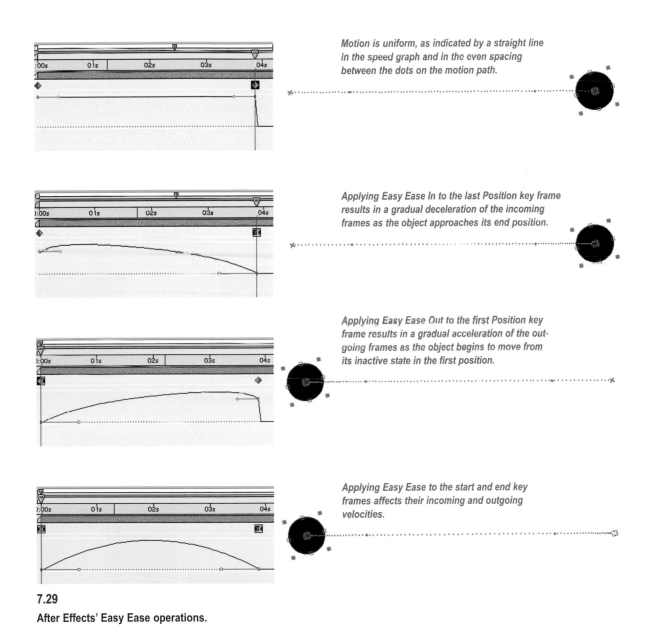

Motion is uniform, as indicated by a straight line in the speed graph and in the even spacing between the dots on the motion path.

Applying Easy Ease In to the last Position key frame results in a gradual deceleration of the incoming frames as the object approaches its end position.

Applying Easy Ease Out to the first Position key frame results in a gradual acceleration of the outgoing frames as the object begins to move from its inactive state in the first position.

Applying Easy Ease to the start and end key frames affects their incoming and outgoing velocities.

7.29
After Effects' Easy Ease operations.

time stretching

You can use time stretching to create the effects of slow motion, fast motion, delay, frame stutter, and backward play-back. After Effects' "Time Stretch" command (7.30) allows you to enter a numerical value or percentage to change a layer's duration. For example, stretching a layer to 200% doubles the frame length so that the animation plays at half speed. Reducing the length to 50% doubles the playback speed. By default, when layers are time-stretched, the positions of their key frames are stretched proportionally. If you wish to change a layer's duration without affecting its key frames, you can cut the key frames to the clipboard, perform the time stretch on the desired layer, move the time marker to the point at which the first key frame should appear, and paste the key frames back into position (7.31). Time stretching may also be applied to segments of an animation. For example, you can

7.30

In Adobe After Effects, the Layer In-Point, Current Frame, and Layer Out-Point allow you to determine exactly where a time stretch will occur.

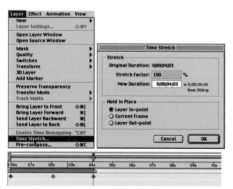

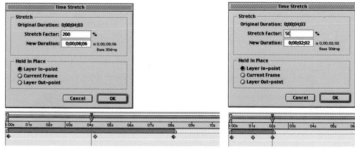

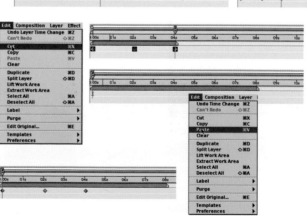

7.31

Stretching a layer independently of its key frames involves cutting the frames to the clipboard, stretching the duration bar to a new length, and pasting the frames back into position.

play a portion of an interpolation in slow motion, while the remainder of the sequence plays back at normal speed. This is accomplished by splitting a layer into multiple layers, each having its own timeline.

time remapping

The process of time remapping allows you to change the duration and playback speed of video footage, audio, or pre-composed (nested) layers over time without having to create cuts, change in and out points, or duplicate layers. The time between key frames can be stretched or compressed, slowing down or speeding up the playback of your material.

7.32

Adobe After Effects' Time parameter, which is treated as a physical attribute of a layer, allows you to speed up or slow down playback by entering key frame values on the Timeline.

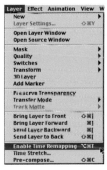
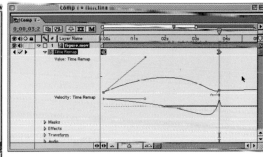

7.33

Time remapping can be performed in Pinnacle Commotion's Curve Editor to align a layer's speed changes with key frames of other layers in a composition.

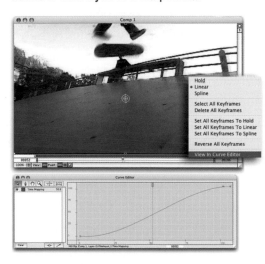
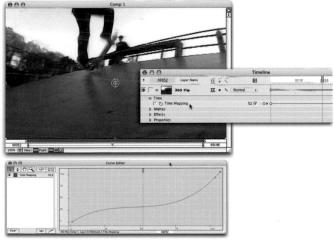

The effects described here barely scratch the surface of those available. (In addition to countless third-party plug-in effects currently on the market, Adobe After Effects and Pinnacle Commotion each offer more than 75 individual filters.) Be careful to exercise mature artistic judgment when using effects filters; "filter out" effects that look cool but are irrelevant to the concept that you are trying to portray.

Interpolating Change

Interpolating change involves animating an element's appearance over time through the use of key frames.

animating opacity

The property of opacity (or transparency) can be altered to simulate the nature of semiopaque materials such as glass or water, or to achieve a layering of form, color, and texture in an animation. Interpolating opacity on a timeline often is used to create simple dissolves between key frames, allow images to appear, disappear, and fade into each other.

animating special effects

effects categories

The rapid development of special effects filters in today's marketplace is overwhelming, particularly if you consider the range of possibilities that exist when they are used in combination. What follows is an overview of basic effects categories, along with a brief mention of effects that are useful in animation. All of these filters offer a broad range of parameters that can be keyframed over time.

standard value and color adjustments

Value and color operations, the most common category of special effects, can be applied to an image universally or to any one or combination of its red, blue, and green channels. You can perform luminosity operations such as Levels, Curves, and Brightness/Contrast to enhance images and animate tonal effects. Each provides a method of modifying the tonal range across the highlights, shadows, and midtones of an image. Levels and Curves operations offer the most accurate control over how values are distributed. Levels is useful for making basic image adjustments. After Effects' Levels functions in the same manner as Photoshop's Levels; both remap the range of input values onto a new range of output

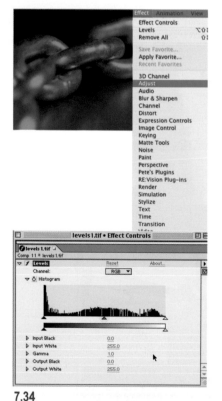

7.34

After Effects' Levels operation.

Keyframing midrange brightness values lifts out more detail from the shadow areas without dramatically altering extreme shadows and highlights.

values, while changing the gamma correction curve (7.34). Color correction settings can improve an image's overall color distribution and can be animated over time. For example, a Levels operation can perform color correction by setting key frames that control the input and output color luminance for each of its channels. Color Balance affects the amount of red, green, and blue in a layer. A value of –100 removes all color, while a value of +100 intensifies the color. Hue/Saturation allows you to move around the color wheel, adjust the intensity of color, and use the Colorize option to add color to an image or add a color tint to a monochromatic image. Posterization allows you to reduce the number of colors in an image to produce interesting color effects.

7.35

Hue/Saturation is applied to increase saturation levels, and Color Balance is keyframed to shift the color cast over time.

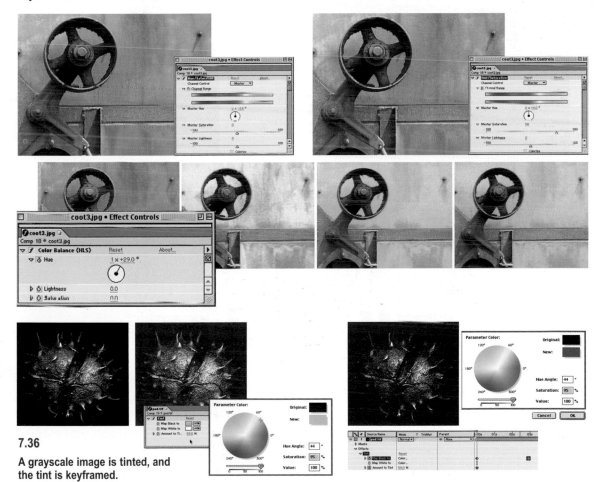

7.36

A grayscale image is tinted, and the tint is keyframed.

channel alteration

Color channel effects give you specific control over an image's individual color components. After Effects' Channel Mixer, for example, can manipulate colors based on a blending of its red, green, and blue data. By entering percentage values, you can emulate sepia tones or tints, and swapping or duplicating channels can produce astonishing effects. A Set Channels operation also allows channel data to be swapped between layers. In Figure 7.38, the luminance of one layer is assigned to the red channel of another layer. The Shift Channels effect replaces red, green, blue, and alpha channels in the image with other channels.

7.37

After Effects' Channel Mixer.

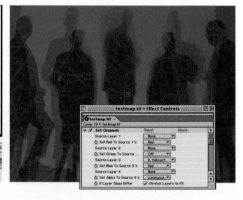

7.38

After Effects' Set Channels operation is used to assign the luminance of one layer to the red channel of another layer. Swapping and duplicating channels using the Set Channels effect produces a variety of provocative color effects.

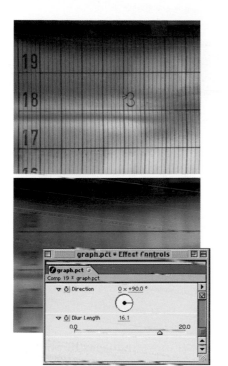

7.39

Interpolating the Directional Blur effect can produce the illusion of motion.

blurring and sharpening

Blurring and sharpening effects are used to either suppress or accentuate details. For example, After Effects' Directional Blur produces the illusion of motion, while Compound Blur is useful for simulating smudges, fingerprints, or atmospheric phenomena such as fog or smoke. Compound Blur applies a superimposed layer to act as a luminance map, in which bright areas produce the most blurring and dark areas produce the least amount of blurring in the affected layer (7.40). Channel Blur allows you to blur a layer's red, green, and blue channels individually horizontally, vertically, or both (7.42). This operation is useful for animating glowing effects.

After Effects' Sharpen and Unsharp Mask operations can increase an image's contrast where color changes occur. Unsharp Mask, most commonly used to accentuate highlight and shadow detail, increases the contrast between values or colors that define an edge.

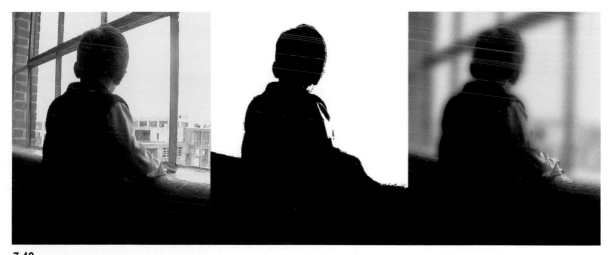

7.40

After Effects' Compound blur references a superimposed "blur layer" as a luminance map. Bright areas produce the most blur in the affected layer, while darker areas produce the least amount of blur.

7.41

Radial blurs, which produce blurring around a specific point, can be used to create camera zooms and rotation.

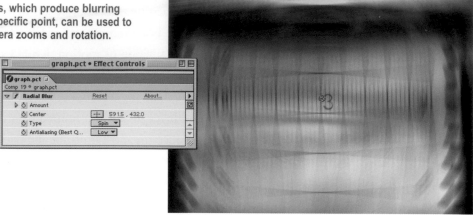

distortion

Distortion effects allow you to warp images by shifting around their pixels. Pinnacle Commotion's Corner Pin effect treats an image as if it were a sheet of rubber. Four reference points corresponding to the corners of a distortion grid can be repositioned to slant or scale an image (7.44). A Perspective feature produces a foreshortened image by contracting the top portion and expanding the bottom portion. Commotion's Hall of Mirrors (7.45) and Mirage filters can generate more complex image patterns that can be controlled with a wide variety of settings.

After Effects' Offset operation transposes a layer's center point to a new location. This can be used to create the effect of panning; elements that are pushed off one side reappear on the opposite side.

After Effects' Production Bundle contains a Bezier Warp filter, which allows you to reshape an image based on a Bezier path. The path consists of four segments, each having a vertex with two tangent points for controlling the path's curvature.

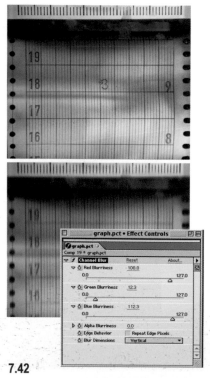

7.42

Channel Blur, which affects a layer's red, green, and blue channels individually, is used to produce an animated glowing effect. Edge Behavior and Repeat Edge Pixels options define how the edges of a blurred image are treated.

You can manipulate each vertex and tangent handle to alter the curve that forms the layer's edge. This is useful for correcting unwanted distortions, such as those resulting from a wide-angle lens. Animating this effect can imitate the motion of something blowing in the wind or moving under water.

7.43

After Effects' Bezier Warp filter is used to make type appear to flutter in the breeze over a frame range.

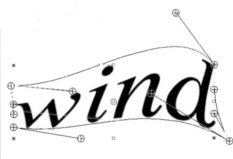

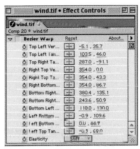

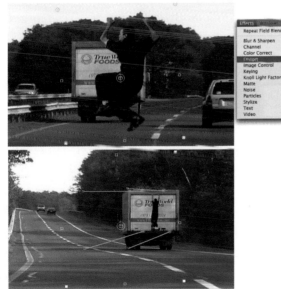

7.44

Pinnacle Commotion's Corner Pin effect. Footage and illustration by Ryan McKenna.

7.45

Pinnacle Commotion's Hall of Mirrors.

7.46

Pinnacle Commotion's Fractal Brimstone controls.

particles

Particle generators simulate complex natural occurrences such as light reflections, explosions, water movement, and atmospheric phenomena. Pinnacle Commotion is a leading particle simulation tool for the Macintosh platform. Its fractal-based filters utilize powerful CGI operations to create variations of clouds, explosions, water surfaces, solar flares, and land surfaces. Fractal Brimstone is the *Tyrannosaurus rex* of organic particle generators. Its complicated algorithms allow you to synthesize organics such as water, mist, and molecules from scratch. A set of extremely complex controls enable you to choose where and how particles are generated, as well as their color, texture, and method of distribution. Particle Controls, for example, govern the speed, gravity, and air resistance in which particles are generated.

After Effects' Production Bundle offers "Particle Playground," which is better equipped than Commotion's fractal-based systems to produce realistic simulations of elements moving independently (for example, a swarm of bees or a flock of geese). Particle Playground adjusts a layer's particles with a high level of control over their size, color, and the speed at which they move.

After Effects' Shatter filter creates the effect of an image exploding into glass shards or bricks. Light areas in a referenced "gradient map" are shattered first, and darker areas are shattered last.

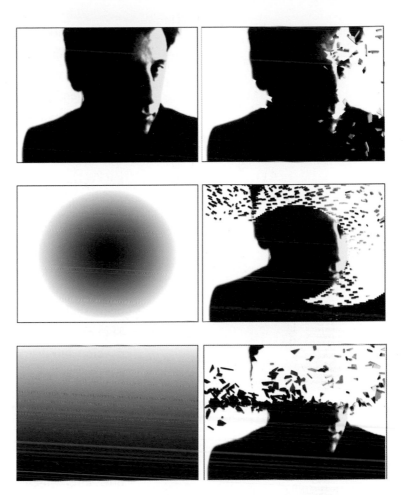

After Effects' Shatter filter (7.47) allows you to "blow things up" by exploding a layer into pieces that vary in shape and size and dispersing them over space. You can designate explosion points, choose from a variety of shapes, and extrude them along the Z axis to give them depth. Setting a radius value allows you to define the area where the effect will take place; anything outside the radius remains unaltered.

Atomic Power's Evolution filters (packaged with After Effects' Production Bundle) includes a 3D Shatter plug-in which provides excellent control over the shape and texture of the extruded pieces. A collision detection mechanism prevents colliding pieces from traveling through each other.

You can choose from a variety of preset "shatter maps" to create complex types of explosions. Wave World, Caustics and Foam also are also part of Atomic's Evolution set. Wave World generates liquid surfaces that are subjected to waves; Caustics generate light that appears to be reflected and refracted through water. Used together, Wave World and Caustics can create naturalistic moving surfaces. Foam's particle system generates realistic-looking particles that interact with each other and with their environment.

third-party plug-ins

In addition to the vast number of plug-in filters that come bundled with motion graphics applications, third-party developers such as DigiEffects, Artel Software, ElectricFX, Alien Skin Software, and Atomic Power Corporation continue to develop and distribute compatible plug-ins, many of which are intricate enough to serve as stand-alone applications. Several of these are worth special mention and can be downloaded from the Internet in demo form for evaluation. (Note that demos contain certain restrictions. In some, the output is watermarked; others are fully functional only for a limited time, after which you will be required to make a purchase.)

Adobe Power Pack for After Effects

Adobe Systems' Plug-In Power Pack filters are designed for use in After Effects. A Change to Color effect allows you to select portions of an image with an eyedropper tool and change the color. A Magnify filter allows you to perform scaling beyond 100% without sacrificing image resolution. A 3D Glasses plug-in makes stereoscopic viewing possible by combining left and right 3D views.

Alien Skin Eye Candy

Alien Skin Software's Eye Candy, a set of filters for After Effects, generates provocative textures, distortions, blurs,

Plug-ins are software modules that enhance and extend the productivity of a particular software package. For example, Apple's QuickTime plug-in allows video, MIDI, audio, and VR panoramas to be displayed in a Web browser.

Plug-in interchangeability between programs continues to improve. For example, After Effects can animate filters from other Adobe-compatible applications such as Photoshop, Commotion, and Boris Red now support the use of most After Effects plug-ins.

Additional information on the third-party plug-ins mentioned in this section can be found at the following URLs:

Adobe Power Pack for After Effects
adobe.com/aftereffects

Eye Candy
www.alienskin.com/ecae/ecae_effects.html

eFX Pyro
www.electricfx.com

Delirium, Berserk, and CineMotion
www.digieffects.com

and organic phenomena. "Fire," for example, generates flamelike shapes that move and twist about based on a layer's alpha boundary. "Glass" simulates the effect of placing a sheet of colored glass over an image. "Squint" generates a blur in which pixels are spread around the edge of a circle, producing the effect of an image being projected out of focus.

ElectricFX eFX Pyro

ElectricFX's eFX Pyro, also an After Effects product, utilizes sophisticated volumetric simulation to generate even more convincing fire and smoke elements. External lighting parameters such as Buoyancy, Turbulence, Vorticity, and Illumination allow you to produce realistic 3D-looking imagery without requiring any knowledge of 3D software. This plug-in was used in feature films such as *Devil's Advocate*, *The Truman Show,* and *The Fifth Element*.

Boris FX and Boris Continuum Complete

Boris FX, a Boston-based developer of effects technology, maintains strong partnerships with software manufacturers such as Adobe, Apple, Avid, Discreet, Media 100, and Sony. Over the years, this company has developed a range of plug-in filters, ranging from 3D imaging to color correction, texture generation, and image processing. Boris recently introduced Continuum Complete, a bundle of compositing and effects filters for Adobe After Effects, Apple Final Cut Pro, Discreet Combustion, and Boris RED. An advanced particle system allows you to emit particles from a source over space, as opposed to exploding an image into pieces. Parameters such as width, height, velocity, tumble, rotate, spin, and spread amount can alter the appearance of a particle type such as a streak, line, or bubble. Settings such as gravity, air resistance, velocity variance, bounce friction, and floor height give you precise control over how particles move and interact with each other and with their environment.

DigiEffects Delirium, Berserk, and CineMotion

DigiEffects Delirium's particle-based plug-ins for After Effects contains an AutoAnimate feature that can generate key frames to produce natural phenomena such as rain, snow, fire, and smoke, as well as photographic effects such as solarizations, lens flares, camera shakes, film flashes, and video malfunctions. Camera Shake, for example, generates a series of key frames consisting of randomized movements and blurred motion.

Berserk, a set of additional particle plug-ins, includes Fog Bank, which generates realistic fog or smoke particles that can be keyframed. News Print produces animated halftones that you can interpolate using parameters such as halftone shape, offset, dot size, and angle. CineMotion for After Effects is designed to make video footage behave like film. With this plug-in, you can customize presets to create effects such as aged film grain, interlace flicker, banding artifacts, and posterization.

7.48

Adobe After Effects' Effect Controls window lists all filters that have been applied to a layer from top to bottom. Filters also appear in After Effects' Timeline under the layer name.

applying effects

Typically, effects are animated on a Timeline by setting key frames. In addition, most motion graphic programs provide a method for controlling the degree of an effect. For example, Adobe After Effects and Pinnacle Commotion provide a "Blend with Original" parameter. A value of 0 fully applies the effect, while a value of 100 produces no change in visual appearance. You can also interpolate this parameter to create gradual dissolves in and out.

After Effects' adjustment layers

An adjustment layer in Adobe After Effects is an invisible solid that lets you to apply multiple effects to layers that appear beneath it in the Timeline. When one or more effects are applied to an adjustment layer, all underlying layers take on its properties (7.50). Altering an adjustment layer's opacity controls the degree to which the effects apply to its underlying layers. Since opacity can be interpolated, you easily can animate the progression of an effect, making it more or less intense over time. A "Blend with Original" parameter also can be keyframed to control the layer's intensity. Further, an adjustment layer can contain a Bezier mask to restrict its effects to a designated portion of the underlying layers (7.51).

After Effects' filter operations do not destroy the original footage. Commotion's filters, however, are destructive; you cannot change the settings without reverting to the last saved version and reapplying the effect.

7.49

Effects can be modified by adjusting their parameters on a slider. Alternatively, you can enter or "scrub" numerical values by clicking on the value and dragging the mouse to the left or right.

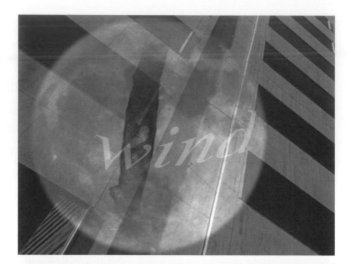

7.50

Effects applied to an adjustment layer in
After Effects affect all layers below it in
the Timeline's stacking order.

7.51

A Bezier mask can be created on an
adjustment layer to restrict its effects to
a portion of the layers beneath it.

animating shape

Animating a shape's geometry is achieved through *morphing*, a key-frameable technique that can produce controlled transformations of one subject into another. This process involves defining parameters that direct the software to assemble a range of intermediate frames representing the changes from a source to a destination image. Filmmakers and music video producers often use morphing to achieve sophisticated special effects, transitions between video frames, warping, and mixing photos to establish an identity.

morphing techniques

Cross-dissolve and warp are the two most common morphing procedures used digitally.

cross-dissolve

Cross-dissolving involves the interpolation of pixel color from a source image to a corresponding destination image. Since this method does not alter geometry, it is effective when the initial images have similar structures (7.52).

warp

Warping shifts the locations of pixels between two images without transforming their colors. Two types of warping are forward mapping and reverse mapping. *Forward mapping* shifts the pixels of a source image to new positions in a destination image. You then calculate the intermediate pixel locations through interpolation. *Point warping* is a forward mapping technique that uses control points to modify the geometry in which pixels shift their positions in space. *Reverse mapping* analyzes each pixel in a destination image and samples an appropriate source image pixel. As a result, all destination pixels are mapped to the source image. *Line transformation*, a common reverse mapping technique, maps a line of pixels from a source image to a corresponding line

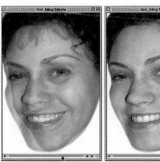

7.52

An example of cross-dissolve.

in a destination image. Other portions of the source image are shifted with regard to their relative positions to the line.

Combining these techniques can produce effective results such as the morphing scheme demonstrated in Figure 7.54 in which a cross-dissolve is combined with point warping.

7.53

Point warping distorts image geometry.

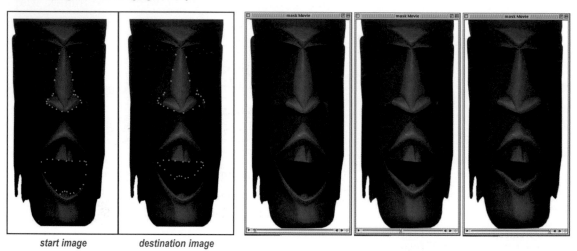

start image　　*destination image*

7.54

Cross-dissolve combined with point warping.

start image　　*destination image*

morphing tools

Flash

Shape tweening in Macromedia Flash produces the effect of geometric morphing by keyframing vector shape changes over time. Figure 7.55 illustrates this technique performed on two symbols, each containing a vector graphic.

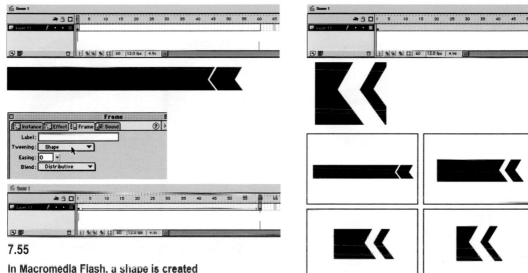

7.55

In Macromedia Flash, a shape is created in a key frame on a layer. A second key frame is created later on the Timeline, and at this frame, the shape is deleted and replaced with a slightly different graphic through copy and paste. The first key frame indicating the beginning of the interpolation is selected, and the Tweening option is set to "Shape."

Shape tweening in Flash is designed strictly for vector-based graphics created in Flash or imported from Adobe Illustrator or Macromedia Freehand.

Shape-tweened key frames are indicated by a black dot, and intermediate frames are represented by a black arrow on a light green background (7.55).

Shape hints are useful when animating complex shape changes, as they identify points that must match locations in the starting and ending shapes. For example, if you are morphing a graphic image of one animal into another, you can use shape hints to specify the legs, head, and tail regions of the start and finish image. This instructs the software to tween each area separately, allowing more control over each.

Here are a few tips for mastering shape hints in Flash:

1. Be patient.

Don't become frustrated if the effect you wish to achieve does not happen on the first try. Be prepared to tweak the placement of Shape Hints in the start and end key frames several times to achieve the desired effect.

original shape tween

shape hints applied to start and end key frames

shape tween with shape hints

7.56

In Flash, shape hints can be added to the start and end key frames of a shape tweened sequence and positioned relative to each other at each key frame. This allows you to control the geometry of the morph during the interpolation.

2. Use onion-skinning.

Activating the Onion Skin button in the Timeline allows you to view before and after frames simultaneously.

3. Fine-tune the effect by adding hints after the morph is established.

Flash allows you to use up to 26 shape hints. (View>Show Shape Hints displays all hints that you have applied.)

4. Carefully consider the order of hint placement.

The order in which you place shape hints is of paramount importance. For example, if you are working with rectangular images consisting of four hints, the hints in the

A few additional morphing applications are Morph Man, Etchelon Tracer, and Morpher. Information can be found at:

Morph Man:
www.stoik.com

Etchelon Tracer:
www.website.lineone.net/~andy.pritchard/
tracer.html

Morpher:
www.asahi-net.or.jp/~ΓX6M-F,IMY/
index2.html

first key frame should be in the same order as the image in the last key frame. You can delete a shape hint by dragging it off the stage. All shape hints can be deleted at once by choosing Modify>Transform>Remove All Hints.

5. Shape hints work best when they are placed in counter-clockwise order starting from the top left corner of the image.

6. Experiment with the two types of blends that Flash offers. The Distributive blend produces a soft, smooth shape tweening; the Angular option preserves corners and straight lines. Both are located in the Blend option of the Frame panel.

7. Apply acceleration or deceleration to naturalize. Choosing a value in the Ease option of the Frame panel lets you adjust the rate of change between tweened frames, producing a believable effect of acceleration or deceleration.

8. Apply shape tweening to multiple layers. Separating individual parts of an image onto different layers and tweening each layer separately gives you the greatest control and best results when performing complex morphing.

Interpolating the View

emulating camera motion

You can create pan, tilt, and zoom effects by setting key frame values according to an image's Scale and Anchor Point. In Figure 7.57, a large image of a map is placed into a large composition. This precomp is nested into a smaller composition, where Anchor Point and Scale properties are keyframed to create the effect of panning and zooming simultaneously.

7.57

Emulating panning in Adobe After Effects
is accomplished by interpolating the
Anchor Point property on the X axis.

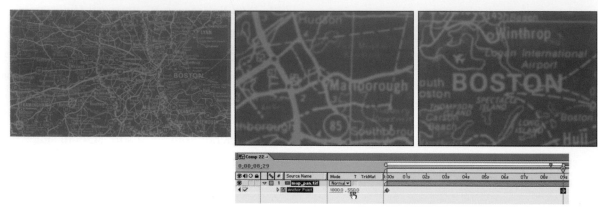

7.58

Emulating a zoom in Adobe After Effects.

Here zooming involves interpolating a
layer's Scale property.

7.59

Combining panning, tilting, and zooming in Adobe After Effects.

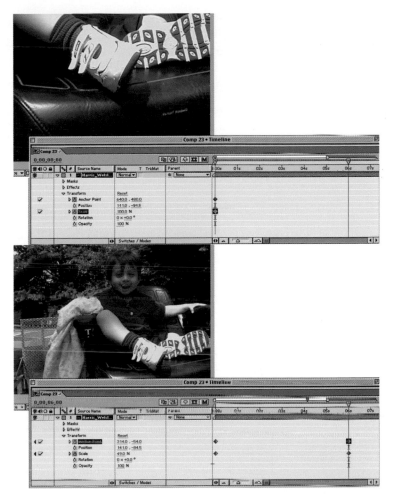

Keep these guidelines in mind when emulating camera motion through interpolation:

1. To properly frame an image, set an anchor point value prior to key-framing anchor point, position, or scale properties.

2. The resolution of an image is directly linked to the amount of scaling or panning you perform.

Since high-resolution images appear larger than the dimensions of the composition you are working in, you can pan around the image without having to scale it up. As a test, try creating a Photoshop document equal to your composition's size in pixels. Then copy and paste the image that will be

Using images that are smaller than your composition size will result in decreased resolution when they are scaled over 100%. As a general rule, follow this formula:

input resolution = amount of zoom x 72

imported into After Effects as a layer in Photoshop. Finally, move it around and scale it to see how it will look when panned or zoomed. Its resolution will tell you how far you can go in a zoom without sacrificing quality.

3. The proportions and orientation of an image dictate what type of camera movements will work best.
For example, vertical images are more suitable for upward tilts, rather than zooming out, which would reveal edges. Wide images qualify best for panning; again, zooming out could reveal the edges.

4. Consider image quality.
Make sure that you are not working with a file that was compressed for the Web. JPEGs often appear "blocky" on broadcast monitors. Dust, dirt specks, and coffee stains will be magnified. You may need to take the time to retouch.

5. Apply nonlinear acceleration/deceleration to key frames to create a more fluid motion when emulating a pan or zoom.

6. If an image is especially tall or wide, feathering the edges creates a softer transition from the image to the background.
Feathering can be performed directly in After Effects by creating a mask and setting its feather property to a high value. (Alternatively, you can do this in Photoshop using a matte.) This produces a more professional result than having the background appear suddenly as the edges come into view.

7.60

Feathering the edge of a long image creates a less abrupt transition to the background at the end of a pan or zoom. Here, a mask for a layer is created in After Effects' Layer window, and its feather parameter is set to a high value.

7. Match velocities of scale, anchor point, and position.
Emulating panning and zooming simultaneously can produce
odd movements when the rate of change for the scale property
differs from the rate of change for the anchor point or position
properties. A work-around is to adjust the curve for the anchor
point or position values on the speed graph to more closely
match the velocity of scale interpolation. Alternatively, After
Effects provides an "Exponential Scale" command that helps
to compensate for this.

8

animation compositing

SYNTHESIZING KINETIC IMAGES AND TYPE

Digital video and animation compositing techniques have become more advanced, allowing for the seamless integration of diverse imagery. The advent of digital technology has both enhanced and complicated the process of compositing, and "thinking in layers" has become a standard trend in the film and broadcast design industries. In the fine arts realm, hybrid forms of animation that integrate both digital and traditional media are now possible, and unusual creative possibilities are pushing the limits of artistic experimentation and expression.

"There are contexts in which what is happening in the whole cannot be deduced from the characteristics of the separate pieces, but conversely; what happens to a part of the whole is, in clearcut cases, determined by the laws of the inner structure of its whole."

— *Max Wertheimer*

composite (com-pos-it-z)
The Art of Seamless Assembly;
A structure made up of distinct
components; The arrangement
of artistic parts so as to form
a single unified entity.

00:00:00:08

The Nature of Compositing

Compositing is the process of seamlessly merging separate visual elements into the same compositional picture space to create unusual relationships that are impossible to achieve in the real, physical world.

Early 20th-century Dadaist and Futurist artists were among the first to liberate ideas through the process of compositing images through collage and photomontage. The German Dada movement at the end of World War I prompted painters and graphic designers to explore collage and photographers to experiment with multiple exposures, combination printing, and assembling cut-out pieces of photographs. The works of George Grosz, John Heartfield, Herbert Matter, and Kurt Schwitters were among the most influential of this period, demonstrating a heavy reliance on experimentation, playfulness, and spontaneity.

Digital technology has allowed processes such as composite modes, keys, masks, mattes, alpha transparency, and nesting. The objective of all these closely related techniques is to create a seamless, believable integration of content with control over transparency, color, and visual arrangement. The majority of film title sequences, television show openings, newscasts, station identifications, and interactive digital presentations today demonstrate a compilation of all of these processes.

Layer Blending Operations

During the mid-1990s, Painter and Specular Collage were among the first paint applications to introduce the digital world to the technology of layering. Almost a decade has passed since Adobe Systems first featured layers as a major advancement in 1994. Photoshop's superior layering facilities

continue to reign as an industry leader for synthesizing static image content, while After Effects is recognized as a leader for its intuitive layering processes in animation compositing.

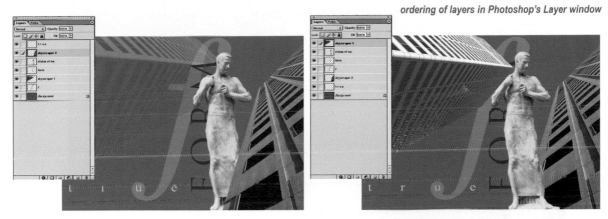

ordering of layers in Photoshop's Layer window

ordering of layers in After Effects' TimeLine

8.1

After Effects' Timeline is comparable to Photoshop's Layers palette, in that the layer located at the top occupies the foremost position in the composition. Dragging the layers up or down allows you to control their spatial hierarchy.

opacity

Opacity is a variable that can be modified to achieve a variety of transparencies within a composition. Like transformations, it is an attribute that can be interpolated over time to emulate semi-opaque materials or to create simple dissolves between key frames.

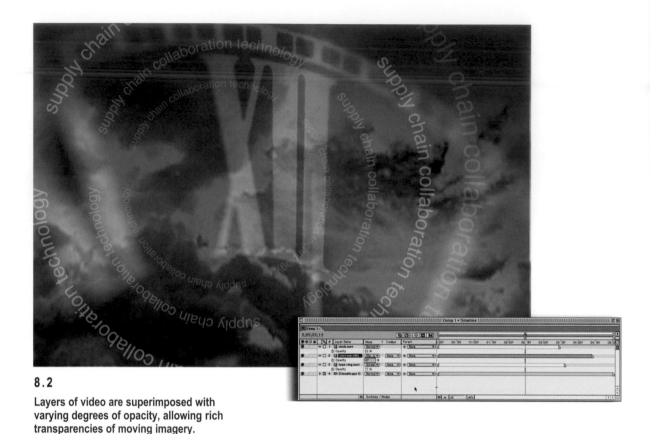

8.2

Layers of video are superimposed with varying degrees of opacity, allowing rich transparencies of moving imagery.

Compositors played a unique role in traditional video postproduction. As real-time editing tools were replaced by digital, non-linear processes, the distinctions among compositing, editing, and CGI have become blurred. As the disciplines of video and animation have converged, compositing is becoming linked to animation, and live-action footage is becoming more of an integral part of motion graphics presentations. Today, most digital video applications offer compositing tools that are also available in motion graphics software.

composite modes

Composite modes (also referred to as *blend modes*) are mathematical functions that compare the hue, saturation, and brightness levels of the pixels of a superimposed layer with those of an underlying layer to determine how the images mix visually. The most standard blend operations are illustrated in Figure 8.3. *Multiply* references the color and brightness information in the RGB channels of both layers and multiplies their pixel values to create the effect of overlaying strokes created with a magic marker. *Screen* multiplies the inverse of each layer's pixel values, producing lighter colors. This can be compared to projecting several photographic transparencies on top of each other. *Overlay* mixes pixel values of the layers by multiplying or screening depending on the color and brightness information of the underlying layer. *Darken* overlays pixels from a top layer that are darker in value than the

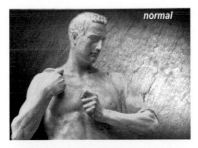

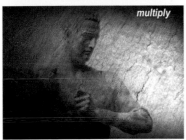

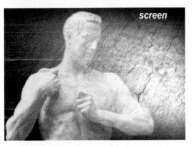

layer(s) below. *Lighten* produces the opposite effect of darken. *Difference* subtracts pixel values of the top layer from the bottom layer or vice versa, depending on which ones have the greater value. *Exclusion* produces a similar effect, but with lower contrast. *Hue* generates a result based on the brightness and saturation levels of the bottom layer's pixels and the hue of the top layer's pixels. *Saturation* considers the luminance and hue of the top layer's pixels and the saturation of those of the underlying layer, while *luminosity* takes into account the hue and saturation values of the bottom layer and the luminance values of the top layer.

8.3

Layer composite modes.

Keying

Keying is a compositing technique by which colors of a selected range are punched out, allowing areas of transparency. Often this technique is used to combine live-action actors shot on a solid color screen with other layers of footage. Keying can be used to perform automatic matte extraction using a uniform color or brightness value to create a key signal. As a result, that signal is "knocked out" or made transparent, allowing underlying imagery to show through.

chroma keying

Chroma keys are single colors used to "knock out" image data to be substituted with new image data. The technique of chroma keying in motion pictures has made it possible for actors and scale models to be placed into imaginary situations in a manner that appears completely realistic. For example, the classic *Sgt. Pepper Party* filmed an elephant against a green screen. The green backdrop was interpreted by the computer as a hole and replaced with a "background plate" of the Adelphi Hotel. In *Spiderman*, the main actor is filmed leaping around in a room painted with a flat background color which is substituted with footage of a cityscape. Filming *The Matrix* involved placing multiple cameras in a 360-degree room painted with green or blue. Computer-generated images were keyed into the scene to create a seamless composite.

In Figure 8.4, the blue screen technique is used to create a traveling matte from which a live video sequence and a static background are combined into one scene. (A *matte* acts as a stencil, in that it governs the visibility of another image. A *traveling matte* is a matte that is different for each frame. Since the subject moves, a new matte is needed for each frame.) High-contrast black-and-white film was used to create positive and negative mattes, which were generated from the

The term *keying* is derived from the word "keyhole" and is interpreted as a signal from which a hole can be cut into an image and filled with an underlying image source.

The term *chroma key* means "color key" and is commonly used in the video industry, whereas in film, the term *matte* is more common. Both processes are closely related in that mattes can be generated from color or luma keys as demonstrated in figure 8.4. When a foreground subject is shot against a blue screen, the chroma key process removes the blue hue. A matte is left behind from the foreground image (similar to how a cookie cutter works).

bright blue color that, when subjected to a red filter, turned black. The background footage was then composited with the subject's moving silhouette in the traveling matte. The film was then rewound and re-exposed to lay the footage of the subject into the "hole" generated from the matte.

Individual mattes that conform to the shape of the subject moving in each frame could have been created by hand—a tedious, time-consuming process. The advantage of the blue screen technique is that it generated all of the mattes automatically, in this case, using optical film techniques.

8.4

A traveling matte generated from a blue screen key.

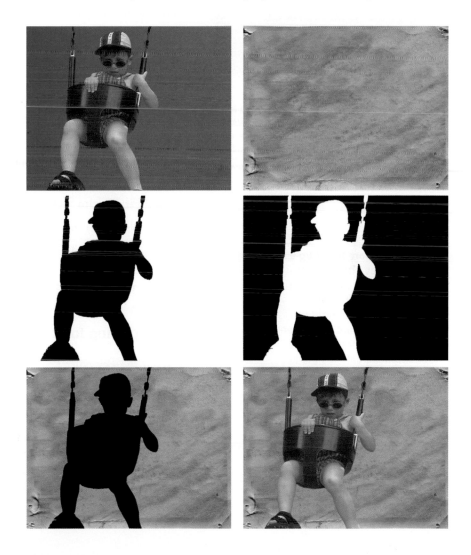

8.5

The talent who appears to be talking in front of an animated weather map is, in reality, sitting in front of a blue screen. Map footage is inserted into the broadcast in the production room. Photo courtesy of AiH Group.

"If you were to set up a luma-key shot of a TV personality in front of a white backdrop, things might go fine, right up until the talent starts perspiring. When his shiny forehead catches the key light and reflects back a 100 percent luma level to the video camera—whoops. Your expert suddenly has a hole in his head. This is a bad thing."

— *Bill Davis*

The most well-known implementations of chromakeying in television occur in the local news. In Figure 8.5, a talent who appears to be speaking in front of an animated weather map is really sitting in front of a blue backdrop. The blue hue is keyed out in the production room, and the animated map footage is inserted into the broadcast.

Traditionally, the two colors that have been considered the video broadcast standard for chroma keying are bright blue or green. (This process is often referred to as *blue-screen* or *green-screen matting*.) Since video signals are captured in channels of red, green, and blue (the additive colors of light), these colors became the first choices for keying.

luma keying

In addition to color, luminosity enables a range of brightness values to become transparent. Luma keying works best with high-contrast footage in which background information contains different tonal ranges than those of foreground elements.

In the digital realm, pixels that contain no brightness are black, having a luminance value of 0, and those that are white are assigned a value of 255. In Figure 8.6, Adobe After Effects' Luma Keying process makes all the pixels that are above or below a specified threshold value transparent.

tips: capturing for keying

1. *Avoid the key color!*
Be sure your subject does not contain values or colors that are similar to the type of key being used (8.8). For example, if your subject contains bright values, luma keying it against a white background may result in "dropout." You may need to reshoot or recreate your subject on a background that is more suitable for keying.

8.6

Adobe After Effects' Luma Key effect.

A Threshold value determines what pixels will become transparent according to their level of brightness.

2. *Green or blue?*

In the era of digital postproduction, a chroma backdrop can be any color, as long as it consistent and is not found in your foreground subject. Green and blue are still the most widely used in video, since this medium is built from red, green, and blue (or in some cases YUV) signals. The decision to shoot against a blue or green screen is based on multiple factors. If your subject contains blue, green would be the preferred chroma key choice, and vice versa. Skin pigments of people vary; some work better with a blue screen, while others are better equipped for green. If you are keying live action footage, the DV format prioritizes luminance over chroma. Since green has a higher luma content than blue, green usually yields a better result in digital video keying.

3. *Get the right materials.*

Although chroma-key blue or green paint ensures a consistent color match with minimal contamination, it can be expensive. Your local hardware or home improvement store can provide you with much more affordable paint to be mixed at 100% purity at your request. As an alternative to paint, any type of blue or green fabric can be used as long as it is smooth and free of wrinkles. Muslin, which can be purchased at any art supply store, can be stretched over a wooden frame and painted to make the fabric tight. Bulletin board paper from any local school or office supply store can also be handy and allow you to extend the screen onto the floor. Rolls of green or blue photographers' paper can also be used. Try to prevent wrinkling, crumpling, or tearing, which can cause subtle fluctuations in color value.

4. *Light wisely!*

Lighting is a critical factor in keying. Color uniformity is a necessity, and the backdrop should be evenly lit with several bright, diffused light sources. Lighting inconsistencies can be

8.7

Rosco's Ultimatte acrylic paint, sold for approximately $43 per 1–gallon container, is formulated to provide high luminance values and color saturation for keying effects. The acrylic colors provide a one-coat coverage for nearly any surface.

Information on Rosco's products, including Ultimatte paint, can be found at www.rosco.com.

Many production houses have *cyc walls* (or *infinity walls*) consisting of two walls and a floor that curve into each other. A seamless transition between wall and floor gives the illusion of infinite background space. This facility can be rented with the inclusion of lighting equipment.

caused by unwanted shadows from backgrounds that are not uniformly lit or from subjects placed in close proximity to the backdrop. Because of subtle fluctuations in tone, the color of shadows may not be uniform enough for your software to produce an accurate key. A handheld meter can confirm that light distribution is consistent. Place your subject as far away from the background as possible to prevent shadows from falling onto the screen.

Measures can prevent or minimize the effect of *spillover* that occurs when background light reflects onto the subject. An overhead ambient light with an amber or yellow gel can wash out color that might spill over into hair detail. A backlight with a color gel that is complementary to the key color also can reduce spill by neutralizing the effect. (Try using a magenta gel against a green screen or an orange gel against a blue screen.) Be sure that light falling onto the subject is not falling onto the background. Separate the subject from the background at a substantial distance. Finally, imitating the lighting of the environment that will be keyed in behind the subject adds a sense of realism to the final composite. Cheap floor fans come in handy if you can't afford a wind machine!

5. Close the iris and use lots of light!
Shooting with a small iris opening will allow for a good key, sharply separating the foreground subject from the color screen. (A setting of 8.0 or higher works well.)

6. Use high-quality footage.
Despite the superior quality of digital video over analog video formats, its compression codec is prone to producing video artifacts, blockiness, and noticeable aliasing along curved and diagonal edges when keying. Therefore, high-end analog video formats such as Beta-SP are recommended over DV when capturing footage to be keyed in the studio. S-VHS

Animation Compositing

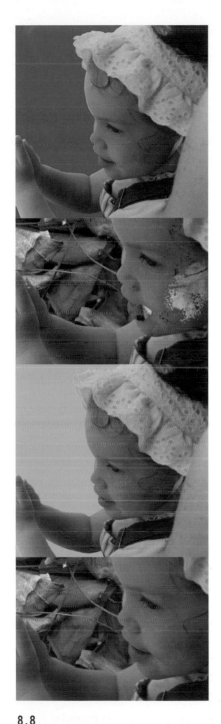

or Hi-8 produce troublesome edges, and VHS is out of the question. If your only choice is to capture your footage with a digital video camera, there are work-arounds.

7. *Experiment.*

Spend considerable time experimenting with lighting, camera settings, and the positions of your subject and backdrop. Planning in advance will save time and labor in the long run.

tips: digital keying

In the motion graphics, video, and special effects industries, digital keying has become a viable compositing practice, offering a quick solution to generating traveling mattes.

1. *Choose your tools wisely.*

The capacity for successful keys to be pulled from even the most difficult footage, including digital video, depends on the level of the software being used. These represent just a few that are available on the market, and each claims to sport the most sophisticated methods for creating seamless color key composites. Research which tools best suit *your* personal needs before investing.

2. *Choose the right key color.*

Be sure that the background for your subject is different from the colors or brightness levels of your subject. Some colors are more difficult than others to key, such as reds, because of the high constant of red in many color variations. Even the most subtle movements or changes in lighting can cause a red key to bleed into the image.

8.8

In this case, red was not a wise choice to key from because of the amount of red found in the skin tones. Green proved to be a more effective chroma key.

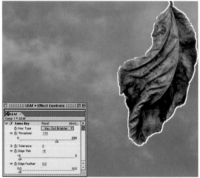

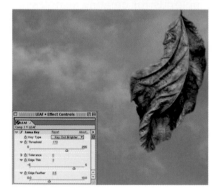

8.9

Adobe After Effects' Luma and Color Key operations allow you to soften the transition between subject and background by adjusting the transparency of edge pixels. In this example, the Edge Thin operation was applied to constrict the matte by a value of 2 pixels; the Edge Feather setting was assigned a value of 2, resulting in an increase in foreground edge transparency over 2 pixels.

3. *Work closely.*

Zoom in closely to the composite to make sure that the edges of your foreground elements look clean.

4. *Soften the transition.*

Effective keys avoid the harsh look of hard-edged foreground elements that appear cut out with a pair of scissors. Softening a key's effect with a slight feather or edge blur can help fuse foreground and background images together naturally, giving the appearance of the two being indistinguishable. Edge blurring works especially well with moving images, as the eye is more focused on the action than on the image.

5. *Be patient.*

Shadows and fine details can be difficult to work with, even with the most sophisticated software. Therefore, plan to dedicate considerable time to testing your key and cleaning up your mattes if necessary.

keying tools

In the past, keying tools were out of the price league of independent animators and could only be found in professional television studios. Today, they are well integrated into most animation, editing, and compositing software. Whether you are keying out fine detail, out-of-focus images, semi-transparent elements, image reflections, or shadows, many chroma-key tools are on the market.

the Ultimatte

In the 1970s, Petro Viahos invented the Ultimatte. This analog video processor performed soft edge matting. In the mid-1990s, the term Ultimatte denoted a closer association with the chroma-key process in which foreground subjects were shot against colored backdrops to be substituted with new backgrounds consisting of live or graphic images.

As a high-end real-time compositing system distributed by Ultimatte Corporation, the Ultimatte has been used since the 1990s by broadcasting and film studios around the world. When a subject is placed in front of a blue screen, the Ultimatte activates the background image and allows it to appear in proportion to the amount of blue that it sees in the camera's blue channel. Areas containing the brightest and most saturated blues are replaced with the background source, while darker blue areas cause less of the background to show through. A well-executed Ultimatte composite contains minimal clues as to what background key was used. Shadows cast onto the blue screen cause the blues in the shadow region to be darker. When foreground and background images are composited, the background source is restricted to pass through those regions, according to the variations of darkness in the shadows. The final result is that foreground elements appear to cast realistic shadows onto the background.

Further, Ultimattes are equipped with patented circuitry that is capable of eliminating blue or green spillover on subjects. Some units allow color correction on both foreground and background elements to compensate for poorly lit backdrops.

digital chroma keying tools

In addition to high-end hardware that is capable of performing sophisticated chroma-keying operations, keying tools in software are continuing to improve. The software-based methods that are described here are a few examples that are currently available on the market.

Ultimatte AdvantEdge

Ultimatte AdvantEdge (8.10) offers a set of highly refined tools that were developed to help resolve problems that existed in conventional blue or green screen chroma keying. The process of pulling a key involves selecting a range of pixels to key out. Areas that are not keyed can be scrubbed

8.10

Ultimatte AdvantEdge screen shots.

Ultimatte AdvantEdge offers plug-ins for Adobe After Effects, Premiere, Apple Final Cut Pro, Shake, Avid Media Composer, Xpress, XpressDV, and Discreet Combustion. Linux, SGI, Mac (OS X and 9), and Windows operating systems are supported.

with an eyedropper tool with just a few passes. You can easily view the alpha matte of your footage and replenish areas of the subject that have inadvertently been removed. Controls such as Matte Density, Spill Suppression, or Shadows can fine-tune the edges. For DV, AdvantEdge offers an intelligent chroma correction algorithm that can repair compression artifacts in 4:2:2, 4:2:0, and 4:1:1 footage. Although Ultimatte AdvantEdge's plug-ins are pricey, they are a great alternative to purchasing a $20,000 Ultimatte system!

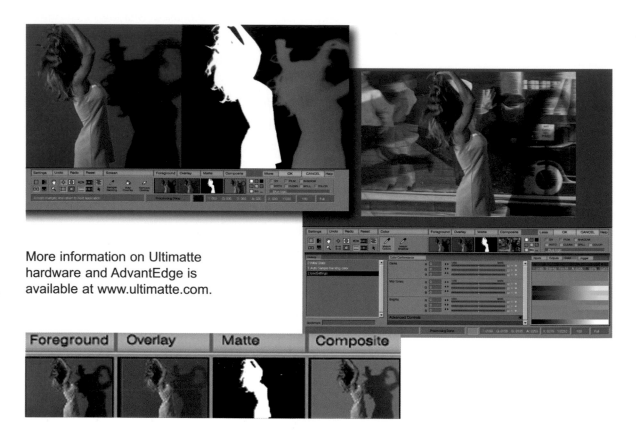

More information on Ultimatte hardware and AdvantEdge is available at www.ultimatte.com.

Adobe After Effects

Adobe After Effects contains versatile tools for extracting and refining mattes created from color keys. A Color Key effect allows you to drop out evenly lit backgrounds which have minimal or no variation in color (8.11). If a background contains subtle color fluctuations due to uneven lighting, a

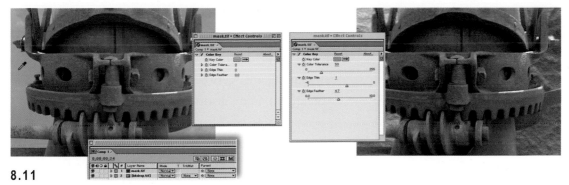

8.11

After Effects' Color Key operation.

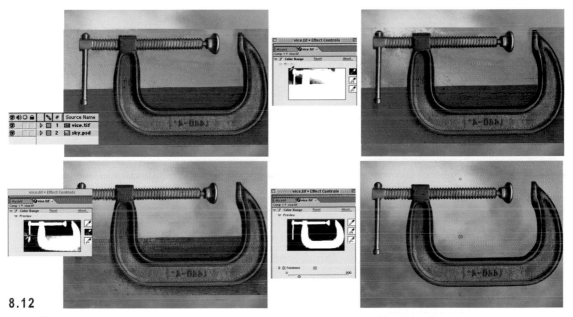

8.12

After Effects' Color Range filter.

A key color is defined in the matte thumb-nail with the Color Key Eyedropper. A few applications of the Eyedropper Add tool expanded the color range, allowing the matte to be "painted" over to achieve a better key. Finally, the Fuzziness slider was used to soften the edges between transparent and opaque regions.

Color Tolerance function can help knock out shady regions. Additionally, Edge Thin can help eliminate edge pixels that contain the key color, and an Edge Feather can help soften the transition between foreground and background. A more advanced Color Range operation allows you to select a range of colors to key out. The resulting color key matte can be refined using an add or subtract eyedropper tool (8.12).

Since areas consisting of fine detail may be difficult to key out, After Effects provides two choking methods that help

After Effects' Simple Choker and Matte Choker operations.

8.14

After Effects' Color Difference Key.

After a color key is determined, the Eyedropper tools are used to increase the matte's contrast. The Matte Choker is then used to blur the transition between foreground and background images.

refine your key (8.13). For hard edges, the Simple Choker is ideal for cleaning up or tightening a key; however, it does not provide refined control. The Matte Choker's detailed settings can blur the area between the subject and the keyed background, providing a softer transition.

Another effective keying operation is After Effects' Color Difference Key. In Figure 8.14, a Key Color Eyedropper is used to select a general key color. The B preview in the Effect Controls window shows the luminance matte that has been extracted from the key. (The A preview shows a reverse matte.) In addition to this thumbnail, the Comp window can be set to a variety of outputs, allowing you to view the matte in progress. Black represents full transparency, allowing the underlying background image to pass through, and white represents full opacity, restricting the background image's pixels from passing through. Gray tones in the subject prevent these regions from being composited at full opacity, resulting in a translucent appearance in the final composite. Therefore, the solution is to refine the matte in a manner that eliminates gray values (or *partial alphas*) to prevent underlying pixels from coming through the foreground and allow it to show through the key regions at full opacity. This is achieved by adjusting the Gamma values to increase the matte's contrast. The Matte Choker operation was then applied to soften the foreground-to-background transition.

Pinnacle Commotion

Pinnacle Commotion offers advanced chroma keying features that have the capacity to eliminate spill, correct inaccurate edges, and control transparency levels while maintaining foreground detail and image reflections.

Primatte Keyer

Another versatile chroma-keying tool is Primatte, distributed by Red Giant software. Its unique patented algorithm has proven to be effective in generating precise color key mattes that correct blue-spill and hard edges. Primatte has been well integrated into a variety of host applications including Apple SHAKE, Adobe After Effects, and Pinnacle Commotion. It can also be purchased as a stand-alone system for SGI or integrated into hardware such as the Avid.

Red Giant's Primatte plug-in for Photoshop and an application manual can be downloaded at www.redgiantsoftware.com.

8.15

Red Giant's Primatte Keyer interface and spill removal controls.

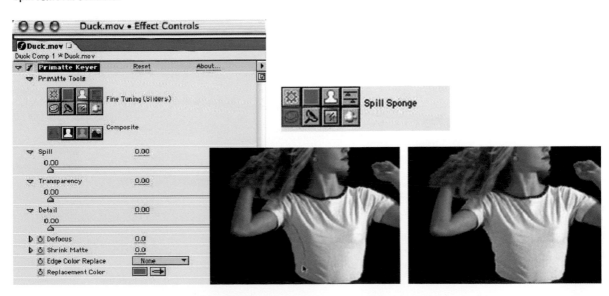

Alpha Channels

Alpha channels are one of the most powerful compositing mechanisms that are used to synthesize static and moving image and typographic content.

the secret behind alpha

Understanding the meaning alpha necessitates understanding 24-bit color (or RGB color). Every pixel in an RGB image contains three channels of information corresponding to each of the three additive primary colors of light—red, green, and blue. Each color channel contains 8 bits or 256 values of data ranging from 0 to 255. A value of 0 indicates no color present, and a value of 255 signifies the maximum intensity of that color. The many possible combinations of the three channels combine to form images that have the potential to display up to 16.7 million colors (256 x 256 x 256 or 8 to the eighth power). Most digital video images have 24-bit depths.

The term "alpha channel" is based on a 32-bit file architecture. A 32-bit image carries a fourth alpha channel, which functions to store transparency information. That data is used to

Alpha channels should not be confused with an image's red, green, and blue color channels. 24 bits of RGB data controls color. An alpha channel's 8-bit data is reserved to give a static image or a video clip shape and transparency when composited with other elements in a time-based environment.

Illustrator graphics and Photoshop images created on transparent backgrounds retain transparency when imported into programs such as After Effects, as an alpha channel matte is automatically generated.

24 BITS: (R + G + B)
8 bits (256 levels) R +
8 bits (256 levels) G +
8 bits (256 levels) B
256 x 256 x 256 = 16.7 million possible colors

32 BITS: (R + G + B + A)
8 bits (256 levels) R +
8 bits (256 levels) G +
8 bits (256 levels) B +
8 bits (256 levels) Alpha
256 x 256 x 256 = 16.7 million possible colors
PLUS 256 levels opacity

Animation Compositing

determine image visibility when imported into a time-based animation or video environment. Transparency, like color, is based on 8 bits or 256 levels of data that dictate which areas of the image will become concealed, which areas will remain visible, and which portions will be semivisible (or partially concealed). Alpha channels can contain any type of visual data including simple graphic shapes, letterforms, gradient blends, and elaborate continuous tone images.

The secret behind alpha is often first understood in the context of static layering applications such as Adobe Photoshop. (Alpha channels have been one of Photoshop's most powerful features since its early inception in the 1980s.) Transparency data that is stored inside an alpha channel can be applied to an image as a mask (or a selection) or can be imported into a time-based editing/compositing environment.

putting alpha into motion

When a 32-bit image containing an alpha channel is brought into a video /motion graphics environment, its visibility honors the alpha, meaning the image is displayed only where a white or gray level is present in the alpha channel. Underlying content can be keyed through the transparent regions.

In Figure 8.20, the visibility of a superimposed image on top of a background is governed by the brightness levels of a *track matte*—an external matte. Black areas function as the mask, and white areas permit the background to pass through at 100% opacity, like paint being pushed through the holes of a stencil. Intermediate gray values represent varying levels of transparency, allowing the image to pass through partially, depending on how light or dark the gray levels are. (The lighter the gray, the more opaque the image will be; the darker the gray, the more transparent it will be. This is not physically possible with traditional stenciling.)

8.16

Nonlinear video editing/compositing systems such as the Media 100i system can create titles and graphic overlays by blending imported text or graphics that have an alpha channel with background video. A "G" track in the timeline is reserved specifically for imported PICT or QuickTime files.

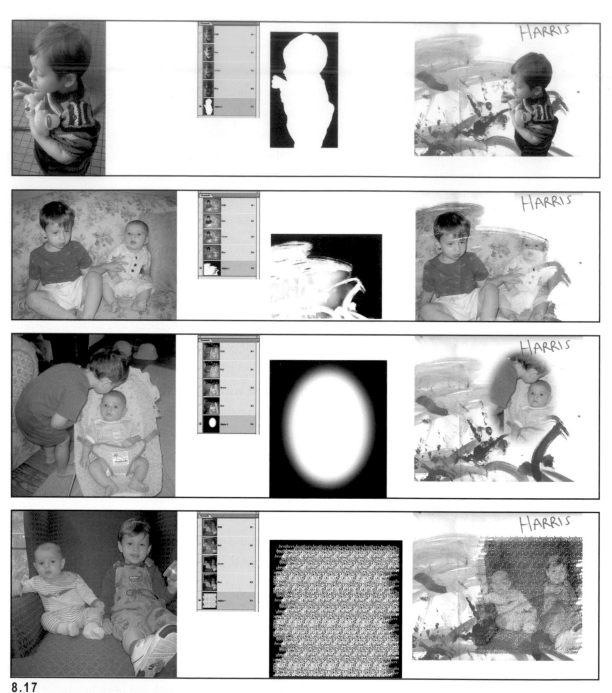

8.17

Image visibility conforms to the data stored inside each image's alpha channel. When composited with a background image in the animation environment, the underlying image appears through the transparent alpha portion.

8.18

Alpha channel matte compositing in Adobe After Effects.

An Adobe Photoshop image containing an alpha channel is made partially transparent when imported into After Effects.

After Effects automatically generates an alpha channel matte for a layered Photoshop image that was created on a transparent background.

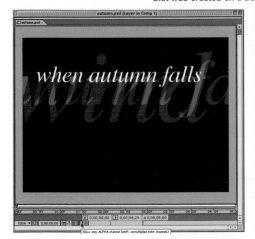

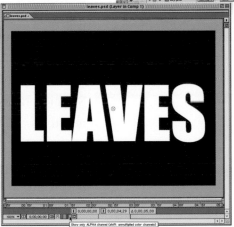

Each layer's alpha channel (plus its R, G, and B channels) can be viewed independently.

More About Mattes

the secret behind mattes

A *matte* is a static or moving static image which, based on its red, green, and blue luminance values, can be used to govern the visibility of another image. As an integral part of video and animation compositing, mattes provide unlimited creative possibilities in combining images and type.

Matting techniques in film have been used to create a variety of illusions since the beginning of motion pictures. One of the oldest special-effect techniques used in the film industry involved the use of a double-exposure matte. For example, a cameraman would film a group of actors cautiously walking across a bridge, and a piece of black paper or tape would cover a portion of the lens corresponding to the sky, leaving that area unexposed. The film was rewound, and black paper or tape was placed on the lens to cover the exposed portion of the film. A menacing thunderstorm scene was then filmed at a slow film speed, so that when played back normally, the clouds appear to be quickly rolling in across the sky. Both scenes might be shot separately on separate pieces of film, and through optical compositing, projected onto a third piece of film one frame at a time. Alternatively, both film sequences can be scanned into the computer, digitally composited, and written back out to a third piece of film with a film printer.

The analogy of the stencil is useful to describe digital matting. Stencils are actually conventional mattes that act as precut negatives. They allow decorative patterns and letterforms to be applied to a surface with speed and accuracy. Both the negative and positive areas of a stencil determine what portions of a surface will be affected by the application of a medium such as paint. Areas that correspond to the negative, unmasked portions of the stencil (or the holes) are vulnerable

Producer and cinematographer Edwin S. Porter began to experiment with mattes and double exposures during the early 20th century. Porter's film *The Great Train Robbery* from 1903 features a scene in which the camera is matted and a double exposure is shot.

8.19
Traditional silkscreen printing.

to alteration. The nonpermeable material of the mask is impervious to the medium, preventing it from being pushed through to the surface. Silkscreen printing offers a similar analogy. Think of ink being pushed through the permeable areas of a silkscreen. A tightly stretched fabric is partially covered with a nonpermeable substance to prevent ink from penetrating through certain areas. The screen is placed on top of paper or cloth, and ink is squeezed through the fabric with a squeegee. Regions that are unblocked allow ink to penetrate through to create a positive image. Photo silkscreen reproduces photographic images through a light-sensitive photo emulsion. When exposed to light through a film positive, hardened areas are washed away to leave a negative impression in the screen. Ink is then forced through the porous areas to generate a positive image.

The traditional stencil and silkscreen analogies can be applied to using digital mattes to blend images. Think of the brightest areas of a matte as the holes of a stencil or the porous areas of a silkscreen. Imagine the darkest regions representing the protected areas as the stencil itself or emulsion of the screen.

alpha versus luma mattes

The relationship between alpha channels and mattes may seem confusing, since these terms are used loosely in the film and video industries. An alpha matte is an *internal matte* derived from a 32-bit image's alpha channel. A luminance matte (or *RGB matte*) makes portions of another image transparent, based on its combination of RGB brightness values.

It is important to understand that alpha channels are attached to images; the data residing inside of an alpha channel is used to control what parts of the image will be visible. (It also determines how visible the parts will be, according to

Alpha, mattes, masks, and *keys* are terms that have been used interchangeably. Photoshop artists often refer to mattes as "alpha channels" or "masks." Analog video artists commonly use the terms "matte" and "key." Although these processes work differently, they all aim to accomplish the same goal—to create transparency.

the brightness levels.) Luminance mattes are external to images and are needed when an alpha channel is not present (for example, QuickTime video). Alpha mattes are 8-bit images, and luminance mattes can be 8-bit or 24-bit with three RGB channels. Luminance mattes can be static or kinetic, while alpha channel mattes can only be static.

Adobe After Effects' Track Matte feature involves the use of Luma and Alpha mattes. Their difference has to do with where the information determining visibility resides—in an image's RGB channels or in its alpha channel (if it has one).

8.20

In Adobe After Effects, layer visibility can be governed by the brightness levels of a *track matte*—an external luminance matte that is used for reference.

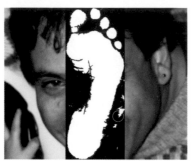

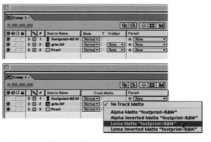

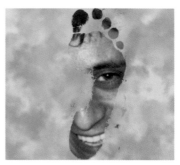

Black areas of the matte act as the mask, and white areas permit background imagery to pass through at 100% opacity. The matte layer being referenced is automatically turned off in the TimeLine.

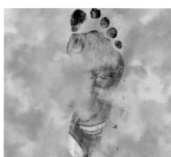

Intermediate values between black and white represent varying levels of transparency, allowing background pixels to pass through only partially.

matte styles

Both alpha channel mattes and luminance mattes can be composed of solid shapes, typographic forms, feathered shapes, gradients, and continuous tone images.

8.21

In Adobe After Effects, a track matte consisting of white type on black is used to composite a static background and a superimposed QuickTime layer. The video layer referencing the matte is sandwiched between the matte and background layers. Dark areas of the matte clip the footage to the letter forms, allowing background imagery to show through regions outside the type.

solid mattes

High-contrast black-and-white mattes mimic conventional stenciling or silkscreening in that they can confine images to simple geometric shapes and typographic forms. In Figure 8.21, live video footage appears through a matte consisting of white text on a black background. The footage is clipped to the areas of the matte containing the brightest luminosity values, allowing the background to appear at full opacity through the regions of the matte that are black.

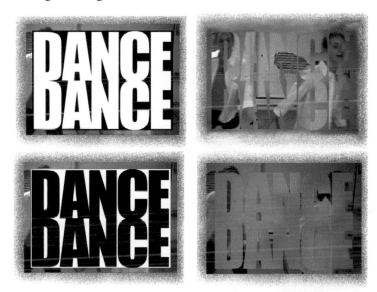

When the matte is inverted, the background's visibility conforms to the letterforms, while the video layer appears outside of the letterforms.

8.22

A split screen effect using a solid matte.

continuous tone mattes

Unlike traditional stencils, mattes can function beyond acting as cookie cutters, since they can carry intermediary ranges of gray between black-and-white, allowing for semipermeability. With this in mind, images can be layered at varying degrees of transparency. Portions of a matte containing values of 128 (halfway between black-and-white or 0 and 255) allow images to be superimposed at 50% opacity. Values of 192 will allow superimpositions at a 25% opacity, and so on.

In addition to solid shapes and typographic forms, semipermeable masks consisting of feathered edges, paint strokes, gradient blends, and complex grayscale images can be used to offer more intriguing and versatile layering possibilities. In Figures 8.23 through 8.25, the concealed, transparent areas of the imagery conform to the dark areas of the matte, permitting underlying background pixels to show through.

matte generation

Creating a seamless integration of layers requires establishing smooth visual transitions between them. Whether mattes are derived from keys, from alpha channels, or from luminance data, making them accurate mattes takes time and patience.

8.23

A matte containing a feathered-edged shape is used to produce a vignette. As values become darker over the transition from the edge to background, the image fades at its edges accordingly.

8.24

A gradient matte containing evenly distributed changes of tone is used to fade a superimposed image out at its edges.

Mattes consisting of images can offer a variety of artistic effects.

Painting them digitally from black, white, and gray values from brushes varying in size and degrees of edge softness offers the most artistic freedom and accuracy. The alpha channel matte in Figure 8.26 was created in Photoshop. Notice that the alpha channel being worked on is highlighted in the channels palette while the eye icon corresponding to the RGB channel is activated to reveal the image underneath. A color and opacity level is assigned to the channel in order to view both the matte in progress and the RGB image simultaneously. The matte is added to with white or subtracted from with black, similar to adding or washing away emulsion from a silkscreen (for those of you with a printmaking background).

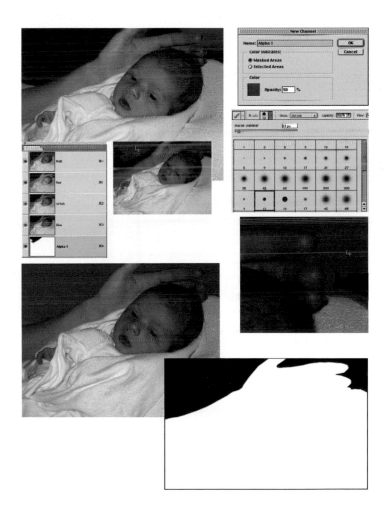

8.26

Alpha matte generation in Photoshop.

traveling mattes

Revealing action through a limited viewpoint such as a peep-
hole, a periscope, or a pair of binocular lenses is a common
cinematic technique that has been used since early motion
pictures. This process often involved the use of traveling
mattes—moving mattes that restricted the view to the shape
of the peephole or binocular lenses.

Traveling mattes offer a wide range of visual possibilities. In
Figure 8.28, a magnifying glass containing its own alpha
transparency, a circular matte based on the shape of the lens,
a background containing text, and a fill layer consisting of
larger text are composited. Notice the order of these layers
on After Effects' Timeline from bottom to top: background
text layer, magnifying glass layer, fill layer, and matte layer.
The fill layer's transfer controls are set to Luma Matte,
restricting its visibility to the matte's shape. The matte layer

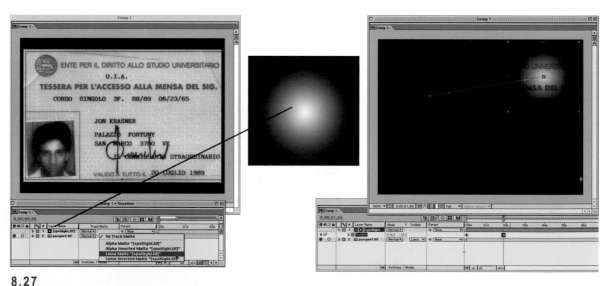

8.27

A *traveling matte* corresponding to the
illumination of a spotlight animates from
side to side to scan the view.

Animation Compositing

is then positioned in appropriate registration with the lens and is parented with the lens layer so that both can move together as one unit. The lens' position property is key-framed, and the matte pans along, revealing portions of the fill layer. At the same time, scale key frames are created for the fill layer to simulate the effect of zooming.

8.28

In Adobe After Effects, a layer containing an image of a magnifying lens has its own alpha transparency, allowing it to be free-floating against the background. A matte conforming to the inside shape of the lens is imported in After Effects and moved into registration. The visibility of a layer containing clear text is set to reference the matte. The lens layer is parented to the matte layer, allowing them to function together as a unit. Finally, the matte layer's Position is key-framed.

8.29

Open and closed Bezier spline paths.

Masks

the nature of splines

Similar to mattes, masks can be applied to images to define their transparency. However, unlike mattes, which establish transparency through grayscale information, masks are defined by splines or paths that consist of a series of interconnected points that form a line segment or curve. Two types of splines that are most commonly used in imaging, animation, and compositing software are Bezier splines and B-splines. Bezier splines, which are inherent to most desktop applications such as Illustrator, Freehand, and Photoshop, consist of both anchor points and tangents. B-splines (also known as *natural splines*) are defined only by anchor points that, depending on their proximity to each other, determine the curvature of a path. These types of splines are more common among high-end workstation applications, some of which offer 3D modeling.

Like a stencil, the portion of the image corresponding to the interior of the mask's shape shows through, while pixels outside the mask's parameters are made transparent.

It is important to recognize the difference between spline masks and luminance mattes. Figure 8.30 compares the use of Adobe Illustrator text as an alpha channel matte and as a Bezier mask. A video clip of a moving sky appears through the white areas (or the alpha portion) of the matte. The outlines of the letter forms are then used as a Bezier mask, allowing access to the vertices of the paths. In turn, the paths can be key-framed over time.

Because the terms mask and matte are interchangeable and have been used loosely in the industry, for our purposes, we will refer to masking as a compositing technique involving the use of spline paths.

8.30

left: An animated simulation of a panned image appears through the white areas of the matte (the letterforms). The matte's black areas clip the animation outside the letterforms.

right: Text outlines are used as a mask, allowing access to the Bezier path's vertices. The shapes of the letterforms are animated through setting key frames.

The Adobe Illustrator file imported into After Effects contains an alpha matte.

Type outlines from Illustrator are copied to the clipboard.

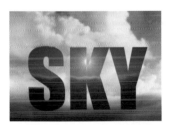

The outlines are pasted into the QuickTime layer window in After Effects to create a Bezier mask.

The QuickTime layer is set to reference the matte of the Illustrator layer above it. (The Illustrartor layer is turned off to hide its visibility.)

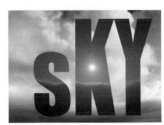

The mask's shape is key framed on the TimeLine.

masking in After Effects

Bezier spline generation

Adobe After Effects' masking operation, which is based on the use of Bezier splines, is among the most popular in setting the standard for animation and video compositing. Splines can be created with the primitive rectangle and ellipse tools or drawn from scratch with the Bezier pen tool. A series of vector paint tools introduced in version 5.5 can also be used to generate Bezier spline masks.

Each layer contains a respective window from which up to 127 masks can be created. (Alternatively, mask shapes can be generated and edited directly in the Composition window.) After a closed path (or mask) is created inside a layer, only the contents that exist within the mask's boundaries are visible, while information outside those parameters becomes transparent during the layer's duration in the Timeline.

Vector paths from applications such as Adobe Illustrator and Photoshop can be used as masks in After Effects by copying and pasting them directly into a layer's clip window. In Figure 8.30, the text path created in Illustrator was copied and pasted into the QuickTime clip's Layer window to function as a mask for the video to play through.

8.31

After Effects' Bezier mask feature.

The effect of a mask created in the Layer window appears in the Comp window.

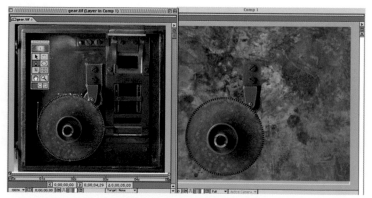

path editing

Modifying the shape of a mask in After Effects involves the use of standard point editing techniques that are found in vector-based imaging applications such as Adobe Illustrator and Macromedia Freehand. These processes allow a path's vertices to be repositioned, added, deleted, and converted between corner, cusp, and smooth to affect the nature of the line segment.

mask properties

In After Effects mask properties including shape, opacity, feather, and edge expansion can be interpolated. The Mask Feather property offers control over the manner in which edge pixels dissipate in transparency from the mask's edge outward (8.32). The mask's edges can also be expanded using the Mask Expansion property (8.33). Values that are represented in pixels determine how far from the original boundary a mask can grow outward or contract inward.

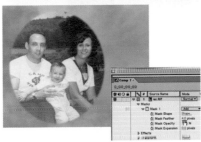

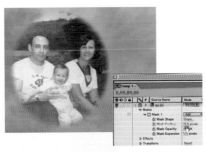

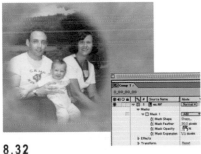

8.32

A mask with a feathering value of 4, 15, 30, and 60 pixels.

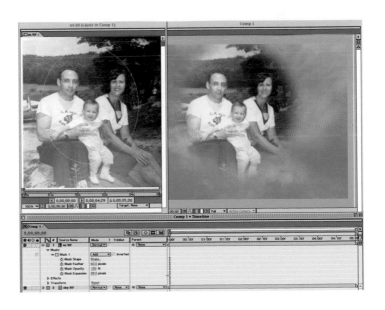

8.33

After Effects' Mask Feather and Mask Expansion properties can work together.

mask modes

After Effects' mask modes allow you to generate and refine complex paths through Boolean-like operations. In Figure 8.34, two paths are combined in a manner that produces multiple transparent areas at the points where they intersect.

8.34

Two overlapping layer masks are set to different mask modes.

None:
After Effects ignores the selected mask, having no impact on the associated layer. This option can be used to apply strokes or fills, without creating transparent areas in a layer.

Add:
After Effects adds the selected path to the other paths, displaying all mask contents in the Composition window.

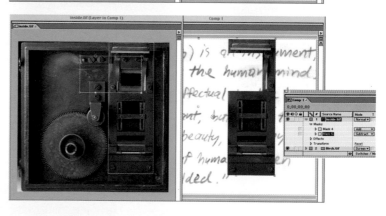

Subtract:
After Effects subtracts the selected mask from the masks located above it in the Timeline. This option can be used like a cookie cutter to create the appearance of a transparent hole.

Animation Compositing

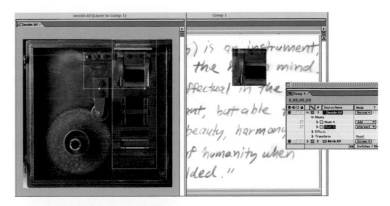

Intersect:
After Effects adds the selected mask to all masks above it, displaying only the portion where the selected mask and other existing masks intersect.

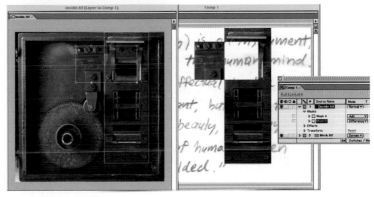

Difference:
After Effects adds the selected mask to the masks above it, displaying the contents of all masked areas minus those areas where the masks intersect.

Adobe After Effects' mask modes are similar to Illustrator's pathfinder operations, which are used to combine shapes or cut out shapes with other shapes.

rotospline masks in Commotion

Pinnacle Commotion is also considered to be an effective application for handling transparency through masks. Rotosplines, one of the program's most powerful features, provide a unique method of creating unlimited mask shapes from Bezier spline or B-spline curves. Either method allows you to draw complex transparency paths that can be easily edited and keyframed over time. Commotion's Rotospline tool is based on the same conventions as the Pen tool found in Adobe Illustrator, Photoshop, and After Effects. Similar to creating and editing paths in After Effects, this process involves establishing a series of anchor points to form a closed path, and then refining the curves through point manipulation. A Rotosplines palette houses several path editing tools, a list of splines that correspond to the active layer, and settings that let you adjust spline parameters such as fill, motion blur, and feather.

Like After Effects, a closed spline automatically becomes applied to the layer's alpha channel as transparency data. As a result, pixel data that corresponds to the inside of the spline shape is masked, while data outside the spline allows background layers to appear through.

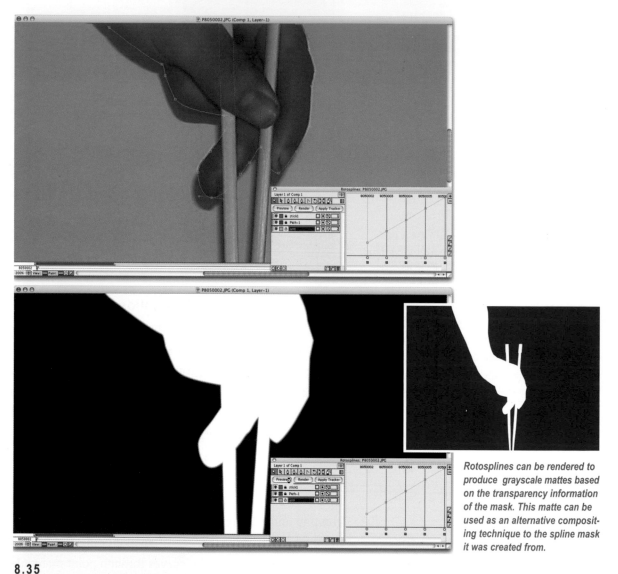

Rotosplines can be rendered to produce grayscale mattes based on the transparency information of the mask. This matte can be used as an alternative compositing technique to the spline mask it was created from.

8.35

Pinnacle Commotion's Rotospline feature.

A Preview button, located on the Rotosplines palette, generates a preview of the alpha channel according to the splines and their configurations.

masking in Flash

Mask layers in Macromedia Flash contain vector-based shapes that create "holes" through which the contents of underlying layers appear. Areas outside a mask make the information of the layer below it transparent (8.36).

The process of masking in Flash begins by creating a layer containing the content to be masked on the Timeline. Another layer that will function as the mask is inserted above it, and the Mask option is chosen. A shape is generated on the mask layer, and this shape permits the underlying layer's contents to show through. Regions of the mask layer that are outside the shape become opaque, concealing the underlying image.

Mask properties such as position, scale, rotation, and shape can be interpolated by setting key frames. This is useful in creating spotlight effects and transitions between images.

8.36

Masking in Macromedia Flash. Drawing by Jon Krasner. © JK Design.

In Flash's Timeline, a masked layer's name is indented, and its icon changes to a right-pointing arrow. The layer acting as the mask is placed above the layer being masked. Double-clicking each layer's name in the Timeline allows you to specify the correct settings.

Key-framing the position of the mask layer exposes the underlying fill layer as the mask animates across the frame.

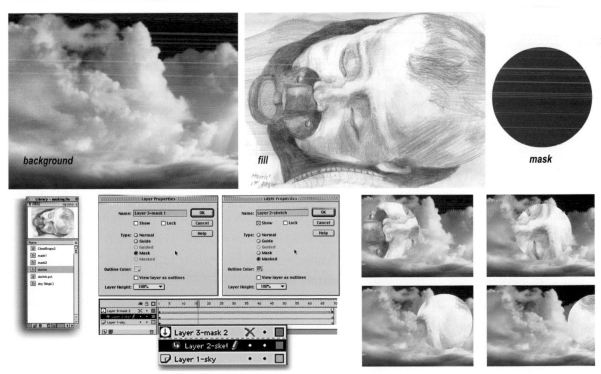

background

fill

mask

In Macromedia Flash, several shapes can be created inside of a symbol, and that symbol can be used as a mask.

The invention of Max Fleischer's Rotograph enabled animated characters to be placed into naturalistic settings. Since then, rotoscoping has served many purposes in the film and video industries. Creating animation by tracing over live-action frames, painting on top of video, manipulating or enhancing content through filtering and special effects, and retouching have all been performed on a frame-by-frame basis. Eventually the term rotoscoping became synonymous with any process executed on a frame-by-frame basis, including compositing.

rotoscoping via animated masks

Generating precise hand-executed mattes for moving images on a frame-by-frame basis depicts traditional rotoscoping in its true form. This process constitutes laborious hours spent on meticulous detail. The development of key-frameable spline masks in digital compositing has automated this process.

In the film *Titanic*, puffs of human breath were used to depict the chilled environment of the North Atlantic. (A large portion of the film was shot near the warm waters of the Pacific.) Several breath sequences were filmed and combined onto the original footage. Masks were created to protect foreground elements such as heads and shoulders so that a superimposed breath appearing to coming out of an actor's mouth would disappear behind them. Each mask was animated with extreme precision to follow the motions of those foreground elements. At points where registration was inaccurate, the compositor manually refined the mask's shape and position at certain key frames.

Motion graphics packages such as Pinnacle Commotion and Adobe After Effects have somewhat different methods for animating masks. In After Effects, mask properties are key framed on the Timeline in the same manner that transformations are interpolated. In Figure 8.38, a mask is created on frame 1 of a layer containing a video clip of the pages of a book being opened by a gust of air generated from a fan. A key frame is established for the Mask Shape, Mask Feather, and Mask Expansion properties. At frame 4, the shape of the mask is altered to conform to the updated image. A new key frame for the mask's shape is generated, and in-between shapes are interpolated. Additional key frames are created in-between, allowing the mask to be further refined in order to more closely adhere to the subject being rotoscoped.

8.38

Rotoscoping through mask interpolation
in Adobe After Effects.

In addition to the most common motion graphics packages, expensive high-end programs such as Matador Paint, Flame, Cincon, and Domino offer advanced masking tools that are specifically designed for rotoscoping live video footage.

motion tracking

Motion tracking is a process that allows you to monitor the movement of a group of pixels and generate a motion path from those pixels. The coordinates of the motion path can be used to rotoscoping properties of layers in a composition. In Figure 8.40, for example, motion tracking is used to make two layers follow the pixels from a video clip. The motion of the pixels that make up the duck's head and tail is tracked from frame to frame, and the resulting X and Y position data of each track are applied to the layers containing the text and the illustration.

Since the precision of the track data relies on the amount of chroma or luma differentiation in the tracking area, low resolution DV footage can be problematic. Inconsistencies between frames should be manually cleaned up ahead of time.

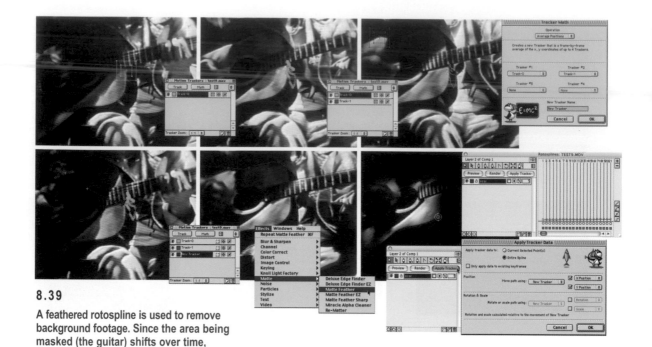

8.39

A feathered rotospline is used to remove background footage. Since the area being masked (the guitar) shifts over time, Pinnacle Commotion's motion tracker is used to generate a path based on the movement of a specified pixel. The path is applied to the rotospline, allowing it to follow the movement of the footage.

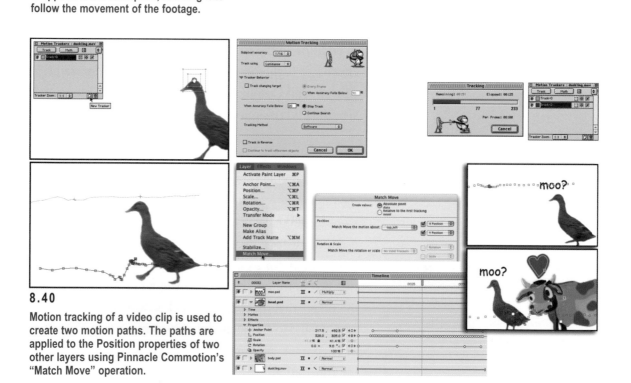

8.40

Motion tracking of a video clip is used to create two motion paths. The paths are applied to the Position properties of two other layers using Pinnacle Commotion's "Match Move" operation.

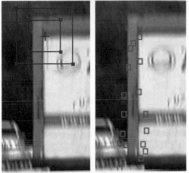

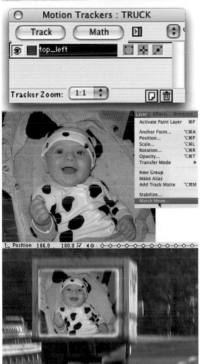

8.41

In Commotion, motion tracking is used to apply a motion path to the Position of a layer using the "Match Move" operation.

establishing consistency

Viewers become immediately drawn to elements that appear to be unnatural in the way that they move or change. Therefore, professional "roto artists" dedicate serious attention to maintaining visual consistency, since their goal is to minimize distractions that can be obvious to the most scrutinizing eyes. Even in this modern digital age, rotoscoping can be a tricky and meticulous process. Achieving precision over time can be considered an art in and of itself. Here are several tips:

1. Think like an animator.
The first step of roto-masking requires a careful analysis of the motion of the element(s) being masked. This means first identifying those frames that represent the subject's most extreme changes in position. Once these are established, the mask can be altered at each key frame to conform to the image, and your program of choice can perform the duty of interpolating the in-between positions.

2. Zoom into your work.
When generating masks, working close up is critical for achieving precision, especially along complex edges.

3. Choose naturalism over accuracy.
It is likely that you will need to tweak frames in-between the key frames in order to accurately conform the shape of the mask to the shape of the moving element(s). The advantages of this method, versus attempting to articulate every edge nuance in every frame, are time and consistency. The software's ability to calculate in-between keyframes saves a great deal of time and labor. More importantly, the mask will adhere to an element's motion in a more naturalistic way.

4. *Minimize the number of vertices.*

An undesirable effect of sloppy compositing is edge chatter—a phenomenon that occurs when a mask's outline changes irregularly from one frame to the next. This is usually a result of using too many vertex points along the path and moving those points inconsistently between frames. Creating a mask on the frame where an element's shape is intricate allows you to determine the minimum number of vertices needed to adequately mask it over the frames that are being rotoscoped. If you are masking in After Effects, consider using the Smart Mask Interpolation Keyframe Assistant for shapes that require the number of vertices to change.

5. *Break down complex images into multiple masks.*

Consider breaking the parts of a complex image down into separate masks and animating those masks individually. This will help establish accuracy and consistency and will also help maintain the integrity of the paths over time. Some mask shapes will only require interpolation of position or scale, while others may mandate alteration of geometry through the repositioning of vertex points. Mattes that conform to different parts of a subject can be articulated separately and can be individually animated.

6. *Consider B-splines for detailed masks.*

Software such as Commotion and Matador offers B-splines as an alternative to Bezier splines. When generating complex, detailed masks, most professional compositors prefer B-spline curves, since the tangent handles associated with Bezier paths can be distracting to the eye. Although B-splines may feel awkward at first, once you develop a level of comfort with them, they can result in easier editing and cleaner paths than Bezier curves.

8.42

In Pinnacle Commotion, a layered Photoshop file is imported as a series of separate images which are grouped together into a single folder that acts similar to a nested composition.

A composition can contain unlimited groups, and each group can contain an unlimited number of layers.

7. Weigh the options among masking, matting, and keying.
In compositing video images, there are advantages of Bezier masking over keying, such as the elimination of spillover caused by poor lighting conditions and the ease of performing in a natural setting versus on a synthetic blue-screen set (in the case of using people as subjects). On the other hand, keying elements that move against a uniform background can be much easier than animating the position and shape of a corresponding mask frame-by-frame. If only the position of the image (not its geometry) changes over time, a traveling matte or an alpha channel would be better options.

Nesting

One of the most powerful and convenient compositing techniques for constructing complex animation sequences that are easy to edit is nesting. This process involves two steps: building a layered composition and having it function as a single layer inside of another composition. (It may be helpful to think of nesting as a sequence within a sequence.)

nesting tools

Most professional nonlinear editing tools leverage the ability to nest in their timelines. The Avid Xpress system, for example, allows you to create and composite multiple video layers into a single track. In Apple's Final Cut Pro, any number of clips can be nested into a new sequence, and audio tracks that belonged to the original clips are automatically consolidated into a single track. A recent addition to Pinnacle Commotion is Grouping, which gives you the ability to perform nesting. Although you are limited to having one composition per project, you can have an unlimited number of groups within that composition, and each group can consist of an unlimited

8.43

Symbol nesting in Macromedia Flash.

Each animated character is integrated into a symbol, and the symbol's position is animated across the screen. The animation of each character can be refined independently in its original symbol.

number of layers. The process of nesting in Macromedia Flash was addressed in Chapter 7 with regard to combining relative movements. In Figure 8.43, Flash uses nesting as a compositing tool, in which several animated images are combined into a single scene and animated further.

building hierarchy

The goal of nesting is to implement an organized hierarchy of compositions in order to make the editing process easier and more effective. In Figure 8.44, several QuickTime video clips have been arranged into a *precomp* (a term that After Effects uses to describe an intermediate versus a final composition) to emulate the look of a video wall. The precomp is brought into a new composition as a single layer, and its Position, Scale, Y-Rotation, and X-Rotation is interpolated. Aditionally, a color tint is applied. This is an example of how nesting allows you to efficiently organize your composites. Rather than having to apply a transformation or an effect to each layer individually, nesting gives you the benefit of applying it only once to affect all layers in the nest. If, at any point, the layers in the original composite are tweaked, those changes are automatically updated in the nested composition.

You can establish many levels of nesting. Figure 8.45 demonstrates a series of nested compositions that make use of a single image. Comp 1, which contains a Hebrew–derived letterform, is nested into Comp 2 and is 3D enabled. Y Rotation key frames allow it to spin around its vertical axis. This composition is nested numerous times inside of Comp 3, and each instance of Comp 2 is assigned a different scale and position value. Additionally, their in-points are offset to vary their rotations. The final composite, Comp 4, contains a background video layer and an instance of Comp 3, which is luma

8.44

Nesting two levels in Adobe After Effects.

A composite (Comp 1) consisting of multiple QuickTime video layers is nested into a second composition (Comp 2). As a single layer in the nested Comp, a color effect is applied, and its Position, Scale, and Y Rotation properties are interpolated as each clip plays separately.

keyed above the video layer. Finally, Comp 3's Position and Transparency are key-framed over time. The speed of rotation for all the letterforms in the composite can be controlled by tweaking only two key frames in Comp 2. Changes are automatically reflected in every composition that Comp 2 is nested in. If the original image is replaced with a new image in Comp 1, every Comp containing Comp 1 will be updated accordingly while key-frame data is retained.

8.45

Nesting four levels deep in After Effects.

Comp 1 containing original image

Comp 2 containing an instance of Comp 1

Comp 3 containing multiple instances of Comp 2

Comp 4 containing a background and an instance of Comp 3

Animation Compositing

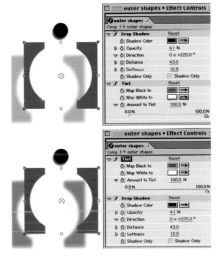

considering render order

Render order refers to the sequence in which motion, effects, and compositing data are calculated. For example, in Adobe After Effects, these are processed in the order by which they appear on the Timeline (8.46). The manner in which you nest allows you to override the application's default rendering order, giving you the ability to control what is processed first, second, and so on. Figure 8.47 shows a composition consisting of an animated logo that is assigned a drop shadow. Since After Effects calculates effects before transformations, scaling and rotating the logo causes the drop shadow to be affected inappropriately by the direction of rotation and amount of scaling that is applied. Comp 2 consists of the same animation minus the drop shadow. As a precomp, Comp 2 is nested inside of Comp 3. Since the Position and Rotation properties of Comp 2's layers are calculated before the effect applied in Comp 3, the shadow's correct orientation is maintained throughout the animation.

8.46

Adobe After Effects renders information in the order by which it appears on the Timeline: 1. Masks, 2. Effects, and 3. Transformations. Layers are rendered from the bottom up on the Timeline, and effects are processed from the top down in the Effect Controls or Timeline window.

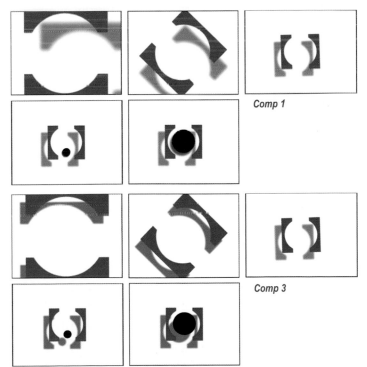

Comp 1

Comp 3

8.47

Nesting is used in After Effects to override the application's default render order. This allows the position and orientation of a drop shadow to be properly maintained during an animation.

nesting tips

1. *Establish hierarchy.*

Levels of hierarchy can make editing easier and allow you to synchronize elements of your animation. Adjusting the motions of multiple layers in a single composition could become an editing nightmare, especially if movements must match.

2. *Invest in RAM!*

Although the depth of nesting you can employ is virtually unlimited, nesting can be RAM intensive. Every frame of a nested sequence traces back to the original media file that is stored on your hard drive. This process requires a large portion of available RAM, and if you have RAM limitations, loading up multiple nests simultaneously can result in sluggish behavior on the part of your hardware.

3. *Keep organized.*

Assigning useful names to your nested sequences can save time by eliminating the need to search around to determine what elements and interpolation each precomp contains.

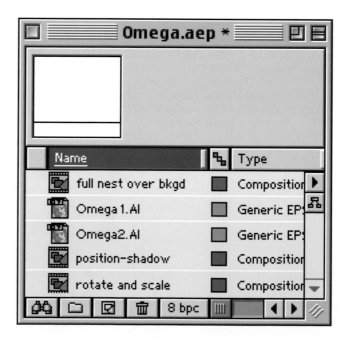

8.48

Names are assigned to compositions in Adobe After Effects to help identify what elements and interpolation each contains.

Animation Compositing

v Output and Delivery

9

output criteria

If you are designing for print, criteria such as font size, color use, and composition dimensions are often dictated by the final output format. Designing a traditional business card for a one-person operation might require the use of small typefaces within a small rectangular space. If the printing budget is low, the palette may be limited to one or two process colors. A poster for an art institution, by comparison, will probably allow for a more liberal use of point sizes within a larger, vertical format. If the budget allows four-color printing, the designer will have an unlimited palette. Likewise, distribution formats such as film, videotape, and digital media play an important role in determining how animations/motion graphic presentations are produced and delivered.

"All the technological advancements and distribution choices are meaningless without stories told with passion, artistry, and honesty—that's the truth."

— *Jan Roberts–Breslin*

chapter outline

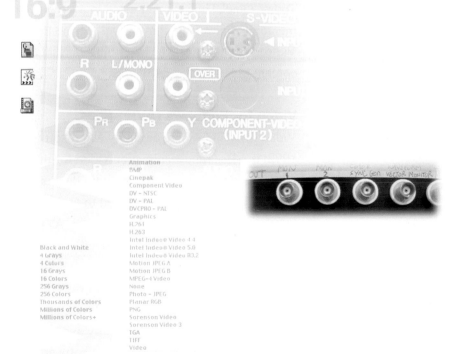

00 : 00 : 00 : 09

Animation File Types: An Overview

QuickTime

Historically, QuickTime and AVI have been the most widely used digital video formats. QuickTime was developed by Apple Computer and released in 1991 as a video/animation technology that allowed moving images to be displayed on Macintosh computers. Since then, it has become a widely used multiplatform, industry-standard architecture for creating and delivering video and audio files across a wide range of distribution formats. The QuickTime format is well suited for the delivery of animation on CD-ROM since it is a cross-platform standard that is supported by Macintosh and Windows platforms. QuickTime animations can be created in most motion graphics applications.

Today, QuickTime is manifested in a suite of programs including QuickTime Player, QuickTime Pro, and Picture Viewer, and in several browser plug-ins that allow QuickTime content to be viewed on Web pages.

Video for Windows (AVI)

Video for Windows, released by Microsoft Corporation in 1992, is a less robust animation/video format than QuickTime that is used to store video and audio data on the PC. Video for Windows files is also referred to as AVI (Audio Video Interleave), since they are saved with a .AVI extension. (Video and audio is interleaved consecutively, meaning that a segment of video information is immediately followed by a segment of audio.) AVI files, which are read by Windows Media Player, have not yet been replaced by QuickTime because the majority of computers owned by average consumers today are PCs (and can play AVIs without software download).

The latest version of QuickTime and related plug-ins can be found at www.apple.com. The utilities are free with the exception of QuickTime Pro. QuickTime Pro is the full version of Apple's QuickTime player, designed for video editing and multimedia authoring. For a small fee, it is worth purchasing from Apple.

Flash

Macromedia Flash has become a popular animation format for the World Wide Web. Because of its capacity for full-screen playback on all monitor sizes and across multiple platforms, animators and multimedia developers have deemed it a more enticing Web distribution format than traditional Web technologies. Flash files can be viewed using Flash Player, Java, Director projectors, or Shockwave.

The Macromedia Flash Player can be downloaded for free at www.macromedia.com.

Although Flash animations were initially designed for Web delivery, they can easily be tailored for CD-ROM with high frame rates, large images, and high-quality output settings that are not optimal for Web display. If a Flash piece is intended to run from a CD-ROM, its settings can be changed to reduce its file size and enable it to load quickly over the Internet with minimal tweaking of the original version (provided that high-resolution bitmap images are not used).

animated GIF

In the early days of the Internet when the Web was a static environment, the advent of the Gif 89a format allowed you to save multiple images in a single GIF document and play them in sequence like a slide show, one frame at a time. Since the mid-1990s, when Netscape Navigator and Microsoft Internet Explorer added support for the Gif 89a format, animated GIFs began to permeate the Web rapidly.

Flash content that is authored in Flash is created for the Flash plug-in. Shockwave content that is authored in Director is created for the Shockwave plug-in.

The fact that the GIF format is supported by most browsers gives assurance that most visitors will be able to view them on your site. Additionally, programming skills are not needed to create animated GIFs, and for these reasons, this delivery format has powerful advantages over other Web formats such as QuickTime, Shockwave, and Flash.

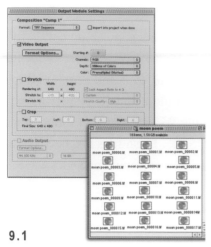

9.1

A sequence of rendered TIFF files named with "padded" numbers.

file sequences

Although movie files are most convenient for easy previewing, a sequence of still images can be used to develop frame-by-frame animations, transfer frames to film using a film recorder, and output for storyboard production. Many motion graphics applications have the ability to export animations as numbered files in a variety of formats.

Rendering

Rendering, a process that is common to most desktop motion graphics applications, is the final phase of development, prior to final output, in which a sequence of bitmap image frames are generated in chronological order at a specified frame rate. Each image exhibits all the components of the animation— the images, changes in motion, speed data, camera views, lighting conditions, and special effects.

A composition is rendered in Adobe After Effects by placing it into a render queue (9.2) and assigning specific render settings to it. At this stage, specifications such as file format, frame rate, frame dimensions, compression scheme, and audio output are determined. Once these settings have been specified, the computer renders the file accordingly. The time it takes for an animation to render is partly hardware dependent, relying on the computer's central processing unit and hard drive. Rendering speed also depends on several other factors. Large frame dimensions (or number of pixels in each frame) for broadcast television output require considerably longer computations than smaller resolutions for Internet or CD-ROM delivery. An animation that is rendered at a frame

9.2

Adobe After Effects' render queue window.

After Effects allows you to "batch render" several compositions in a project.

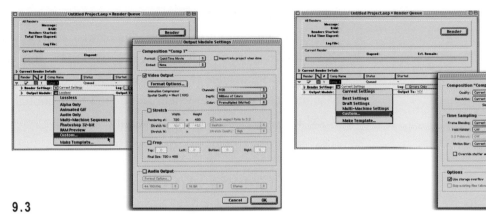

9.3

Adobe After Effects' Render Settings and Output Module.

rate of 30 fps will take twice as much processing time than if it is rendered at a rate of 15 fps, since there are twice as many frames to calculate. The number of layers in a composition also plays a major role in determining rendering speed. The complexity of motion, determined by amount and types of operations that have interpolation, as well as the number of key frames that are used for interpolation, affects rendering speed. Color depth is also an indication of rendering speed: 32-bit color images with alpha data require more calculations than 24-bit or 8-bit renderings. Data compression, which may be necessary if the work is intended to be displayed on a hard drive, CD-ROM, or over the Internet, also requires additional processing time.

A single frame, a specified frame range, or an entire composition can be rendered, and the output can be generated in different sizes to meet the demands of multiple delivery formats. For example, a 720 x 480 movie can be created for DVD-Video encoding or videotape recording, while a smaller 320 x 240 pixel movie can also be created to be displayed in an on-screen presentation or on a CD-ROM. You can create a template that saves your render settings to a file to be used on another computer. Additionally, After Effects allows you to create low-resolution thumbnails for motion tests. For example, if your composition's dimensions are 720 x 480, you specify a quarter resolution, resulting in a 320 x 240

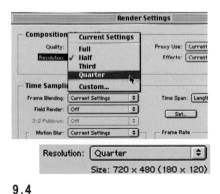

9.4

In Adobe After Effects, creating a small "test render" is accomplished in the Render Settings dialog.

movie that is rendered almost four times faster than at full resolution. This will give you an idea of what motion will be like and allow you to make changes accordingly. This is strongly recommended if you are working on a standard Macintosh or Windows system and do not have enough RAM to preview your work in real time.

Output Criteria: An Overview

Whether your work is intended for analog display on a television monitor or for digital presentation over the Internet or on a CD-ROM, there are several output criteria that should be considered ahead of time. Depending on the situation, you may need to perform a juggling act to determine which ones should be given highest priority. For example, CD-ROM or Web delivery might entail that image quality be sacrificed through data compression in order to achieve smooth playback from disk over a network. It is up to you to view these constraints as technically frustrating or creatively challenging.

frame rate

The maximum speed in which an animation can play corresponds to its *frame rate*, measured in frames per second (fps). This indicates the amount of times per second that pictures are updated sequentially to create the illusion of persistence of vision. For example, motion picture film has a rate of 24 fps, while American broadcast video has a standard rate of 29.97 fps. The EBU (European Broadcasting Union) standard of 25 fps is used throughout Europe and Australia, where color TV systems are based on PAL or SECAM resolutions. All three of these speeds are sufficient to achieve believable motion for filmed or animated subjects.

Frame-by-frame animations can be produced at lower frame rates (between 8 and 15 frames per second) than live-action video, since they contain less detail. (A frame rate of 12–15 fps usually yields adequate results for CD-ROM and Web output.) However, if the frame rate is too slow, an animation can appear too choppy. If the playback rate is set to a higher value than the speed at which the original footage was created, frames will be duplicated, resulting in an unnecessary addition of data and larger file size. If the rate is set to a lower value than the initial speed, frames will be dropped out, which will reduce file size; however, dropping too many may produce choppy motion.

> The human optical system is capable of capturing pictures 18–20 times per second; in order to give a more convincing illusion of motion, a frame rate that is greater than this is necessary.

frame dimensions

Frame dimensions refer to the height and width of each animation frame in pixel units. (This is also referred to as frame resolution, not to be confused with image resolution.) Full-screen television video sizes, for example, include 720 x 480 for D1/DV NTSC and 720 x 576 pixels for D1/DV PAL/SECAM. Common display sizes for Web and CD-ROM delivery are 320 x 240, 240 x 180, and 160 x 120.

data transfer rate

The *data transfer rate* is the amount of data that a computer interface can deliver each second. This criteria is sometimes expressed in megabytes per second (or Mbps). For example, Ethernet data networks, which are designed to transfer data over relatively short distances, have standardized data rates of 10 megabytes per second (Mbps).

In order for an animation to play back smoothly from a hard drive or over the Internet, a process called *compression* is applied to reduce the data rate to a more manageable number that is compatible with the capacity of the system delivering it.

When uncompressed digital video is captured, the sampling process can generate high data rates over 24 Mbps. For that matter, data transfer rates for Internet connectivity will continue to increase, eventually allowing Web communication to encompass full-screen video without compromises.

image quality

Depending upon the final delivery format, image quality may need to be subordinated to smooth motion. For CD-ROM and Web distribution, applying compression is usually a necessary measure of facilitating acceptable playback.

file storage

In the past, file size was a serious consideration for full-screen animations intended to perform at speeds applicable for film or television. Sufficient disk space had to be available to accommodate the rendered image data. Today, external drives, DVD-ROMs, and network servers offer storage capacities that can handle large amounts of data.

Optimization: Data Compression

Optimization is the process by which images, static or animated, are prepared to be displayed on the computer screen (i.e., from a hard drive or over a network). Optimization techniques can minimize storage requirements and decrease bandwidth for the transmission of moving images within and between systems. Whether you are producing a QuickTime animation for a CD-ROM or an animated GIF to be displayed on the Web, the objective is to create an aesthetically engaging production that looks good and plays smoothly on all possible platforms. The two most common techniques of optimization are palette reduction (or color depth reduction) and data compression.

Data compression is a process by which image data is reduced and reconfigured in exchange for smaller file sizes and steady playback. In the case of Web and multimedia delivery, QuickTime or Video for Windows files can be enormous, especially if they are intended to be played at high

File Size: 4 MB (2,288,395 bytes)

File Size: 40.9 MB (42,994,456 bytes)

9.5

Lossy compression versus nonlossy compression of a video clip.

frame rates above 15 fps and at large frame sizes of 320 x 240 or greater. Data compression reduces them to more manageable sizes. However, image quality is sacrificed, depending on the amount of compression that is applied.

lossy, lossless, and temporal compression

Lossy compression strategically removes visual data that are least apparent. High-quality settings work most effectively with footage containing a high level of detail. Low-quality settings result in a noticeable difference as more image data is discarded.

Lossless compression maintains the original integrity of the images by restructuring the original data without removing it. Lossy compression typically uses the process of *run-length encoding*—a technique in which continuous areas of similar color are disregarded. This process works best with imagery that consists of shapes of identical colors such as simple graphics and text. Lossless compression does not work well with live video imagery consisting of continuous-tone images.

Temporal compression is a strategy for conserving image areas that do not change between frames. One method of accomplishing this is called *frame differencing*. With frame differencing, the "key frame" is saved in entirety, while intervening frames are compressed based on their differences from the key frames. This is usually for 30 fps use between 1 and 10 key frames per second and for 15 fps use between 1 and 5 per second. The number of key frames will be dependent on the amount of change per second in your footage. Panning movements do not key-frame well. Key framing will default to every frame unless set otherwise.

software and hardware compression

Software compression can reduce file sizes by as much as 100 times and works best with small frame sizes (320 x 240 pixels or less) that are intended for CD-ROM or Web display. QuickTime supports several software *codecs* (short for compressor/decompressor). *Hardware compression* is the most effective yet most expensive method of capturing and outputting high-quality, full-motion video. Nonlinear editing systems such as the Avid and Media 100 provide high-quality hardware compression schemes. Hardware compression expansion boards offer another solution for outputting video to analog camcorders and tape decks. M-JPEG and MPEG are the most common types of hardware compressors.

QuickTime software codecs

Over the past few years, the demands of new communications media have caused the industry to develop improved compression algorithms in order to achieve better quality video and audio with less disk storage requirements.

Codecs work by eliminating any type of redundancy such as areas where most of the picture remains the same over time and large areas of similar color or value. This technology can reduce file sizes by as much as 100 times.

Factors that can determine which codec is most appropriate for your particular distribution method are the types of content being animated (solid graphic shapes, photographic images, live video, etc.), the speed at which things move and the size of the images relative to the frame.

The cross-platform QuickTime codecs that are described are some of the most widely used compressors for disk-based and Web output. Each differs with regard to how compression is performed, and many allow the compression ratio (or

Substantial time should be invested in experimentation and testing in order to determine which codec is best suited for your particular situation.

amount of compression that is applied) to be manually adjusted. This gives you control over the balance between image quality and playback quality.

None

None is a lossless compressor that is often used as an intermediate solution for storing raw data that needs to be archived. It is inefficient for final output, since it produces huge files that usually cannot play back smoothly from a standard computer system.

Video

Apple's Video codec was created to record and deliver fast compression for live-action analog video. Both spatial and temporal compression are used to achieve moderate-quality playback from a hard disk and from CD-ROM. Recompression (or repeated passes of the codec) can be applied to enhance playback with a minimal amount of image degradation. The Video compressor plays well on very old machines, making it a safe codec for a wide range of Macintosh CPUs. However, the image quality that results is not acceptable for animation. Therefore, this codec is most suited for motion testing, but not for final delivery.

Animation

The Animation compressor, developed by Apple, is most suitable for digitally generated animations (versus live-action video) that contain large areas of solid colors. Its algorithm, which uses a run length encoding technique, performs minimal compression. As a result, most of the original image data is retained, and resulting files are usually large. This codec can be lossless or lossy, depending on the settings that are specified. (If set to 100% or "Most," the result is lossless. Settings between 1% and 99% are lossy.) The animation codec works well with areas of continuous tone and is therefore useful for

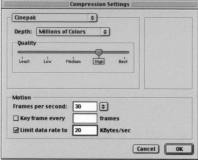

9.6

Apple Cinepak's codec allows you to specify a data transfer rate ahead of time. Image artifacts become apparent at data rates below 30 KBps.

title sequences and 32-bit motion graphics containing alpha channels. (Animation is not a good delivery format since the resulting file sizes are usually too large. However, it is good for transporting graphic elements, but only at 100%.)

Cinepak

For the past decade, Cinepak has been a popular compression scheme for multimedia and Web-based animations. This codec discards large amounts of image data, attaining low data rates and small file sizes for CD-ROM and the Web. Although Cinepak compression slows down rendering time, both image quality and playback speed are considerably greater than with the Video codec. In contrast to the Animation codec, image quality is compromised as a consequence of the heavy compression that is performed. This is the trade-off for smooth playback quality. Applying this codec to raw, uncompressed data, or data that has been treated with a lossless codec, yields optimal results.

Sorenson Video

The Sorenson codec, developed by Apple Computer and Sorenson Media, is one of the best compressors for CD-ROM and Web delivery. It retains superior image quality and small file sizes (in comparison to Cinepak) and supports large frame dimensions with low data transfer rates. It also uses temporal scalability to allow movies intended for fast processors to play back smoothly on low-end computer systems.

Graphics

Apple's Graphics compressor works most effectively with hand-executed or digitally generated animations that are intended for playback on systems that have a maximum display depth of 8 bits (or 256 colors). Although this codec compresses files at a greater ratio than the Animation compressor, it does not play as quickly and is a poor choice for playback on CD/DVD-ROMs.

DV-NTSC and DV-PAL

Apple's DV-NTSC and DV-PAL codecs were designed to compress video to be transferred directly from a DV deck or camera using the Firewire interface on Macintosh computers. They also work as transcoders for transferring video across platforms that are equipped with digital video capture cards. Both of these compressors have a fixed data rate of 3.6 MB/second and frame size of 720 x 480. DV-NTSC is native to DV cameras manufactured in North America and Japan; DV-PAL is designed for European-manufactured DV cameras. DV-NTSC and DV-PAL are considered a software–hardware hybrid, as there are DV capture cards that come equipped with their own hardware version of this codec.

MPEG-2

MPEG-2 video has gained a considerable reputation due to its excellent signal and ability to interlace video for NTSC or PAL/SECAM resolutions. It is also capable of storing and outputting information at low data transfer rates. Its algorithm is usually tailored toward hardware capture cards and DVD production. Most software allows you to import and export MPEG-2 files with minimal loss of quality using a capture card that supports MPEG-2 compression. MPEG-2 video is comparable in quality to S-VHS videotape and supports interlaced video.

MPEG-1

MPEG-1 is suitable for video distributed on CD-ROM, DVD, and Video CD since it produces small file sizes and low data rates (approximately 8 MB per minute). Comparable to consumer VHS videotape, MPEG-1 video is noninterlaced, containing no fields. It yields longer playing times than MPEG-2 at the sacrifice of decreased image resolution. This type of encoding is used where playing time takes precedence over resolution. (For most purposes, MPEG-2 is more commonly used to achieve maximum quality.)

Because of their high level of spatial and temporal interframe compression, MPEG-1 and MPEG-2 should be used for final output only, since recompression produces unacceptable loss in image quality. Most systems cannot play back MPEG-1 encoded files without special-purpose hardware, although software playback is becoming common on PCs.

MPEG-4

Evolving from MPEG-2 and developed by the Moving Picture Experts Group, MPEG-4 compression is designed to produce higher compression ratios in order to distribute real-time video and audio content with minimal loss of quality and a range of data rates "from narrowband to broadband and beyond" over the Internet and on CD-ROM. It has been stated that MPEG-4 will play a major role in interactive, digital television and become a universal language for broadcasting, motion pictures, and multimedia presentations.

JPEG

Developed by the Joint Photographic Experts Group, JPEG became an international file format for compressing static images. This software-based compressor can be used for animation in cases where image quality takes precedence over motion. However, it is not intended to be played back at high frame rates, since it is mathematically complex, requiring considerable CPU processing power. It is best used for animations that contain photographic image content, versus solid graphics with sharp edge details.

At high quality settings, the result of Photo-JPEG compression is almost indistinguishable from the original. However, since it is a lossy codec, is not recommended for editing purposes, as image quality is reduced each time the file is updated.

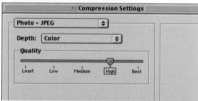

9.7
Results of Photo-JPEG compression.

Motion JPEG A and Motion JPEG B

Motion JPEG A and B are versions of JPEG codecs that are implemented by many video capture cards to transfer video files between computer systems. Both types of compressors are not fast enough to play back animations with sound at acceptable frame rates. Additionally, they require considerable disk space and have slow rendering times.

10

output for motion pictures and television

DELIVERING ANIMATION FOR FILM AND VIDEO

Film and videotape are the two most traditional delivery formats for motion pictures and television. Both have lived parallel although not concurrent lives, allowing full motion, high quality images that are synchronized with audio to be to presented to audiences. Film has enjoyed consistent international standards since its inception while videotape has progressed through numerous formats and incompatible broadcast standards worldwide. In the television industry, there is currently a significant move toward the use of digital formats to attain better image quality. With the advent of high-definition video, the format of the cinema and of the home may merge.

"Videographers must be prepared to learn the language that film shooters have built over the last 100 years. It's a language made up of camera movements, filtering techniques, subtleties of focus, and depth of field. And it's a language coming into the video world through the gateway of high-definition television."

— *Pierre de Lespinois*

chapter outline

00 : 00 : 00 : 1 0

Film

Motion picture film is the oldest medium for delivering large-scale moving images. It continues to be the most common delivery format for theatre projection because it can reach large audiences at once. The experience of traveling to a film festival, museum, gallery, or a local theatre to view animation on "the big screen" can further elevate the excitement and impact of the work.

specifications of film

frame rate and the art of 24p

In standard motion-picture film with sound, individual images are passed on to the eye through reflected light at 24 frames per second. (35mm film projectors interrupt the display twice to create a perceived frame rate of 48 fps.) *24p* refers to a frame rate of 24 progressive frames per second (as opposed to interlaced fields per second used in video).

Traditional animation cels that were produced by hand were shot as progressive film frames without interlacing. Today, many animators still honor the technique of 24p to emulate the look of film, maximize production time, and allow their animations to be viewed on film and on standard interlaced video devices.

The familiar effect of "slow-motion" subjects in action is obtained by operating the camera at three or more times its normal frame rate, allowing the image's duration to be extended three or more times its initial duration when it is projected at normal speed. When the camera is operated at a slower-than-normal speed, the illusion of fast motion occurs, producing a time lapse effect.

In film, each frame is described as a numerical value, with no association with time. The terms "frames" and "feet" used in the film industry refer to the number of frames per foot of 16mm or 35mm motion-picture film.

Scientific uses of time-lapse filming include the observation of weather patterns and natural phenomena such as seed germination. Rather than filming in frames per second, a single frame can be photographed in varying time intervals (i.e., every 30 seconds, 1 minute, 5 minutes, 30 minutes, hour, etc.) depending on the nature of the subject and the abilities of the camera.

picture resolution

Video frames are composed of scan lines, whereas film is an analog chemical-based process that etches images directly onto film emulsion. The quality of the film image is far superior to that of video. As opposed to video's random electronic noise, granular patterns of film grain are chaotic but consistent, created by silver particles that hold the image.

Video is an electronic process that transmits images directly from phosphor emissions in a cathode ray tube (CRT). Each frame of video is composed of two fields (or partial frames) of odd and even line information in odd and even fields at a sample rate of 59.94 fields per second or 29.97 frames per second, alternating between odd and even field transmission. Since video fields carry both time and motion data within the frame, there is a more heightened fluidity of movement during playback. Similar to a noninterlaced monitor, film tends to exhibit more pronounced "strobelike" effects at low frame rates. (This was true during the silent film era.) However, the quality of filmed images is far superior to that of video.

When film frames are stored digitally, a horizontal resolution of 1K, 2K, 3K, or 4K can be used. (2K and 4K are the most common.) Pixel height varies depending on the aspect ratio. 1K resolution is the lowest, yielding a result that is similar to video, and 3K and 4K resolutions are the most aesthetically desirable. 2K resolution is the most common because of reduced file size and less taxing output requirements.

If you are digitizing images for eventual film output, you can calculate what the appropriate scanning resolution should be by dividing the film resolution that will be used by the horizontal dimensions of your image in inches. For example, if the output resolution will be 2K, and your image measures 10 inches horizontally, you would scan it at 200 dpi.

frame aspect ratio

Up until the early 1950s, motion pictures were filmed in an aspect ratio of 1.33:1 (technically, it was actually 1.37:1, but 1.33:1 is the recognized standard). This means that the picture is 1.33 times as wide as it is tall or measures 4 units of width for every 3 of height. Recognized formally by the Academy of Motion Picture Arts and Sciences in the 1930s, this eventually became known as Academy Standard. Classic films such as *Gone With the Wind, The Wizard of Oz,* and *Singing in the Rain* appeared in this ratio.

Film frame aspect ratios have changed over the course of history in order to accommodate sound and to compete against television by offering wide-screen pictures. The development of wide-screen formats aimed to create a more visually breathtaking experience that would give viewers an incentive to attend the theatre rather stay at home. Currently, the two most common standards of 16mm and 35mm motion picture film are Academy (1.33:1 or 4:3) and wide-screen (1.85:1 or 16:9). The Academy format has been traditionally used by television. Today, films are rarely exhibited in the Academy format unless they are screened for television. In the United States, 35mm is usually projected at a wide-screen ratio of 1.85:1 by cutting off the top and bottom of the frame. A less widely used format is CinemaScope (also called "letterbox" or "anamorphic") with an aspect ratio of 2.35:1.

10.1

Academy and widescreen film formats.

1:33:1
Academy Standard
NTSC Television (4x3)

1:85:1
Academy Flat

2:35:1
Anamorphic Scope
(Panavision/CinemaScope)

Most three-chip digital video cameras are suitable for capturing images for film output. DVFilm recommends several models: Canon XL-1S or GL-2, Sony VX-2000, PD-150, JVC 16:9-capable GY-DV700, and Panasonic DVX100. The Sony DSR-500WS (about $15,000) has close to DigiBeta quality with true 16:9. Whether the camera is digital or analog, the most important specs are "lines of resolution." Analog video captured with a broadcast-quality card is as good as DV. Three-chip cameras are generally better than single-chip cameras.

Suggested video output settings:

frame rate: 24 fps

frame dimensions for 16mm: 640 x 480 or 1280 x 960 square pixels (1.33:1 Academy)

frame dimensions for 35mm: 1280 x 720 or 1920 x 1080 square pixels (16:9 Wide Screen)

1204 x 1024, 2:1 horizontal squeeze or 2408 x 1024 square pixels (2.35:1 CinemaScope)

software codec(s): None or Apple DV

Audio should be saved in AIFF or WAV format separately and edited into 20-minute segments to prepare the film's sound track.

preparing content for film distribution

capturing live footage (shooting 16:9)

Live-action footage to be integrated into animation for film should be shot with a 16:9 ratio. The output can also be used for standard-definition televisions to achieve a wide-screen, cinematic feel. If your camcorder can shoot in 16:9, you can capture your content anamorphically. This method, however, yields the lowest resolution, since the top and bottom of the frame are cropped off and stretched. Alternatively, you can shoot and protect a 16:9 picture on 4:3. A more expensive option is to purchase an anamorphic lens—a wide-angle lens that optically distorts the 16:9 image into a 4:3 frame before sending it into your camcorder's charged coupled device. Since this is done optically, the result is clean and clear and takes advantage of the full DV frame.

deinterlacing

If your animation contains video elements that have been captured, they will need to be deinterlaced into progressive frames to be outputted to film. Inexpensive film motion software is available to convert interlaced video to progressive scan. This gives the footage a more cinematic look as it creates 30 images per second (versus video's 60 fields per second). DVFilm Maker and DVFilm Atlantis are two excellent programs for converting interlaced video to progressive scan, making it look like it was shot on film. (DVFilm Atlantis also converts PAL to NTSC.)

film formats

high-end professional formats

35mm and 70mm

The cost of 35mm and 70mm filmmaking is not affordable for independent and low-budget productions. 35mm is the most common format among feature films, motion picture

theatres, television commercials, music videos, and television shows (with the exception of news programs). Although 70mm film is more than twice as expensive to buy and process, it is not obsolete among large theatres and wealthy producers. No other analog format matches its color sharpness and clarity.

standard professional and amateur formats

16mm

16mm was introduced in the United States in the early 1920s. During the 1930s and 1940s, almost all films were 16mm; today, it is still considered the standard picture format for commercial, educational, and documentary film. 16mm also remains popular in upper-level education and among independent filmmakers, since stock and processing costs are reasonably affordable. Additionally, 16mm equipment is lightweight and easily portable for filming on location.

8mm

Based on the 16mm format, Kodak issued an 8mm medium called "Cine Kodak Eight" in 1932. Its objective was to provide amateurs and home moviemakers with an affordable means of filmmaking. For almost two decades, 8mm was the most popular motion picture format among amateurs and student filmmakers. By the 1950s, 8mm movies were a common source of family entertainment at home parties. Today, 8mm film is no longer being manufactured.

Super 8mm

The Super 8mm film format, introduced by Kodak in 1965, was a replacement for 8mm film. A larger picture area and easier camera loading allowed this format to compete with 16mm. Today, it is still the most affordable format, and its crude quality offers a unique, "raw" look that many digital animators have attempted to emulate. A growing community of filmmakers have expressed a revived interest in Super8

10.2

Standard 8mm, super 8mm, 16mm, and 35mm film.

Based on the 16mm format, 8mm (also called *Double8*) measures one half the height and width of 16mm film and contains sprocket holes on one side of each frame. Super 8mm film features smaller sprocket holes and less space between frames than regular 8mm format, resulting in a 50% greater viewing area.

Output for Motion Pictures and Television

Super 8 cameras throughout the 1970s and 1980s were used like video camcorders are used today—for documenting family vacations, birthdays, and peculiar pet footage to submit to "Animal Outtakes!"

Information about MovieStuff's facilities and transfer costs can be found at www.moviestuff.biz.

If you wish to transfer a PAL project to film, it is best for the time-conversion process from 25 to 24 fps to provide separate music, voice, and sound effects tracks on a CD-ROM disk or external hard drive. The tracks will be time-expanded to 24 fps and mixed to produce the final track.

filmmaking, and evidence that this format prevails is stated in one of Kodak's Web sites: *"From its beginnings as the home movie medium of the 60s, Super 8 film is alive and well and making it possible for virtually anyone to bring the unmistakable 'look and feel' of real film to the screen."*

If you cannot afford 16mm film, Super 8mm is a less costly format for capturing animation frame-by-frame. Companies such as MovieStuff specialize in transferring Super 8 footage to DV tape for digital storage and postproduction. Because the availability of Super 8mm stock is limited, it is best to purchase it directly from Kodak (www.kodak.com).

film transfer

Transferring digital files to film for theatrical distribution requires a film laboratory or *transfer house*. This type of facility uses high-end systems to capture, store, and resample analog or digital video at 24 fps. Images are recorded onto a 35mm or 16mm negative at 2K resolution, and audio is recorded to timecode DAT and transferred to an optical sound negative. The image and sound track negatives are printed to positive film using a contact printer. The resulting print is compatible with any worldwide movie theatre system. Film transfer is quite expensive. (Some services offer scrolling titles for free if you provide high-resolution files on disk.) Feature-length transfers to 35mm can range upward from $20,000, and $13,000 for 75 minutes on 16mm. DVFilm is one of the lowest-cost digital transfer facilities in the world, offering special rates to members of a mailing list. Its Los Angeles-based lab is open to visitors, and you can screen your completed work there for free. You can also mail the company a disk containing a few of your frames, and they will transfer them to 35mm slides for you to project. Alternatively, you can arrange to have a 35mm silent test made of a few minutes of your work at a cost of $275 per minute for 35mm with a 2-minute minimum.

Film transfer facilities have certain preparation guidelines that, if followed, can keep the overall cost down. (Otherwise, fees will be charged for editing time.) Since 35mm prints are manufactured and shipped on 20-minute reels, your work should be edited into 20-minute segments. (Multiplex cinemas splice the reels together for projection, while small theatres and art houses usually show one after the other with a two-projector system.) DVFilm requires that each 20-minute segment be preceded by a leader consisting of 30 seconds of black, a .05 sec, 1-kHz head beep accompanied by a video frame of the number 2 in sync with the beep, followed by 59 video frames of black. Following the reel, there must be an audio "pull-up" consisting of 50 video frames of black with a copy of the sound from the first 50 frames of the next reel.

More information about DVFilm's facilities and transfer costs can be found at www.dvfilm.com.

delivery guidelines

The following tips are applicable to producing animation that is destined to be displayed on the "big screen."

1. Create and render your animation at 16:9.
The wide-screen frame is ideal for outputting to film.

2. Avoid film effects.
There are an abundance of "film look" plug-ins that can add grain or diffusion to the picture. However, these subtract from the clarity of the image. Because film prints already contain natural amounts of graininess, there is no need to add these effects electronically. If you wish to emulate the "film look" on videotape, create a separate version of your animation with no added effects for film transfer purposes.

3. Do not mix 24p with interlaced 29.97 fps.
For the most professional-looking results, avoid mixing frame rates of animation and live action shot on video or film. Mixing 24p animations with 29.97 interlaced live-action footage can create a strobe-like quality, making the

animated elements appear to be incorrectly rendered, versus the rest of the video, which will look fluid in comparison.

4. Scan according to the final output film resolution.
Be sure to scan images at an appropriate resolution by dividing the output film resolution (1000, 2000, 3000, or 4000) by the field size of your image in inches. Scanning a little larger can allow you to crop the image if necessary.

5. Make both high- and low-resolution copies of your images.
Low-resolution images can be used in the working file to allow motion to be previewed in real time during production. These can later be replaced with the high-res versions before rendering. (In Adobe After Effects, this is called a *proxy*.)

6. Always keep high-resolution master files of your work!

Videotape

Videotape today is intended for many different venues, including broadcast television, institutional training videos, promotional videos, and corporate presentations.

specifications of video

accessing frames: time code
Time code, developed in 1967 by the Society of Motion Picture and Television Engineers (SMPTE), describes time numerically, allowing individual frames to be identified on a time line. Each frame is expressed in hours, minutes, seconds, and frames. For example, a time of 2 seconds in SMPTE time is expressed as "00:00:02.00." Time code is encoded onto videotape to enable you to edit with precision, synchronize sound and image, and coordinate the timing of different video sources that are composited together.

frame aspect ratio

Motion pictures that predated wide-screen formats used the Academy format, which yielded a 4:3 aspect ratio. Digital video and DVD-Video formats also use the Academy format. This aspect ratio has been the tradition of television for many years, although a wide-screen format of 16:9 is being adopted with the emergence of HDTV.

frame resolution

Video frames are composed of pixels representing color and luminance values. The more pixels there are per frame, the higher the resolution. A single frame of NTSC digital video contains approximately 345,600 (720 x 480) pixels, while PAL digital video frames yield slightly greater resolutions of about 414,720 (720 x 576) pixels.

square versus rectangular pixels

Although most computer displays are based on square pixels, rectangular pixels are a concept that digital video artists and animators must come to terms with. Television's actual resolution is 720 x 486, which does not match up to a 4:3 aspect ratio. As a result, rectangular pixels are used to compensate. After Effects assigns nonsquare pixel aspect ratios for certain frame sizes such as 720 x 480 or 720 x 486. As a general rule, importing nonsquare pixel video footage into a nonsquare composition is recommended over stretching it to fit a square pixel comp. If you are working in Photoshop or Illustrator, avoid sizes such as 720 x 480 and 720 x 486 as After Effects will treat them as nonsquare and cause image distortions.

interlaced fields versus progressive frames

Digital video comes in two frame formats: interlaced or non-interlaced. In interlaced video, every frame of footage consists of two fields: an odd (or upper) and an even (or lower) field. Therefore, one second of interlaced video consists of 30

frames and 60 fields. (The playback rate of video is really 60 fields per second, alternating between odd and even field transmission.) Interlacing produces smooth, high-quality motion and has become adopted as the NTSC's standard for the broadcast television industry. The electron beam of a television monitor scans approximately 525 lines on the screen at a rate of 59.94 fields per second to maintain a rate of 29.97 frames per second. The first odd field of alternating lines is displayed first, then the even field fills in the spaces. A flickering effect is apparent when a freeze frame of video of a rapidly moving object is paused. The object appears to vibrate rapidly as the monitor attempts to display both fields of the frame simultaneously.

Noninterlaced video is similar to motion-picture film, in that each frame is displayed as a single image. (Progressive frames mean that interlacing is not present, resulting in a full vertical frame of information.) Frames are generated from scan lines that are drawn in one vertical pass from top to bottom. The majority of computer monitors operate in noninterlaced mode, and the scan refresh rate is at least twice as frequent as that of NTSC screens. (This is the reason why filming a computer screen produces the appearance of distracting horizontal lines.) Noninterlaced monitors can easily play back digitized interlaced footage, and noninterlaced video will display as interlaced on NTSC screens.

Interlaced video displays involve an electron beam which scans 525 lines on the television monitor at a rate of 59.94 fields per second to maintain a speed of 29.97 fps. The first odd field of alternating lines is displayed, then the even field fills in the spaces.

Early TV sets necessitated interlacing because the screen phosphors would fade too quickly to display an entire frame. As scan lines were drawn from top to bottom, the top half of the image was gone by the time the last scan line was drawn.

10.3

Field rendering can be enabled or disabled in programs such as Pinnacle Systems Commotion and Adobe After Effects.

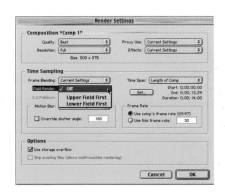

international broadcast television standards

Prior to the advent of digital television, there have been approximately 14 different broadcast standards in use at different times throughout the world. In the United States, institutions such as National Television Standards Committee (NTSC) and Society of Motion Picture and Television Engineers (SMPTE) have adopted standardized criteria for the format of broadcast video. Today, there are three basic systems that serve the vast majority of countries: NTSC, SECAM (Sequential Color And Memory), and PAL (Phase Alternating Line). The difference between these centers around (1) the number of horizontal lines in the frame, (2) the number of frames displayed per second, (3) the signal's electronic bandwidth, and (4) the use of an AM or FM signal for transmitting audio and video. Compatibility between these formats has been limited, although some VCRs and many DVD players have the capacity to recognize all three types. Televisions, however, are not commonly multiformat.

the NTSC standard

In 1941, the NTSC adopted a black-and-white television standard known as the 525-line, 60-field system. Originally based on the electrical 60-Hz electrical cycle used in many countries, it is shared by the United States, Canada, Greenland, Mexico, Cuba, Panama, Japan, the Philippines, Puerto Rico, and most of South America. (Since other countries in the world use a 50-Hz electrical system, it was logical for them to develop a television system based on 50 fields per second.)

NTSC's standard is over 60 years old, and many advances have been introduced during this period. In 1955, color was established, and more recently, digital television standards have provided major improvements in quality.

Electronic television was invented in the United States by Philo T. Farnsworth, and his system had 300 lines per frame. Because of patent litigation in the United States, this technology was first exploited in Britain. The original (now obsolete) British television system used 25 fps and 405 lines.

PAL and SECAM standards

The two other European standards, SECAM and PAL, are used by over half of the countries in the world. SECAM was developed in France and is used in parts of Europe; PAL was developed in Germany and is used in Britain and most of Western Europe. Both systems are based on 525 scan lines and a frame rate of 25 fps. Since this is close to the international film standard of 24 fps, PAL video can actually be transferred to film frame-for-frame, and film can be converted to the PAL and SECAM video systems.

frame rates

Broadcast video relies on four standard frame rates: SMPTE, NTSC, 30 Drop Frame, and EBU.

SMPTE time code and 30 fps

SMPTE's rate of 30 fps is often used in America with Sony's audio recording format for music CDs. It also has its origins in the obsolete American monochromatic television standard.

NTSC and 29.97 fps

Upon the introduction of color, the NTSC developed a frame rate of 29.97 fps in order to accommodate the color-burst signal.

NTSC and the 30 Drop Frame format

NTSC video uses a drop-frame method in order to match SMPTE's time code. (This compensates for the fact that 29.97 is not a whole number.) This is achieved by regularly bumping up the frame count to catch up in time with the actual clock. The first two frames, 0 and 1, are skipped in the first second of every minute with the exception of every tenth minute. For example, at 1:06:59:29 (one hour, six minutes, fifty-nine seconds on the twenty-ninth frame), the next frame number skips to 1:07:00:02. This process allows a sequence of time code running at 29.97 fps to continually jump back into sync with an actual clock. NTSC's 30 Drop Frame Format is

required for video for display in the United States, Japan, and other countries that use a 60-Hz electrical frequency.

EBU and 25 fps

The EBU (European Broadcasting Union) standard of 25 fps continues to be used throughout Europe, Australia, and countries where the main frequency is 50 Hz and color television systems are PAL or SECAM.

digital and high-definition television

High-definition television (HDTV) contains more than 2 million individual picture elements that result in images six to ten times sharper than standard television images. In addition to an improved resolution, images are presented in widescreen (16:9) format. Over the next decade, television stations will be required to simultaneously broadcast the same program using two TV channels in order to accommodate the existing analog format, along with the emerging digital format.

image considerations

Because of the different methods by which pictures are displayed on television and computer monitors, certain factors such as color, picture resolution, and title-safe and action-safe zones should be considered during production. The differences between these displays should lead you to expect image degradation when outputting your video to an analog NTSC or PAL source.

color

When designing for television, your final output should be "broadcast safe" or acceptable for television reproduction.

In contrast to analog television monitors, the computer's ability to separate RGB colors produces a much sharper image in which colors are more defined. Computers calculate colors

Output for Motion Pictures and Television

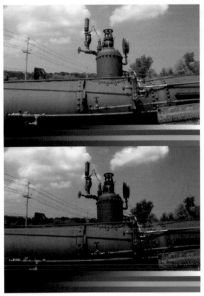

10.4

Comparison of subtle, dark colors as they appear on a computer monitor and on an NTSC monitor. On the TV screen, the first 20% of each color is invisible.

10.5

Sythetic Aperature's Echo Fire Video Color Picker, available in Photoshop and After Effects, allows you to preview and "legalize" your colors for broadcast use.

Echo Fire defines "Illegal" colors as those with chroma levels above 110 IRE or below -20 IRE.

based on the additive primaries (red, green, and blue), whereas television systems, which compress color and brightness levels, cannot display colors above a certain amplitude. Therefore, subtle color effects that may be visible on a computer monitor may not be reproduced well in standard NTSC color space. For example, oversaturated colors may bleed across television scan lines, dark subtle colors may appear as black, and light subtle colors may appear as white.

Broadcast color translation can be controlled with broadcast color safe utilities such as Final Cut Pro's Broadcast Safe filter or Synthetic Aperture's Echo Fire to restrict the range of colors on your computer screen to be within "legal" broadcast levels.

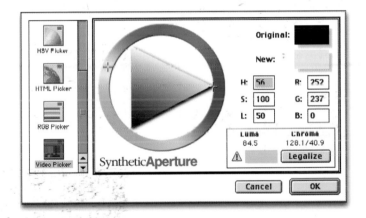

It is also wise to make bold color choices and avoid ramps (or color blends), since they are prone to produce midtone banding which is caused by compression. Tools such as Adobe After Effects' Ramp Scatter filter can eliminate banding in areas that contain color ramps. The simplest way to prevent undesirable color occurrences is to view your work on an NTSC monitor during production and base your decisions on

the appearance of your content on the TV screen. Field interlacing can cause horizontal details to flicker. Therefore, be prepared to make subtle effects bolder and use larger font sizes and sans serif fonts. Adobe After Effects offers a "Reduce Interlace Flicker" operation that can be applied to an adjustment layer to help prevent color flicker (10.7). Performing a Levels operation can reduce the output black and white levels (10.8).

10.6

Banding can result from gradient blends that appear normal on the computer. Adobe After Effects' Ramp Scatter filter is used to disperss the color blend to eliminate visible banding.

10.7

Applying "Reduce Interlace Flicker" to an adjustment layer in After Effects can help prevent color flicker.

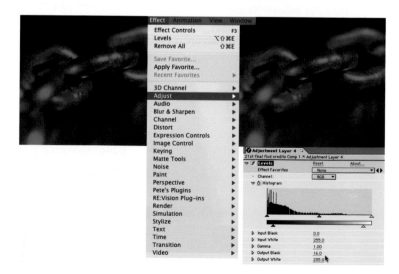

10.8

A Levels operation is applied to an adjusment layer in After Effects to reduce the output black and white levels. An output black level 16 and white level of 235 usually gives effective results.

picture quality

Picture quality can be judged by the smoothness of edges, tonal continuity, and sharpness of detail. The differences in picture quality among print, computer display, and television display are great. Designing for print, which can offer resolutions between 300 and 2400 dpi (dots per inch), allows minute details to be rendered very clearly. By comparison, designing for the computer screen involves fixed resolutions between 72 and 96 pixels per inch. Although fine details may look great in print and even on a computer screen, noticeable image degradation can result in the translation to a television monitor. Since standard television sets have the lowest picture quality (26-inch sets offer resolutions of less than 40 dpi), small point sizes and detailed serifs tend to "drop out," becoming unreadable. Additionally, field interlacing can cause horizontal details to flicker.

Because of the differences in how images are scanned on computer and television displays, edge artifacts may be apparent on NTSC monitors with certain types of images. For example, an antialiased outline of a solid shape such as a logo may look great on the computer screen, but on a television monitor it may have a dark fringe when presented against a light background or a light fringe against a dark background. You will need to be the judge in deciding whether solid graphic shapes should be aliased or antialiased.

The tape or disk format that stores your final output will also dictate the picture quality of your animation. For example, DV, Beta-SP, and DVD give much sharper pictures than VHS.

overscanning

Because there is no standardization among television manufacturers, overscanning can occur when the image extends beyond the title-safe and/or action-safe zones or is displayed

with a black border around the edge. Both of these regions must be considered early on when creating your work for television output. Fortunately, most motion graphics packages provide both title safe and action safe guides that correspond to NTSC or PAL to ensure that important material is not cropped at the frame's edges.

formats for television output

Digital video sequences can be composed and saved in several file formats. The most important consideration is their portability on different hardware platforms.

QuickTime

QuickTime is the most common file type for outputting animations files to tape. Suggested QuickTime video and audio settings are listed on this page.

Flash

There is more of a demand for animations to be created concurrently for broadcast television and the Web, and Flash is becoming a more worthwhile investment. Although it is not a file format for television output, it can be used to generate content. Since vector-based animations require minimal processing power, disk space, and bandwidth, mock-ups can be e-mailed to clients through dial-up connections without the need for an FTP server.

In order for a Flash animation to be composited with other material (for example, live video), it must be published from Flash as a QuickTime movie with an alpha channel. Before you compose the animation, there are several important factors to be considered. The Flash movie's frame rate should be set to 59.94 (29.97 frames per second for NTSC output) and the stage size to 720 x 540. If the file is opened in QuickTime Player (version 4 and above), a 59.94 fps full-

Suggested QuickTime settings for DV-NTSC:

frame rate: 29.97 fps (NTSC) or 25 fps (PAL/SECAM)

frame dimensions:
720 x 480 pixels (NTSC) or 720 x 576 pixels (PAL/SECAM)

aspect ratio: 1.33:1 (4:3)

software codec(s): Apple DV

screen video will include a Flash track in the its specification (Figure 11.1). Since many compositing applications do not recognize QuickTime Flash tracks, you will need to convert the file into a bitmap and compress it with a codec that is supported by application you are working in. If you import the 59.94 fps QuickTime movie into Adobe After Effects, you can place it into a 29.97 fps composition and render it as a QuickTime DV-NTSC with field rendering turn on. This will produce the smoothest motion possible.

Since Flash does not contain action-safe and title-safe guides, you will need to build a safety grid in Adobe Illustrator or Macromedia Freehand and import it into Flash. Remember to delete it before publishing the final movie.

hardware requirements

In recording animation directly to video, hardware resources are required. First, there must be an output mechanism to transfer the digital video stream from your computer to tape. Second, the hard drive must be read fast enough to deliver the data to the video interface. Third, a recording device such as a camcorder or tape deck is necessary for transferring work from the computer to a videotape format. Then, fourth, an external NTSC (or PAL) monitor allows the differences between computer and television display to be instantly seen and corrected prior to final output.

analog connectivity

Analog video connections transmit analog video formats such as VHS, 8mm, S-VHS, Hi-8, 3/4" SP, and Beta-SP to and from a computer. The three most common types of analog connections on camcorders, television sets, tape decks, and analog video cards are Composite, S-Video, and Component. *Composite* (also called *RCA*) was developed by the NTSC as a standard to carry a video signal through a single cable.

Applications such as Apple Final Cut Pro, Discreet Cleaner, and Apple QuickTime Pro can convert a Flash track to a bitmap track for use in other software. It may need to be resized to an NTSC pixel aspect ratio.

10.9

Composite video ports and plugs are color coded yellow and use RCA or screw-on coaxial BNC connectors. RCA audio plugs and cables are red and white.

10.10

An S-Video port uses a small four pin connector.

10.11

Component video ports and plugs use 3 RCA connectors. The most common Component connection on DVD players is three RCA jacks.

Audio is transported in mono through a single RCA cable or in stereo from a red and white color-coded cable. Of all the analog connection formats, composite produces the lowest video signal. Compression artifacts and blurring often result in transferring data through this type of connection.

Introduced in the 1980s, *S-Video* provided better color signals than composite video. Most analog devices and digital devices have S-Video connections which yield better results than composite signals since color and brightness information are transmitted independently.

Component video is used on DVDs, TVs, satellite receivers, and cable TV boxes and on some computers with TV outputs. Based on resolution and color accuracy, component video delivers the highest quality analog signal. Component YUV is separated into three parts: a luminance channel and two chrominance channels. RGB component video breaks the signal into red, green, and blue. Component connectors are most commonly used on most TV and HDTV set-top boxes, DVD players, and Beta-SP cameras and decks.

analog AV cards

Capturing or outputting video from or to an analog source requires an analog AV card. Analog cards are available at a variety of prices, and most support input and output of composite and S-video signals.

Firewire has drowned out the use of analog video cards; RCA and S-video ports have suddenly disappeared. Fortunately, solutions like PYRO's A/V Link can convert analog material into digital video and export digital content to several analog formats including High-8, Beta-SP, DV, and VHS. ATC Computers manufactures a line of video cards that can digitize analog video from composite and S-Video

Composite video was originally used in the 1950s to translate a television signal from black and white to color on low-resolution color TV screens. Black-and-white sets ignored the color information, while newer sets separated out the color component and displayed it with the black-and-white picture.

as well as digital video from DV cameras with Firewire. Formac's Studio video cards can capture analog material, convert it to a DV format, and export it back to an analog tape. They contain a variety of input and output ports, including Firewire, S-Video, and composite inputs, a coaxial cable input for your TV, and a coaxial antenna input for your radio. Digital Voodoo manufactures a variety of analog and digital AV cards for the Macintosh.

For the Windows platform, Dazzle's Digital Video Creator II and Pinnacle Systems Studio AV's PCI cards allow you to output MPEG-2 video files to all types of analog video sources including camcorders and VCRs at both NTSC and PAL frame rates and playback resolutions.

digital connectivity

The two most ubiquitous methods of digital connectivity today are USB and Firewire. Both options are appearing on digital camcorders and other consumer electronic devices.

SCSI

SCSI (Small Computer System Interface) connectivity was Apple's standard for connecting scanners, hard drives, and printers to the Macintosh system. SCSI cables allow multiple devices to be connected externally and routed to each other (or daisy chained). Up to 15 devices could be added to a SCSI chain. Because of its extremely high data transfer rates, SCSI has remained a standard in high-end applications.

USB

USB (Universal Serial Bus) connectivity, developed by Intel in the mid-1990s, simplified personal computing by replacing older types of serial and parallel ports for connecting all types of peripherals such as digital cameras, camcorders, hard drives, printers, and scanners. Its "jack-of-all-trades" nature helped standardize connectivity on both Macintosh

10.12
SCSI cable connector and ports.

and PC systems. Unlike SCSI, serial, or parallel connections, USB connections use a small, inexpensive cable (USB A-B) that is easy to attach. Up to 127 devices could be interconnected through external hubs, which provide additional ports. Originally, USB 1.1 had slow data transfer rates of 1.5 mbps, limiting its use for demanding tasks such as transferring large video files to and from digital camcorders. However, an improved USB 2.0, released in 2000, offers target speeds of 480 Mbps, 12 Mbps, and 1.5 Mbps, making it suitable for capturing and outputting video and allowing backwards compatibility with older USB devices.

Firewire

Digital video output is commonly transferred on low-end editors through the Firewire port, a standard feature of Sony and Apple computers. Invented by Apple Computer Inc. during the mid-1990s, Firewire (also known as IEEE 1394) was specifically designed as a data storage solution. However, its high-speed architecture led to the replacement of slow input/output connections for DV cameras, hard drives, printers, and scanners. It is one of the fastest interfaces ever developed and has been established as an industry standard by companies such as Sony, Canon, JVC, and Kodak and by average consumers and professionals. Firewire offers a data rate of 800 Mbps, making it an ideal solution for high speed video transfer and storage. Luckily, all Macintosh G3s, G4s, and G5s are equipped with Firewire ports. If your computer does not have a Firewire port, you can purchase an adapter for your computer.

Apple's Firewire interface has been honored by the Academy of Television Arts & Sciences. In 2001, Apple received a Primetime Emmy Engineering Award for Firewire's impact on the television industry.

real-time preview and delivery

Real-time playback of your animation without delayed or out-of-order frames is a luxury for previewing it during its development and a necessity for outputting it to videotape. Full-screen video playback at 29.97 frames per second may not be an issue for television stations, postproduction houses,

10.13
Avid's nonlinear editing workstation.

Many analog and digital video cards, manufactured by companies such as PYRO's A/V Link, ATC Computers, Formac, and Digital Voodoo also offer hardware compression.

or large corporations that own high-end workstations. If the budget allows, renting a powerful nonlinear editing workstation such as an Avid or a Media 100 can be a worthwhile short-term investment. Alternatively, purchasing a hardware compression board can help boost playback performance. Hardware compression boards enable full-screen animations to be recorded by performing compression and heavy-duty processing, allowing the CPU to concentrate on transporting the data to disk. Hardware compression boards range in price, depending on their quality. Most use Motion-JPEG compression to accelerate capture and make real-time playback possible. These boards usually have analog video out connections for sending data back to tape.

If you cannot afford to rent a high-end system or purchase video acceleration hardware, there are ways to help you improve your work flow. Programs such as Adobe After Effects or Pinnacle Systems Commotion allow you to lower the quality of your layers or turn off the ones that are not being worked on to accelerate processing. Although play back will be improved, real-time motion of high resolution images is unlikely. You can also create "test renderings" at small frame sizes such as 320 x 240 to observe your work in real time during its development.

Commotion Pro contains a powerful feature called Super Cache Disk Playback (10.14), which allows you to preview your work in real time during its production. It achieves this by loading high resolution QuickTime clips into RAM to be played at their full size and frame rate. The amount of data that can be loaded depends on the amount of memory that is installed on your computer. (This is a case where there is no such thing as having too much RAM!)

10.14

Pinnacle Commotion's Super Cache Disk Playback feature.

data storage solutions

Designing animation for broadcast delivery requires planning ahead of time to determine how data will be stored before it is transferred to videotape. Since high quality video files are huge, sufficient disk space must be available to accommodate rendered image data. Today, there are many hard-drive storage solutions. These include removable disks, frame buffers, and external hard drives. Five factors that should be used to determine the best type of storage solution are data storage capacity, data transfer rate, cost, portability, and reliability.

The disk capacity that is needed can be determined by the data rate of the video that you are most likely to use. For example, Apple's DV codec uses a data rate of approximately 3.6 MB per second for a 720 x 480 composition. Therefore, 10 minutes (or 600 seconds) of video would require roughly 2 GB of disk space, and a 90-minute piece would require approximately 18 GB of storage. The data rate of your storage device should exceed your video data rate in order to play it back properly when previewing it or outputting it to tape.

removable external disks

Low-end removable disks, such as Zip disks, work well for holding and transporting small amounts of data. However, they are not large enough or fast enough for storing high-quality video files. Additionally, their slow data rates (1.5 MB per second for a Zip disk) is clearly not acceptable for playback. Data on a CD-ROM can be accessed much faster with a high-speed drive (a 40x drive gives a maximum data rate of between 2.8 and 6 MB per second); however, the maximum storage capacity is 700 MB. DVD data disks offer the most generous disk capacity of 4.7GB, which is capable of archiving up to 2 hours of MPEG-2 compressed video.

hard drives

Hard drives provide another solution for storing large amounts of data. The drive should have a sustained read rate that is capable of handling the performance that you require. The most common types of hard drives, identified their method of connectivity, are ATA, SCSI, USB, and Firewire. Each of these standards come with varying storage capacities and maximum data transfer rates.

ATA (also referred to as IDE or EIDE) drives are the least expensive and offer high sustained data rates. Additionally, they offer extremely generous storage capacities. Internal installation makes them a somewhat permanent component of your system; mobility is difficult. Additionally, heating can become problematic, as the computer's cooling fan will have another item to deal with. (There is a limit to how much "stuff" should be "stuffed" into a system.) Therefore, external hard drives are a more convenient solution, since they are portable and do not add heat to the platform's interior.

10.15
SCSI portable hard drives are connected to each other and to a Macintosh that has SCSI connections.

SCSI hard drives come from an older generation of connectivity standards for Macintosh computers. Their much higher cost is a trade-off for higher speed, since they are configured

with high data transfer rates. Additionally, their longer cables allow them to be externally connected and daisy-chained together (10.15). While SCSI interfaces are used by high-end production facilities, ATA drives are more popular among Firewire DV editors.

Although USB drives have smaller data transfer rates than Firewire drives, they remain a standard in allowing data to easily be transferred between Mac and Windows platforms.

Firewire drives provide the most extensive range of storage solutions to distributors worldwide. Over 60 Firewire drives can be simultaneously connected to a Macintosh G4 system. Today, many companies manufacture drives that have both Firewire and USB connectivity. Lacie's Data Bank drive, for example, stores up to 20 GB of data, and its PocketDrive, intended for traveling, can carry up to 60 GB of data on the road. Maxtor Corporation (www.Maxtor.com) manufactures a 300 GB hard drive that provides ample storage of over 15 hours of digital video.

external monitors

The differences in which computer and television displays scan images can lead to gamma and color encoding shifts, overscanning, field flicker, and aliasing problems in the final output. Additionally, computer monitors display square pixels and lack interlacing, while television screens work with nonsquare pixels and use interlacing. Therefore, connecting and working from an external broadcast monitor will enable you to observe your work in progress as it will appear in its final state and make necessary changes accordingly.

You can spend anywhere between $300 and $5000 on an analog television monitor, depending on its size and picture quality. The most recommended models are Sony, JVC, Mitsubishi, NEC, and Panasonic.

10.16

A JVC external NTSC production monitor.

URLs for manufacturers of NTSC monitors:

www.dvshop.ca

www.powerdv.com

www.dvgear.com

www.vidcan.com

www.integratedmidi.com

recording devices

Finally, you will need to purchase a camcorder or video recording deck to output your work to tape. High-end analog video decks are currently priced between $2000 and $2500, while the cost of digital decks is not significantly higher. Camcorders, however, offer a dual function of footage acquisition and editing. This yields a greater cost savings in the long run. Additionally, camcorders are much more portable and can run on batteries. Unless you plan on performing heavy-duty video editing (the tape mechanisms of decks are better designed to handling editing), a three-chip camcorder is sufficient for creating a master tape. If you are outputting your work to an analog format, be sure the camera's video and audio ports are compatible with those on your computer. If you are outputting to a digital format, Firewire alleviates compatibility issues, since all digital camcorders and most standard computer systems are Firewire-enabled.

tape formats

An extraordinary number of professional videotape formats have been developed over the years. Choosing the right one to output your work can be difficult, since many are still available on the market today. It is best to back up your work as data and create several masters that are compatible with venues you plan to submit to.

traditional analog formats

Originally, 2-inch tape began the video recording process. After about 3 decades of use, it gave way to 1-inch reel to reel tape. Initially there were "Type A" and "Type B" versions; however, it was Type C that became the next standard. With the 1-inch Type C format, still-frame slow and accelerated-motion playbacks became possible for the first time. During the 1980s Type C was the dominant format in broadcasting and production facilities.

10.17

3/4-inch U-Matic videocassette.

3/4-inch U-Matic cassettes have a record lockout function to prevent material from accidentally being erased. When the red button is removed, machines will not record onto the tape.

The first cassette format to replace reel-to-reel tape was 3/4-inch U-Matic (10.17), introduced in 1972. Intended for home and institutional use, it revolutionized TV news and quickly replaced 16mm film. Because of its small size, it was adopted for broadcast field production. Since quality was limited to 260 lines of resolution, it was not considered to be a quality production format, even after its picture sharpness was increased to 330 lines.

Sony's amateur 8mm format was introduced to the market in 1984, and for many years, it was the preferred medium for handheld camcorders.

contemporary analog formats

In analog video, electronic signals are recorded onto tape as magnetic patterns. The quality of those patterns is dictated by the format being used. The most common analog formats are VHS, S-VHS, High-8, and Beta-SP.

VHS

VHS provides a horizontal line resolution of 240 (the quality of a local Blockbuster video). This amateur format is intended for viewing home projects or creating demo reels; its quality is unacceptable for professional production. For many years, independent producers, educational institutions, and small corporations with limited budgets were fans of an improved S-VHS (or Super VHS) format, which offered a resolution of 400 lines—a major step up from VHS quality pictures.

High-8

The High-8 version of 8mm, introduced by Sony in 1989, provides a resolution of 400–440 lines (the 8mm equivalent of S-VHS). Its quality is far superior to that of VHS, S-VHS, and 8mm. The price of Beta-SP recorders is out of the range of what most independent animators can afford. With the exception of digital camcorders, consumer High-8 cameras offer the sharpest picture available to the general public.

10.18
A Betacam-SP videocassette.

In 2002, Sony discontinued analog Betacam, but has continued with its popular digital version of the format.

Betacam

Sony Corp. introduced Betacam in 1982. It was based on a 1/2-inch tape format and combined the camera and recorder into a single unit—a camcorder. In 1987 Sony improved on the concept with Betacam SP (for superior performance). This format established itself as the top-end analog format for commercial use in the broadcast industry. Its quality is superior to that of S-VHS and Hi8 because of its separate recording tracks for luminance and chroma. Most broadcast stations, news-gathering operations, and professional video production firms today still prefer Betacam SP source footage. Beta-SP is perhaps the most popular component format for field acquisition and postproduction today.

Betacam has gone through several upgrades that have resulted in numerous new features, including improved audio and video quality. In 1993, Digital Betacam was introduced and brought the higher quality to the widely used Betacam line.

digital formats
D-1 to D-9

D-1, the world's first digital videotape format, is still used in postproduction situations that require extensive special effects. The D-5 format has the capacity of storing up to 2 hours of material with minimal compression, a high digital sampling rate, and the ability to record luminance and chrominance information independently, making it adaptable for DTV and HDTV production. JVC's D-9 format (originally *digital-S*) became available in 2000, offering four channels of uncompressed audio. Although it uses a basic VHS tape transport mechanism, it is far superior to S-VHS. A pre-read feature allows you to play back video and audio, while simultaneously recording new content in its place. This allows the original signal to be modified before being re-recorded onto the same tape. For example, titles and special effects can be added as a tape is played back.

DVCAM and Beta SX

Currently, Sony's professional digital formats are DVCAM and Beta SX. Both operate with a range of linear and non-linear editing equipment.

DVCPRO

The popularity of DVCRPO is increasing. It was originally a 4:1:1 format, but in late 1997, an improved 4:2:2 version called DVCPRO 50 was introduced, and in early 2000, an HDTV version of DVCPRO was added—DVCPRO HD. A major advantage of DVCPRO is that its tape cartridges can be loaded into a special drive on a PC, and content can be transferred to a hard drive four times faster than normal speed.

general delivery guidelines

1. If you need to boost your efficiency, do not use virtual memory. Invest in more RAM!

Since virtual memory uses hard disk space to emulate the function of RAM, the lower speed of the hard drive will impede your work flow. RAM chips are capable of fast data rates of up to 90 Mbps. If you are using MAC OS 9, be sure that virtual memory is turned off in the Memory Control Panel. Memory prices are low, and there is little reason for your computer to have less than 256 MB of real RAM.

2. Turn off or lower the resolution of layers not being worked on to accelerate preview.

If you cannot afford a video acceleration card to preview your work in real time, most applications allow you to hide layers or lower their resolution for quicker data processing (10.19).

3. Create small "test renderings."

If you cannot afford a video acceleration card to preview your work in real time, create "test renderings" at 160 x 120 to observe and critique your work with real-time playback.

10.19

Programs such as Adobe After Effects allow you to turn off a layer or lower its quality in order to accelerate processing.

Output for Motion Pictures and Television

4. Beware of title-safe and action-safe zones.
Be aware of the title-safe and action-safe zones because of overscanning on video displays. Most applications offer title-safe and action-safe guides. If you are working in Flash, you can build a safety grid in Adobe Illustrator or Macromedia Freehand and import it into Flash.

5. Avoid small details.
Overabundant detail may result in image degradation when your work is displayed on a television monitor. Subtle details should be eliminated or made bolder.

6. Stick with large font sizes and sans serif fonts.
Keep the point size above 14 points and the letterforms simple. Small point sizes and detailed serifs tend to "drop out" especially when displayed on an NTSC monitor and when transferred to VHS tape.

7. Use broadcast-safe colors.
Utilities such as Echo Fire's Video Color Picker, Apple Final Cut Pro's Broadcast Safe filter, and Adobe Photoshop's NTSC Colors video filter will ensure that your colors look acceptable when displayed on standard television monitors.

8. Design for the screen. Connect to an analog monitor.
Previewing your animation on a computer monitor does not show you what your work will look like in its final format. Color and gamma differences, interlace artifacts, image dropout, and overscanning should be accounted for prior to output. Connecting to an external NTSC or PAL monitor allows you to make design decisions and changes based on how your work appears on the television screen.

9. Record directly to the end format (especially if low-end).
If the end product is VHS, record directly to a VHS tape to ensure that there is no generation loss.

11

output for digital media

CONSIDERING INTERACTIVE DELIVERY FORMATS

Since the inception of film and then television, the ultimate goal has been to present full-motion, high-quality video synchronized with audio at maximum frame sizes. During the mid-1980s, the industry regressed to primitive communications media, because of the availability of simpler, more affordable technologies. Multiple projector slide shows and digital HyperCard presentations were just a few of the economical solutions for engaging audiences. These interim steps attempted to emulate what film and television had already accomplished—large-scale images in motion.

Where are we now? Today, we strive to produce better quality video that can be played at higher bandwidths over the Web. HDTV, improved digital video projectors, and newer distribution formats are enabling the display of high-quality content on bigger screens.

chapter outline

00 : 00 : 00 : 11

CD-ROM and DVD-ROM

an overview

The Compact Disc Digital Audio (CD-DA) was introduced to the Japanese market by Philips and Sony in 1982. This was the first digital consumer format to represent audio. In 1984, the CD-ROM format was released by Philips and Sony and intended as an extension of the CD audio standard. Conceived as a general-purpose data storage medium, it was capable of prerecording and storing large digital data files to be read on a computer. CD-ROMs differ from CD audio (CD-DA) disks in that data is divided into sectors and contained in a hierarchal file structure. The interactive CD (CD-i) made its appearance during the mid- to late-1980s as a more elaborate multimedia system for home use, education, and training. In the early 1990s, the CD-ROM (Compact Disc Read Only Memory) became a ubiquitous means of distributing multimedia presentations on computers and was an effective vehicle for delivering numerous animated formats for interactive presentation. Although the CD-i was withdrawn from the market in the mid-1990s, it continued in use for training and professional applications in the United States, until the DVD provided a better alternative.

CD-Rs are random-access storage devices that allow fast retrieval of archive material. Typical CD-Rs have a capacity of 650 MB, and the ubiquity of CD-ROM drives makes them an excellent medium for transferring large files between Macs and PCs. Today, CD-ROM disks are sold in bulk at a cost of approximately 22 cents each.

One disadvantage of the CD-R is that data cannot be erased or modified. Data can only be added incrementally by leaving a session "open" (or not recording to the entire disk, which poses the risk of incompatibility with some players).

Mini-CDs (also called business card CDs) are conventional CD-Rs that are refashioned by removing two sides or by trimming all four sides to create a perfect rectangle. They offer a capacity of between 20 and 60 MB. They are affordable alternatives to printed business cards or brochures that can promote individuals or organizations using images, video, audio, and text.

Additionally, the CD-R format is infamous for compatibility problems with first generation CD-ROM and DVD-ROM drives. Fortunately, Philips and Sony developed another standard—the CD-Rewritable (CD-RW). It's specifications allow users to reformat a disk by deleting files or recording over old data. (CD-RW rewritability is less than perfect, resulting in reduced storage capacity.) CD-RWs also ensure compatibility within the entire family of CD products, as well as forward compatibility with DVD-ROM drives.

Both CD-R and CD-RW formats are readable by CD-R and CD-RW drives, as well as current and future generations of DVD-ROM drives. A further advantage is the low cost of media. CD-RWs usually cost less than a $1, and CD-R media is even cheaper.

A DVD (Digital Versatile Disk) is used as a larger optical storage device (or "giant CD-ROM") for computer playback. The advantage of a DVD-ROM over a CD-ROM is storage space, as a DVD can hold approximately 4.7 GB (versus 650 MB). Still in its infancy, the DVD was developed in 1995 by Philips and Sony, Toshiba, and Time Warner. This format is common to all types of DVD-ROM computer applications, DVD-Video, and DVD-Audio disks, allowing the same content to be recognized by stand-alone devices as well as computer systems. (DVD-Video is discussed later in this chapter with regard to television output.)

DVD+R, a variation of DVD-R, is also compatible with the majority of stand-alone DVD players and DVD-ROM drives.

Variations of the DVD-RW format include DVD+RW and DVD/RW. DVD+RW disks can be updated, while DVD-RW disks must be erased prior to recording. However, DVD+RW is slightly less compatible with stand-alone players and DVD-ROM drives. DVD/RW was the first DVD recording format compatible with stand-alone DVD players. It supports a DVD-5 (single-sided 4.7-GB) and a DVD-10 (double-sided 9.4-GB).

The DVD-R (DVD-Recordable) format, introduced to the market in 2000, is today's most widely recognized recordable DVD format and is compatible with most DVD drives and DVD players. DVD-R is a write-once, single-sided, non-rewritable format with a capacity of 4.7 GB. The two rewritable DVD formats used for video recording are DVD-RW and DVD-RAM. DVD-RW is a single-sided format that can hold

either 4.7 or 9.4 GB of data. Like DVD-R, this popular format is compatible with the majority of DVD players. DVD-RAM is a less common rewritable single- or double-sided format that is designed primarily for random access. It has a capacity of either 4.7 or 9.4 GB.

authoring tools and animation file formats

The most popular authoring tools are QuickTime, Director Flash, and DVD StudioPro, now the standard for creating disk-based interactive multimedia presentations.

Director

Director is an ideal application for delivering content on CD-ROM, since it was designed to quickly load and unload data into system memory for optimal playback. Almost all media types can be combined into a presentation, including vector graphics, bitmap images, video, sound, and sprite animation (animation created internally from Director).

Director's native file format is cross-platform, allowing you to open and author files on both Macintosh and Windows operating systems. When authoring is complete, a stand-alone, executable "Projector" file can be created to distribute to your end users. This file is designed as a self-contained application and can be targeted to either the Macintosh or Windows operating systems without requiring the presence of Director or an associated plug-in. However, there are certain protocols necessary for cross-platform delivery. Macintosh Projector files can be created only on Macintosh systems with a Macintosh version of Director. Likewise, Windows Projector files can only be created on Windows computers with a Windows version of Director. Therefore, you will need both a PC and a Mac version of Director to ensure cross-platform compatibility.

11.1

Macromedia Director's object-oriented Lingo syntax is used to develop interactivity in CD-ROM titles, kiosks, and Web presentations. It has similarities to other programming languages such as Visual Basic, Action-Script, and JavaScript.

11.2

Macromedia Director MX: Cast, Score, and Stage windows.

The cast contains a presentation's assets, such as QuickTime files, Flash animations, sounds, bitmap images, and vector graphics. These are arranged on Director's score. The results are immediately apparent on the stage.

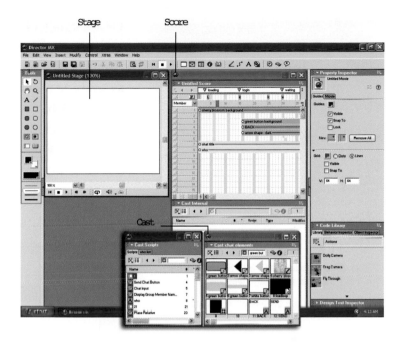

11.3

When creating a projector file, you can turn on Director's "Full Screen" option to extend the stage color and hide the Macintosh or Windows desktop.

Information on Authorware can be found at www.authorware.com. A free trial version of the program and the Authorware Player is available at www.macromedia.com/software/authorware/download.

Authorware

According to Macromedia, Authorware is "the leading authoring tool for creating rich-media e-learning applications for corporate networks, CD/DVD, and the web." Authorware uses an icon-based intuitive flowline authoring scheme that is ideal for presentations that require heavy and complex interactivity. Icons for all types of media assets such as graphics, animation, and audio are added to a flow-line in the order in which they should appear on the screen. Although Authorware is not ideal for complex animations, Director, Flash, and QuickTime movies can be imported to increase functionality.

Flash

Macromedia Flash has earned its solid reputation in the areas of Web animation and interactive Web authoring. With improved interactive programming capabilities, it now is also a desirable tool for CD/DVD-ROM authoring.

Flash's Symbol Library, TimeLine, and Stage windows are analogous to Director's Cast, Score, and Stage windows. However, Flash arranges its assets from the Symbol Library as layers on the timeline, each able to contain multiple symbols. A Flash presentation can be authored to play on both Macintosh and PC. Unlike a self-contained Director projector file, Flash movies require the Flash player on the CD/DVD-ROM in order to run. (The Flash Player is licensed for free use and occupies less than 1 MB of disk storage.)

11.4

Macromedia Flash MX: Symbol Library, TimeLine, and Stage windows.

Symbols are organized as layers in the TimeLine window.

QuickTime

QuickTime is the common animation file format for CD/DVD-ROM titles. Suggested QuickTime video output settings are listed on the following page.

playback performance: the juggling act

The objective of multimedia developers is to reach a target audience. Because CD-ROM and DVD-ROM disks are intended for direct playback on a computer system, the user's processing speed and CD/DVD disk drive speed are factors in determining the quality of the viewing experience.

Suggested video output settings:

frame rate: 15 fps

frame dimensions:
320 x 240 pixels

pixel/bit depth:
millions of colors

software codec(s):
Cinepak, Sorenson or Sorenson 3

Although the technical constraints of CD/DVD-ROM output are more robust than those that are associated with Internet transmission, optimization for CD/DVD-ROM delivery still is necessary to enable consistent playback across platforms, as well as to minimize storage requirements. (Storage is almost a nonissue for DVD-ROM, unless you are designing an animated encyclopedia!) Although CPU power and the speed of disk playable peripherals are ever-increasing, smooth playback of video usually mandates speeds of 15 fps or less and frame sizes no larger than 320 x 240 pixels (quarter-screen). Additionally, data compression is necessary to allow your content to display correctly on the widest possible range of computer systems and monitor displays.

Playing back QuickTime video on a CD/DVD-ROM requires data compression in order to facilitate smooth motion at the desirable frame rate. (Chapter 9 lists several cross-platform software codecs.)

burning software and hardware

Applications such as Roxio's Easy CD Creator for Windows and Toast for Macintosh allow you to burn a CD or DVD data disk simply by dropping your files into the main data window and pressing the "record" button. In addition to burning software, a burner is necessary to write your data onto disk. Entry-level computers such as Apple's iMac and Gateway's Profile 4 come with internal CD/DVD writers. External recordable burners have dropped significantly in price and are now affordable to average consumers.

DVD-ROM drives, which can read CD-ROM disks, are beginning to replace CD-ROM drives. Most DVD writers have the capacity to burn CD-RWs and CD-Rs.

Applications such as Roxio's Toast for the Macintosh or easy CD Creator for the PC enable you to create hybrid CDs that are compatible with both Macintosh and Windows platforms.

See www.roxio.com for details on creating CD-ROM hybrids using Roxio Toast.

general delivery guidelines

The following production guidelines can help you achieve the best possible output on a CD/DVD-ROM disk:

1. "Garbage in, garbage out."
If you are integrating live-action video into your work, be sure to capture your footage onto a digital format or a high-end analog format such as Beta-SP. Capturing footage in a consumer analog format such as VHS or S-VHS produces "noisy" images. Image quality will be reduced further during compression, especially if you are using a lossy compressor such as Cinepak.

2. Capture live content on a high-quality format.
If you are incorporating live-action footage into your motion graphics presentation, capture the original material on a high quality digital format such as D1, D5, DigiBeta, D9, or DVCPro 50. If you are shooting onto DV or DV-Cam, make sure that your camera has three CCDs in order to reproduce the color more accurately. All of these digital formats use component video signals, meaning that the encoded color signals remain separate, producing a more defined image with minimal bleeding edges or chroma crawl.

3. Be thrifty but creative when using QuickTime in Director.
Although full-screen video is possible, some QuickTime codecs require a lot of processing power to play back efficiently. Therefore, smaller frame sizes may be necessary. There are still ways to be creative given this limitation. For example, you can integrate a small QuickTime clip into a larger pictorial framework composed of static elements. In Figure 11.5, the picture space is used aesthetically and resourcefully; the entire composition is treated as a landscape for static imagery, typographic content, and video.

11.5

The composition of this Director movie is treated as an interactive landscape for static images, Director animation, live video, and typographic content.

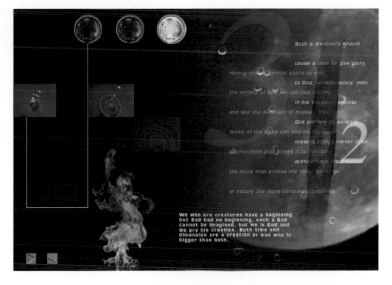

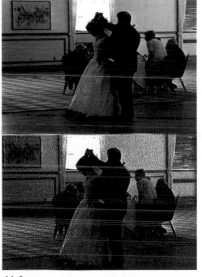

4. Experiment artistically with low color depths.
Experimenting with low color depths can achieve surprising artistic effects while keeping file size to a minimum.

5. Place small video clips inside of frames.
QuickTime clips that are directed to the Stage (or placed in the extreme front) can appear inside of larger static images.

6. Experiment with and test a variety of different codecs and their settings before rendering your final animation.

11.6

This QuickTime video clip was reduced to a color depth of 1-bit using Apple's Animation codec. This achieved a unique style while keeping file size small enough to enable smooth playback.

11.7

In a 640 x 480 pixel Director movie, a QuickTime animation is composed of several small video clips that animate across the frame. The QuickTime movie is superimposed over a static bitmap image designed to frame the animation.

11.8

A feathered mask is created for each animated composition in Adobe After Effects to give the impression of the elements fading into the background as they approach the bottom edge of the frame. In Macromedia Director, the QuickTime animations are placed on top of a bitmap image designed to frame the animation. Courtesy of Candle Corporation and the Devereux Group. © 2004 Candle Corporation.

7. Choose a cross-platform and backwards compatible codec. Cinepak is an example of a QuickTime codec that is recognized by both Mac and Windows platforms. Please refer to Chapter 9 for a listing of cross-platform software codecs.

8. Minimize the number of cast members on the stage. Director is not a rendering application; therefore, the number of cast members present on the screen at one time can hinder playback performance, especially if they are bitmap images. Numerous complicated movements also can cause delays in the animation. Bottom line: keep the animation simple.

9. Design a stub movie as an introduction. A stub movie is a small Director projector file that serves as an introduction while the main presentation is launching. The stub movie must be kept simple so that it loads quickly, allowing your main movie to download while it plays.

10. Use minimal color depth for Director presentations. Images saved at 24-bit resolutions have larger memory requirements than those with bit depths of 256 colors or less. As a result, animation redraw rates may slow down. If motion is a critical factor, it is better to trade color depth for better playback performance, since 8-bit content will spool from the hard drive faster.

Output for Digital Media

For information about creating stub movies, visit Macromedia at www.macromedia.com.

11. If Director is your final delivery format, use a stage that is the size of the smallest playback screen.

This will ensure that your movie will look the same on all monitor sizes without scaling. A simpler approach is to create separate projectors with stage sizes appropriate for different monitor sizes. You can assign file names to each projector that correspond to the monitor sizes to help your users select the appropriate one for their system. This, however, will require the most storage space. If you are confident with Lingo, Director's scripting language, you can design a single projector to play a small movie that uses the Lingo function "the deskTopRectList" to detect the user's monitor size.

Web

The improvement of Internet bandwidth is decreasing the popularity of the CD-ROM as Web developers improve authoring tools.

The prospect of facilitating real-time motion over the Web has been a technical challenge over the years. Additionally, the lack of an industry-standard animation format remains a problem. For example, Dynamic Hypertext Markup Language (dHTML) has strong animation support, but until Microsoft and Netscape mutually agree on how it should work, it cannot be deemed a standard. Some types of animations require browser plug-ins, while others can run on their own. Yet, traditional independent and commercial artists strive to push their ideas into this territory.

playback performance: the juggling act

Connection speed is the largest factor in determining how well an animation's frames will play back sequentially. The differences between modems, DSL, and cable connections are significant, and you should be aware of the transmission systems your target audience is most likely to have. Bandwidth can impose severe limitations in transmitting animations over the Web. Large files mean long download times and less efficient playback performance. The more data, the more

challenging it is for images to be displayed sequentially at smooth frame rates. File size is determined by frame dimensions, frame rate, color depth, and compression format.

So far, the Internet cannot support full-screen, high-quality animations with high frame rates. Therefore, we are forced to make compromises and decide where to place our priorities. For example, if motion is the most critical goal, you may need to sacrifice frame size to achieve smooth playback. (Most QuickTime movies on the Web use frame sizes of 320 x 240 or smaller.) Data compression to reduce the bandwidth requirements is also necessary for achieving reasonable download times. If image details are of prime importance, decreasing the frame rate may be the necessary trade-off for retaining acceptable picture quality.

Juggling these variables amid technical constraints can be viewed as obstacles or creative guidelines. As artists, it is our job to push the envelope both creatively and technically while we wait for the Web to mature.

static images for Web delivery

The two most common static image file formats used for Internet graphics are GIF and JPEG. You can optimize these image types through palette reduction and data compression. Macromedia Fireworks, Adobe Image Ready, and Discreet Cleaner are among the best available optimization tools.

GIF palette reduction

GIF images are capable of storing up to 256 different colors. These colors can be derived from the Web-safe palette, the Macintosh system palette, the Windows system palette, or an adaptive palette. However, the fewer colors used, the smaller the file and the faster it will download. Trimming colors to a more limited Web-safe palette not only dramatically reduces

the image's file size but also gives you a preview of how it will appear on both Macintosh and Windows systems.

JPEG compression

The international JPEG standard originally was developed to compress static bitmap images with the intention of reducing file size. It is an ideal format for photographic images that have gradual color shifts and continuous tones, versus solid graphics that contain sharp edge details.

When saving a JPEG file, most imaging programs provide a "Quality" or "Compression" option. A quality setting between 75 and 80% usually produces acceptable results. However, optimization programs such as Macromedia Fireworks or Adobe Image Ready give you much more control in finding a balance between file size and image quality.

Zooming into a bitmap that has been JPEG-compressed reveals artifacts that occur in areas of contrast where edges meet background imagery (11.9). As a lossy compressor, JPEG is not a suitable file format for storing data that is to be edited, since quality is lost every time the image is written and the data cannot be retrieved. An uncompressed format such as TIFF or Photoshop is a more appropriate choice for storing your original master images.

GIF animation

The most common file formats for delivering animations over the Web are animated GIF, QuickTime, and Flash.

The animated GIF format is an ideal low-tech option for adding kinetic images to Web pages. Animated GIFs can be produced simply by saving or exporting your work in animated GIF format from an animation/motion graphics program such

> If your only original image is a JPEG and you have no choice but to edit it, be sure to save it as a TIFF or Photoshop file to avoid further compression.

11.9

Closeup of artifacts that result from JPEG compression.

Compared to the original bitmap, sharp contrasty edges of letterforms and graphic shapes are the first to suffer.

as Adobe After Effects. Alternatively, individual frames created in an imaging program such as Adobe Photoshop or Procreate Painter, or generated by traditional hand-executed methods, can be compiled into an animated sequence with GIF animation software. With regard to the latter, each image frame (or cel) must be the same size and saved in GIF format. Using a sequential numbering scheme to name each image will prove helpful during the process of assembling the animation. (Tip: Begin with "01" instead of "1" if your piece contains more than 10 images.) Once the frames are created, they must be assembled into an animated sequence using Macromedia Fireworks or Adobe ImageReady. Once the animation is assembled, images can be manually inserted, modified, duplicated, or deleted.

Your first objective in delivering effective GIF animation is to make it aesthetically engaging. This means choosing colors that appear consistent on all video displays and being sure that there are enough frames to achieve believable motion. Your second objective is to deliver the piece smoothly and efficiently on all platforms by keeping file size to a minimum. This can be a challenging balancing act but well worth the effort. File size directly affects download time and playback performance. The smaller the file, the faster it will load and the better it will play. File size is a numbers game; the primary dictating factors are the number of pixels that change from frame to frame and the number of colors in the animation.

considering frame dimensions and timing

With regard to GIF animations (versus static GIF images), frame dimension is a primary criterion for determining file size, download time, and playback efficiency. Your goal is to keep the frame as small as possible while maintaining the effect that you want to achieve. An 8-bit 200 x 200 pixel GIF

weighs in at 40K, and LZW compression takes this down to 30K. Increasing the dimensions of the image to 400 x 400 pixels yields a size of 66K. Cropping away unneeded space lowers bandwidth requirements.

The number of frames and frame timing also are important considerations in GIF animations. The number of frames can affect the smoothness of the implied motion or change. Frame number also can affect file size, which in turn affects playback efficiency. (The pixels of every frame in a GIF animation are tallied to compute the total file size. For example, a single 15K image that is animated in eight frames results in a 120K animated GIF.) Successful GIF animations do not necessarily need large numbers of frames. Reducing the frame number can maintain the illusion of movement while conserving file size. You want to use the minimum number of images needed to accomplish the desired effect. This number depends on what kind of subject you are animating, and it often helps to visualize it first by producing a rough storyboard. It is not critical that you establish the correct number of frames immediately, as frames can be easily added or removed later. Also, an animation's timing does not have to be consistent throughout; each frame's display time can be specified independently. For example, frame 2 may appear on the screen for a quarter of a second, while frame 3 delays for 2 seconds.

managing colors and pixels

With static GIF images, an animated GIF's color palette can be reduced to a limited Web-safe or Adaptive palette in order to lower file size. Figure 11.10 demonstrates the effect of palette reduction on an animated GIF. In addition to the global palette that provides the default colors for an animation, each frame contains its own "local" color palette. Since each color requires 2–4 bytes for its description, a 256-color palette may

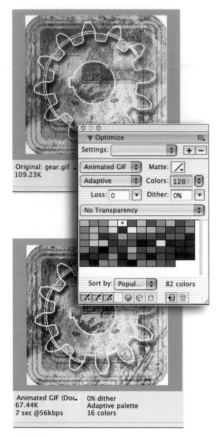

Original: gear.gif
109.23K

Animated GIF (Doc... 0% dither
67.44K Adaptive palette
7 sec @56kbps 16 colors

11.10

Adaptive palette reduction of an animated GIF eliminates redundant colors, which results in a smaller file.

Animated GIFs "stream" in the sense that they begin to play before they fully download. It may be asking a lot for viewers to wait for a 100K still image to load, but a 100K GIF animation that starts to play after 50K has loaded seems more reasonable.

GIF images use a lossless compression scheme designed by Lempel-Ziv-Welch (LZW) that can reduce a file to 38% of its original size.

require up to 1K. Forcing the cels to reference only colors from the global palette can reduce file size by approximately 1K per cel.

Another way to lower the size requirements of an animation is to prune out redundant pixels that recur from frame to frame and save only the pixels that change. Two fundamental techniques for accomplishing this are *minimum bounding box* and *frame differencing*. In the minimum bounding box technique, the second frame covers only the portion of the first frame that needs to be updated, where the change takes place. This partial image can be assembled into the animation as a replacement for a full frame containing redundant pixels that do not change. In frame differencing (also referred to as *dirty rectangle compression*), details in frame 2 that are redundant with the first image are substituted with transparency. Each subsequent frame contains only data that differs from the first frame, which continues to display underneath (11.11).

considering looping and frame disposal

Looping animated GIFs can offer an efficient solution for continuous animation on the Web. Looping is a setting that determines the number of times an animation will repeat. For example, a setting of 2 repeats a sequence twice after its initial run-through, while a setting of 0 produces infinite repetition. A loop also can be deleted, allowing a sequence to play once and stop. A short animated loop can be an effective way to hold your viewer's attention, while he or she waits for other material to download. If executed properly, your animated loop should be seamless, with a smooth transition between the last and first frame. If you design your animation not to loop, be sure that the last frame is considered.

Frame disposal methods allow you to control how images are removed after they are displayed in a GIF animation

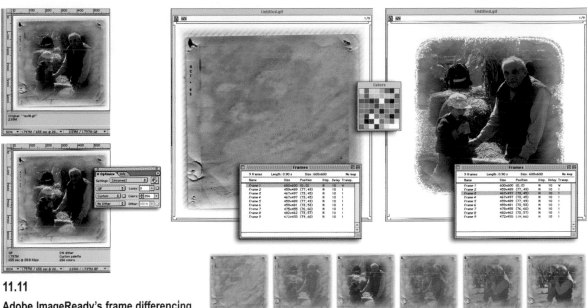

11.11

Adobe ImageReady's frame differencing (or "dirty rectangle") compression.

Following frame 1, redundant pixels in subsequent frames are replaced with transparency. The region behind the transparency is the imagery carried over from the first frame.

To use the page color as a background, you can use the BGCOLOR tag. This eliminates the background of the GIF, further reducing its size and bandwidth requirements.

sequence. For example, Gifbuilder's disposal options are: Unspecified, Do Not Dispose, Restore to Background, and Restore to Previous. "Do Not Dispose" displays the pixels from the previous frame beneath the frame that follows. As a result, frames build up in a stack, and every frame's pixels are displayed simultaneously. Each frame, however, does not have to contain a full image. In fact, a previously displayed frame or a solid background color can remain on the screen underneath subsequent frames that contain only the portion of the animation that changes. In Figure 11.12, using background transparency and frame disposal together decreases each frame's file size, improving the animation's performance. After the background color is made transparent, "Restore to Background" disposal displays that background color underneath each frame that follows. Only pixels that change are displayed on top of the background. You can specify a background color in the GIF file or determine it by the background color of the Web page. In Figure 11.13, "Restore to Previous" disposal is used to display smaller frames above a larger frame preceding it. Although this removal method also reduces file size, it is not supported by all Web browsers.

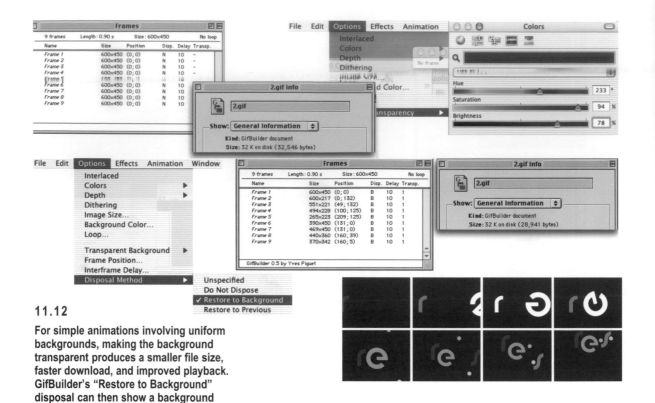

11.12

For simple animations involving uniform backgrounds, making the background transparent produces a smaller file size, faster download, and improved playback. GifBuilder's "Restore to Background" disposal can then show a background color underneath each frame.

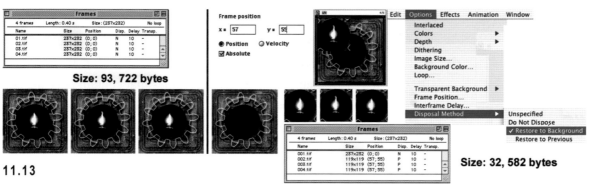

Size: 93, 722 bytes

Size: 32, 582 bytes

11.13

GifBuilder's "Restore to Previous" frame disposal method is used to display moving objects on top of a large, static background. Since frames 2, 3, and 4 containing the parts of the animation that change are smaller then the first frame, download time is quicker, and playback is improved.

incorporating animated GIFS onto a Web page

GIF animations can be used on a Web page as navigational buttons, links, or image maps, but not as background images. Fortunately, programming and plug-ins are not required; a common HTML tag is sufficient. A wise practice is to include HEIGHT and WIDTH parameters along with the actual animation's size for faster page downloading.

The GIF format contains an option for adding text statements such as copyright notices. This requires a nominal amount of space but should be used sparingly.

GIF data are stored as changes in the pixels across a horizontal scan. The fewer changes in color across each horizontal line of the image, the smaller the file.

delivery guidelines

1. Trim the fat!

Cropping unneeded space can shave a few pixels and help reduce file size. You might also create an animation at a slightly smaller dimension than desired and scale it up on your Web page. You lose minimal quality, but save precious file size and lower bandwidth requirements in the bargain.

2. Use interleaving.

Although interleaving can slightly increase file size, enabling this function allows the first cel to display immediately after it has been received by the browser. This gives your users something to look at while the remaining frames load.

3. Use an alternate text HTML tag.

Labeling your animation with alternate HTML text will tell your users what they are waiting for as the file downloads.

4. Reduce the colors to a limited Web-safe palette.

As mentioned earlier, the fewer colors that are used, the smaller the file, allowing for quicker download and more efficient playback. An ideal balance between image quality, download time, and playback is achieved when the number of colors is set to the middle range of these options: 2, 4, 8, 16, 32, 64, 128, or 256.

5. Match your animation style to GIF format.

Since large areas of flat colors and horizontal patterns compress better than graduated fills, soft shadows, and vertical patterns, stick to solid geometric shapes, horizontal lines, and text consisting of single colors (for example, logos and informational graphics).

6. Resolve color issues in advance, and use one palette.
Be sure that each image contains the final color palette before assembling the animation. Different palettes will produce bizarre results. Some GIF animation packages will set your first frame as the global palette and remap subsequent frames to that palette; others edit and remap the frames to a specified palette. The latter is not recommended, as it can impair the animation. For best results, choose Web-safe colors. This prevents undesirable color shifts and dithering from occurring on 8-bit systems.

7. For simple graphics and type, avoid dithering.
Although dithering can give a smoother appearance to areas of gradual color gradations, it significantly bumps up file size and download time. Dithering is unnecessary in the case of nonphotographic images and type (11.14).

8. Avoid interlacing.
GIF files have a save option for interlacing, allowing an animation to become progressively clearer as it downloads. Although this can give the illusion of a faster download, interlacing is notorious for hindering playback and increasing file size.

9. If you design your animation not to loop, be sure that the last frame is what you want to be seen after the animation has played.

10. Avoid automated effects and fancy transitions, since these quickly boost file size.

11. Create a rough storyboard to help you visualize timing.
A rough storyboard can help you choose the minimum number of frames needed to accomplish the desired motion or change.

11.14

For simple, nonphotographic images, removing the option of dithering maintains image quality and reduces the file size.

Output for Digital Media

12. Save the masters.

Always save a "master" RGB file or your original animation frames. If these consist of Photoshop layers and masks, be sure to save each file in native Photoshop format. GIF is not a suitable format for storing images that are to be edited, as color data is lost and cannot be recovered. An uncompressed format that supports 24-bit color such as TIFF or Photoshop should be used to store master copies of your work.

QuickTime animation

Although there are decent browsers and great desktop video tools, the state of video over the Web today is embryonic, from both a technical and a political standpoint. Currently, QuickTime, AVI video, and RealPlayer are the predominant Web video formats over the Internet. Yet, there is still not enough "horsepower" to deliver rich, full-screen video presentations on the Web, because of bandwidth constraints. Until the technology matures (and until public data networks change), having a purely video-driven Web site remains a pipe dream. Nevertheless, independent and commercial video and motion graphic artists continue to pursue their vision over the Web.

downloading versus streaming

All Web video formats, including QuickTime, Windows Media Player, and RealPlayer, allow data to be delivered over the Web through downloading or streaming. *Basic download* involves copying an animation from a server to a local computer and playing it back from the computer's hard drive. An improvement over basic download is *progressive download,* which allows animations to be saved in a manner that places the most critical information at the beginning of the file structure. Duration is no longer a determining factor for download time; the viewer only has to wait for the first portion of data to be copied. As this portion plays, the second

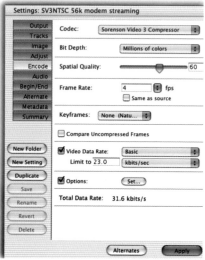

11.15

Discreet Cleaner provides suggested settings for processing QuickTime, RealSystem, and Windows Media files.

Dedicated media servers are available through SGI, IBM, Cisco, and Cornell Information Technologies.

portion downloads, and so forth. If the user's connection is within the range of the animation's data rate, the piece plays smoothly from beginning to end without a pause. If the user's bandwidth is too slow, delays in playback may occur during download. However, once the entire piece is downloaded, it can be played back repeatedly without hiccups related to slow connections and network congestion.

Unlike basic or progressive download, *streaming* allows animations to be delivered across a network almost immediately, without the hassle of long download times. This is achieved by keeping the user's computer in constant contact with a dedicated server running your movie. The animation begins playing as soon as the download process begins. During playback, new data continues to stream, while old data is automatically discarded after it is viewed. If the client's connection is slow, or if there is network congestion, data transfer rate is reduced and frames are dropped in order to preserve real-time playback. This type of delivery is best suited for long animations that are more than 2–3 minutes in length. Where the duration is long and there is a concern for audience attention span, streaming may be the best solution. Downloading, on the other hand, is the better option for short works, since it usually offers higher quality video. It is your responsibility to understand your audience and choose a method that suits their needs.

data compression

Digital video is one of the most bandwidth-intensive assets that are delivered over the Internet. Although playback of uncompressed, full-screen video over the Internet may be possible one day, compression is still necessary to facilitate smooth playback on the Web. Compressed video clips are reduced to more manageable file sizes, allowing them to download or stream more efficiently. As noted earlier, data

compression results in the reduction and reconfiguration of image data. QuickTime codecs work best for animations that are created or exported at 320 x 240 pixels or less.

delivery guidelines for digital video on the Web

1. Chop your movie clip into segments.
If you have a lengthy QuickTime movie that must play on low-end machines or with slow connections, chop it into smaller chunks so that it can be easily accessed.

2. Set the data rate slightly lower than your audience's connection speed.
If you are processing QuickTime material, Discreet Cleaner allows you to specify a "safe" data rate (11.16).

3. Design your work to handle the low frame rates required for Web delivery.
High frame rates are not necessary to achieve a persistence of vision. Animations that contain limited motion can get away with playback speeds of 8–12 fps. Collage and cutout animation, for example, tends to have a disjointed look, as images quickly change from one frame to the next. This limited-movement approach transfers well to the Web environment, where file size and bandwidth are critical agents.

4. Design your animation to handle the compression and size reduction required for Web delivery.
Image subtleties can be lost when an animation is scaled down to a smaller frame size. Compressed type may be illegible. Therefore, think BIG and avoid using excessive detail. Use close-range imagery that will hold up under downsizing. Use point sizes that stand up to data loss. Being aware of final output size and understanding how image quality may be affected can help you make wise artistic decisions in advance.

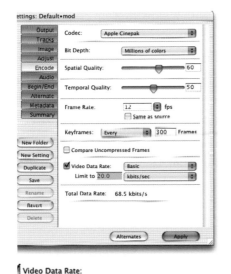

11.16

In Discreet Cleaner, VideoData Rate can be limited to a "safe" number in kilobytes or kilobits per second, depending upon the minimum target system that the video will be viewed on.

11.17
Image details can be lost when frame reduction and data compression are applied. Using a larger image in the frame helped maintain its overall quality.

5. Choose the right codec for your final distribution method. A list of cross-platform QuickTime codecs is provided in Chapter 9. Render a small portion of your piece with several different codecs and test them over the Web before rendering the final animation.

6. Choose compression settings based on the weakest possible link.
If a portion of your audience has slow Internet connections, you will need to accommodate users with dial-up modems. Remember that the higher the data rate, the better the quality, but the bigger the file and bandwidth requirements. Test your settings from a system with a slow dial-up connection.

Shockwave animation

Shockwave is a Web distribution mechanism for animations and interactive presentations created with Macromedia Director to play back over the Web. Shockwave ensures that Director content can be played back reliably, with identical performance on Windows and Macintosh and in Internet Explorer, Netscape Navigator, and AOL browsers.

A Director animation exported as a Shockwave movie for the Web is immediately viewable on both Macintosh and Windows platforms. This is not the case with CD-ROM authoring, where both the Windows and Macintosh versions of Director are required to ensure cross-platform compatibility.

End users will require the Shockwave player to view these files. Macromedia began distributing Shockwave Player in 1995 as a free utility, enabling Internet users to view Director content over the Web. Since it is backwards compatible, content that is produced in earlier versions of Director is viewable with the most current version of Shockwave Player.

Macromedia Shockwave Player can be downloaded for free at www.macromedia.com and www.shockwave.com.

delivery guidelines

1. Design for the version of Shockwave your audience is most likely to have.

There are some aspects of Shockwave that should be kept in mind if you plan to animate in Director (as opposed to Flash). First, if you are working in the most current version of Director, your viewers will need the most current Shockwave plug-in to view your animation. In considering your potential audience, determine which version of the Shockwave player they are more likely to have. This will help dictate which version of Director to use.

2. Keep cast members and motions to a minimum.

Too many elements moving on the stage at one time can hinder and delay playback. Keep your motions simple.

3. Minimize bitmaps and long sounds.

File size and bandwidth demands are attributed largely to imported bitmapped images and audio. Therefore, use bitmaps sparingly and compress them in a program such as Macromedia Fireworks or Adobe ImageReady. Use short looped sound sequences with low sample rates rather than long sounds at high sample rates.

4. Design for your audience's screen size.

Since different browsers provide different content-display areas, browser testing should be performed to determine the Stage dimensions of your Director presentation.

11.18

The 216-color Web-safe palette.

5. Use a Web 216 palette.

A Web-safe palette ensures color compatibility across both Macintosh and Windows platforms.

6. Design a "streamable stub."

Unlike Flash animations that load instantaneously, Shockwave displays a progress bar and Macromedia ad while your presentation loads. This is one reason many Web developers dislike Director as an authoring tool. A solution is to design your movie to be streamable and create a "stub movie" as an introduction that plays while the main movie assets download.

7. Provide an alternative viewing method for users who cannot recognize Shockwave content.

If you have doubts about your audience's ability to recognize Shockwave, generate an animated GIF or an image map so viewers will have something to watch without the Shockwave player. JavaScript provides a code that can detect whether Shockwave is installed on a user's browser. Alternatively, a plug-in Shockwave sniffer can detect the Shockwave plug-in on a user's machine and automatically redirects the user to a page containing an alternative format.

Flash animation

Considered Director's "little brother," Macromedia Flash was originally designed to provide true animation capabilities over the Web. Its vector-based format supports consistent, full-screen playback on all monitor sizes and across multiple platforms. Flash files can be viewed on Flash Player, Java, Director projectors, or Shockwave. Most Web users today have the Flash plug-in. (Macromedia claims over 80% of browsers in use currently contain the plug-in.)

Since Flash was originally designed as a Web animation and authoring program, SMPTE time code is not applicable. The time it takes for a movie to play back depends on factors such as Internet connection speed, complexity of image content, and computer processor speed.

The image's contrast is enhanced in order to achieve a better trace.

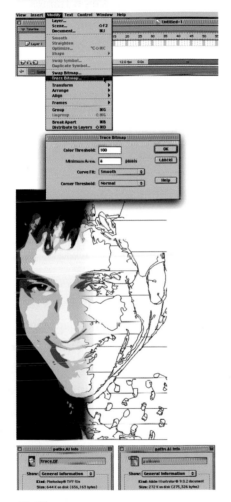

11.19

Flash's Trace Bitmap operation.

The Color Threshold setting controls the amount of colors; the higher the number, the fewer the colors. Minimum Area determines the size of the shapes created, and Curve Fit determines how Flash approximates the curves in the image.

delivery guidelines

1. Consider users with slow modem connections.

Flash uses streaming to transfer data from the server to the user's machine. An animation might play smoothly on a system that is connected to the Internet through DSL or a cable modem. However, slower transmissions may impede playback. An animation may stutter when it reaches a frame that marks the beginning of a complex motion sequence.

2. Stick with vector imagery.

Vector images take advantage of Flash's low bandwidth requirements. Bitmaps are bandwidth-heavy and should be avoided or used sparingly. If your presentation requires bitmapped images, compress them in an application such as Macromedia Fireworks or Adobe ImageReady. One of the best tools for bitmap-to-vector conversion is Macromedia Flash's Trace Bitmap function (11.19). Settings such as Color Threshold, Minimum Area, Curve Fit, and Corner Threshold allow you to control the accuracy with which the image is re-created. The resulting vector image can be used in a Flash animation or exported to Illustrator for further manipulation. Pixel-based content can also be manually converted into editable, scalable vector paths through the autotrace features in programs such as CorelDraw and Adobe llustrator

3. Trim the fat; keep file size to a minimum.

The more thrifty you are, the more efficiently your animation will stream over the Web. Keep the Symbol Library as small as possible. Symbols can be reused on the stage. Remove unnecessary symbols. If your animation contains audio, use short sound loops with low sample rates. Do not hesitate to compress the audio in sound application and reimport it into Flash. (Just be sure to delete the original sound file in Flash.)

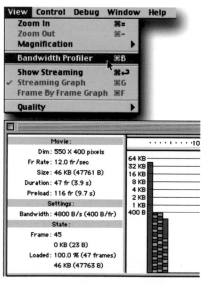

```
Movie Report
-----------------------------------------------
FrameFrame #   Frame Bytes   Total Bytes   Page
-----------------------------------------------
    1     46603      46603     Scene 1
    2       22      46625      2
    3       22      46647      3
    4       22      46669      4
    5       22      46691      5
    6       22      46713      6
    7       22      46735      7
    8       22      46757      8
    9       22      46779      9
   10       23      46802     10
Page                  Shape Bytes   Text Bytes
-----------------------------------------------
Scene 1                   0           0

Embedded Objects        226           0

Page                 Symbol Bytes   Text Bytes
-----------------------------------------------
Symbol 4               1842          0
Symbol 3                  0          0
Symbol 2                  0          0
Symbol 1                  0          0

Bitmap              Compressed   Compression
-----------------------------------------------
ball.pct              14236       88800   JPEG Quality=100
air1                  30949      110776
```

11.20

A size report can be generated when a Shockwave movie is published.

11.21

Flash's Bandwidth Profiler displays a kilobyte profile for each frame. Each bar represents a frame of the movie, and its size corresponds to the frame's size. The red line indicates if a frame will stream in real time with the modem speed specified. If a bar extends above the line, the movie must wait for that frame to load.

4. Generate a size report.

Flash allows you to generate a file size report to test your animation (11.20). If you open a .swf file, the Bandwidth Profiler allows you to view download performance graphically (11.21). By estimating typical Internet performance, it can eliminate some of the guesswork in determining where and how to save memory. Once you realize which frames are slowing playback, you can optimize or eliminate some of the content in those frames.

5. Avoid embedding QuickTime.

Although Flash MX is capable of integrating QuickTime, adding video capabilities to the Flash player increases its size. As an alternative, include a link to a QuickTime movie.

6. Keep the animation as simple as possible.

Too many elements that are moving on the stage at once can hinder playback performance, causing delays in your animation.

7. Create an alternative to viewing Flash content.

If you have doubts about your audience's ability to recognize Flash content, an animated GIF or an image map will allow your visitors to view something without the Flash player. A JavaScript code or a Flash plug-in sniffer can detect if the Flash Player is installed on your user's machine and redirect the user to a page containing an alternative format. (Information on creating a Flash sniffer is available at www.macromedia.com.)

general output guidelines

1. Assess your audience's network access, processing power, and memory configuration, and plan accordingly.

These factors affect how your work will download and play back on your user's machines.

2. Avoid useless animation.

Excessive animation not only adds to download time but can be disruptive to the viewer. Each animated element should be meaningful and add useful content to your page. A modest alternative to large video files that require heavy compression and size reduction is a sequence of still images in conjunction with good-quality audio narration.

3. Entertain during download.

Download delays annoy viewers. If the format you use requires an initial download, telling your audience that the animation is "loading" provides little comfort. A small distraction such as a looped GIF animation, sound, or a Flash or Shockwave introduction (for example, a credit sequence) may be enough to hold their attention until the main program is loaded.

4. If a Director Projector is your final delivery format, use a stage that is the size of the smallest playback screen.

This ensures that your movie will fit all monitor sizes.

Hard Drive

In comparison to disk-based presentations, hard drives offer the most forgiving and predictable delivery solution for direct playback on computer, especially if your animation is presented on the same system on which it was produced. If your work will be displayed on a different system, be aware of that machine's hard drive specifications, as well as the operating system it is running. The capacity to play back an animation from a hard drive depends on the sustained read rate of the drive, the power of the computer's CPU, and the capability of the video card. Ideally, your drive will have a read rate capable of handling the performance you require.

Suggested QuickTime output settings for hard drive playback:

frame rate: 15–29.97 fps

frame dimensions:
variable; standard sizes are 320 x 240, 640 x 480, and 720 x 480

pixel/bit depth:
millions of colors

software codec(s):
Cinepak, Sorenson, MPEG-2, and MPEG-4

animation file formats

The same animation file formats and authoring tools used for delivering Web and optical disk-based presentations can be used to deliver content directly from a computer's hard drive.

QuickTime

QuickTime is an industry standard format for delivering animations in presentations and as stand-alone movies on portable computers.

Flash

Flash MX's support for QuickTime, Action scripting, and advanced interactive programming capabilities work well for authoring presentations intended for direct hard drive playback. You can author Flash movies to play on either Mac or Windows. However, you will need a Flash player.

DVD-Video

The term DVD-Video applies to DVDs that are intended for the commercial distribution of prerecorded motion pictures.

DVD-Video hit the public marketplace in 1996, replacing the LaserDisc for home television viewing. The objective was to use digital media as a means of presenting full-length feature films for the motion picture industry. As an alternative to videotape, DVD-Video enables you to view content at the full size of the television screen at 29.97 frames per second. By 1999, it players, audio players, and recorders entered the Japanese, American, and European markets. Today, DVD-Video is the format of choice for movies, television, and music videos. Compared to standard VHS, image quality is superlative. As a digital format, the content does not degrade over time. Navigational features allow the incorporation of biographies, directors' commentaries, playlists, multi-angle viewing, surround sound, and random shuffle playback, extending the format to offer a more engaging experience. Interactive navigation allows viewers to jump between

different portions of a movie. Even DVD-ROM content, ranging from Web site links to interactive games based on the movie, can be viewed on a personal computer.

Although incompatibilities exist, DVD-Vs can play on most set-top players, as well as on most desktop computer systems that are equipped with a DVD drive and playback software.

output specifications

QuickTime is the most common file type for encoding animation to DVD-V compliant MPEG-2 for television display.

encoding and authoring

The most compliant video formats supported by DVD-Video are MPEG-1 and MPEG-2. Both are lossy compression schemes, as they discard redundant pixel information in order to gain storage space. MPEG-1 video is comparable to VHS resolution and also is used for VCDs (Video CDs). It yields longer playing times at the expense of reduced image quality without interlacing. MPEG-1 encoding is used where playing time takes precedence over resolution. For maximum quality, use MPEG-2, with a superior encoding algorithm and the capability of interlacing video for NTSC and PAL/SECAM.

Once you have created a QuickTime (or AVI) file, the next step in preparing your work for television output is *encoding*—a process that converts your video into the MPEG-1 or MPEG-2 format. Accompanying sound tracks are usually converted to separate AIFF or WAV components. There are several versatile applications capable of encoding for the DVD-Video standard. The most popular ones are Sony Slick Click to DVD, discreet Cleaner, Canopus ProCoder, and Nero Express.

Suggested QuickTime output settings for DVD-Video:

frame rate:
29.97 fps (NTSC) or 25 fps (PAL/SECAM)

frame dimensions:
720 x 480 pixels (NTSC), 720 x 576 pixels (PAL/SECAM)

pixel/bit depth: 24 bits

software codec(s): MPEG-2

Many applications compatible with the DVD-Video standard can author, encode, and burn prosumer-quality video and audio files to a DVD-R drive. Two common packages are iDVD and DVD Studio Pro.

Apple's iDVD provides a basic tool set for burning QuickTime content and still images onto a DVD-R disk. This program only works with Apple's internal SuperDrive; it does not support external third-party DVD burners. Additionally, it cannot burn to rewriteables. However, it is convenient in that it is tightly integrated with Apple's iLife utilities, such as iTunes, iPhoto, and iMovie. Apple's DVD Studio Pro is a more comprehensive DVD authoring program for the Macintosh, intended to work with Apple's DVD-R drive on Power Mac G4 systems. In comparison to iDVD, this application offers a broader array of control features such as motion menus (or small video clips intended to function as navigation elements). Apple also promises that "DVDs authored with DVD Studio Pro will run on most TV and computer-based players that are compliant with the DVD-Video standard."

URLs for DVD-V encoding:

www.sonystyle.com

www.discreet.com

www.canopus.com

www.nero.com

For the Windows platform, Sonic manufactures several DVD authoring programs. DVD Producer has an advanced DVD encoding engine. A more affordable package is Sonic ReelDVD, specifically designed for broadcast and business-to-business applications. DVDit! is designed to convert AVI, QuickTime, MPEG, and common bitmap images into appropriate formats and record them directly to DVD-R or CD-R.

URLs for DVD-V authoring:

www.apple.com/idvd

www.apple.com/dvdstudiopro

www.sonic.com

burning hardware and facilities

Most current desktop systems, such as Apple's iMac and Gateway's Profile 4, come with internal DVD recorders, putting DVD production within the reach of the average consumer. In 2001, Apple began selling a DVD-R/CD-RW

"SuperDrive" with its high-end G4 Macintosh computers. PowerBook systems also have become "ultraportable DVD-authoring stations." In the Windows realm, Sony's Dual RW DVD/CD drives support all popular DVD formats and are compatible with most home DVD players.

External recordable DVD drives (and recordable DVDs) continue to drop in price as worldwide demand accelerates. Manufacturers of external recordable DVD drives include FirewireDirect, Pioneer, Sony, and LaCie.

Information and pricing on recordable DVD drives can be found at the following URLs:

www.firewiredirect.com

www.pioneerelectronics.com

www.sony.com

www.lacie.com

If you do not own a DVD burner, there are DVD production facilities that can burn a master disk for you, as well as make duplicates. You will need to output your work to digital tape, a DVD-RAM disk, or a portable hard drive. Most facilities accept almost any tape and file format. The DVD Foundry, a licensed authoring facility, accepts Adobe After Effects or Apple Final Cut Pro timelines and their imported assets and will render the work to disk to achieve high-quality video for DVD-V playback. This eliminates the problems associated with transferring large video files. The DVD Foundry also can convert Macromedia Flash project files to the proper format for use in a DVD presentation.

general output guidelines

1. Designing for television takes careful planning.
Considerations for videotape output for television (e.g., color, picture quality, field flicker, and overscanning) also apply to DVD-Video for television display. (Please refer to guidelines for broadcast television output in Chapter 10.)

2. "Garbage in, garbage out."
MPEG-2 compression does not improve material originating from a low-quality video format or tape device. In fact, picture quality degrades even further during encoding. If you are

Video noise that is inherent in VHS and S-VHS is inconsistent between frames. The MPEG-2 encoder has difficulty distinguishing real image data from this noise and, as a result, produces a larger file. Noise-free formats such as D1 and D5, DigiBeta, D9, DVCPro 50, DVCam, DVCPro, and DV work best for MPEG-2 encoding. Analog tape formats such as Beta-SP and MII produce sufficient results, due to low noise and acceptable resolution. Since they are component formats, they also produce stable colors.

incorporating live-action footage, avoid capturing onto a consumer analog format such as VHS or S-VHS. Live video or computer-generated animation should be imported into the encoding software from the best possible source—your computer or a high-quality tape device.

3. Save your audio and video as separate files when outsourcing your work to a service bureau.
QuickTime Pro Player can export separate audio and video tracks. If DVD Studio Pro is installed on your system, you can use QuickTime Pro Player to access an export option called "Movie to MPEG 2." This allows you to save the visual component in MPEG2 format with a ".m2v" extension.

4. Make sure your DVD-Recordable drive is compatible with your DVD player.
Contact your DVD-ROM or DVD-video player manufacturer for specific compatibility information.

5. If you have access to a DVD-RAM drive, record your material to the DVD-RAM format.
This is an inexpensive way to test your project before committing it to other media.

Alternative Disk Formats

Several formats offer economical alternatives to purchasing DVD disks, DVD-V authoring software, and DVD recorders. These formats can be played on computers and on many stand-alone DVD players. Whether the following formats will endure in the industry is an open question.

A miniDVD (mini Digital Versatile Disc) is a CD-ROM containing an authored DVD-V presentation. This format includes the features of DVD-Video, minus the amount of

MiniDVDs are CD-ROMs that can store small amounts of DVD-authored video. A miniDVD also is referred to as a cDVD.

Suggested video output settings:

frame rate:
29.97 fps (NTSC) or 25 fps (PAL/SECAM)

frame dimensions:
720 x 480 pixels (NTSC), 720 x 576 pixels (PAL/SECAM)

pixel/bit depth: 24 bits

software codec(s): MPEG-2

The impetus behind the Video Compact Disc was to replace the older VHD video system used in Karaoke bars in Japan.

Suggested video output settings:

frame rate:
29.97 fps (NTSC) or 25 fps (PAL/SECAM)

frame dimensions:
352 x 240 (NTSC), 352 x 280 (PAL)

pixel/bit depth: 24 bits

software codec(s): MPEG-1

Despite the emergence of DVD-V, Super Video CD players are promoted in China as enhanced CD players that are capable of video playback.

Suggested video output settings:

frame rate:
29.97 fps (NTSC) or 25 fps (PAL/SECAM)

frame dimensions:
480 x 480 (NTSC), 480 x 576 (PAL)

pixel/bit depth: 24 bits

software codec(s): MPEG-2

playing time. MiniDVDs can store approximately 15–20 minutes of full-motion MPEG-2 video encoded at a data rate of 4 Mbps. There are a small number of stand-alone DVD set-top players with CD-R or CD-RW playback capabilities. However, miniDVDs can be played back on computers equipped with DVD-ROM drives and DVD playback software.

A Video Compact Disc (VCD) is a CD-ROM disk that holds approximately 74 minutes of MPEG-1 video and stereo-quality audio. Unlike the miniDVD, video picture quality is limited. Almost all computer DVD/CD-ROM drives and stand-alone VCD or DVD set-top players with CD-R or CD-RW playback capabilities will recognize a Video CD. Movies that have been released on Video CD require two disks.

A Super Video CD or Super VCD (SVCD) is a CD-ROM disk that holds approximately 35–45 minutes of MPEG-2 video and stereo-quality audio. Almost all computer DVD/CD-ROM drives and stand-alone VCD or DVD set-top players with CD-R or CD-RW playback capabilities will recognize a Super Video CD. Movies that have been released on SVCD usually require two or three disks.

index

Transition (continued)
between animation and live action, 163–164
between key frames, 207,
continuity in storyboarding, 103, 105–106
explanation and types, 140–142
foregound-to-background, 244, 258, 261–262, 272
in velocity, 219
Trees for Life, 53–54, 96, 169
Trumbull, Douglas, 60

U
Ultimatte
AdvantEdge, 259–260
compositing system, 258–259
paint products, 256
USB
connection, 333–334
drives, 337–338

V
Value, 111–113, 121, 131, 133
Vanderbeek, Stan, 33–34
Vector-based animation, 75, 177, 196–197, 204, 239
Velocity
control in After Effects, 145, 209, 211, 217, 219–220
explanation, 143
linear, 217–218
nonlinear, 219
Video
analog signals, 331–332
analog formats, 339–341
comparison to film, 315
digital formats, 341–342
guidelines for CD/DVD-ROM display, 352–355
guidelines for Web display, 367–368

Video (continued)
output settings for film transfer, 317
specifications, 321–323

W
Web animation, 359–377
animated GIFs, *see* GIFs animated
delivery guidelines, 363–365
Flash, *see* Flash (Macromedia)
playback performance, 355–356
QuickTime, *see* QuickTime for Web display
Whitney, James, 32–33
Whitney, John, 31–33, 35

X
Xerography, 162–163, 166

Z
Zoetrope, *see* Optical inventions
Zohar, Noga, 52